D0719756

Crisis of the Real

Joe Gioia, *Andy Grundberg*, 1988

WRITERS AND ARTISTS ON PHOTOGRAPHY

ANDY GRUNDBERG

Crisis of the Real

Writings on Photography Since 1974

APERTURE

OTHER BOOKS IN THE SERIES

Wright Morris
Time Pieces: Photography, Writing, and Memory

Nancy Newhall
From Adams to Stieglitz: Pioneers of Modern Photography

Fred Ritchin
In Our Own Image: The Coming Revolution in Photography

Copyright © 1999 by Aperture Foundation, Inc. Text copyright © 1999 by Andy Grundberg. Photograph copyrights listed on page 280. All rights reserved under International and Pan-American Copyright Conventions. No part of this book may be reproduced in any form whatsoever without written permission from the publisher.

Library of Congress Catalog number 99-61682
Hardcover ISBN 0-89381-854-2; Paperback ISBN 0-89381-855-0

Book design by Wendy Byrne
Jacket design by Michelle M. Dunn
Typesetting by Danielle R. Spencer

Printed and bound by RR Donnelly & Sons Company.

The staff at Aperture for *Crisis of the Real* is Michael E. Hoffman, *Executive Director*; Steve Dietz, *Vice President, Editorial—Books*; Jane Marsching, *Assistant Editor*; Shelby Burt, Thomas Seelig, *Editorial Work-Scholars*; Stevan Baron, *Vice President, Production*; Linda Tarack, *Production Associate*. Series editor: Steve Dietz. Series design: Wendy Byrne. Editor for revised edition: Phyllis Thompson Reid. Editorial Work-Scholar: Rebecca A. Kandel.

Aperture Foundation, Inc., publishes a periodical, books, and portfolios of fine photography to communicate with serious photographers and creative people everywhere. A complete catalog is available upon request. Address: 20 East 23 Street, New York, NY 10010. Phone: (518) 789-9003. Fax: (518) 789-3394. Toll-free: (800) 929-2323. Visit the Aperture website at: http://www.aperture.org

Aperture Foundation books are distributed internationally through: CANADA: General/Irwin Publishing Co., Ltd., 325 Humber College Blvd., Etobicoke, Ontario, M9W 7C3. Fax: (416) 213 1917 UNITED KINGDOM, SCANDINAVIA, AND CONTINENTAL EUROPE: Robert Hale, Ltd., Clerkenwell House, 45-47 Clerkenwell Green, London EC1R OHT. Fax: 44-171-490-4958; NETHERLANDS, BELGIUM, LUXEMBURG: Nilsson & Lamm, BV, Pampuslaan 212-214, P.O. Box 195, 1382 JS Weesp. Fax: 31-294-415054; AUSTRALIA: Tower Books Pty. Ltd. Unit 9/19 Rodborough Road, Frenchs Forest, New South Wales. Fax: 61-2-99755599; NEW ZEALAND: Tandem Press, 2, Rugby Road, Birkenhead, Auckland 10, New Zealand. Fax: 64-9-480 14 55; INDIA: TBI Publishers, 46, Housing Project, South Extension Part I, New Delhi 110049. Fax: 91-11-461-0576.

For international magazine subscription orders for the periodical *Aperture*, contact Aperture International Subscription Service, P.O. Box 14, Harold Hill, Romford, RM3 8EQ, United Kingdom. One year: £30.00. Price subject to change.

To subscribe to the periodical *Aperture* in the U.S.A. write Aperture, P.O. Box 3000, Denville, New Jersey 07834. Toll-free: 1-800-783-4903. One year: $40.00. Two years: $66.00.

Second edition

10 9 8 7 6 5 4 3 2

Contents

Illustrations

Acknowledgments

I HAVE HAD MANY sympathetic and vigilant editors over the years. Among those who deserve special mention are the following:

At the *New York Times*, I have been privileged to work with Sunday Arts and Leisure editors William Honan, Robert Berkvist, Michael Leahy, and Constance Rosenblum; and Ann Barry, Jack Schwartz, and Marilyn Minden. At the *New York Times Book Review*, Harvey Shapiro, LeAnn Schreiber, Michael Levitas, and Rebecca Sinkler have welcomed my contributions over the years, as have Marvin Siegel, Annette Grant, and Myra Forsberg on the daily. In addition, my colleagues John Russell, Michael Brenson, Michael Kimmelman, and Roberta Smith have established an environment of critical rigor that has been indispensable to my own thinking.

Elsewhere, those who have provided selfless enthusiasm and support include Constance Sullivan of Polaroid's *Close Up* magazine; Lise Holst of Independent Curators Incorporated; David Featherstone at The Friends of Photography; and, at Aperture, Steve Dietz. As the editor of this book, Steve has shown great insight, understanding, and firmness in the face of my incorrigible procrastination.

One's deepest debts often are located in one's beginnings. In regard to my career as a critic, and much else besides, I owe more than gratitude to Julia Scully, former editor of *Modern Photography* magazine, whose intelligent guidance and assistance have been crucial to my development. I also am indebted to the encouragement and perseverance of Elizabeth C. Baker, Joan Simon, and Scott Burton, who nursed me through my early reviews at *Art in America* in the 1970s; Charles Hagen, then of *Afterimage* and now a friend and sounding board; Gerald Marzorati, who signed me on as photography critic of *The Soho Weekly News*; and Hilton Kramer, who as chief art critic of the *New York Times* added me to the roster of *Times* writers.

Critics do not spring full-grown from the earth; they have to find their legs (and ideas) while wallowing in the public eye. I have been fortunate to have had editors who allowed me to develop at my own pace, and to have had my work appear in publications that honor the written word.

Foreword to the Second Edition

SINCE THE FIRST edition of this book appeared at the beginning of the 1990s, postmodernism in the visual arts has come to seem an historical episode, if not an historical artifact. Artists, curators, and critics now go to great lengths to avoid using the word, as if the idealistic aspirations to revolutionize artmaking in the 1980s were, in retrospect, somewhat embarrassing and something of a failure (and despite the lack of a new catchall term for the art of the nineties). Yet the ways in which photography was employed to advance the project of postmodernist art in the eighties continue to resonate in the art of today.

While the camera art of the last quarter of the twentieth century ultimately may not have replaced our belief in the progressive development of modernism with an ahistorical conviction in the impossibility of originality and authorship, it remains vitally important for its role in bringing photography fully and finally into the arena of painting and sculpture. The institutions that support this arena no longer have an interest in viewing photography as a medium apart; indeed, the grounds on which photographs were accepted as museum objects and collectible objects in the 1970s seem even more distant today than they did ten years ago. What has fallen away in the last ten years is not the use and appreciation of photography within the wider world of art but the intense (and, in retrospect, narrow) concentration on mass media as our culture's most important formative influence.

Instead of seeking to decode and deconstruct images from television, cinema, fashion, and advertising, many of the artists using photography in the 1990s have focused their attentions on representations of a putatively more authentic nature, from abstraction to autobiographical and cultural documentation. At the same time, their awareness of the lens's ability to create believable fictions has not been suppressed, so that much of today's most intriguing work is simultaneously true and false, authentic and artificial. The final section of this edition contains several additional essays, written in the last ten years, that elaborate on these developments.

As for my own changes, my critical perspective has been fundamentally altered since the first edition by my decision in 1991 to forsake daily journalism, in the form of writing for the *New York Times*, for the dubious remove of the museum and the academy. I also removed myself from New York City for much of the nineties in the hope of acquiring a less provincial point of view. While this made my deadlines arrive less frequently, it has not required me to renounce anything that appears on these pages. Nor has it stilled my enthusiasm for writing about photography and art.

Introduction

TO WRITE ABOUT PHOTOGRAPHY in the 1970s and 1980s was to bear witness to a remarkable flowering of the medium as an art. At the same time, however, there was a fundamental shift in what the art of photography was considered to be. When I made my first attempts to comprehend the medium, starting in 1974, photography was still perceived primarily as an instrument of social reality, able to represent the way things really were in the world. Despite this, its status as an art was usually measured by the degree to which its reality-bearing function could be violated by the subjectivity that photographers managed to instill in their pictures.

By the late 1970s, it became clear that this view of photography's role as an art was both insular and problematic. Its objective/subjective polarities, and its assumptions about the photograph's autonomy and authorship, seemed increasingly distant from the medium's functioning in popular culture and its omnipresence in everyday life. To account for these manifestations, a new breed of photographic artists, one with relatively little allegiance to photography's history or traditions, transformed the very definition of what constitutes the art of photography.

Today, as throughout most of the medium's more than 150 years, the question of what the art of photography is or should be remains contested—which is all to the good, in my opinion. Nonetheless, this collection of essays, articles, and reviews represents an attempt to sort through the various claims advanced in the course of the last two decades on behalf of photography's aesthetic realm. It includes reassessments of the contributions of major figures in twentieth-century photography, considerations of the meanings and manifestations of postmodernist art, and what I would consider a predominantly skeptical analysis of the established traditions of photographic practice, from photojournalism to portraiture. I have also ventured to speculate on photography's future role in the culture, both as an art form and as a social instrument, now that what Walter Benjamin called the age of mechanical reproduction has given way to the age of electronic simulation.

Another characteristic of the climate for photography in the 1970s and 1980s was a dramatic increase in the amount and quality of criticism addressed to it. In part, this was a consequence of an exhaustion of new ideas about painting and sculpture, but more important was the recognition of how much and how well photography defines our social reality. The theoretical and critical

investigation of photographs as signs, and of the medium as a sign system much like language but fundamentally different from it, has shaped not only these essays but also the field of photography criticism as it now exists. To an extent, my writings represent a dialogue between the ideas advanced by theorists like Benjamin, Roland Barthes, and Jean Baudrillard and the concrete, immediate, and unruly realms I confront when looking at camera pictures.

In compiling any collection of writings, there are choices to be made. In deciding what to include here, I was motivated by sometimes conflicting desires: to represent the art and ideas of my time as well as my personal preoccupations, to focus on artists who seem particularly important as individuals and also on those whose works embody crucial critical questions, and to give as broad an account of the last two decades as possible. I have also endeavored to organize the various essays in a way that would give them an overall coherence and shape—without, I hope, oversimplifying the texture of photographic practice of the last twenty years.

The blessing and curse of being an editor is wanting to make things clearer. My editors over the years have been an admirable and hard-working lot, and many of their suggestions and corrections have kept me from atrocities of thought and language I now shudder to recall. In some cases I have incorporated their editorial changes, giving them claim to a share of authorship; in other instances I have returned to my prepublication original, feeling that the exigencies of clarity may have erased some of the intricacies of meaning. By nature I prefer complexity to simplicity, which may explain the lack of a single, absolute ideology in my writing. It is a lack that I do not regret.

I do regret having earned, through no impulse of my own, the title of "photography critic." I firmly believe that criticism is a discipline of its own, involving habits of analytical thought and close attention, and that its practice ultimately remains outside of considerations of medium or material. I also believe that photography as I encounter it in galleries, museums, and books is a form of art. At best I am an art critic who specializes in writing about photography, not unlike those art critics who confine themselves to writing about painting or sculpture. The distinction is important, I think, because it reflects another, more invidious one: that between photography and art. Today, as I believe these essays make clear, photographs do not have an appositional relationship to art, but an integral one. If anything, camera pictures constitute some of the most compelling works of art of the late twentieth century. I consider myself fortunate to have been able to see and respond to many of them when they first appeared in the public eye.

I. The Crisis of the Real

The Crisis of the Real

Disneyland is presented as imaginary in order to make us believe that the rest is real, when in fact all of Los Angeles and the America surrounding it are no longer real, but of the order of the hyperreal and of simulation. It is no longer a question of a false representation of reality (ideology), but of concealing the fact that the real is no longer real JEAN BAUDRILLARD[1]

TODAY WE FACE A CONDITION in the arts that for many is both confusing and irritating—a condition that goes by the name postmodernism. But what do we mean when we call a work of art postmodernist? And what does postmodernism mean for photography? How does it relate to, and challenge, the tradition of photographic practice as Beaumont Newhall has so conscientiously described it?[2] Why are the ideas and practices of postmodernist art so unsettling to our traditional ways of thinking? These are questions that need to be examined if we are to understand the nature of today's photography, and its relation to the larger art world.

What is postmodernism? Is it a method, like the practice of using images that already exist? Is it an attitude, like irony? Is it an ideology, like Marxism? Or is it a plot hatched by a cabal of New York artists, dealers, and critics, designed to overturn the art-world establishment and to shower money and fame on those involved? These are all definitions that have been proposed, and, like the blind men's description of the elephant, they all may contain a small share of truth. But as I hope to make clear, postmodernist art did not arise in a vacuum, and it is more than a mere demonstration of certain theoretical concerns dear to twentieth-century intellectuals. I would argue, in short, that postmodernism, in its art and its theory, is a reflection of the conditions of our times.

One complication in arriving at any neat definition of postmodernism is that it means different things in different artistic media. The term first gained wide currency in the field of architecture,[3] as a way of describing a turn away from the hermetically sealed glass boxes and walled concrete bunkers of modern architecture. In coming up with the term postmodern, architects had a very specific and clearly defined target in mind: the "less is more" reductivism of Mies van der Rohe and his disciples. At first postmodernism in architecture meant eclecticism: the use of stylistic flourishes and decorative ornament with a kind of carefree, slapdash, and ultimately value-free abandon.

Postmodernist architecture, however, combines old and new styles with an almost hedonistic intensity. Freed of the rigors of Miesian design, architects felt at

liberty to reintroduce precisely those elements of architectural syntax that Mies had purged from the vocabulary: historical allusion, metaphor, jokey illusionism, spatial ambiguity. What the English architectural critic Charles Jencks says of Michael Graves's Portland building is true of postmodern architecture as a whole: "It is evidently an architecture of inclusion which takes the multiplicity of differing demands seriously: ornament, colour, representational sculpture, urban morphology—and more purely architectural demands such as structure, space, and light."[4]

If architecture's postmodernism is involved with redecorating the stripped-down elements of architectural modernism, thereby restoring some of the emotional complexity and spiritual capacity that the best buildings seem to have, the postmodernism of dance is something else. Modern dance as we have come to know it consists of a tradition extending from Löie Fuller, in Paris in the 1890s, through Martha Graham, in New York in the 1930s. As anyone who has seen Miss Graham's dances can attest, emotional, subjective expressionism is a hallmark of modern dance, albeit within a technically polished framework. Postmodernist dance, which dates from the experimental work performed at the Judson Church in New York City in the early 1960s, was and is an attempt to throw off the heroicism and expressionism of modernist dance by making dance more vernacular.[5] Inspired by the pioneering accomplishments of Merce Cunningham, the dancers of the Judson Dance Theater—who included Trisha Brown, Lucinda Childs, Steve Paxton and Yvonne Rainer—based their movements on everyday gestures such as walking and turning, and often enlisted the audience or used untrained walk-ons as dancers. Postmodern dance eliminated narrative, reduced decoration, and purged allusion—in other words, it was, and is, not far removed from what we call modern in architecture.

It is interesting to note that more recently this aesthetic of postmodernist dance has been replaced in vanguard circles in New York by an as-yet-unnamed style that seeks to reinject elements of biography, narrative, and political issues into the structure of the dance, using allusion and decoration and difficult dance steps in the process. It is, in its own way, exactly what postmodern architecture is, inasmuch as it attempts to revitalize the art form through inclusion rather than exclusion. Clearly, then, the term postmodernism is used to mean something very different in dance than it does in architecture. The same condition exists in music, and in literature—each defines its postmodernism in relation to its own peculiar modernism.

To edge closer to the situation in photography, consider postmodernism as it is constituted in today's art world—which is to say, within the tradition and practice of painting and sculpture. For a while, in the 1970s, it was possible to think of postmodernism as equivalent to pluralism, a catchword that was the art-world

equivalent of Tom Wolfe's phrase "The Me Decade." According to the pluralists, the tradition of modernism, from Cézanne to Kenneth Noland, had plumb tuckered out—had, through its own assumptions, run itself into the ground. Painting was finished, and all that was left to do was either minimalism (which no one much liked to look at) or conceptualism (which no one could look at, its goal being to avoid producing still more art "objects"). Decoration and representation were out, eye appeal was suspect, emotional appeal thought sloppy, if not gauche.

Facing this exhaustion, the artists of the 1970s went off in a hundred directions at once, at least according to the pluralist model. Some started painting frankly decorative pattern paintings. Some made sculpture from the earth, or from abandoned buildings. Some started using photography and video, mixing media and adding to the pluralist stew. One consequence of the opening of the modernist gates was that photography, that seemingly perennial second-class citizen, became a naturalized member of the gallery and museum circuit. But the main thrust was that modernism's reductivism—or, to be fair about it, *what was seen as modernism's reductivism*—was countered with a flood of new practices, some of them clearly antithetical to modernism.

But was this pluralism, which is no longer much in evidence, truly an attack on the underlying assumptions of modernism, as modernism was perceived in the mid- to late 1970s? Or was it, as the critic Douglas Crimp has written, one of the "morbid symptoms of modernism's demise"?[6] According to those of Crimp's critical persuasion (which is to say, of the persuasion of *October* magazine) postmodernism in the art world means something more than simply what comes after modernism. It means, for them, an attack on modernism, an undercutting of its basic assumptions about the role of art in the culture and about the role of the artist in relation to his or her art. This undercutting function has come to be known as "deconstruction," a term for which the French philosopher Jacques Derrida is responsible.[7] Behind it lies a theory about the way we perceive the world that is both rooted in, and a reaction to, structuralism.

Structuralism is a theory of language and knowledge, and it is largely based on the Swiss linguist Ferdinand de Saussure's *Course in General Linguistics* (1916). It is allied with, if not inseparable from, the theory of semiotics, or signs, pioneered by the American philosopher Charles S. Peirce about the same time. What structuralist linguistic theory and semiotic sign theory have in common is the belief that things in the world—literary texts, images, what have you—do not wear their meanings on their sleeves. They must be deciphered, or decoded, in order to be understood. In other words, things have a "deeper structure" than common sense permits us to comprehend, and structuralism purports to provide a method that allows us to penetrate that deeper structure.

Basically, its method is to divide everything in two. It takes the sign—a word, say, in language, or an image, or even a pair of women's shoes—and separates it

into the "signifier" and the "signified." The signifier is like a pointer, and the signified is what gets pointed to. (In Morse code, the dots and dashes are the signifiers and the letters of the alphabet the signifieds.) Now this seems pretty reasonable, if not exactly simple. But structuralism also holds that the signifier is wholly arbitrary, a convention of social practice rather than a universal law. Therefore, structuralism in practice ignores the "meaning," or the signified part of the sign, and concentrates on the relations of the signifiers within any given work. In a sense, it holds that the obvious meaning is irrelevant; instead, it finds its territory within the structure of things—hence the name structuralism. Some of the consequences of this approach are detailed in Terry Eagleton's book *Literary Theory: An Introduction:*

> First, it does not matter to structuralism that [a] story is hardly an example of great literature. The method is quite indifferent to the cultural value of its object. . . . Second, structuralism is a calculated affront to common sense. . . . It does not take the text at face value, but 'displaces' it into a quite different kind of object. Third, if the particular contents of the text are replaceable, there is a sense in which one can say that the 'content' of the narrative is its structure.[8]

We might think about structuralism in the same way that we think about sociology, in the sense that they are pseudosciences. Both attempt to find a rationalist, scientific basis for understanding human activities—social behavior in sociology's case, writing and speech in structuralism's. They are symptoms of a certain historical desire to make the realm of human activity a bit more neat, a bit more calculable. Structuralism fits into another historical process as well, which is the gradual replacement of our faith in the obvious with an equally compelling faith in what is not obvious—in what can be uncovered or discovered through analysis. We might date this shift to Copernicus, who had the audacity to claim that the earth revolves around the sun even though it is obvious to all of us that the sun revolves around the earth, and does so once a day. To quote Eagleton:

> Copernicus was followed by Marx, who claimed that the true significance of social processes went on 'behind the backs' of individual agents, and after Marx, Freud argued that the real meanings of our words and actions were quite imperceptible to the conscious mind. Structuralism is the modern inheritor of this belief that reality, and our experience of it, are discontinuous with each other.[9]

Poststructuralism, with Derrida, goes a step further. According to the poststructuralists, our perceptions only tell us about what our perceptions are, not about the true conditions of the world. Authors and other sign makers do not control their meanings through their intentions; instead, their meanings are undercut, or "deconstructed," by the texts themselves. Nor is there any way to arrive at the

"ultimate" meaning of anything. Meaning is always withheld, and to believe the opposite is tantamount to mythology. As Eagleton says, summarizing Derrida:

> Nothing is ever fully present in signs: it is an illusion for me to believe that I can ever be fully present to you in what I say or write, because, to use signs at all entails that my meaning is always somehow dispersed, divided and never quite at one with itself. Not only my meaning, indeed, but me: since language *is* something I am made out of, rather than merely a convenient tool I use, the whole idea that I am a stable unified entity must also be a fiction. . . . It is not that I can have a pure, unblemished meaning, intention *or* experience which then gets distorted and refracted by the flawed medium of language; because language is the very air I breathe, I can never have a pure, unblemished meaning or experience at all.[10]

This inability to have "pure, unblemished meaning or experience at all" is, I would submit, exactly the premise of the art we call postmodernist. And, I would add, it is the theme that characterizes most contemporary photography, explicitly or implicitly. Calling it a "theme" is perhaps too bland: it is the crisis that photography and all other forms of art face in the late twentieth century.

But once we know postmodernism's theoretical underpinnings, how are we to recognize it in art? Under what guise does it appear in pictures? If we return to how postmodernism was first conceived in the art world of the 1970s—namely, under the banner of pluralism—we can say quite blithely that postmodernist art is art that looks like anything *except* modernist art. In fact, we could even concede that postmodernist art could incorporate the modernist "look" as part of its diversity. But this pinpoints exactly why no one was ever satisfied with pluralism as a concept: it may well describe the absence of a single prevailing style, but it does not describe the *presence* of anything. A critical concept that embraces everything imaginable is not of much use.

The critical theory descended from structuralism has a much better chance of defining what postmodernist visual art should look like, but even with that there is some latitude. Most postmodernist critics of this ideological bent insist that postmodernist art be oppositional. This opposition can be conceived in two ways: as counter to the modernist tradition, and/or as counter to the ruling "mythologies" of Western culture, which, the theory goes, led to the creation of the modernist tradition in the first place. These same critics believe that postmodernist art therefore must debunk or "deconstruct" the "myths" of the autonomous individual ("the myth of the author") and of the individual subject ("the myth of originality"). But when we get to the level of how these aims are best accomplished—that is, what style of art might achieve these ends—we encounter critical disagreement and ambiguity.

One concept of postmodernist style is that it should consist of a mixture of media, thereby dispelling modernism's fetishistic concentration on the medium

as message—painting about painting, photography about photography, and so on. For example, one could make theatrical paintings, or filmic photographs, or combine pictures with the written word. A corollary to this suggests that the use of so-called alternative media—anything other than, say, painting on canvas and sculpture in metal—is a hallmark of the postmodern. This is a view that actually lifts photography up from its traditional second-class status, and privileges it as the medium of the moment.

And there is yet another view that holds that the medium doesn't matter at all, that what matters is the way in which art operates within and against the culture. As Rosalind Krauss has written, "Within the situation of postmodernism, practice is not defined in relation to a given medium—[e.g.,] sculpture—but rather in relation to the logical operations on a set of cultural terms, for which any medium—photography, books, lines on walls, mirrors, or sculpture itself— might be used."[11] Still, there is no denying that, beginning in the 1970s, photography came to assume a position of importance within the realm of postmodernist art, as Krauss herself has observed.[12]

Stylistically, if we may entertain the notion of style of postmodernist art, certain practices have been advanced as essentially postmodernist. Foremost among these is the concept of pastiche, of assembling one's art from a variety of sources. This is not done in the spirit of honoring one's artistic heritage, but neither is it done as parody. As Frederic Jameson explains in an essay called "Postmodernism and Consumer Society":

> Pastiche is, like parody, the imitation of a peculiar or unique style, the wearing of a stylistic mask, speech in a dead language; but it is a neutral practice of such mimicry, without parody's ulterior motive, without the satirical motive, without laughter, without that still latent feeling that there exists something *normal* compared to which what is being imitated is rather comic. Pastiche is blank parody, parody that has lost its sense of humor[13]

Pastiche can take many forms; it doesn't necessarily mean, for example, that one must collage one's sources together, although Robert Rauschenberg has been cited as a kind of Ur-postmodernist for his combine paintings of the 1950s and photocollages of the early 1960s.[14] Pastiche can also be understood as a peculiar form of mimicry in which a simultaneous process of masking and unmasking occurs.

We can see this process at work in any number of artworks of the 1980s. One example is a 1982 painting by Walter Robinson titled *Revenge*. The first thing to be said about *Revenge* is that it looks like something out of a romance magazine, not something in the tradition of Picasso or Rothko. It takes as its subject a rather debased, stereotypical view of the negligee-clad femme fatale, and paints her in a rather debased, illustrative manner. We might say that it adopts the

tawdry, male-dominated discourse of female sexuality as found at the lower depths of the mass media. It wears that discourse as a mask, but it wears this mask not to poke fun at it, nor to flatter it by imitation, nor to point us in the direction of something more genuine that lies behind it. It wears this mask in order to unmask it, to point to its internal inconsistencies, its inadequacies, its failures, its stereotypical unreality.

Other examples can be found in the paintings of Thomas Lawson, such as his 1981 canvas *Battered to Death*. Now nothing in this work—which depicts a blandly quizzical child's face in almost photo-realist style—prepares us in the least for the title *Battered to Death*. Which is very much to the point: the artist has used as his source for the portrait a newspaper photograph, which bore the unhappy headline that is the painting's title. The painting wears the mask of banality, but that mask is broken by the title, shifted onto a whole other level of meaning, just as it was when it appeared in the newspaper. So this painting per- haps tells us something about the ways in which newspapers alter or manipulate "objectivity," but it also speaks to the separation between style and meaning, image and text, object and intention in today's visual universe. In the act of donning a mask it unmasks—or, in Derrida's terminology, it deconstructs.

There is, it goes without saying, a certain self-consciousness in paintings like these, but it is not a self-consciousness that promotes an identification with the artist in any traditional sense, as in Velázquez's *Las Meninas*. Rather, as Mark Tansey's painting *Homage to Susan Sontag* (1982) makes explicit, it is a self- consciousness that promotes an awareness of photographic representation, of the camera's role in creating and disseminating the "commodities" of visual culture.

This self-conscious awareness of being in a camera-based and camera-bound culture is an essential feature of the contemporary photography that has come to be called postmodernist. In Cindy Sherman's well-known series "Untitled Film Stills" for example, the 8-by-10 glossy is used as the model from which the artist manufactures a series of masks for herself. In the process, Sherman unmasks the conventions not only of *film noir* but also of woman-as-depicted-object. The stilted submissiveness of her subjects refers to stereotypes in the depiction of women and, in a larger way, questions the whole idea of personal identity, male or female. Since she uses herself as her subject in all her photographs, we might want to call these self-portraits, but in essence they deny the self.

A number of observers have pointed out that Sherman's imagery borrows heavily from the almost subliminal image universe of film, television, fashion photography, and advertising. One can see, for instance, certain correspondences between her photographs and actual film publicity stills of the 1950s. But her pictures are not so much specific borrowings from the past as they are distil- lations of cultural types. The masks Sherman creates are neither mere parodies of cultural roles nor are they layers, like the skin of an onion, which, peeled back,

might reveal some inner essence. Hers are perfectly poststructuralist portraits, for they admit to the ultimate unknowableness of the "I." They challenge the essential assumption of a discrete, identifiable, recognizable author.

Another kind of masking goes on in Eileen Cowin's tableaux images taken since 1980, which she once called *Family Docudramas*. Modeled loosely on soap-opera vignettes, film stills, or the sort of scenes one finds in a European *photo-roman*, these rather elegant color photographs depict arranged family situations in which a sense of discord and anxiety prevails. Like Sherman, Cowin uses herself as the foil of the piece, and she goes further, including her own family and, at times, her identical twin sister. In the pictures that show us both twins at once, we read the two women as one: as participant and as observer, as reality and fantasy, as anxious ego and critical superego. Cowin's work unmasks many of the conventions of familial self-depiction, but even more importantly, they unmask conventional notions of interpersonal behavior, opening onto a chilling awareness of the disparity between how we think we behave and how we are seen by others to behave.

Laurie Simmons's photographs are as carefully staged—as fabricated, as directorial—as those of Cindy Sherman and Eileen Cowin, but she usually makes use of miniaturized representations of human beings in equally miniaturized environments. In her early dollhouse images, female figures grapple somewhat uncertainly with the accouterments of everyday middle-class life— cleaning bathrooms, confronting dirty kitchen tables, bending over large lipstick containers. Simmons clearly uses the doll figures as stand-ins for her parents, for herself, for cultural models as she remembers them from the 1960s, when she was a child growing up in the suburbs. She is simultaneously interested in examining the conventions of behavior she acquired in her childhood and in exposing the conventions of representations that were the means by which these behavior patterns were transmitted. As is true also of the work of Ellen Brooks, the dollhouse functions as a reminder of lost innocence.

The works of Sherman, Cowin, and Simmons create surrogates, emphasizing the masked or masking quality of postmodernist photographic practice. Other photographers, however, make work that concentrates our attention on the process of unmasking. One of the these is Richard Prince, the leading practitioner of the art of "rephotography." Prince photographs pictures that he finds in magazines, cropping them as he sees fit, with the aim of unmasking the syntax of the advertising-photography language. His art also implies the exhaustion of the image universe: it suggests that a photographer can find more than enough images already existing in the world without the bother of making new ones. Pressed on this point, Prince will admit that he has no desire to create images from the raw material of the physical world; he is perfectly content—happy, actually—to glean his material from photographic reproductions.

1. Sherrie Levine, *After Walker Evans: 2,* 1981

Prince is also a writer of considerable talent. In his book *Why I Go to the Movies Alone*, we learn something of his attitudes toward the world—attitudes that are shared by many artists of the postmodernist persuasion. The characters he creates are called "he" or "they," but we might just as well see them as stand-ins for the artist, as his own verbal masks:

Magazines, movies, TV, and records. It wasn't everybody's condition but to him it sometimes seemed like it was, and if it really wasn't, that was alright, but it was going to be hard for him to connect with someone who passed themselves off as an example or a version of a life put together from reasonable matter. . . .

And a second passage:

They were always impressed by the photographs of Jackson Pollock, but didn't particularly think much about his paintings, since painting was something they associated with a way to put things together that seemed to them pretty much taken care of. They hung the photographs of Pollock right next to these new "personality" posters they just bought. These posters had just come out. They were black and white blow-ups . . . at least thirty by forty inches. And picking one out felt like doing something any new artist should do.

The photographs of Pollock were what they thought Pollock was about. And this kind of take wasn't as much a position as an attitude, a feeling that an abstract expressionist, a TV star, a Hollywood celebrity, a president of a country, a baseball great, could easily mix and associate together . . . and what measurements or speculations that used to separate their value could now be done away with. . . .

I mean it seemed to them that Pollock's photographs looked pretty good next to Steve McQueen's, next to JFK's, next to Vince Edwards, next to Jimmy Piersal's and so on. . . .[15]

Prince's activity is one version of a postmodernist practice that has come to be called appropriation. In intelligent hands like those of Prince, appropriation is certainly postmodernist, but it is not the *sine qua non* of postmodernism. In certain quarters appropriation has gained considerable notoriety, thanks largely to works like Sherrie Levine's 1979 *Untitled (After Edward Weston)*, for which the artist simply made a copy print from a reproduction of a famous 1926 Edward Weston image *(Torso of Neil)* and claimed it as her own. It seems important to stress that appropriation as a tactic is not designed *per se* to tweak the noses of the Weston heirs, to *epater la bourgeoisie* or to test the limits of the First Amendment. It is, rather, a direct, if somewhat crude, assertion of the finiteness of the visual universe. And it should be said that Levine's *tabula rasa* appropriations frequently depend on (one) their captions and (two) a theoretical explanation that one must find elsewhere.

Those artists using others' images believe, like Prince, that it is dishonest to pretend that untapped visual resources are still out there in the woods, waiting to

be found by artists who can then claim to be original. For them, imagery is now overdetermined—that is, the world already has been glutted with pictures taken in the woods. Even if this weren't the case, however, no one ever comes upon the woods culture-free. In fact, these artists believe, we enter the woods as prisoners of our preconceived image of the woods, and what we bring back on film merely confirms our preconceptions.

Another artist to emphasize the unmasking aspect of postmodernist practice is Louise Lawler. While perhaps less well known and publicized than Sherrie Levine, Lawler examines with great resourcefulness the structures and contexts in which images are seen. In Lawler's work, unlike Levine's, it is possible to read at least some of its message from the medium itself. Her art-making activities fall into several groups: photographs of arrangements of pictures made by others, photographs of arrangements of pictures arranged by the artist herself, and installations of arrangements of pictures.

Why the emphasis on arrangement? Because for Lawler—and for all postmodernist artists, for that matter—the meaning of images is always a matter of their context, especially their relation to other images. One often gets the feeling in looking at her work of trying to decode a rebus: the choice, sequence and position of the pictures she shows us imply a rudimentary grammar or syntax. Using pictures by others—Jenny Holzer, Peter Nadin, Sherrie Levine's notorious torso of Neil—she urges us to consider the reverberations between them.

In James Welling's pictures yet another strategy is at work, a strategy that might be called appropriation by inference. Instead of re-presenting someone else's image, they present the archetype of a certain kind of image. Unlike Prince and Lawler, he molds raw material to create his pictures, but the raw material he uses is likely to be as mundane as crumpled aluminum foil, Jell-O, or flakes of dough spilled on a velvet drape. These pictures look like pictures we have seen—abstractionist photographs from the Equivalent school of modernism, for instances, with their aspirations to embody some essence of human emotion. In Welling's work, however, the promise of emotional expressionism is always unfulfilled.

Welling's pictures present a state of contradiction. In expressive terms they seem to be "about" something specific, yet they are "about" everything and nothing. In the artist's eyes they embody tensions between seeing and blindness; they offer the viewer the promise of insight but at the same time reveal nothing but the inconsequence of the materials with which they were made. They are in one sense landscapes, in another abstractions; in still another sense they are dramatizations of the postmodern condition of representation.

The kind of postmodernist art I have been discussing is on the whole not responsive to the canon of art photography. It takes up photography because photography is an explicitly reproducible medium, because it is the common coin of cultural image interchange, and because it avoids the aura of authorship

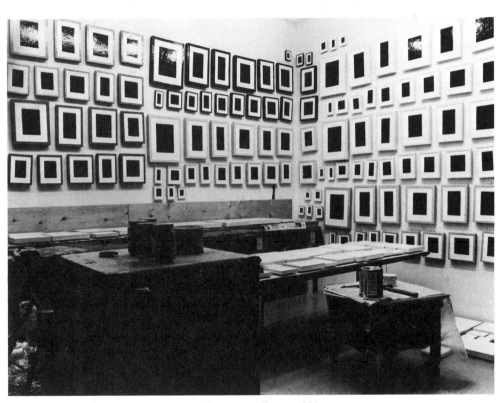

2. Louise Lawler, *Artist's Studio (Allan McCollum)*, 1983

that post-structuralist thought calls into question—or at least it avoids that
aura to a greater extent than do painting and sculpture. Photography is, for
these artists, the medium of choice; it is not necessarily their aim to be photogra-
phers, or, for most of them, to be allied with the traditions of art photography.
Indeed, some of them remain quite happily ignorant of the photographic tradition.
They come, by and large, from another tradition, one rooted theoretically in
American art criticism since World War II and one rooted practically in concep-
tual art, which influenced many of them when they were in art school. But at
least as large an influence on these artists is the experience of present-day life
itself, as perceived through popular culture—TV, films, advertising, corporate
logoism, PR, *People* magazine—in short, the entire industry of mass-media
image making.

I hope I have made clear so far that postmodernism means something differ-
ent to architects and dancers and painters, and that it also has different meanings
and applications depending on which architect or dancer or painter one is listen-
ing to. And I hope that I have explained some of the critical issues of
postmodernism as they have made themselves manifest in the art world, and
shown how these issues are embodied in photographs that are called postmod-
ernist. But there remains, for photographers, still another question: "What about
Heinecken?" That is to say, didn't photography long ago become involved with
pastiche, appropriation, questions of mass-media representation, and so on?
Wasn't Robert Heinecken rephotographing magazine imagery, in works like *Are
You Real?*, as early as 1966, when Richard Prince was still in knickers?

To clarify the relationship between today's art-world-derived postmodernist
photography and what some feel are its undersung photographic antecedents,
we need to consider what I would call photography's inherent strain of post-
modernism. To do this we have to define photography's modernism.

Modernism in photography is a twentieth-century aesthetic which subscribes
to the concept of the "photographic" and bases its critical judgments about what
constitutes a good photograph accordingly. Under modernism, as it developed
over the course of this century, photography was held to be unique, with capabil-
ities of description and a capacity for verisimilitude beyond those of painting,
sculpture, printmaking, or any other medium. Modernism in the visual arts
valued (I use the past tense here partly as a matter of convenience, to separate
modernism from postmodernism, and partly to suggest modernism's current
vestigial status) the notion that painting should be about painting, sculpture
about sculpture, photography about photography. If photography were merely a
description of what the pyramids along the Nile looked like, or of the dissipated
visage of Charles Baudelaire, then it could hardly be said to be a form of art.
Modernism required that photography cultivate the photographic—indeed, that it
invent the photographic—so that its legitimacy would not be questioned.

In a nutshell, two strands—Alfred Stieglitz's American purism and László Moholy-Nagy's European experimental formalism—conspired to cultivate the photographic, and together they wove the shape of modernism in American photography. Moholy, it should be remembered, practically invented photographic education in America, having founded the Institute of Design in Chicago in 1937. As the heritage of Stieglitzian purism and Moholy's revolutionary formalism developed and coalesced over the course of this century, it came to represent photography's claim to be a modern art. Ironically, however, just at the moment when this claim was coming to be more fully recognized by the art world—and I refer to the building of a photographic marketplace in the 1970s—the ground shifted underneath the medium's feet.

Suddenly, it seemed, artists without any allegiance to this tradition were using photographs and, even worse, gaining a great deal more attention than traditional photographers. People who hardly seemed to be serious about photography as a medium—Rauschenberg, Ed Ruscha, Lucas Samaras, William Wegman, David Haxton, Robert Cumming, Bernd and Hilla Becher, David Hockney, and so on— were incorporating it into their work or using it plain. Photographic-ness was no longer an issue, once formalism's domain in the art world collapsed. The stage was set for what we now call postmodernism.[16] Yet one can see the seeds of a postmodernist attitude within what we think of as American modernist photography, beginning, I would argue, with Walker Evans. However much we admire Evans as a documentarian, as the photographer of *Let Us Now Praise Famous Men,* as a "straight" photographer of considerable formal intelligence and resourcefulness, one cannot help but notice in studying his work of the 1930s how frequently billboards, posters, road signs, and even other photographs are found in his pictures.

It is possible to believe, as some have contended, that these images within Evans's images are merely self-referential—that they are there to double us back and bring us into awareness of the act of photographing and the two-dimensional, cropped-from-a-larger-context condition of the photograph as a picture. But they are also there as signs. They are, of course, signs in the literal sense, but they are also signs of the growing dominion of acculturated imagery. In other words, Evans shows us that even in the dirt-poor South, images of Hollywood glamour and consumer pleasures—images designed to create desire— were omnipresent. The Nehi sign Evans pictured was, in its time, as much a universal sign as the Golden Arches of hamburgerland are today.

Evans's attention to signs, and to photography as a sign-making or semiotic medium, goes beyond the literal. As we can see in the images he included in *American Photographs,* and in their sequencing, Evans was attempting to create a *text* with his photographs. He in fact created an evocative nexus of signs, a symbology of things American. Read the way one reads a novel, with each page

building on those that came before, this symbology describes American experience as no other photographs had done before. And the experience Evans's opus describes is one in which imagery plays a role which can only be described as political. The America of *American Photographs* is governed by the dominion of signs.

A similar attempt to create a symbolic statement of American life can be seen in Robert Frank's book *The Americans*. Frank used the automobile and the road as metonymic metaphors of the American cultural condition, which he envisioned every bit as pessimistically as postmodernists do today. While not quite as obsessive about commonplace or popular-culture images as Evans, he did conceive of imagery as a text—as a sign system capable of signification. In a sense, he gave Evans's take on life in these United States a critical mass of pessimism and persuasiveness.

The inheritors of Frank's and Evans's legacy adopted both their faith in the photograph as a social sign and what has been interpreted to be their skeptical view of American culture. Lee Friedlander's work, for example, despite having earned a reputation as formalist in some quarters, largely consists of a critique of our conditioned ways of seeing. In his picture *Mount Rushmore,* we find an amazingly compact commentary on the role of images in the late twentieth century. Natural site has become acculturated sight. Man has carved the mountain in his own image. The tourists look at it through the intervention of lenses, like the photographer himself. The scene appears only as a reflection, mirroring or doubling the condition of photographic appearances, and it is framed, cropped by the windows, just like a photograph.

Although Friedlander took this picture in 1969, well before anyone thought to connect photography and postmodernism, it is more than a modernist explication of photographic self-referentiality—I believe it also functions critically in a postmodernist sense. It could almost be used as an illustration for Jean Baudrillard's apocalyptic statement, "For the heavenly fire no longer strikes depraved cities, it is rather the lens which cuts through ordinary reality like a laser, putting it to death."[17] The photograph suggests that our image of reality is made up of images. It makes explicit the dominion of mediation.

We might also look again at the work of younger photographers we are accustomed to thinking of as strictly modernist. Consider John Pfahl's 1977 image *Moonrise over Pie Pan,* from the series "Altered Landscapes." Pfahl uses his irrepressible humor to mask a more serious intention, which is to call attention to our absence of innocence with regard to the landscape. By intervening in the land with his partly conceptual, partly madcap bag of tricks, and by referencing us not to the scene itself but to another photograph, Ansel Adams's *Moonrise over Hernandez,* Pfahl supplies evidence of the postmodern condition: it seems impossible to claim that one can have a direct, unmediated experience of the world; all we see is seen through the kaleidoscope of all that we have seen before.

So, in response to the Heinecken question, there is abundant evidence that the photographic tradition incorporates the sensibility of postmodernism within its late or high modernist practice. This overlap seems to appear not only in photography but in the painting and sculpture tradition as well, where, for example, one can see as proto-postmodern Rauschenberg's work of the 1950s and 1960s or even aspects of pop art, such as Andy Warhol's silkscreen paintings based on photographs.[18] Not only did Rauschenberg, Johns, Warhol, Lichtenstein, and others break with abstract expressionism, they also brought into play the photographic image as raw material, and the idea of pastiche as artistic practice.

It seems unreasonable to claim, then, that postmodernism in the visual arts necessarily represents a clean break with modernism—that, as Douglas Crimp has written, "Postmodernism can only be understood as a specific breach with modernism, with those institutions which are the preconditions for and which shape the discourse of modernism."[19] Indeed, there is even an argument that postmodernism is inextricably linked with modernism—an argument advanced most radically by the French philosopher Jean-François Lyotard in the book *The Postmodern Condition: A Report on Knowledge.*

> What, then, is the Postmodern? . . . It is undoubtedly a part of the modern. All that has been received, if only yesterday . . . must be suspected. What space does Cézanne challenge? The Impressionists. What object do Picasso and Braque attack? Cézanne's. What presupposition does Duchamp break with in 1912? That which says one must make a painting. . . . A work *can become modern only if it is first postmodern.* Postmodernism thus understood is not modernism at its end but in the nascent state, and this state is constant.[20]

It is clear, in short, that postmodernism as I have explained it—not the postmodernism of pluralism, but the postmodernism that seeks to problematize the relations of art and culture—is itself problematic. It swims in the same seas as the art marketplace, yet claims to have an oppositional stance toward that marketplace. It attempts to critique our culture from inside that culture, believing that no "outside" position is possible. It rejects the notion of the avant-garde as one of the myths of modernism, yet in practice it functions as an avant-garde. And its linkage to linguistic and literary theory means that its critical rationale tends to value intellect more than visual analysis. But for all that, it has captured the imagination of a young generation of artists. And the intensity of the reactions to postmodernist art suggests that it is more than simply the latest fashion in this year's art world.

Many people, photographers among them, view postmodernism with some hostility, tinged in most cases with considerable defensiveness. I suspect that the problem with the idea of postmodernism for most of us is the premise that it represents a rupture with the past, with the traditions of art that most of us grew

up with and love. But it is only through considerable intellectual contortions that one can postulate so clean a break. One has to fence-in modernism so tightly, be so restrictive about its practice, that the effort hardly seems worthwhile. So perhaps, contra Crimp, we can find a way to conceive of postmodernism in a way that acknowledges its evolution from modernism but retains its criticality.

One of the ways we might do this is by shifting the ground on which we define postmodernism from questions of style and intention to the question of how one conceives the world. Postmodernist art accepts the world as an endless hall of mirrors, as a place where images constitute what we are, as in Cindy Sherman's world, and where images constitute all of what we *know,* as in Richard Prince's universe. There is no place in the postmodern world for a belief in the authenticity of experience, in the sanctity of the individual artist's vision, in genius, or originality. What postmodernist art finally tells us is that things have been used up, that we are at the end of the line, that we are all prisoners of what we see. Clearly these are disconcerting and radical ideas, and it takes no great imagination to see that photography, as a nearly indiscriminate producer of images, is in large part responsible for them.

This essay was published in the fall 1986 issue of *Views,* the journal of the Photographic Resource Center in Boston, and appeared, in revised form, in the catalog to *Photography and Art: Interactions Since 1946* (Abbeville, 1987). It began life as a lecture delivered in February 1984 at the Friends of Photography in Carmel, California, for whom I had organized an exhibition titled *Masking/Unmasking: Aspects of Postmodern Photography.*

II. Re: Mastering Modernism

Alfred Stieglitz and
the Contradictions of Modernism

TO UNDERSTAND what modernism has meant for photography, we inevitably have to take into account the vast and continuing influence of Alfred Stieglitz. In the course of his complex career, he functioned as a critic, editor, gallery owner, promoter, enthusiast, and nurturer, but he started as a photographer and he remained one throughout his life.

Stieglitz, who was active as an art photographer from the mid-1880s to 1937 (he died in 1946), was a tireless advocate not only for modern photography but also of modern painting. He encouraged and supported the American painters John Marin, Marsden Hartley, Arthur Dove, and Georgia O'Keeffe at the beginnings of their careers, as well as photographers such as Paul Strand and Ansel Adams. He introduced Picasso, Braque, and other Europeans to the United States at his influential gallery "291." Because of all this promotional activity, Stieglitz's own contribution to the picture-making tradition has not been fully appreciated, at least according to Sarah Greenough's account in *Alfred Stieglitz: Photographs and Writings*.[1]

It was Stieglitz's good fortune to have been working in a crucial period when both the arts and Western civilization were undergoing a significant transformation. That is to say, he witnessed, and played a significant role in, the birth of modernism in America. The individualism of the nineteenth century was perceived as giving way to the mass, machine-age culture of the twentieth, yet it was still possible to believe in their compatibility. Like László Moholy-Nagy, who represents the European modernist strain in photography just as Stieglitz represents the American, he saw the medium as a radical instrument, one that forged a union between the machine and the human spirit.

Yet there is a significant gap between Stieglitz's earliest pictures, taken in Europe, and his turn-of-the-century scenes of New York. The European pictures have obvious precedents in European painting of the time (compare, for example, his 1890 beach scene *At Biarritz* with Eugène Boudin's 1863 painting *The Beach at Trouville,* owned by the National Gallery); most resemble the rural genre scenes of Courbet and Millet. Stieglitz's New York photographs, on the other hand, depict

ferry boats, skyscrapers, railroad tracks, and other aspects of the urban scene. Whereas a few years earlier he had paid his respects to tradition, here he optimistically greets the steam, smoke, congestion, and verticality of the city. It is no accident that many of these urban pictures concern arrival and transport; they are signs of Stieglitz's sense of the openness and possibility of the New World, and of a new age.

At about the same time, Stieglitz was transforming himself from an ambitious photographic prodigy—one who gained international recognition in salon circles by age twenty-three—to a prematurely grayed sage and stylistic arbiter. Conventional wisdom about Stieglitz is that following this conversion he became the champion of pictorialism, a style allied with tonalist and symbolist painting. He founded the Photo-Secession, whose members practiced pictorialism with a vengeance. By 1916, however, he had concluded that painting and photography were antithetical rather than allied pursuits. He came to believe, in Greenough's words, "that it was not the function of photography to give aesthetic pleasure, but to provide visual 'truths' about the world." Thus, he overthrew gauzy pictorialism for purism, a hard-edged, seemingly objective style which, while not synonymous with photographic modernism, embodies its first American manifestation.

His own work, however, does not entirely adhere to this interpretation. For one, Stieglitz's pictures were never as pictorialist as those of the photographers he championed in his journal *Camera Work* (Robert Demachy, Clarence White, early Edward Steichen), nor were they as purist as those of photographers like Strand. In addition, modern art influences distinctly mark his supposedly antipainterly photographs of the twenties and thirties. It is difficult to conceive of this work— views of New York City taken from windows, landscapes of Lake George, pictures of clouds—without the example of cubism in particular and abstraction in general.

The abstractionist cloud photographs of the twenties and thirties, most of which bear the title "Equivalent," in a sense represent the apotheosis of Stieglitz's art. They remain photography's most radical demonstration of faith in the existence of a reality behind and beyond that offered by the world of appearances. They are intended to function evocatively, like music, and they express a desire to leave behind the physical world, a desire symbolized by the virtual absence of horizon and scale clues within the frame. Emotion resides solely in form, they assert, not in the specifics of time and place. Yet, for all that they demonstrate about Stieglitz's aesthetic, the Equivalents distort photography's role. Like the single-color paintings of Malevich, the Russian Suprematist, their extreme abstraction poses a dead end rather than a solution.

The real center of Stieglitz's considerable accomplishment as a photographer lies elsewhere, most strikingly in the sensual and sexually charged portraits of women he made throughout his mature career. There is, of course, his tour de

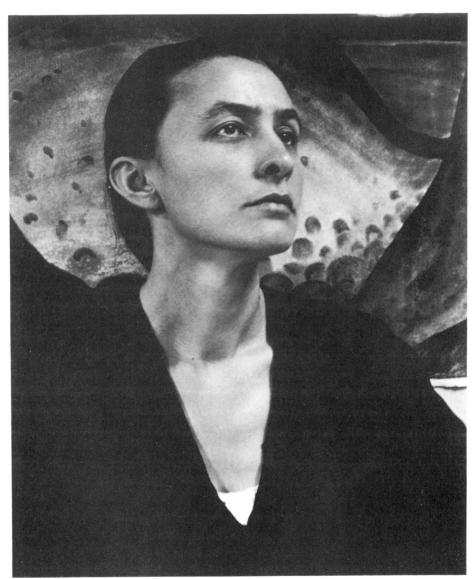

3. Alfred Stieglitz, *Georgia O'Keeffe*, 1918

force portrait of his wife Georgia O'Keeffe, consisting of hundreds of prints of her face, hands, and torso. But there also are single images of concentrated power, of such friends and acquaintances as Marie Rapp, Rebecca Strand, Margaret Treadwell, Georgia Engelhard, and Dorothy Norman.[2] Such direct, unflinching confrontations with the female presence seem characteristic of the purist spirit; Edward Weston's equally charged portraits and nudes date from the same time.

Yet despite creating more than his fair share of classic images, Stieglitz seems to have ended his career in a profound state of discouragement. He never felt he achieved the widespread acceptance of modern art that he fought for, and he never felt that he won the battle to have photography recognized as an equal and independent art medium. Time, of course, has proven his feelings wrong by proving his causes right. But he may also have finally sensed the underlying contradiction in his own art. Although he never stopped trying to find visual means to reconcile the romantic world view he carried over from the nineteenth century with his faith in twentieth-century progress, his attempts carry less and less conviction.

His 1935 picture of O'Keeffe's hand on a spare wheel of a shiny new V-8 car is typical: it romanticizes the machine but in the process dehumanizes the hand. As a result, a sense of closure replaces the sense of openness and possibility found in the early pictures of New York's streets and harbor. We can see this in the Equivalents, which become increasingly dark in tone and morose in feeling, and in the New York views taken from windows, in which the city is blocked off by ever more claustrophobia-inducing construction. The later portraits of O'Keeffe, emptied of the freshness of romance, seem like valedictories to a remembered past.

This conflict, between tradition and the new, is as embedded in modernist art as it is in Stieglitz's photographs, and it is what makes his pictures so important today, when the tradition of modernism itself is being widely challenged. Through his photographs, we can see not only the contractions of modernist faith, but also its exhilaration and persuasiveness.

This review was written on the occasion of the exhibition *Alfred Stieglitz*, organized for the National Gallery of Art by Sarah Greenough and Juan Hamilton, and published in the *New York Times*, February 1983.

Edward Weston's Late Landscapes

I have not attempted to make a geographical, historical, or sociological record.
My work this year as in the past has been directed toward photographing Life.
EDWARD WESTON, *Camera Craft,* February 1939[3]

IT HAS BECOME A CONVENTION of photography history to speak of Edward
Weston's incredibly fertile and multifaceted career in terms of a number of distinct
and separate subcareers. To take but one example, biographer Ben Maddow follows
Weston through such "periods" as pre-Mexican (1918–23), Mexican (1923–27),
pre-Guggenheim (1927–37), Guggenheim (1937–39), and post-Guggenheim
(39–48).[4] And there is widespread if not unanimous agreement that, of all these
periods, the work from the early 1930s (that is, "pre-Guggenheim")—including
Weston's close-up nudes—is the strongest of his career.[5] On the other hand, much
of Weston's work from his last ten years as an active photographer—from 1939 to
1948, when Parkinson's disease finally made it impossible for him to photograph—
carries the taint of failure in the eyes of many of his avid fans. This is especially
true of his "satiric" pictures taken during the war years, and of his sentimental
records of his housecats, which represent something of an embarrassment to
virtually all of the photographer's otherwise staunch supporters.

There is evidence, however, that Weston's mature, modernist career is not
comprised of a series of progressive periods based on biographical events; rather,
it is split quite decisively and dramatically into two halves. The first, dating to
1937, is concerned primarily with formal abstraction and is expressive of Weston's
libidinal preoccupations; the second, from 1937 on, is marked by an increasingly
open style involved with complex spatial organization and pictorial depth, while
conveying intimations of ruin, decay, and death.[6] Weston's assertion, in 1939, that
his intention during the two years of his Guggenheim grant was "photographing
Life" is, in retrospective, ironic. For beginning with the Guggenheim project—and
perhaps without the artist realizing it—the subject of Weston's photography
became Death.

This late work, which consists in large measure of landscapes, also contains
evidence of a political consciousness absent in Weston's earlier photography,
which is made up primarily of portraits, nudes, and close-ups of natural forms. In
the last ten years of his working life, Weston perceived the American landscape
not as something grand, primordial, and innocent, but as inhabited, acculturated

and, in many places, despoiled. Not only do many of his pictures from this era recall Walker Evans's photography of the 1930s, but they also point directly to the socially conscious but stylistically restrained "New Topographic" mode of landscape photography of the last ten years, by photographers such as Robert Adams, Lewis Baltz, Joe Deal, Frank Gohlke and Stephen Shore. One need only compare Weston's image of a coffee cup sign in the Mojave Desert (titled *Siberia* in *California and the West,*[7] the published collection of his Guggenheim work) with a picture like Robert Adams's *On Top of Flagstaff Mountain, Boulder County, Colorado,* reproduced in *From the Missouri West,*[8] which shows a trash can in the foreground of an otherwise scenic vista, to sense how much Weston's vision had veered from its earlier high modernist trajectory.

Beaumont Newhall, in the 1982 edition of his *History of Photography,* takes note of the change, saying that with the 1937 Guggenheim grant Weston's "style expanded, the variety of subject matter increased, and a rich human quality pervaded his later work." And John Szarkowski, characteristically, articulates it most persuasively. Writing in *American Landscapes*, he notes, "Until the mid-1930s [Weston] tended to avoid the horizon, or use it as a beautiful line, a graphic obligato at the top of the picture, contenting himself with an order that could be managed in a taut, shallow space, almost in two dimensions. But by the late 1930s, when he was at the height of his powers, no space seemed too broad or deep for him."[9] Clearly, Szarkowski's view of Weston's career does not follow received opinion.

It is perhaps even not too far-fetched to suggest that Weston's late landscapes helped point photography away from photographic modernism's preoccupation with reductive abstraction and toward a more capacious, complex, naturalistic, and stylistically transparent style. It is clear from the pictures in *California and the West* and from those in the Limited Editions Club's volume of Walt Whitman's *Leaves of Grass,*[10] which Weston was assigned to illustrate in 1941, that the photographer's way of seeing became, in his last decade of work, less reductive, less dramatic, and less insistently graphic, while becoming more inclusive, accepting, and—given its theme—resigned.

This is not to suggest that the photographer "discovered" the landscape as a subject in the late 1930s; he began taking views of distant land and sky forms on his arrival in Mexico in 1923.[11] He even allowed signs of human presence to penetrate his otherwise clinical compositions of the time. But as much as they prefigure aspects of the later work, the Mexican landscapes are different. Some, including views of the villages of Janitzio and Patzcuaro, seem composed according to cubist models; others, like his 1923 image of the Piramide del Sol, are iconic if not monumental. In a photograph which the scholar Amy Conger has identified as Weston's first cloud-form picture,[12] a towering nimbus fills the vertical frame; the cloud's resemblance to male genitalia is so marked it hardly needs to be

remarked on. (Weston's trip to Mexico was, one might note, his first assertion of his own artistic independence—and of his independence from his wife.)

By the time Weston set out in 1937 with a new Ford, $2,000 from the Guggenheim Foundation, and a $50-a-month contract to supply scenic photographs for *Westways* magazine, he was a much more self-confident artist than the one who had sailed for Mexico in 1923. He had the security of a mature artistic style—one that had made him a commanding figure in photography circles nationwide—and he was an articulate, admired spokesman for the purist aesthetic. He was fifty-one, a mid-career photographer with grown sons, a young, intelligent, and "liberated" lover (Charis, soon to be his wife), and the distinction of having just received the first Guggenheim ever awarded a photographer.

But instead of pictures of phallic clouds and recumbent nudes, celebrating his artistic empowerment and vitality, Weston proceeded to take landscapes of a distinctly elegiac tenor. Among the subjects recorded on the 1,500 negatives he made between 1937 and 1939[13] are a burnt-out automobile, a wrecked car, an abandoned soda works, a dead man, a crumbling building in a Nevada ghost town, long views of Death Valley, the skull of a steer, the charred remnants of a forest fire, gravestones; the twisted, bleached bark of juniper trees—a virtual catalog of decay, dissolution, and ruin.

Not all of the Guggenheim work fits this category, of course. There are enough photographs of "innocent" subjects—dunes, cloud studies, majestic views of mountaintops, valleys, and the Pacific coastline—to suggest that Weston was not exclusively preoccupied with death. However, this does not negate the fact that decay, dissolution, and ruin were new additions to Weston's artistic repertory at the time, and that their existence signals a fundamental turn in the photographer's themes and—coincidentally—his style.

The stylistic differences are readily obvious if one compares, for example, his Oceano sand dune pictures of 1936 with his Death Valley dunes of 1938. The former are dramatic, abstractly seen and ambiguous in scale; they look—remarkably enough—like American abstract expressionist painting of fifteen years later. The latter are less radically cropped and more naturalistic, with undulating lines that sweep the eye off into deep space. A similar change can be seen by comparing his 4-by-5 nudes of 1934 with a nude image of Charis taken in New Mexico in 1937. The 1934 pictures are studio constructs, studies in form and flesh tones taken against a dark backdrop; the 1937 image is more like a landscape, with Charis lying on a blanket in front of an adobe wall, a shadowed oven, like a tunnel, beyond her raised knee. The combination of figure and background give the photograph an erotic resonance unequaled by the more decorous studio nudes.

The change in photographic style from a strictly organized, close-up and exclusionary formalism to a more relaxed and inclusive naturalism is inseparable

from the expansion of Weston's range of subject matter during the Guggenheim project. His ability to encompass entire towns within his frame—places like Jerome, Arizona, and Albion, California—harks back to the nineteenth century promotional photography of Carleton E. Watkins. Weston's interest in the land also extended to hayfields, vineyards, and even the harbor of San Francisco. These pictures, following by less than ten years his close-ups of shells and vegetables, represent a decisive step away from the increasingly circumscribed high-modernist practice of Alfred Stieglitz—a break that seems to have gone unrecorded in the criticism of the time, and is barely spoken of today.

In applying for the Guggenheim fellowship, Weston apparently did not anticipate the dramatic change coming over his work. He couched his plan to travel throughout the West (especially in California) in terms of a continuation of his artistic concerns. His initial application read, "I wish to continue an epic series of photographs of the West, begun about 1929; this will include a range from satires on advertising to ranch life, from beach kelp to mountains. The publication of the above seems assured."[14] Later, he elaborated on this laconic proposal in a letter to Henry Allen Moe of the Guggenheim Foundation: "In a single day's work, within the radius of a mile, I might discover and record the skeleton of a bird, a blossoming fruit tree, a cloud, a smokestack; each of these being not only a part of the whole, but each, in itself, becoming a symbol for the whole, of life."[15]

What exactly constituted "satires on advertising" in his work at the time is unclear (unless we dare to presume he meant *Pepper #30* and his other vegetable pictures to function in this way); however, in pictures like *Hot Coffee,* taken during his Guggenheim travels, his intention becomes apparent. Also of interest, in retrospect, is his elaboration of potential subject matter in the letter to Moe; as it turned out, bird skeletons, fruit trees, clouds, and smokestacks do not make up a significant part of his actual accomplishment. Instead of using the detail to make "a symbol for the whole," Weston in actual practice attempted to fit the whole within the frame.

This tendency continued in his next major project, a series of landscapes and portraits taken to illustrate Walt Whitman's great nineteenth-century American epic poem *Leaves of Grass.* Weston was commissioned by the Limited Editions Club in 1941 and spent ten months traveling to twenty-four states, logging some 20,000 miles.[16] In many cases the photographs Weston made for the *Leaves of Grass* project are recapitulations of the advances made during his Guggenheim travels, and some might be judged as merely obligatory exposures (Weston was, after all, on assignment—a condition that never fully agreed with him). But in two respects they are novel: for one, many of them are, in the words of Weston's biographer, "frankly funereal";[17] for another, they embrace urban civilization and industry to a degree unprecedented in Weston's career.

It seems likely that the photographic message of the forty-nine pictures chosen for reproduction by the Limited Editions Club is purposefully less depressing than a representative cross-section of the pictures Weston made on his cross-country tour would have been. With one exception, graveyards and gravestones are not among the subjects selected for the book, yet Weston seems to have stopped to record them wherever he went. Nor is there much weight given his pictures of crumbling Southern plantations, so Walker Evans-like in both form and feeling, or of the log-cabin culture of rural poverty Weston kept seeing in the South. Instead, in the published work there are superabundant images of steel bridges, railyards, skyscrapers and other indications of "progress" in the spirit of Whitman. These are, on the one hand, antidotes to the images of ruin and decay that managed to survive the editing process (most of which, tellingly, were taken in the South) and, on the other, topographic "inhabited landscapes" that survey the changing face of America with a nearly neutral, even spectral, gaze.

The difference between Weston's early and late styles is nowhere more apparent than in the gulf between the work he did on Point Lobos in the years 1929 to 1934 and his Point Lobos pictures of 1939, 1940, and 1944 to 1948—the last having been made when the progressively crippling effects of his Parkinson's disease had become unmistakable. In the earlier work, eroded rocks on the beach are isolated by the camera so that their scale and context are eradicated, thereby emphasizing their poetic, metonymic qualities. (Many, it goes without saying, resemble torsos.) The fluid lines and liquid surfaces of kelp are emphasized in vivid close-ups, and the roots of cypress trees are shown to have all the potential energy and pent-up power of ocean waves. In the photographs from 1939 on, however, the Point Lobos peninsula is a veritable theater of death. Dead pelicans and dead kelp float in translucent pools; the cypress tress are shown whole, their bare limbs white and wizened; rocky cliffs appear as jumbled as if a landslide had just struck.

In *California and the West*, Charis Wilson, Weston's wife from 1938 to 1946, took note of Weston's initial resistance to returning to Point Lobos as a subject near the end of his Guggenheim years. "Edward began by saying that he was all through with it.... Hadn't he photographed every twisted cypress on the cliffs and every eroded rock on the beaches? True enough, but that had been a period of close-ups: details of rocks, fragments of trees."[18] More recently she remarked that "Edward was a confirmed reductionist, apt to prune and snip and condense ideas until nothing remained but a bit of branchless stalk...."[19] Her choice of words seems to indicate that she recognized the photographer's penchant for elimination and reduction as something less than completely auspicious—a feeling not expressed by any of Weston's other intimates, who included Beaumont and Nancy Newhall, Willard van Dyke and Ansel Adams. We might surmise, given her attitude and the correspondence of Weston's change in style with her entry

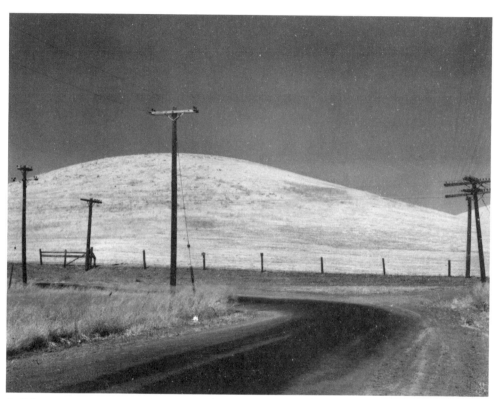

4. Edward Weston, *Hill and Telephone Poles, Ranch County,* 1937

into his life (they first met in late 1933, and became lovers in the spring of 1934, according to Maddow), that Charis Weston was in fact part of the process of weaning him from his "reductionist" ways.

Certainly their relationship, which followed on the heels of a score of love affairs and years of compulsive womanizing on Weston's part, served as a token of the photographer's growing self-assurance in the world. It is not unreasonable to assume that as he became less anxious and more expansive in his personal life, he felt less need to exclude so much of the world. The fact that his last ten years as an active artist were devoted primarily to landscapes, and that he became involved with first the West and then the United States as a subject, signals a new, extroverted Weston. It is this Weston who then turns from the realm of the erotic to consider the specter of death in the living, visible world.

One can, of course, cite other influences to account for the more open, capacious style of Weston's late landscapes. There was the example of Ansel Adams, alongside of whom Weston photographed Yosemite during the Guggenheim years. There was the example of Eugène Atget, whose ethereal and haunted pictures of Paris and its environs came to the American photographer's attention in 1930. And it seems likely that Weston also knew Walker Evans's pictures of the South, taken for the Farm Security Administration in the 1930s. Unlike Adams, both Atget and Evans dwelt on evidence of cultural dissolution. But whatever the reasons—and surely they were plural—Weston's shift from high modernist to late modernist style constitutes a crowning accomplishment in a career remarkable for its sheer number of achievements. That this shift occurred just at the historical moment when high modernist style was beginning to ossify into mannerism places Weston's late landscapes in the forefront of the major aesthetic watershed of mid-twentieth-century photography.

From *EW 100: Centennial Essays in Honor of Edward Weston,* Carmel, California: The Friends of Photography, 1986.

Ansel Adams

THE POLITICS OF NATURAL SPACE

WHEN ANSEL ADAMS DIED in April 1984 he was the best-known and most widely admired photographer in the United States, if not the world. In the last decade of his life he maintained the high profile of a public figure—appearing on television in automobile advertisements and in print on the cover of *Time*, being interviewed by *Playboy,* having a private audience with President Reagan—and his photographs took on the status of public monuments. His 1941 image *Moonrise over Hernandez* became the hit of the auction and collecting world in the late 1970s, but public taste gravitated equally to his classic images of Yosemite valley, including *Monolith, The Face of Half Dome* of 1927 and *Clearing Winter Storm* of 1944. For all the popular acclaim and critical plaudits during his lifetime, however, the exact nature of his aesthetic achievement is remarkably unresolved.

Adams was not innocent of aspiring to be the world-famous photographer he became. His celebrity was no doubt enhanced by his having cultivated an image as the grand old man of the West, complete with Gabby Hayes visage and frontier demeanor, and by his lifelong efforts at publicizing and promoting the medium in which he worked. Early on, he befriended historian Beaumont Newhall and Newhall's wife, Nancy, a writer, helped them and David McAlpin found the photography department of the Museum of Modern Art in 1940, established a department to teach photography at the San Francisco Art Institute after World War II, and in 1967 was instrumental in the founding of the Friends of Photography near his home in Carmel, California. In 1977 he provided the funds to endow the Beaumont and Nancy Newhall Curatorial Fellowship at the Museum of Modern Art.

In addition, Adams was the author of more than thirty-five books, some devoted to his pictures and some purely technical, and of a substantial number of articles and reviews, dating back to the 1930s, that advance the cause of the "photographic" in photography. He also was a figure in conservation circles, serving as a Sierra Club director from 1936 to 1970 and advocating the preservation of wilderness areas and national parks. Given such a record of activity, it is not surprising that he managed to be a respected senior figure in the photography community. Still, what made Adams so popular in the public mind first and foremost was his photography

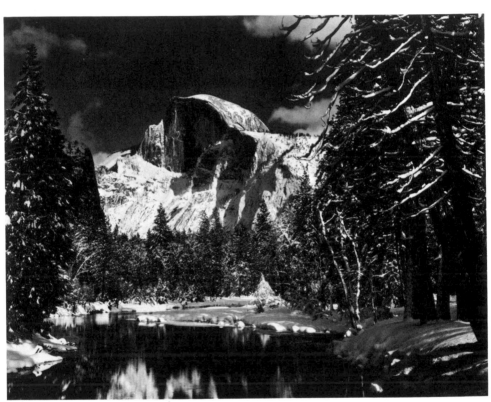

5. Ansel Adams, *Half Dome, Merced River, Winter, Yosemite National Park*, ca. 1938

—especially those images that show the natural site as a majestic and indomitable force impervious to the depredations of time and tourism alike.

These pictures are among the most visually imposing, dramatically printed images of twentieth-century photography. (Ironically, they are most often seen as reproductions, in books and magazines and on posters and postcards.) They reveal a dedication to the craft of photographic printmaking that finds its nearest equivalent in the turn-of-the-century pictorialist era, when hand-applied emulsions and arcane toners were employed to achieve a misty, painterly "look." Yet Adams's photographs are otherwise diametrically opposed to the values of pictorialism. If they have any precedent in the medium's traditions, it is the straightforward, richly detailed early Western frontier views of William Henry Jackson, Timothy O'Sullivan and Carleton Watkins. They are minutely descriptive in a way that seems transparently documentary, and they depict a topography that has yet to show the traces of human occupation.

But unlike those nineteenth-century pioneers of American landscape photography, whose views more often than not suggest that the natural world is totally alien and inhospitable, Adams pictured nature as *scenery*. In his landscape images, the natural world presents itself for human delectation; whatever threatening quality its sharp cliffs, precipitous gorges, and compacted thunderheads may have had is by and large neutralized and neutered. As I had occasion to observe in reviewing the Museum of Modern Art's 1979 exhibition *Ansel Adams and the West,* in Adams's universe the moon seems always to be rising and storms always to be clearing—symptoms, it would seem, of Adams's essentially modernist optimism about the future of the human spirit.

There is, however, another aspect to Adams's landscape photography: it shows us a natural world so precisely ordered and so cleansed of ills that we might suspect it had been sanitized by a cosmic disinfecting agent in advance of the photographer's appearance on the scene. This fundamentally hygienic conception of the world is apparent not only in Adams's pictures but also in the ways in which he discussed the particular style of photography to which he was devoted. While he disliked the term "purist" to describe his style, purity was essential to it. Writing in the photography magazine *Camera Craft* in 1940, he spoke of his commitment to "a clean, straightforward approach to photography." Elsewhere he wrote of the need for "clean standards" to capture the "vigor" and "virility" of the natural world.[20]

That this yearning for the hygienic extended to nature is clear from a 1922 letter to his future wife, Virginia, in which he wrote, "I long for the high places—they are so clean and pure and untouched." In the same letter, which is quoted in Nancy Newhall's admiring 1963 biography *The Eloquent Light,* Adams complains about the crowds in the Yosemite valley—crowds that are never seen in his photographs and says: "How I wish that the Valley could be now like it was forty years ago—a pure wilderness, with only a wagon road through it, and no automobiles nor mobs."[21]

A similar desire for purity may lie behind his almost fetishistic concentration on craft, which in the 1930s led him to develop a systematic procedure for "pre-visualizing" the final printed image while the exposure was being made. Called the Zone System, it enabled Adams to adjust his exposure and development times to produce negatives ideally suited for enlargement—and, most important for Adams, negatives that contained within them the germ of his original "vision" of the subject. Adams was not the first photographer to place a high value on visualizing the final image in advance, any more than he was the first to swear allegiance to sharply focused and finely detailed prints (his friend Edward Weston, for one, preceded him on both counts), but he was the first to combine the science of sensitometry with the aesthetic of the expressive photograph.

Vision, for Adams, was what transcended technique and justified calling photography an art form. "A great photograph," he wrote in a document called "A Personal Credo" in 1944, "is a full expression of what one feels about what is being photographed." To rationalize the notion that a straight, unmanipulated print could express the personal vision of its maker as fully as any picture or painting made entirely by the hand of an artist, Adams drew upon the already existing aesthetic of the Equivalent, as conceived by Alfred Stieglitz. Stieglitz held that photographs, besides being documents of what they are of, are expressions of something else—that something else being the vision or feeling of the photographer.

For all its virtues in making us engage photographs more closely and complexly, the aesthetic of the Equivalent as it developed from Stieglitz through Adams and Minor White has one major shortcoming: after asserting that an apparently transparent image of the world is imbued with an individual vision or feeling, it has difficulty defining what that vision or feeling is. Used as a critical instrument, the theory of Equivalence is unable to determine any intended meaning in a photograph. But as a credo, it has served as the dominant aesthetic of American photographic modernist practice. Its assumptions are enshrined not only in the photography of Adams, Stieglitz, Strand, Weston, et al. but also in Beaumont Newhall's *The History of Photography from 1839 to the Present,* which serves as today's gospel of the photographic tradition.

Not surprisingly, Adams throughout his life refused to speak of the meanings of his pictures—preferring, presumably, to let them speak for themselves. But if Adams's pictures are expressive, as he made clear he intended them to be, the criticism of modernist photography has yet to describe what they are expressive of. If they are equivalents of the artist's deepest feelings, what are those feelings? As the photographer Robert Adams has written in regard to Minor White's imagery, "Sooner or later, one has to ask of all pictures what kind of life they promote."

Newhall, in the 1964 edition of his history, has this to say about Adams's accomplishment: "Mr. Adams, in his photography, his writing and his teaching, has brilliantly demonstrated the capabilities of straight photography as a medium

of expression."[22] Of the Adams images shown at Stieglitz's American Place gallery in 1936, Newhall says that they "had sensitivity and direct, honest integrity that were rare" (sic). Today, these efforts at getting to Adams's importance seem not unlike the kind of evasions ambivalent critics sometimes undertake. But Newhall, a longtime ally of Adams's, is not alone in stopping short of telling us what Adams achieves in his pictures. One can search all the panegyrical commentary on the photographer's work and not find a single description of the meaning of Adams's vision of the natural world—or, for that matter, any clue as to what his unmatched technical brilliance allowed him to express.

The silence, coupled with the absence of any body of criticism that takes issue with the work, is what has left Adams's place in the art of this century surprisingly unsettled. One sign of this was the large degree of misinformation that accompanied the tributes marking his death in the spring of 1984. Some obituary writers hailed him as the inventor of "straight" photography, others as the pioneer of purist style, still others as the originator of the crisply delineated "f/64" style. More than one editorial claimed that he had revealed the splendors of Yosemite to us for the first time. Even so circumspect a historian as Peter Bunnell let hyperbole exceed clear judgment when he wrote that Adams's technique "fundamentally altered our conception of photographic picture making in the twentieth century."[23]

The truth is, Adams came on the scene too late to pioneer the style in which he worked. "Straight" photography was already being discussed as early as 1901 by the critic Charles Caffin, a member of Stieglitz's early circle. "Purism" was first developed in the years following World War I by Paul Strand and Edward Steichen and was arrived at more or less independently by Edward Weston in Mexico in the mid-1920s—at a time when Adams was deciding to devote himself full time to photographing Yosemite National Park. As was clear from the Museum of Modern Art's 1979 exhibition of Adams's Yosemite work, *Ansel Adams and the West,* Adams's early silver prints (which he called "Parmelian prints") have a small, self-consciously arty look to them; it was only in 1930, the year Paul Strand showed Adams his photographs, that Adams's pictures began to acquire the dramatic contrasts and expansive scale of his mature work. Throughout the 1930s and 1940s he worked in close proximity to Weston, whose more abstractionist dramatic style no doubt strengthened Adams's commitment to purist practice.

As for who first showed the splendors of Yosemite to the American public, we have to go back to the mid-nineteenth century, when wet-plate photographers such as C. L. Weed, Carleton Watkins, and Eadweard Muybridge made the arduous journey into what then was unsurveyed territory. Watkins in particular was devoted to the Yosemite landscape, visiting it several times throughout his career with both mammoth-plate and stereo cameras. Adams himself recognized those precedents, claiming allegiance to them as a way of rejecting his immediate pictorialist inheritance. In Adams's photographs, however, we see Yosemite *as if*

for the first time—so different is his conception of it from that of the nineteenth-century landscape photographers that Yosemite seems remade.

Perhaps the person who has come closest to suggesting the nature of Adams's accomplishment as a picture maker is John Szarkowski, director of the Department of Photography at the Museum of Modern Art and the curator of *Ansel Adams and the West.* In his wall label for that exhibition he wrote, "He is the last of those Romantic artists who have seen the great spaces of the wilderness as a metaphor for freedom and heroic aspirations." Here we can begin to see the outlines of Adams's vision, the limitations of its usefulness in describing today's world, and the widespread appeal it continues to have in the face of its obsolescence.

Today, the experience of Yosemite depicted in Adams's photographs is no longer ours, nor even available to us—as anyone who has visited the park recently surely knows. Our present-day experience is more like that depicted in Bruce Davidson's 1965 photograph of a crowded campsite on the valley floor, all folding lawn furniture and cars among the trees. Here, the democratic nature of the photographic image finds its counterpoint in the democracy of the national park system, with none of Adams's rarefied isolation and elegance. This isn't to say that Davidson is Adams's equal as a photographer, merely that he is—like most of us—beyond the reach of the romantic imagination. What is interesting to us in retrospect are the lengths to which Adams went in his time to avoid quotidian reality both in his choice of subject matter and in his printing style, which became increasingly theatrical and hyperbolic over the course of his career.

Clearly, however, there still exists a longing for the "clean and pure and untouched" spaces that Adams's landscapes depict in such loving detail. This longing may be rooted in the tailings of the nineteenth-century notion of the sublime, which elevated landscape imagery to the status of religious icon, but it just as likely reflects an urge to escape the depredations and disillusionments of late-twentieth-century life. In the sanitized, immaculate arena of Adams's West, its frontier innocence seemingly intact, there is comfort of a kind entirely lacking in the "man-altered" or "New Topographic" landscape photography practiced today by the likes of Robert Adams, Joe Deal, Lee Friedlander, and Frank Gohlke. Adams's photographs are valued—and I mean the word in both its senses—because they function as surrogates of pristine, uncultured experience at a time when the domain of culture seems unbreachable. And inasmuch as the prints themselves are also clean and pure and un(re)touched, they now function in lieu of the scenic wilderness as artifacts of a lost contentment.

New Criterion, November 1984.

Minor White

THE FALL FROM GRACE
OF A SPIRITUAL GURU

IT IS NOT UNHEARD OF for an artist's work to fall into obscurity in the years immediately following his death, or for reputations maintained by personal magnetism to dissolve abruptly. But when someone who has had an enormous influence on the course of a medium for a good twenty years is summarily consigned to the dust bin of history and almost forgotten, we have a reason to be curious. Such an artist is Minor White, photography's spiritual leader from the early 1950s to the early 1970s, who died in 1976.

To a degree, White's fall from grace has been as precipitous as that of William Mortensen, the latter-day pictorialist who lost the battle for the future of art photography to Ansel Adams and other purists in the 1930s. But whereas Mortensen's aesthetic was attacked, debated, and ultimately rejected, White's simply has been passed by. This is all the more remarkable because White was more than just a photographer; he was a moral and critical guru who insisted on a connection between photography and the most powerful, universal forces.

In today's practice there is hardly any evidence of White's particular brand of abstractionist black-and-white photography, which in its heyday claimed direct descendency from the art and ideas of Alfred Stieglitz. What there is of it is either so derivative it deserves its obscurity, or else it takes the postmodernist form of pastiche, that peculiar amalgam of homage and parody most strikingly found in James Welling's ersatz landscapes consisting of aluminum foil, Jell-O, velvet drapery, and soap flakes. The Stieglitzian notion of the Equivalent, which White defined as "a metaphor of [the photographer's] feeling" and praised as "probably the most mature idea ever presented to picture-making photography,"[24] has been dethroned, replaced by more cool, intellectual, and ironic styles in the late 1960s and early 1970s.

Nevertheless, there has been no shortage of attempts to resuscitate White's reputation. These attempts have been spearheaded by Aperture, the nonprofit magazine and book publishing venture of which White was editor and publisher from 1952 to 1975. During White's lifetime the magazine was renowned for its devotion to creative photography, and for fostering critical discussion. At the

same time, though, it served to promote and promulgate White's idiosyncratic and mystical vision of photography and the world.

The book *Minor White: A Living Remembrance* (also published as *Aperture* number 95) is emblematic of Aperture's efforts to shore up the photographer's flagging reputation. Titled with no apparent sense of irony, it consists of excerpts from White's writings, more than a dozen accounts of his impact as a teacher and photographer (most of them written by other photographers), and reproductions of images by White, of White, and by photographers indebted to White. For the most part, the images that reflect the spirit of White's photographs—by the likes of Walter Chappell, Frederick Sommer, and Brett Weston—date from the 1950s and even the 1940s. The more up-to-date pictures reproduced—by Robert Bourdeau, Edward Ranney, Eugene Richards, and John Yang, among others—are noticeably more documentary and descriptive than anything White and his contemporaries assayed.

Since the publication is so clearly aimed at ensuring a place for White in contemporary photography, it is surprising that not all of its accounts of his influence are laudatory. Paul Caponigro is the most uncharitable toward his onetime teacher, saying, "In his well-meaning attempts to raise the level of photography... Minor overembellished the process and failed to put photography in its right place." Robert Adams, the most literate and eloquent photographer of our time, gives the most critically balanced appraisal of White's influence, noting, for instance, how narrow the range of his subject matter is. "If it was White's achievement to show us that photographs can point beyond themselves," he says, "it was his fate as a human being, limited like the rest of us, sometimes to fail."

What stands out most clearly in this anthology, however, is how outdated White's vision of photography, as conveyed by his imagery and espoused in his teaching, has become. This is, of course, partly a reflection of how removed today's image makers are from the aesthetic of the Equivalent. But it is also a reflection of changing tastes in the art world as a whole. White worked in an era when the vogue in painting was abstract expressionism, when unabashed emotionalism was not only tolerated but courted by painters such as Mark Rothko and Robert Motherwell. While expressionism has made a recent return in painting and sculpture, dressed in the garb of the Neo, it has yet to experience a rebirth in photography. One wonders whether it ever will, given today's devotion to the camera's facility for factuality. What White was for the 1950s and 1960s, we might say, Walker Evans is for the 1970s and 1980s.

But there is another factor in the decline of White's reputation, one that is located not so much in the aesthetic of his photography but in the photographs themselves. Since White's notion of photography held that images had meanings beyond what they literally were of, it followed, for him, that the more abstract and archetypal the imagery the deeper the feelings expressed. Thus his oeuvre is

6. Minor White, *Vicinity of Naples,* New York, 1955

full of pictures of frost on windows, sea foam on sand, weathered barn siding and other apparent microcosms of the cosmos. Faced with so plain-spoken a subject as a tree-lined road (as in *Road and Poplar Trees,* 1955), White turned to infrared film to give it the necessary other-worldly quality.

And what exactly are the feelings embedded in work such as this? They are, needless to say, rather ethereal. There are appeals to our sense of the oneness of the natural world, of the metaphoric nature of reality, of the universe existing on the head of a pin. (Thus the frequent lack of scale clues in the pictures, so that a bullet-pocked rock seems to hold the heavens.) One gets little sense from such photographs of the artist's life as an ordinary mortal, as an individual living in an age of uncertainty and ambivalence. The dissembling character of White's work surely was recognized by Alfred Stieglitz when, after reviewing the younger photographer's portfolio in 1946, he reportedly said, "Have you ever been in love?... Then you can photograph."

Just how much of White's emotional life was excluded from his art can be garnered from James Baker Hall's 1978 biography, *Minor White: Rites & Passages.*[25] Hall's text made public for the first time the extent of the artist's personal difficulties, which were deeply rooted and lifelong. But much of his inner turmoil he hid from the public eye, and it is this suppression, not the turmoil, that appears in his art. This most obviously applies to his homosexuality, which he struggled against much of his life. But he suffered less noticeably from a deep-seated sense of inadequacy—he was obsessed, for example, by Stieglitz's superior charisma, which made his own messianic glow seem a bit dim. So limited is the expressive range of his pictures, one ultimately suspects that they are more evasive than expressive. One suspects as well that his compulsive adoption of a number of mystical philosophies—Zen and Gurdjieff, in particular—served the cause of repression as much as the cause of enlightenment.

Given all this, we well might wonder why there has been so much energy devoted to reviving his career and influence. Obviously in Aperture's case there are reasons both sentimental and material; Aperture's book division has published several volumes of White's work, including his chef d'oeuvre, *Mirrors, Messages, Manifestations,* in 1969. Aperture also is in the business of selling White portfolios and prints. But this is only the tip of the iceberg; White's former students have also joined the publishing parade. In the last few years there have been such privately published encomiums as *Lives I've Never Lived,* with photographs of White by Abe Frajndlich,[26]and Arnold Gassan's *Report: Minor White Workshops and A Dialogue Failed.*[27] Both books seem intended as radical departures from the literature on Minor White, but in fact they merely reinforce the prevailing stereotype of White as a shamanistic modernist hero.

It seems apparent that the industry of memorializing Minor White, existing as it does in the face of a general indifference to his legacy within the mainstream

of contemporary photography, is propelled by something outside the realm of
aesthetics. If one were to hazard a guess as to its source, it would be an appar-
ently widespread desire to believe that the medium has some connection with
the spirit, some role beyond describing the appearances and contours of the
physical world. In today's milieu, characterized most visibly by a hungry mar-
ketplace of auctions, galleries and reputation-making museums, there is no
longer a moral figure of unimpeachable authority who stands ready to lead us
into the light—nor, indeed, does there seem a need for one. There is no apostle
for the creed of photography as spiritual inquiry, no wise man to sing the
epiphanies of photographic seeing, no replacement for Alfred Stieglitz. It would
seem that Minor White, for all his flaws, was the last of the line.

Published in the *New York Times,* September 2, 1984, on the occasion of an issue of *Aperture*
devoted to Minor White's heritage. The precise nature of White's achievement has been refined
more recently by a retrospective exhibition organized by Peter C. Bunnell, *Minor White: The Eye
that Shapes,* which opened at the Museum of Modern Art in the spring of 1989. The accompany-
ing catalog, published by the Art Museum, Princeton University, in association with Bullfinch
Press, adds greatly to our understanding of White's photography, as does Ingrid Sischy's commen-
tary on the exhibition in *The New Yorker,* November 13, 1989. Sischy's comparison of White with
Robert Mapplethorpe suggests that White's reputation may currently be undergoing a real renais-
sance. Such is the transient nature of history's dust bin.

The Radical Failure
Of László Moholy-Nagy

IF EVER FORM could be said to equal content in photography, it is in the
work produced in the 1920s by László Moholy-Nagy. Moholy's program for a
"New Vision" was more than a platform for formalism; it was a radical instru-
ment intended to liberate modern Man from the constraints of habit and history.
In his 1925 book *Painting Photography Film,* Moholy proclaimed that through
the new photography "everyone will be compelled to see that which is optically
true, is explicable in its own terms, is objective, before he can arrive at any
possible subjective position."[28] In short, seeing was to make possible a new
way of believing.

Moholy's photographic work of the time, however, can hardly be construed as
"objective." His investigations of the medium's formal potentials quickly led him
past the "optically true" camera, to create abstractionist shadow pictures he
named photograms and metaphorical photomontages he called photoplastics.
His photograms— which are surprisingly similar to the Rayographs that Man Ray
made simultaneously but independently—have become quite well known and are
frequently shown. But the photomontages, except for few that are repeatedly
reproduced, are seldom seen in this country.

Most were executed during the artist's tenure at the Bauhaus, the innovative
German architecture and design school where Moholy taught from 1923 to 1928.
Using photographs taken by himself and his wife, Lucia, as well as images culled
from magazines and newspapers (we might credit Moholy with belonging to an
early generation of "appropriators"), he cut and pasted and drew until a coherent
image emerged. In most cases the resulting assemblages were then photographed,
so that the final image bears none of the rough edges inherent in the process;
however, in some of the original mock-ups one can see first-hand evidence of
the artist's skill with a razor blade.

Moholy made his photomontages for a number of reasons—commercial,
political and personal—yet their look is remarkably consistent. It is a look greatly
indebted to Russian Constructivism, and if one were to imagine a close equivalent
to the photomontages it would be an El Lissitsky Proun painting onto which

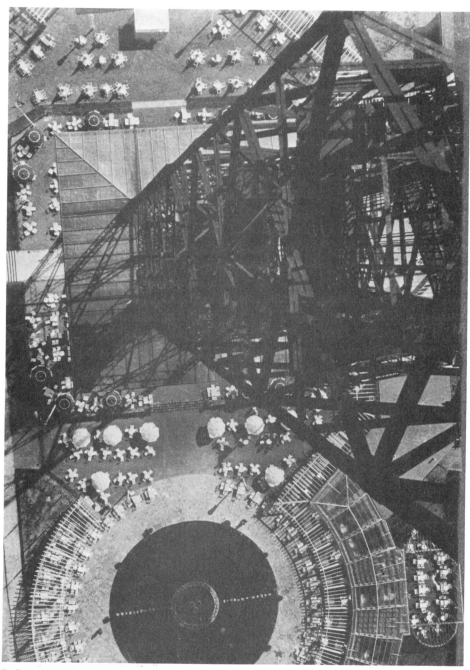

7. László Moholy-Nagy, *Untitled (Looking Down from the Berlin Radio Tower, Berlin)*, 1932

someone had pasted little paper dolls. In *Leda and the Swan; The Myth Inverted* (1925), for example, photographic images of a swan, an ear, and a female diver share spaces with a web of intersecting straight lines.

Precedents for Moholy's use of photomontage are not difficult to find, either. The Dadaists George Grosz, Raoul Hausmann, Hannah Hoch, John Heartfield and Kurt Schwitters all were practicing the art in Germany at the beginning of the 1920s, as were El Lissitsky and Alexander Rodchenko in Russia. According to Julie Saul, Moholy's first photomontage was done while he was sharing a studio with Schwitters, from 1922 to 1923.[29] But as with the photogram, which had been "invented" first of all by William Henry Fox Talbot, Moholy's use of photomontage remains distinctive not because he originated the form but because of what he did with it. Just as his theoretical program was distinct from those of the Dadaists and the Constructivists, so, too, was his imagery. The Dadaists were satirists as the Constructivists were social idealists; Moholy, a romantic who managed to be both a utopian and a pragmatist, was able to span both positions, and more.

Whether attempting to promote pneumatic tires, decry the world arms buildup or hint at the difficulties in his marriage, Moholy worked with economy and wit, which together give his photomontages a spare force that is uniquely his. While not up to Stieglitzian standards in terms of appearance—historian Beaumont Newhall has observed that Moholy "had no interest whatsoever in what we call 'the fine print' "[30]—they are right for what they are: small, modest and just clear enough to convey their charms without showing their seams. Their titles, too, seem just right for their subjects: *Love Thy Neighbor,* alternately titled *Murder on the Railway* (1925), or *A Chick Remains a Chick.* It comes as no surprise to learn that the artist's definition of a "photoplastic" was "a compressed interpenetration of visual and verbal wit."

What does come as a surprise are the photomontages with personal themes, which according to Julie Saul's researches (which are indebted to those of Irene Charlotte Lusk of Berlin) reveal a great deal about the emotional difficulties afflicting the artist during the Bauhaus period. The major element in *The Fool,* for instance, is a portrait of Moholy taken by his wife. His image also appears in *Jealousy,* perhaps his most famous montage, in which an image of a female sniper, which has been positioned within his chest, takes aim at a buxom bathing beauty. Here and in several other images with man/woman themes, Moholy abandons his typical playfulness to exorcise feelings of bitterness and loss.

Yet in the overwhelming majority of these photomontages formal dexterity is of greater consequence than subject matter. There is precious little difference in appearance between those said to have emotionally loaded "personal themes" and those designed as theatrical posters or advertisements. This may make the work seem revolutionary (especially today, when the conflation of art and commerce is perceived as a radical virtue), but it also is its limitation.

As Lucia Moholy-Nagy, the artist's first wife and collaborator, noted in 1972, "At present it would appear that advertising, more than humor, has followed in the wake of those early beginnings."[31] The same could be said of all the innovative European photography of the 1920s and 1930s: that its legacy is more visible in the apparatus of advertising—where image counts for everything, and consumption substitutes for comprehension—than in the rarified world of art and ideas from which it emerged.

The notable exception to this tendency is—or was, until recently—American art photography, which through much of the postwar period was dominated by formalist ideas that can be traced directly to Moholy through the Institute of Design in Chicago. Moholy came to the United States to found the school (originally called The New Bauhaus) in 1937, after his dream of revolutionizing European consciousness failed, and he ran it until his death in 1946. But even here his New Vision was assimilated into something less than radical, becoming by the 1970s a "look," a "Chicago school" with a fixed repertory of "experimental" techniques and styles.

This devolution from radical practice to mere style is characteristic of what has happened to the accomplishments of the Bauhaus. In architecture, the building style meant to enhance commonplace life has been used primarily for corporate headquarters; in design, the chairs and tables intended for "the workers" have become the chic furniture available only through one's interior decorator. Consequently Moholy's marvelous experiments using photography have a vivid poignancy. The photomontages and other photographs are evidence of a faith in form as adamant and uncompromising as that of American modernists such as Edward Weston, and as historical. Today we have largely lost that faith, having stripped form of all its ideological underpinnings. No longer able to conceive of a visual world of infinite possibilities, we think and act largely in terms of style, form's empty shell, quoting from Constructivism and other creeds the way designers quote from fashions of the 1920s.

Written on the occasion of an exhibition of vintage Moholy photographs and photomontages, *Moholy-Nagy Fotoplastiks: The Bauhaus Years,* selected from the Arnold Crane Collection by Julie Saul, and shown at the Bronx Museum of Art in the summer of 1983. *New York Times,* July 31, 1983.

Robert Frank's Existential Refrain

IT HAS BEEN MORE than thirty years since Robert Frank, a Swiss-born emigré armed with a Leica camera and a Guggenheim grant, set out on the photographic odyssey across America that resulted in *The Americans*, a book that did as much to change the face of photography as any other single collection of pictures before or since. The eighty-three pictures of *The Americans* were immediately recognized as politically charged and formally innovative, although not in ways that fit into the cautious climate of the 1950s. Today, however, *The Americans* is a universally acknowledged classic, a watershed in the medium's postwar evolution from putatively objective to openly subjective ways of envisioning the world.

Such has been the acclaim afforded Frank's achievement, one might think *The Americans* was an isolated eruption, a brief flare in the heavens that occurred without warning and ended as suddenly as it had begun. In fact, Frank—who came to the United States in 1947, at the age of twenty-three—had been working intently as a photographer for more than a decade before winning his Guggenheim award, and since *The Americans* he has continued to pursue a creative life, adding filmmaking and video to his visual repertory. We need to look at his career in its entirety, then, if we hope to understand both the nature of his idiosyncratic vision and the full meaning of *The Americans*.

Between 1949 and 1952 Frank photographed in Paris, London, Wales, and Peru, as well as in New York, the photographer's adopted hometown. Obviously, his urge to be "on the road" predates *The Americans*. He was, at the time, an inveterate traveler, no doubt spurred by the same impulses as the Beat poets, who would become his soulmates later in the 1950s. And, the evidence suggests, he was a photographer with an instinctual knack for locating emotional significance within seemingly anecdotal visual events.

At the beginning of the 1950s, however, he had yet fully to arrive at the purposefully offhand, grungy and slightly ominous style that came to maturity in *The Americans*. It appears here and there—in a gloomy nighttime image of a forlorn woman holding a tray of cigarette packages, for example—but elsewhere the young photographer tries on other styles like clothes, searching for the right

fit. In the European work, especially, he seems influenced by the more lyric and upbeat styles of photographers like André Kertész and Henri Cartier-Bresson. But even in these pictures his ability to create symbolic meaning from a bare minimum of material reality is abundantly evident. A photograph from England shows a child running down a deserted street, away from the open back door of what appears to be a hearse.

The symbolism immanent in photographs like this is less political than personal—or, to put it another way, it is political only in the context of its concern for the individual. For if there is any theme to Frank's work before *The Americans*, it is the theme of existential alienation, of the loneliness and isolation of the disaffected artist, reflected in the alien environments that he sought out and, to some degree, cherished. In one image, a woman selling movie tickets is nearly obliterated by posters of Joan Crawford pasted over her booth. In another, a black teenager in the back of a delivery van seems absorbed in a private reverie, totally removed from the bustle around him. The photographer's alliance with the Beats seems, in retrospect, inevitable. They, too, felt displaced, rootless, and cut off from conventional society. They, too, identified with Bowery bums, South American Indians, North American blacks—all representatives, for them, of oppressed (and exotic) outsiders, and all subjects for Frank's camera.

In light of this, the significance of *The Americans* seems subject to reevaluation. Instead of being the masterpiece of incisive social criticism it has come to be considered—a self-conscious revelation of the injustices and inconsistencies of American society—we might see it as the somewhat narcissistic reflection of a personality caught up in the romance of the existential dilemma. By this account, Frank's magnum opus is a telling document of its time, combining equal parts skepticism and solipsism in an attempt to counteract the conformity and conventionality of American life, which he found so oppressive.

His work since *The Americans* tends to confirm this view. From the late 1950s into the 1970s he concentrated on film, making cultish, documentary-style movies featuring the likes of Allen Ginsberg, Peter Orlovsky, Gregory Corso, and Larry Rivers in his cast. More recently (and after a period of relative inactivity), Frank has taken to making Polaroid photographs and videotapes—both artisanal means of producing images that offer the pleasures of nearly instantaneous results.

An example of his more recent photographic work is a series of five 20-by-24 Polaroids titled, with considerable irony, *Home Improvements*. The photographs show Frank's son, his wife, and the photographer himself, each in one image, with a subway scene and a snowy landscape sandwiched between them. Wife and son look anxiously in the direction of the photographer, who peers through his video camera out at the viewer. The pictures are decipherable but indistinct, having been photographed from a television monitor.

To understand this work, it helps to read the hand-lettered banner that Frank has strung under the pictures. And it helps to know that the subway scene is in New York, Frank's longtime home, and that the snowy landscape is in Nova Scotia, his current abode. But without having seen Frank's hour-long videotape from which the scenes were taken, one can glean only a general sense of malaise from the work. The videotape makes the malaise specific: it shows the artist's wife recovering from a cancer operation, and his son in the ward of a Bronx mental hospital. The tape ends with Frank on a barren dirt road, trying to strike up a conversation with the men who pick up his trash.

Unfortunately, however, the videotape of *Home Improvements* has not been broadcast in this country. Without it, the photographs serve primarily to remind us of Frank's continuing commitment to a hermetic, idiosyncratic, subjective form of expression. (Significantly, his only new book of photographs since *The Americans* is called *The Lines of My Hand*.[32]) It is a form ideally suited to his theme of personal isolation, but ever since *The Americans* it has not generated the kind of broad response that would indicate it was striking a universal chord. Nor has it addressed the state of American society directly, as *The Americans* did. To see Frank as a political artist, then, is to see a chimera now more than thirty years old.

Occasioned by an exhibition of sixty-three vintage Frank prints from the late 1940s through the 1950s, at the Armstrong Gallery, and a show of new Polaroid works at the Pace/MacGill Gallery, New York. *New York Times,* July 7, 1985.

III. In Search of America

The Machine and the Garden

PHOTOGRAPHY, TECHNOLOGY, AND
THE END OF INNOCENT SPACE

Poetry and progress are like two ambitious men who hate one another
with an instinctive hatred, and when they meet upon the same road,
one of them has to give place. CHARLES BAUDELAIRE [1]

WHEN BAUDELAIRE WROTE THIS adamant, unflinching sentence in 1859, he was referring to something less literal than "poetry" and something more specific than "progress." He was responding to seeing photographs in the Paris Salon of 1859, exhibited as works of art on a par with painting, and he was referring to photography's relationship to that sphere of aesthetic experience that we call art. Photography, to Baudelaire, was a representation of the nineteenth century's new order, a "new industry" that elevated "external reality" while devaluing the realm of the imagination. Rather than being allied with art, photography was, in Baudelaire's opinion, part of "the great industrial madness of our times."

What the French poet recognized in 1859 was, in fact, true from the very beginnings of the medium. Photography was born into the world both as a product and as a servant of nascent industrial society, one that gradually would replace the traditional faiths of eighteenth-century man with a faith in mechanization, engineering, technology, and urbanization. Photography's growth in the nineteenth century, in short, went hand in hand with the growth of what we now call positivism, a belief in the redeemability of man and in the elimination of all social ills and unjustices through scientific systems, mass production, free enterprise, and hard work.

Clearly, today we no longer agree with the positivist agenda, having seen too much of the pernicious side effects of its materialist cure. Some of us may still believe in science, and some of us may even believe in hard work, but I don't know anyone who really expects social nirvana to arrive at the end of an assembly line, or social equality to be an outcome of increasingly sophisticated technology. Few of us today would subscribe to President Calvin Coolidge's belief that "The man who builds a factory builds a temple. The man who works there worships there." [2] This is an important turn in the cultural beliefs of the United States and, it goes without saying, an important turn for the medium of photography, which is the picture-making system most identified with the positivist faith.

What we need to examine, then, is the transformation of photography from its cultural role as an agency of industrial boosterism to a reformist role entailing skepticism, idealism, and human concerns. We also need to look critically at photography's participation in the process of American industrialization and mechanization in the nineteenth century, and in the subsequent transformation of that society into twentieth-century technological society—in short, to understand the way photographs reflect on, and serve as metaphors of, the optimism and enthusiasm of nineteenth-century life, as well as the disillusioned skepticism of our own times.

It is important to remember that photography was not born into the world alone, or even as a twin, as we have been taught. The same decade that saw the announcement of the invention of photography—by Louis-Jacques-Mandé Daguerre, in France, on January 7, 1839, and by William Henry Fox Talbot, in England, on January 31 of the same year—also saw the invention of the telegraph, the sewing machine, the McCormick reaper, and the Colt revolver. In other words, picture making was not the only human activity to become mechanized for the first time in the 1830s. Communication, in the form of written word, was transformed into electrical impulses; the essentially homebound activity of fashioning garments was converted into a piecework industry; machines began to replace muscle power in agriculture; and interchangeable parts became the rule, allowing for the conquest of ever more and more territory, and the domination of nonindustrialized peoples.

So when we see pictures such as Roger Fenton's bucolic image of 1859 showing a group of gamekeepers on an English estate, we should not make the mistake of thinking that they "document" English life at the time. If they document anything, it is the English ruling class's nostalgia for a pastoral, feudal world that the mechanization of Victorian life rendered vestigial. The new world—the world that allowed Victorian England to extend its influence across the globe—is perhaps best symbolized by the famous Robert Howlett portrait of Isambard Kingdom Brunel, who is shown standing with obvious pride and self-satisfaction in front of the anchor chains of the mammoth steamship *The Great Eastern,* in 1857. What transpires in the gulf between Fenton's and Howlett's pictures is the creation of a new Eden, one in which the ideal of the garden is supplanted by the ideal of the machine.

The notion of the machine and the garden, as they constitute a major theme of nineteenth-century art, is not my own; it belongs to the literary critic Leo Marx, whose book *The Machine in the Garden*[3] traces the conflict of industrial and agrarian world views throughout nineteenth-century American literature. But it seems clear to me that the same characterizing structure holds for photography as well. It may even hold more profoundly for photography, since it was not, like the novel, an innocent bystander in the process of industrialization. Camera images

were used (and continue to be used) to promote the interests of industry, to glorify machinery and the mechanization of labor. Moreover, photography is itself a metaphor of the industrial process, a supplier of mechanically produced and reproduced images, its positive images functioning poetically and to some extent practically as interchangeable parts, and as weapons in the conquest of new territories and new peoples.

In the beginning, during what we might call photography's amateur period, the medium was pretty much a home-brewed affair, like sewing or bread making or bee keeping, except that it was practiced by an almost exclusively upper-class, male breed of hobbyist. Samuel Morse, who took the first photographs in the United States (and, coincidentally, invented the telegraph), took Daguerre's recipe and his own plans to an instrument maker to have his first camera made. Other early pioneers dabbled in chemical formulas in an effort to improve the recalcitrant processes of Daguerre and Talbot.

But in the 1870s, with the introduction of dry plates, photography became standardized. The size of the negatives, the speed of the emulsion, the texture of the paper all became a decision not of the photographer, but of the manufacturer. Photography assumed some aspects of industrial production, as pictures of Kodak's first factory, the Eastman Dry Plate Company in Rochester, New York, suggests. Film and prints became a manufacturing operation, supported by an increasing market fueled by an eager public of new amateurs—not those in the old sense of gentrified tinkerers such as Henry Peach Robinson and Julia Margaret Cameron, but in the new sense of a recreational bourgeoisie. Kodak, naturally, courted the new generation of consumers, and sought in its earliest advertising to enlarge their numbers.

It is clear from early Kodak advertisements, such as one purporting to show the "Kodak Girls" attending the 1893 World Fair's Colombian Exposition in Chicago, that one way to expand the base of photographic consumers was to attract a female constituency largely excluded from the predominantly male preoccupation. And what better place to set the scene of this putatively eman-cipationist message than the Chicago World's Fair, which was designed and produced as a symbol of the new industrial spirit of America? Curiously enough, this particular Kodak ad is illustrated with a drawing, not a photograph. Granted, half-tone reproduction of photographs was still in an uncertain state at the time, but we also might consider the possibility that drawing, per Baudelaire, seemed to appeal more to the imagination than did a photograph, which is so imbued with facticity. And Kodak then as now was selling dreams, not reality.

The reality looked more like an assembly-line factory, if we believe a photograph of Kodak's photofinishing operation in 1894. In this document we again see women allied with the photographic image, but here they are depicted as caretakers and nurturers of vision, not as its creators. As laborers, the female

Kodak employees are clearly not in the same league with the fanciful "Kodak Girls," in either their station in life or their independence.

At the same time we can see that the factory, which once was spoken of as a new form of utopia, as a temple of worship, does not necessarily produce social equality and happiness. Neither, for that matter, do cities, which for much of the nineteenth century were thought of as the meccas of the new industrial society. In fact, it is possible to trace through photographs of cities the changing attitudes toward industrialization as a whole, as Peter Bacon Hales has attempted to do in his book *Silver Cities: The Photography of American Urbanization, 1839–1915*.[4] We can see, for example, in the nineteenth century, a kind of extreme oscillation between attempts to romanticize the city and attempts to describe its most vile aspects. This alternation, which since the 1890s has been a simultaneous process, continues even into our own time. On the one hand we get pictures such as Charles Marville's 1851 calotype of Paris in the snow, in which the city looks much the postindustrial virgin, and on the other we have pictures such as Thomas Annan's of the closes of Glasgow—decrepit blind alleys about to be torn down by the city fathers in what constituted an 1868 version of urban renewal.

The recognition that neither mass mechanization nor the organization of life around the metropolis could bring on the anticipated new Eden—indeed, that mechanization and the metropolis created misery in the course of trying to eliminate it—dawned late in the nineteenth century in England and America, and spawned a social reform movement that enlisted photography in its service. In England, John Thomson took to the streets of London to depict the lower rungs of urban life with a revolutionary candidness and unpretentiousness. In the United States, a muckraking reporter named Jacob Riis took up the camera to help expose the unsanitary, debilitating conditions of slum life. Neither could be said to have made a connection between urban ills and industrialization, but both extended the range of what could be made visible to their respective publics.

Unfortunately, both men's perceptions of urban squalor, for all their trenchancy, were marked by a typically nineteenth-century sentimentality. Today, we read this sentimentality as patronizing. As photographic historian Sally Stein remarked of Riis, it represents an ambivalence "about whether the present inhabitants of the slums could be rescued, or whether they were even worth the effort."[5] In Thomson's case, the sentimentalizing and patronizing of the poor is evident in the captions that accompany the pictures in his book *Street Life in London*, published in 1877–78. One, a precursor of all Bowery-bum photographs ever taken, is titled with a graphic flourish, *The Crawlers*. Moreover, the pictures themselves are resolutely picturesque, so the people in them are refashioned into "types" or "characters."

Jacob Riis, a journalist adept at getting a reader's attention, went a bit further in his 1890 book *How the Other Half Lives*. Using a frantic hyperbole nowadays

reserved for newspapers such as the *National Enquirer,* Riis sought to mobilize
sentiment against slum life in New York City, where in 1877 a population of one
million was housed in some 37,000 tenements. But what's interesting about *How
the Other Half Lives,* as Sally Stein has pointed out, is its ambivalence about the
poor for whose benefit it ostensibly crusades.

Nor was Riis above methods that sociologists today would dismiss as tainted.
Here is Riis's curious caption from *How the Other Half Lives* for a picture of
several boys titled *A Growler Gang in Session:*

> While I was getting the camera ready, I threw out a vague suggestion of cigarette
> pictures, and it took root at once. Nothing would do then but that I must take the
> boldest spirits of the company "in character." One of them tumbled over against a
> shed, as if asleep, while two of the others bent over him searching his pockets with
> a deftness that was highly suggestive. This, they explained for my benefit, was to
> show how they "did the trick."[6]

Does this mark the beginning of the tradition of documentary photography?
One wonders not only at the efficacy of Riis's "vague suggestion" that got these
young ruffians to pose, but also over the usefulness of socially reforming them.
If Riis wanted to elicit sympathy among the better classes for the
underprivileged, this is a curious way of going about it.

Riis also photographed reform institutions, where better lives were being
forged for all, and he did so with a similar reliance on the stage-managed,
directorial mode. His picture of children at prayer in the nursery of the Five
Points Mission and the Five Points House of Industry is captioned as follows:

> The House of Industry is an enormous nursery-school with an average of more
> than four hundred day scholars and constant boarders... it is one of the most
> touching sights in the world to see a score of babies, rescued from homes of
> brutality and desolation... saying their prayers in the nursery at bedtime. Too often
> their white night-gowns hide tortured little bodies and limbs cruelly bruised by
> inhuman hands. In the shelter of this fold they are safe, and a happier little group
> one may seek long and far in vain.[7]

If parenting in the slums was as bad as Riis describes it, why would anyone
want to improve the conditions of the parents' lives? In short, Riis tended to
depict slum dwellers alternately as victims of their circumstances and as thieves,
thugs, and child-abusing sadists. Or as drunks. In *How the Other Half Lives* is
a picture of what Riis called "an ancient woman lodger" known as a "scrub."
His caption explained:

> The scrub is one degree perhaps above the average pauper in this, that she is
> willing to work at least one day in this week, generally the Jewish Sabbath. The
> orthodox Jew can do no work of any sort from Friday evening till sunset on

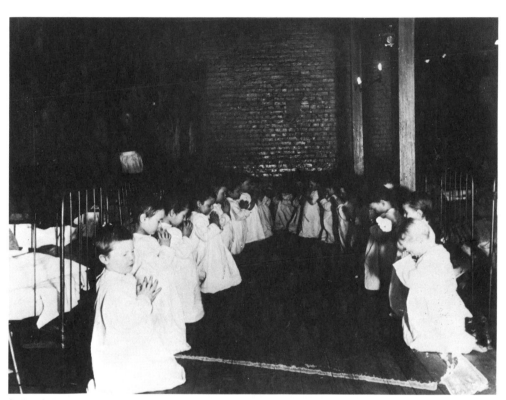

8. Jacob A. Riis, *Prayer Time in the Nursery, Five Points House of Industry,* ca. 1900

Saturday, and this interim the scrub fills out.... The pittance she receives for this vicarious sacrifice of herself upon the altar of the ancient faith buys her rum for at least two days of the week....[8]

Today we are accustomed to seeing prints of the full Riis negative of this image, thanks largely to the Museum of Modern Art, not the cropped version reproduced in Riis's book. The self-referentiality of the full-negative version, with what is likely the photographer's hand included in the frame to remind us of his presence on the scene, appeals to modern tastes, but to Riis it would have ruined his illusion of documentary transparency. It is symptomatic of the aestheticization of Riis's curious work that the full-negative version is the one that has entered the canon of photographic masterpieces.

What's finally interesting to note about Riis's crusade on behalf of the social reform movement of the late nineteenth century—which embraced not only housing, but also such issues as sanitation, health care, and park design—is its effect. The immediate and direct result of his efforts was the demolition of places such as the Five Points slum. That is to say, instead of ensuring the security of the poverty stricken, Riis's project seems—in best twentieth-century urban renewal fashion—merely to have displaced them.

Nevertheless, we have to admire Riis and Thomson today despite their faults, because they were pretty much alone in the nineteenth century in taking a critical view of the effects of the new industrial, urbanized society—albeit a view that is tentative, unfocused, and tainted by class. For the most part, photographers of their era functioned, as Hales put it in *Silver Cities,* as agents in "the transformation of America from a rural and agrarian nation to an urban and industrial one."[9]

Jack Hurley, in his book *Industry and the Photographic Image*, is more specific:

> During the nineteenth century, most photographers seem to have reacted to industrialization on a fairly expository level. That is, they generally appear to have been satisfied to record the railroad locomotive, the steamboat or the factory (usually the exterior) in a straightforward manner without feeling the necessity to search for symbols or metaphors. Visual flights of poetic fancy were usually reserved for pastoral scenes, portraits or morally didactic scenes borrowed from the academic painters of Europe.[10]

And, Hurley continues,

> ...professional photographers closely mirrored the values and presuppositions of their day. They were not reformers, nor were they poets. They were generally in the business of making and selling photographs.[11]

We shouldn't however, take Hurley's remarks about the "straightforward" and "expository" style of most nineteenth-century industrial photography to mean that these photographs are somehow plainly "documentary" in any neutral, natural, or uninflected way. For whether or not there is evidence of some aesthetic sensibility at work in any given picture, there is always evidence of a cultural attitude. In fact, Hurley goes on to discuss what he calls "the heroic theme" of nineteenth-century pictures of industry, pointing out how they show the conquest of man over nature, how the workingman is depicted in terms worthy of a Greek mythological hero, how the poses and compositions consistently convey a sense of mastery and achievement.

These aspects of the nineteenth-century vernacular can be seen in full bloom in a picture like Carleton Watkins's 1983 view of a Carson City lumber yard. Clearly Mother Nature has been conquered and ravished, penetrated by the all-powerful steam locomotive, and denuded of her forests. But as powerful as the locomotive is, in the visual hierarchy of the image Man assumes the highest position, standing atop a pile of finished boards in the foreground, the lord and master of all he surveys.

Invoking Mother Nature and Carleton Watkins, as I have done, brings us to another aspect of nineteenth-century practice that bears examination: the genre of landscape photography, and how it mirrors what I have chosen to call "the end of innocent space."

It would seem that around the time of the Civil War, coincidentally or not, a major shift took place in the way in which Americans depicted the land—in their manner of conceiving of the landscape as a pictorial unit. The arena for this change was the American frontier, which attracted not only those in search of adventure but also those in search of an aesthetic sublime. The terms of the change can be seen in the differences between any one of Albert Bierstadt's paintings depicting the Rocky Mountains or the Sierras and the classic and deservedly famous 1867 image *Cape Horn near Celilo* by Carleton Watkins. For Bierstadt, the conventions of Hudson River School landscape painting applied even into the 1860s: Man takes a front-row seat in the foreground (in some cases, "Man" means American Indians, adding a touch of the exotic); the space from foreground to background gradually and gently recedes, according to the dictates of Renaissance perspective; and the features of the land itself are exaggerated in scale and shape. The result is as much dreamscape as landscape, but to much of Bierstadt's audience these paintings represented the reality of the American West: it was overwhelming, breathtaking, vast, and apparently overpopulated by Indians with time on their hands.

Watkins's picture, by contrast, is acerbically dry, understated, and minimal; instead of the airy, glowing tones of Bierstadt's mountains, we get a somber, penumbral atmosphere that is forbidding rather than inviting. In lieu of the

bucolic Indians encamped on a foreground plain, we are shown a nearly vertical rock face, an alkali sink, and a railroad track. As Russ Anderson has pointed out,[12] the picture is organized around nearly abstract areas of tone, with a great deal of "negative" white space dominating the frame. Moreover, spatial recession is minimized; instead of feeling that the railroad track allows us free passage into and out of the scene, we feel trapped on a track that leads nowhere. Watkins's picture suggests what Bierstadt's doesn't, that the natural world is as likely to be unfriendly as friendly—that, in fact, it has no feeling for man one way or the other. Even Man's most incredible mechanical achievement—the railroad—does not dominate the scene, but seems integrated with it. The collapsed space of the picture is a metaphor of this collapsed distinction between the natural world and Man's presence in it.

The division between the European-derived, East Coast conventional way of seeing the landscape and the one occasioned by the American West also can be seen in the work of the photographer Timothy O'Sullivan. Consider his rather anomalous 1863 picture of Union officers, their wives, and their servants taking a picnic break from the Civil War. As in conventional landscapes since Claude Lorrain's time, we are provided with a populated foreground plane and look through it onto the "scene" of pure pictorial nature. The ease with which our eyes enter the picture space is equivalent to the ease of the people in the foreground, and suggests that the natural world is a pleasant site existing for the sake of Man's delectation.

It is a remarkable picture only in the context of the body of work of the photographer who took it, since O'Sullivan's other pictures of the Civil War are among the most harrowing and vivid that we know. After the Civil War, O'Sullivan served as the official photographer on several government surveys, and made landscapes quite unlike any seen before. In his survey images, there is generally no foreground plane to supply a bridge for our eyes, no sense of inhabitability, nothing inviting about the site. Instead, we look out over some of the most God-forsaken territory imaginable. Yet O'Sullivan has organized these scenes into pictures of considerable force, and in a manner that radically extends our conception of what a landscape can be.

Like Watkins, and to some extent Eadweard Muybridge and William Henry Jackson as well, O'Sullivan imbued his pictures of the American West with a profound skepticism about Man's relation to Nature. Nature seems not so much dispassionate in his pictures as apassionate, remote from man's wishes and intentions. This attitude precedes most skepticism about the relationship of Man and mechanization, but it is analogous to it—which is why, I think, that the late-twentieth-century photographers whose work has been characterized as "New Topographic," such as Robert Adams and Lewis Baltz, turned to O'Sullivan as a model in their search for a way to protest the suburbanization of Western life.

At the same time, however, there persisted the kind of conventional landscape practice that is essentially agrarian, pastoral, and sentimentalized. In England, at least, we can see this kind of landscape—perhaps best epitomized by the works of Peter Henry Emerson in the 1880s—as a reaction to the industrial, urban society that England had by that time become. Like William Morris, who wanted to return to a medieval sort of economy and to restore craftsmanship values to Victorian life, Emerson was a reactionary of a relatively benign sort. His landscape fantasies—which while self-consciously aestheticized also masqueraded as factual—constitute as much a photographic reaction to the industrialization of modern life as did John Thomson's street pictures. The difference, of course, is that Emerson, like Morris, tried to turn back the clock.

There is another difference as well: whereas Thomson conceived of his photographs in terms of a report on how life was lived, Emerson conceived of his photographs as works of art. And thus we get what for photography marks a fundamental watershed: instead of being allied with mechanization and industry and urbanization, as it had been from its beginnings, it gradually developed an alternative practice based on a rejection of them. Rather than romanticize the machine, it would romanticize the garden. Rather than heroicize the mechanic, it would heroicize the eccentric. And the name given this rejectionist practice, appropriately enough, was "art."

In the face of the machine—of which the camera was one—the practice of art photography in the late nineteenth century sought to assert the importance of the individual by valorizing the photographer as an artist. To take the curse off the mechanical nature of camera images, these photographer-artists chose to manipulate their pictures, inserting a craftsmanlike hand into the image-making process. Platinum, carbon, gum bichromate—all were used to separate the images of art photography from the specter of mechanical reproduction.

If we turn to our own country we can see similar contradictions built into turn-of-the-century art photography. Take, for example, the work of Alfred Stieglitz, the godfather of American modernism, who more than any other single person set the course of twentieth-century photography. In 1894 he was making pictures such as *Early Morn,* a genre scene taken in Europe that looks remarkably similar to an Emerson picture from the Norfolk Broads. But by 1902, in America, he was taking pictures of railyards, city streets, and other "modern" subjects, and giving them titles on the order of *The Hand of Man.*

Clearly more than eight years separates these pictures. While in Europe, Stieglitz was under the influence of the kind of art photography fostered by Emerson, as well as the influence of Whistlerian-style painting. The perfect agrarian composition of *Early Morn* reflects an endorsement of rural life, to be sure, but it also, for the city-bred Stieglitz, suggests the exoticism of a foreign consciousness. It is perhaps a trifle harsh to say that *Early Morn* is an example of

Stieglitz slumming in arcadia, but it is nonetheless essentially the case. *The Hand of Man* is more forward-looking and, consequently, looks more modern. Here Stieglitz, back in his native New York, attempted to come to terms with a landscape that could no longer pretend to be innocent of the machine. And, being the photographer that he was, he succeeded in turning what we now would call an industrial landscape into a picture of persuasive conviction. The picture is an anthem to the railroad, which is depicted as a symbol of progress.

Yet one can't help but notice the stylistic similarity of these two photographs. Despite their opposite subject matter, and despite their contradictory views of life's values, they are organized as pictures almost identically. Slightly soft of focus, with a limited depth of field, and relying on atmospheric effects, they make their points in the same way. Both attempt to be art in a style that is essentially nineteenth century. In *The Hand of Man,* this style creates a quite marvelous contradiction between what we would conventionally call form and content. Stieglitz's content is progressive, but his form is reactionary. Obviously such a tension could not last for long, and to Stieglitz's credit he struggled long and hard to resolve it. What was needed to convey modern life, with all its machinery, steam, and smoke—and, soon enough, its proliferation of automobiles—was nothing less than a New Vision.

Soon enough, precisely such a new vision of art photography was created, and American modernism added photography to its fold. This process would involve a radical 180-degree turn from the rejectionist position of the pictorialists, and it would embrace the machine—and the camera with it—with an uncritical passion. Stieglitz himself did not invent the new vision, but he groomed, prompted, and promoted the photographer who did: Paul Strand. Strand's *Automobile Wheel,* taken in 1917, might be said to mark the watershed in art photography from a position antagonistic to industrial production to a position infatuated with it. Shortly thereafter, photographers began falling into ranks behind Strand, joining what Jack Hurley has called "the cult of the machine."[13]

The considerable influence of European modernist art, especially cubist painting, can be seen in the kind of pictures that Ralph Steiner and Paul Outerbridge made as students at the Clarence White School in New York. Steiner's 1921 picture of a typewriter, for example, with its dynamic angle of view and patterned ranks and rows, lends a certain fashionable cachet to what was, at the time, a rather clankety, humdrum machine. And it suggests—no doubt without intending to—that the mechanization of society extends beyond the factory and into high culture, where the mark of the hand has been replaced by a brand of automatic writing.

Transportation was rapidly becoming automated as well, and—as more and more people got the urge to own a car—democratized in the process. The seemingly irresistible urge to photograph car wheels in the 1920s and 1930s can

be attributed, then, not only to the modernist machine cult's fascination with the formal order and precision of the new technology—a probable reaction to the disorder and imprecision of World War I—but also to the prospect of a new social order that this new technology symbolized. Thus we see in the interbellum period institutions like the Bauhaus in Germany, where new designs using new materials were intended to prepare the way for an imminent new age of equality and prosperity. And we see artists like László Moholy-Nagy dedicating themselves to propagandizing for a new vision that would change individual consciousness through the mechanism of the eye. No one, said Moholy, could ignore that which was "optically true."

"Modern" early twentieth-century photographs of cars and trains, taken in abundance in the United States and throughout Europe, are not merely documents of machines; they are pictures with a mission, and that mission is to sell the faith that technological progress entails progress toward a new social order. And at the same time that transportation was being democratized by the automobile, and a new mobile recreational culture was being created, photography was being democratized by the Kodak camera. As the critic Elizabeth McCausland observed in 1938:

> The Brownie is in the cultural field the equivalent of the Model T Ford—
> mass produced, cheap "vision" for every man, as the Ford was mass produced,
> cheap transportation for every man.[14]

Strand's famous 1923 photographs of a factory lathe are probably the most potent demonstration of this new fascination with the machine. Critics at the time observed how Strand had gone not just for formal beauty in these pictures, but right to the heart of the functional part of the lathe. That is to say, if we take them at their word, that what made these pictures great was their reconciliation of form and function. Suddenly, it would seem, the photographer had become a model for the modern architect.

Strand's lathe photographs were taken at the Akeley Camera company's machine shop, which manufactured Strand's movie camera. Strand also photographed the working innards of the camera itself. As with Ralph Steiner's typewriter, once again we see the mechanization of a human function—in this case, sight—being glorified, being made iconic and monumental. But what is Strand's abstractionist image a monument to? Well, perhaps to the god photography, which at the time seemed able to reconcile technology and aesthetics, scientist and artist, machine and garden.

Both modernist photography and the positivism that preceded it are faiths based on a belief in progress through the machine. What separates them is more than style—although certainly the tendency to go for the detail, to abstract and thus symbolize the machine is uniquely modernist. What separates them as faiths

is that the Modernists believed technology and aesthetics to be compatible, not rivals. But to make this appear in photographs, they had to eliminate from the frame anything that would allow the machine to be seen in context. Thus the sense we get today, looking back at this work, that it is idealized to the point that it begins to look like advertising. In fact, a great deal of the constructivist-influenced work done in Europe in the 1920s and 1930s was in the service of advertising. What was being depicted was not just machines, but their products—things to consume, things to indicate one's status in life, things to make one mobile and—presumably—free.

In light of this promise, however, it is interesting to note that part of what gets eliminated in constructivist pictures like Alexander Rodchenko's *Cog Wheels* (1929)—part of the context that has been stripped from this unidentified machine—is the notion of human labor. Photographers such as Strand and Rodchenko were not working in the service of Daddy Warbucks-style capitalists, of course. They were committed leftists who felt their art was engaged in a struggle for social justice, and that it was on the side of the worker. Rodchenko, for one, was directly trying to serve the revolutionary goals of Communism, as an artist of the Soviet Union. So it is strange, if not contradictory, to see a picture like *Dynamo* (1930), in which Rodchenko portrays the Soviet people as so many cogs in a machine. And what exactly is the machine we see abstracted in his photographs? What we would see, were we able to draw back or use a wider-angle lens, would be no less than the engine of the Soviet state, a government ultimately based on the model of industrial production.

One photographer who did concentrate on the worker instead of the machine was Lewis Hine, who began in the first decade of this century to record the real, as opposed to the idealized, workplace. His pictures of child labor, of which there are hundreds, are well known as exemplars of the power of photographs—because of them, we are told, Congress passed legislation outlawing child labor. (We also are told, but far less frequently, that when the United States entered World War I the law had to be repealed.)

Hine was not immune, however, to the idealizing urge. After years of documenting the horrors of the workplace, by 1930 Hine had converted to a style that monumentalized and heroicized the working man. In his pictures of the construction of the Empire State Building in New York City, the workers seem somehow freed from the constraints depicted so tellingly in the photographer's earlier work. Surely Hine did not intend to glorify industry in the process, but the plain fact is that he does. His image of a workman suspended high above the city streets could serve as an advertisement for any high-rise real estate developer. Hine was not alone in his tendency to make architecture into a metaphor for the progressive spirit: witness Charles Sheeler's 1930 *River Rouge Plant* and Edward Weston's *Armco Steel Works* of 1922.

Then there is the example of Margaret Bourke-White. As we know from Vicki Goldberg's biography, Bourke-White made her reputation on the basis of her impressive cantilevered images of industry—a style she transferred from *Fortune* to *Life* magazine in assignments such as her 1936 coverage of the Fort Peck Dam. But this was, after all, the decade of the depression, and she became more and more focused on taking photographs that reflected the social reality of her time. *Louisville Flood* (1937), one of her signature images, shows us a line of people waiting for flood relief before a billboard promising them (and us) better times. Suddenly, it seems, she adopted an ironic stance toward the American dream, and radically revised not only the content of her images but also their style. By the time she photographed Gandhi, she had become a humanistic "concerned" photographer.

In prewar England, Bill Brandt photographed the flip side of the industrial revolution, creating pictures remarkable for their dreariness. Once again, as happened before in the nineteenth century, the bloom was off the rose of industry. In America, we had the Farm Security Administration photographers to remind us of how bad things could get. When Walker Evans traveled to Easton, Pennsylvania, in 1936, he didn't fill the frame with a shining fragment of the Bethlehem Steel Company's open hearth furnace. Instead, he put a graveyard in the picture's foreground, followed by the workers' row houses, followed by a thicket of dirty smokestacks. This image, with admirable economy, tells us that the great industrial age, and our faith in its redemptive possibilities, are over.

Evans continued to photograph industry throughout the 1940s and 1950s, but even as an employee of *Fortune,* the glossy, classy magazine for millionaires, he was never able to completely jump onto the capitalist bandwagon, choosing instead to document the anxieties of the labor force, as in his 1946 essay *Labor Anonymous.* Perhaps Evans's lack of progressive fervor explains why only a few hundred of his images appeared in *Fortune* during his two decades of employment there.

The postwar problem has been to find a style appropriate to the post-industrial age. By that I mean that photographers have had to find ways to dissociate themselves from the booster tradition of vernacular photography and from the machine-cult fixation of modernism. Today photographers can no longer pretend that the natural world exists in a splendid, edenic isolation, remote from human culture and human interference, as Ansel Adams was able to do in 1927. Instead, they are trying to picture the world in a way that conforms not only to our experience of it, but also to the postmodern belief that what we know of it is known through the biases of culture—that there is no stepping outside the bounds of our times and our society. There is, in recent landscape photography, for example, a palpable sense of tragedy, of loss, of diminution and regret.

Some notion of the reification of our experience of the world can be gathered from Lewis Baltz's book *Park City*.[15] Baltz, acting much like a nineteenth-century survey photographer, and at the same time like an unmanned space probe, views the construction of this Utah resort town with an unsettling detachment. In the sequence of the book, he moves in from the surrounding hills, circling closer and closer until he is inside the half-built houses, assaying their pre-fabbed interchangeable-parts, ersatz construction. And finally, in the last image of the book, we see the landscape transformed into a plot plan—what is euphemistically known as real estate, ruptured from anything real, a sad and disheartening image of itself.

Today there is no innocent space, no room to see the garden without also seeing the machine. Neither is there any room for heroicization, for monumentalizing the look of postindustrial society. What remains of the American frontier has already been framed for us, as John Pfahl's picture windows series suggests: it exists in a kind of postcard netherworld from which neither we, nor it, can escape. At the same time, the golden age of industrialization, and our boundless faith in the ameliorative powers of mechanically based technological progress, lie in ruins. What the industrial landscape now looks like can be gathered from Ray Mortenson's pictures of the New Jersey Meadowlands. While Mortenson's photographs have a distinct formal beauty, what they depict exists in a state of disorder and decay. There is even a hint that nature may reclaim the land as its own. A similar vision of industrial decay can be found coexisting with an elegiac nostalgia in the work of Joel Sternfeld, whose pictures suggest that all of Man's efforts—industrial, in the past, and technological, in our own times—are fated to fall apart.

The most convincing recent report on the demise of industrial society is Lee Friedlander's *Factory Valleys*.[16] In surveying what is called the Rust Belt of Ohio and western Pennsylvania, Friedlander shows us, with his typical virtuosity, the factories, streets, trucks, and railyards that once were this country's glory, now reduced to vestigial pockets of economic and spiritual poverty. The most interesting images in *Factory Valleys*, though, are Friedlander's portraits of the workers who labor in what remains of these factories. They are markedly different from Hine's portraits of the men building the Empire State Building, since their subjects completely lack the aura of independence and self-confidence that Hine was so intent on inventing. And they are markedly different from Hine's earlier portraits depicting workers as victims, since Friedlander's pictures resist evoking any pathos for their subjects.

This lack of pathos has led some critics to attack Friedlander as an exploiter, as a cold-hearted formalist merely using the occasion to exercise his own aesthetic whims. But these complaints miss what is most remarkable about the pictures, and what makes them ring true in a way that more blatantly

sympathetic—even sentimentalized—images do not. In Friedlander's factory photographs, workers and their machines are pictured in a state of equilibrium. In one sense, the men and women seem to be parts of the machinery—as, in the largest sense, they truly are. But they also are distinguishable from their machines to a sufficient extent that we can feel the tension of their existence. There is no pretense of an industrial Eden in *Factory Valleys,* no suggestion that the labors being performed, or the products being made, are going to make for a better life. What we see is work, without illusions.

All this makes it seem more than slightly ironic that in the 1980s technology has once again come forward to claim that it possesses the power to improve our lives and even—in a reprise of European modernism—to revolutionize our collective consciousness. I am thinking here not of microwave ovens, nor even home videotape recorders, but of the computer. Already we are hearing that photography as we now know it will be subsumed and consumed by digitalized little pixels that can be rearranged at will. Already there are books being published claiming to illustrate something called "computer art." But will this new technology—called high technology by its advocates—improve our lives any more than mechanization did? Will it promote human happiness any more than the assembly line did? Having seen the history of industrialization of the last 150-odd years through the medium of photography, can we be blamed if we remain skeptical?

This essay was written for a lecture delivered at the San Francisco Museum of Modern Art in 1985 and published for the first time in the first edition of *Crisis of the Real.*

Walker Evans, Connoisseur of the Commonplace

FIFTY YEARS AFTER THE PUBLICATION of his magnum opus, *American Photographs*, and fourteen years after his death, Walker Evans remains a beacon for contemporary photographers. Unlike the other modernist masters who photographed in the 1930s—Alfred Stieglitz, Paul Strand and Ansel Adams among them—Evans seems relevant to our postindustrial, postmodern age. This is paradoxical, since he photographed precisely those elements of American life most vulnerable to the wages of time: clapboard houses, tin-sheathed garages, automobiles and billboards.

What makes Evans's photography seem much closer to hand than, say, Stieglitz's photographs of clouds, is not difficult to discern. He avoided anything with romantic associations, anything that smacked of sentimentality, and anything tinged with syrupy artiness. He was a connoisseur of the commonplace, both in his choice of what to photograph and in how he photographed things. In a sense, he was the first photographer to make photography a truly critical activity. What was allowed within the edges of his frames had to meet the strictest standards, both aesthetically and ethically.

"The most characteristic single feature of Evans's work is its purity, or even its puritanism," Lincoln Kirstein wrote in his introduction to the 1938 edition of *American Photographs*.[17] Kirstein was an early admirer and a formative influence on Evans's sensibility, along with the writers James Agee and Hart Crane. Indeed, there is a literary feel to *American Photographs*, with its virtually invisible narrator injecting notes of irony and social comment within a richly textured narrative structure. One thinks of T. S. Eliot's *Wasteland* in much the same way.

In the twenties Evans had gone to Paris "to get a European perspective," he later recalled. Besides being literary, this perspective provided the cues for the naturalistic style he was to adopt shortly after he took up photography in 1930, at the age of twenty-seven. When he was asked in 1971 what writers had influenced him, he mentioned Gustave Flaubert and Charles Baudelaire—Flaubert "by method" and Baudelaire "in spirit."

9. Walker Evans, *Self Portrait*, 1927

Among photographers, he most admired Eugène Atget, the poetic chronicler of Paris, and Mathew Brady, the American portraitist and documenter of the Civil War. What they shared, with each other and with Evans, was the conviction that a photograph was most expressive when it hewed to the facts with rigor and precision. Like them, he engaged in documentary projects. In 1935 and 1936 he photographed for the Farm Security Administration, recording rural American life in both the North and South, and he took the pictures of southern tenant farmers that appear in *Let Us Now Praise Famous Men,* his 1941 collaboration with Agee.

In stylistic terms, Evans's photography is a series of negations. It is un-embellished, unvarnished and unpretentious. It eschews any atmospheric effects and most of the niceties of traditional composition. Often, in photographs of buildings as well as portraits, the subject is seen head on, in the hard light of midday sun, directly at eye level. As a result, Evans's subjects achieve a clarity, solidity and presence. While plainly temporal, they appear as if they existed outside of time.

In addition, he photographed precisely what others had purged from their pictures: telephone poles and wires, road signs, passing cars, a broom leaning against the cardboard wall of a shanty. He saw in these things the rudiments of a uniquely American language, which he could organize to convey his own sense of American life. This discovery—of a nascent visual language existing within the American vernacular—makes Evans an avatar of today's fascination with semiotics and the sign systems erected by culture.

Evans was also one of the most self-conscious photographers of his time, and probably the most critical of art photography's ambitions. *American Photographs*, for example, opens with two pictures of photographers' portrait studios. The first, taken from a distance, shows a building covered with signs that say "Photos, 5 Cents." The second, a close-up, is filled to the edges with scores of studio portrait proofs, arranged in neat rows behind a store window.

In the context of the pictures that come later, this evidence of vernacular image making serves to set Evans's photographs apart from the then-prevailing styles of photography. Evans found Stieglitz's work too arty and Edward Steichen's pictures full of "parvenu elegance." Photojournalism, the bright new star of the thirties, he disdained as sentimental. *American Photographs* represents his attempt to achieve expressiveness without pretentiousness, and social meaning without bathos.

American Photographs consists of eighty-seven plates, divided into two sections. Each image appears on a right-hand page of its own, surrounded by white, with a blank left-hand page opposite. This style of presentation is now so commonplace in photographic books that it scarcely seems worth noting. But in 1938, when the first edition was published, it represented an almost luxurious assertion of the photograph's right to be considered on its own merits.

The first section of the book is largely devoted to pictures of people, including several taken at the same time as the photographs found in Evans's other major volume, *Let Us Now Praise Famous Men.* While Evans is widely known as a formal, even stately recorder of people and things, many of the images here are energized by a candid, stop-action approach. In an image called *Parked Car, Small Town, Main Street,* a passing truck blurs the area behind a teenage couple seated in a convertible.

Part two is devoted to photographs of buildings, seen either in the context of urban settings or isolated in an iconic splendor. Row houses, factories, wooden-frame churches, and other forms of simple, everyday American architecture are contrasted with such pretentious stuff as a neoclassical office building adorned with a columned portico and a Victorian-style mansion with crenellated trim hugging its eaves.

There are a great many "classic" Evans images in *American Photographs*, some of them ranking among the most memorable achievements of modernist photography. However, it is the structure of the book—the selection and sequencing of the photographs—that has made it such an enormously important volume, one whose influence continues to shape American photography fifty years later.

In designing *American Photographs*, Evans had as clear a vision as he shows in his images. What may have once seemed like a willful arrangement has long since been recognized to have a nearly symphonic complexity. From the beginning, the book sets up an alternation between social reality (as suggested by the tawdry, five-cent photo studio) and the conventional images which serve to mask it (represented, in the book's second photograph, by the hundreds of healthy, smiling white faces). Sometimes one follows the other; sometimes they are compressed into a single image, as in Evans's well-known view of two houses set behind a billboard advertising the film *Love Before Breakfast.*

This primary tension between reality and illusion is supplemented by other tensions—between rich and poor, black and white, North and South, rural and urban. As one page follows the next, Evans's superficially cool and remote images reveal a passion that is all the more remarkable for being expressed primarily through the artist's intellect.

It is no great exaggeration to say that without the example of Evans's *American Photographs*, Robert Frank's *The Americans* would not be the same great book that it is. In photographing the country some twenty years after Evans, Frank followed in his predecessor's footsteps metaphorically, using images of the American flag, automobiles, and juke boxes as signs of a nation obsessed with material values. Frank also adopted the sequential organization of *American Photographs*, creating a narrative that is every bit as ironic, and even more bitter. The connection between the two books is no accident: Frank met Evans in

New York in 1952, and they once worked together on an editorial assignment for *Fortune,* photographing common hand tools.

Since the 1950s, *American Photographs* and Evans's work as a whole have continued to inspire photographers devoted to recording the American scene. Lee Friedlander is perhaps the contemporary photographer closest in spirit to Evans, sharing both his love of the commonplace and his ability to transform even the most ordinary streetcorner into something monumental. Friedlander's 1976 book *The American Monument* was in part a homage to the spirit and example of *American Photographs*.

Evans's influence continues to be felt in the work of Robert Adams, Lewis Baltz, Bernd and Hilla Becher, Nicholas Nixon and other artists associated with a "topographic," or precisely descriptive, style of photography. Like him, they have adopted a style that at first glance seems disinterested and even disembodied. They strive to avoid any hint of sentimentality or romanticization. Instead, they rely on the cumulative impact of their pictures to convey their meanings, and feelings as well. The Bechers, while owing as much to their countryman August Sander as to Evans, are exemplary: their photographs of water towers, coal plants, and steel furnaces are cold and uninviting individually, but when seen in series they reveal the poignancy of industrial decline.

But it is not only photographers who have become fascinated with the commonplace in the last fifty years; artists since Jasper Johns, Robert Rauschenberg and Andy Warhol have taken to reexamining, and recontextualizing, the materials of American mass culture. As a result, one could say that much younger artists involved with the artifacts of popular or "low" culture, such as Jennifer Bolande and Jeff Koons, are also indebted to Walker Evans. So are all postmodern artists of the 1980s, to whom the culture is not a monolithic given but a social construction formed of the aggregate of its signs and symbols.

New York Times, January 19, 1989.

Helen Levitt's Realist Theater

HELEN LEVITT WAS THE FIRST American photographer to fully comprehend the essence of Henri Cartier-Bresson's photographic message and put it into practice. Like Cartier-Bresson, she understood how to combine intuition and intellect to forge sophisticated, lyrical compositions from commonplace events. With the encouragement of her friend Walker Evans, she haunted the streets and subways of New York City in the early 1940s in much the same way that Cartier-Bresson traversed Paris in the early 1930s, infatuated with the possibilities of the hand-held camera.

But while Cartier-Bresson came to rationalize his activity under the rubric of photojournalism—a move that gave him an audience as well as a motive—Levitt's work has remained outside any functional genre. It is "street photography," plain and simple, not quite reportage and not quite the paradigm of art, either. Forty years into her career, she remains something of a cipher in most accounts of twentieth-century photography. This is unfortunate, since her pictures are models of beautiful candid photography done in a way that is non-aggressive, noninvasive and, one wants to say, non-macho.

In his introduction to *A Way of Seeing,* Levitt's now-legendary 1965 book of photographs, James Agee, the celebrated writer and film critic who also was Levitt's friend, called her pictures "unpretentious" and "poetic." It is easy to see what he meant. Her adult subjects, sitting on stoops or leaning in doorways, are fixed by her lens in seemingly inconsequential moments of relaxation and repose. Yet their relationships with each other and with their surroundings speak of much more. They speak of human endurance and grace under pressure.

Levitt's ability to give poetic form to the quotidian is especially marked when her subjects are children. They usually are seen at play, and their bodies, frozen by the camera's shutter, have the look of double-jointed acrobats. Whereas most candid photography concentrates on facial expressions, Levitt's pictures are almost always about gesture. This is as true of an image of a boy bent double to look under a van, taken in the 1940s, as it is of a 1982 picture of another boy

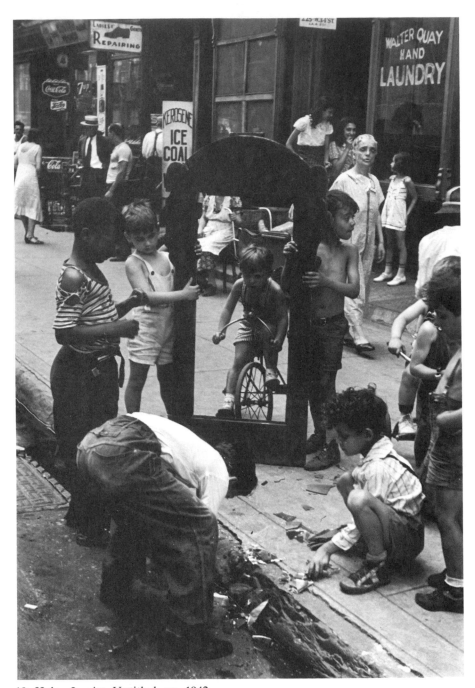

10. Helen Levitt, Untitled, ca. 1942

leaning into the front seat of a car. In each case, body language provides the vortex around which the picture spins.

On occasion Levitt produces photographs of an inspired complexity. In one, a busy sidewalk scene centers on two boys holding up the frame of a mirror. But the mirror has been shattered and lies in pieces in the gutter; instead of seeing a reflection we see another boy, pedaling a tricycle, within the mirrorless frame. This marvelous image, with its scene-within-a-scene, is a cogent metaphor of the essence of street photography. It makes explicit how a photograph puts edges around its subject, taking a slice from a larger context and reflecting it back as if it were life itself.

On the whole, however, Levitt seems less interested in creating finely textured tableaux, in the manner of Cartier-Bresson, than in finding singular moments that reveal the awkward humanity of her subjects. The acrobatic quality of the gestures and postures children assume in her pictures is not of the same order as that of Olympic gymnasts. Levitt's street kids look more ungainly, like sky divers falling through thin air.

Levitt is as adept at capturing momentary gestures in color as she is in black and white. And her range is more broad than *A Way of Seeing* would lead us to believe. Among the other sorts of pictures she has taken are a vintage portrait of Walker Evans, candids of subway riders taken in the 1940s and again in the 1970s, and images of children's graffiti taken between 1938 and 1948.

Levitt has been called a realist, someone whose work echoes back the textures of urban life with a minimum of inflection. Roberta Hellman and Marvin Hoshino, the artist's most sympathetic critics, have coined the term "white style" to describe the transparent illusionism she practices.[18] It is a style that has much in common with Evans and Cartier-Bresson, whose own superficially styleless styles have made them key figures in the artistic pantheon of this century. Like them, Levitt attempts to disappear from her pictures.

But her realism, as much as theirs, is no more or less than a manner of working. Like Emile Zola, the nineteenth-century French writer to whom we owe our literary notion of realism, Levitt usually restricts herself to society's lower rungs. There she transforms life in the streets into a metaphor of middle-class life indoors. It is domestic and family oriented, and its space is as delimited as that of a stage.

The foreshortened depth in most of Levitt's pictures gives them a sense of smallness that in other hands could be mistaken for a smallness of artistic ambition. But her pictures are not so much small as intimate; they demand the same depth of attention Eugène Atget's pictures require, and their rewards are much the same. Her restrained circumspection of city life is every bit as coherent and convincing as the most ambitious, demonstrative street photography.

The lyricism of her way of seeing makes it possible to believe that grace inheres to human beings even in the most reduced circumstances. This is, without a doubt, a comforting message, and it surely accounts in part for the appeal that her best pictures have. Yet it is also an essentially romantic statement. One could go so far as to say that her art depends on the pictorial conversion of New York's poorer neighborhoods into sites of unanticipated beauty—a kind of photographic gentrification.

Levitt's work plainly does not argue for social change. She is no Jacob Riis, hoping to improve the lot of those she photographs. Her pictures are no more about the lower-class areas they depict than they are about mobilizing us on behalf of social justice. So why does she choose poorer neighborhoods? There is perhaps a purely pragmatic reason: privacy is largely a privilege of the well-to-do; the poor live much more of their domestic lives in public spaces, where Levitt's camera operates. Thus the arena of her photography is defined to a large degree by the circumstances of our society. This is not to say, however, that Levitt is a cold-hearted formalist, or that she is oblivious to the conditions under which her subjects live. For what finally separates her from Cartier-Bresson, and is the source of her contribution to twentieth-century photography, is the degree to which she can make us empathize with her subjects. She manages this despite the vast social, economic, and cultural differences between us and them, which is nothing short of miraculous.

A review of a Levitt exhibition at Laurence Miller Gallery, New York, published in the *New York Times,* October 4, 1987.

The Final "Facts" of Garry Winogrand

IT WOULD BE NO GREAT EXAGGERATION to say that over the last ten years, the art of photography has split into two irreconcilable camps. On one side are the postmodernists and their allies, who see photography as a particularly useful and provocative means of making images that address the issues of art in our times. On the other side are those who hold to the more traditional view that photographs are connected not merely to the world of art, but to life itself.

This latter group, which has been on the defensive through most of the 1980s, might find a measure of solace in *Garry Winogrand*, the Museum of Modern Art's 1988 retrospective exhibition. Winogrand, who died in 1984 at the age of fifty-six, in many eyes represents the apotheosis of real-world photography. His pictures have all the vitality, incongruity and inexplicability of daily life. It was Winogrand who is supposed to have said "There is nothing as mysterious as a fact clearly described"—a credo that, perhaps because of its opacity, has become almost a mantra for a subsequent generation of "street photographers." Largely because of Winogrand, there remains a thread of conviction in the notion that describing the world is photography's highest calling.

Moreover, Winogrand is, for the museum's department of photography, the equivalent of what Frank Stella has been for its department of painting and sculpture—that is to say, a kind of favorite son, one whose career has been traced with an almost paternalistic attention. *Garry Winogrand* is the fifth exhibition mounted by the department of a significant body of Winogrand's work, and the third devoted exclusively to it. John Szarkowski, the department's director and curator of the exhibition, has called Winogrand "the central photographer of his generation."

Garry Winogrand consisted of more than 200 of Winogrand's pictures, including some 180 black-and-white prints as well as forty images from the last five years of his career that were projected as slides. In addition, ten mural-sized enlargements of the photographer's contact sheets, each of which shows the consecutive exposures from a single roll of film, were interspersed amongst the prints. By presenting the contact sheets—an unusual step for a museum with

a reputation for taking works of art out of their contexts, rather than vice versa—the exhibition showed us not only the original sources of some of the prints on display, but also Winogrand's characteristic rapid-fire, almost manic shooting style.

In his essay that appears in *Winogrand: Figments from the Real World,*[19] the book that accompanied the exhibition and reproduces all but three of the prints on view, Szarkowski says that Winogrand's ambition ultimately "was not to make good pictures, but through photography to know life." But clearly Winogrand made not just good pictures; he made extraordinary ones. Like Robert Frank, he convincingly demonstrated that the neat, lyrical compositions of photographers in the tradition of Henri Cartier-Bresson were insufficient to comprehend American experience.

Winogrand's variant of "the decisive moment" was much more capacious and fractious than Cartier-Bresson's. After spending much of the 1950s mining the already-trod territory of photojournalism, he began to discover his own metier: images seized from the flux of public life that bordered on, but never trespassed, the chaotic. For Winogrand, as Szarkowski points out, the object was to balance chaos and pictorial organization as precariously as possible. In the photographer's mind, "success—the vitality and energy of the best pictures—came from the contention between the anarchic claims of life and the will to form," the curator concludes.

The pictures from the 1960s best bear out this idea. By using a wide-angle lens, and by turning and tilting his 35-millimeter camera without regard for the horizon, Winogrand filled the rectangular space of his images with a heady abundance of subject matter. But because the pictures seldom have just one center of interest, or even a clearly defined hierarchy of visual encounters, conventional ideas of "subject matter" seem inadequate. One is forced to consider the background as well as the foreground, the edges as well as the center of the frame. As a result, what a Winogrand image has to tell us is often complex, and sometimes untranslatable except in emotional terms.

Nevertheless, there are discernible themes in the photographer's work. He seldom could resist contrasting human beings with their cousins further down the evolutionary chain, with often humorous results. In a 1964 image, a cowboy has his Stetson licked by a bull as if it were ice cream; in another print, a well-dressed woman at the zoo in Central Park lounges in front of two primeval rhinos locked head to head. He also was fascinated by beautiful women encountered on the street. But the humor and voyeurism are never easy; if we laugh, it's as if to dispel something left unexplained and unresolved. The pictures set up narrative expectations but never quite tell a story. And with their acrobatic sense of gesture, they have a primitivism not unlike that of cartoons.

The exhibition was arranged roughly chronologically, with broad groupings that correspond to Winogrand's primary preoccupations. The work from the 1960s was divided into sections on women (many of the pictures here were published in the 1975 book *Women Are Beautiful*), on zoos (from *The Animals,* a 1969 book and show), and on public events in which the presence of the news media figures large (from *Public Relations*, Winogrand's penultimate show at the Museum of Modern Art, in 1977). The 1970s are represented by images of the Fort Worth Fat Stock Show and Rodeo and by pictures taken at various airports. The latter are an updated version of the "on the road" aesthetic of Walker Evans and Robert Frank, which Winogrand had pursued earlier in his career.

Most of the pictures from the 1960s and 1970s have been published or exhibited before. But the exhibition's concluding section of twenty-five prints and forty slides—titled, with considerable restraint, "Unfinished Work"— contained pictures that the photographer himself never saw. Dating from about 1977 to 1983, they were printed from rolls of film that were undeveloped or unproofed at the time of Winogrand's death.

Winogrand left behind some 2,500 rolls of exposed but undeveloped film, plus 6,500 developed rolls for which no contact sheets had been made, making a grand total of more than 300,000 unedited images. The Museum of Modern Art arranged to have the film developed and contact prints made, and three men—Szarkowski and the photographers Tod Papageorge and Thomas Roma— shared the daunting task of selecting representative images to be considered for the show. While we will never know if their choices in any way correspond with Winogrand's intentions, they serve as the only evidence we have of his final years.

That evidence is, as Szarkowski freely admits, less than awe-inspiring. "Deeply flawed" and "a precipitous decline" is what it amounts to in the eyes of the curator, who speculates that Winogrand "was at the end a creative impulse out of control." It might also be said that he was a photographer who had exhausted his inventiveness. Since the early 1960s, after discovering how to free himself from convention by tilting the frame, Winogrand had struggled to develop fresh ways of depicting the world, but he always seemed to arrive back at the same place. He tried changing from one wide-angle lens to another, but found even this minor change disconcerting. As result, by the time the exhibition reaches the mid-1970s his characteristic approach to composition begins to look like a stylistic tic, or mannerism.

One could argue, however, that Winogrand was trying something new in this last, frantic work, something that would renew his sense of photography's possibilities. A native-born New Yorker who felt most at home standing on a street corner, he had moved to Los Angeles in 1978. Unlike pedestrian New York, Los Angeles's street life takes place in cars, and many of the pictures Winogrand

made there were taken from the front seat of an automobile. In some, he seems
to be driving. These pictures, which appear even more unorganized and
enigmatic than his most complex New York images, relegate human beings to
the far distance. It is possible, in short, that the challenge he had set for himself
on the West Coast was to master a new kind of street theater—one in which the
leading actors were made of metal and asphalt, not flesh.

In any case, one felt a doubled sense of poignancy in *Garry Winogrand*.
There was the pathos of the late work itself, which by the evidence presented is
no more than a failed attempt to create new kinds of pictures, and no less than a
replication of Winogrand's earlier astounding work. And there was the pathos
of the museum, which having made so much of Winogrand's earlier career
was forced to admit that the late work has a compulsive, unsatisfying quality.
This sense of diminishment, of high hopes turned to dust, will not cheer those
photographers to whom Winogrand was and is a role model. Nor will it help
their effort to reclaim for photography some of its modernist authority.

Today, if one wants evidence that photographs can still focus on life as much
as on art, and do so without falling prey to stylistic petrification, Lee
Friedlander provides a much more elastic and provocative role model.
Friedlander, like Winogrand, developed a unique style of shooting on city
streets during the 1960s. But he has gone on to encompass landscapes, portraits,
nudes, and a seemingly limitless range of subjects. In addition, his once gritty
style has evolved and broadened to the point that it is capable of expressing
deep compassion as well as curiosity, as his recent portraits of computer
workers amply demonstrate. Two remarkable portraits of Winogrand taken by
Friedlander—one at the start of his career, one near the end—were included in
Garry Winogrand; they served to remind us how little Winogrand's photographs
have to do with the character of our private selves.

Winogrand's photographs served another purpose, however. They describe
with an uncanny agility the character of public behavior, revealing its hypocrisies
and incongruities and finding humor in its Freudian slips. There is an angry,
sometimes bitter side to Winogrand's work, but it coexists with a concupiscent
voyeurism. The men, women and animals in his pictures are seldom seen alone,
and almost never out of context; they exist as social beings, revealing themselves
only through their interrelationships with others. Winogrand was acutely sensitive
to glances, gestures and body language, and especially to the implicit eroticism
of the camera's gaze. His inability to resist taking pleasure in the sights of the
world—his compulsive yen to capture on film nearly everything he saw—is, in
the end, what makes his images irresistible.

This essay was occasioned by the retrospective exhibition at The Museum of Modern Art and
published in the *New York Times*, May 15, 1988.

Lee Friedlander's Portraits

LEE FRIEDLANDER IS AN ARTIST WHO more than any other of his generation has shaped the face of contemporary photography. For more than half his career he was perceived as an unflinching social critic, looking at American life with the jaundiced eyes of a street photographer. His was the skeptical documentary tradition of Walker Evans and Robert Frank, but with a jazz-influenced style and a satiric wit akin to that of Lenny Bruce. However, beginning about 1976—the year in which his book *The American Monument* was published[20]—another Friedlander has been in evidence, one more like a pastoral romantic than a street-wise urban satirist. Many of his pictures of the last few years, of such subjects as birds, flowers, and trees, even border on the sentimental.

Faced with this apparent dichotomy in terms of subject matter and sensibility, many observers have concluded that Friedlander has been something else all along, that something else being—curse of curses—a formalist. This interpretation has dominated the reception of his work since the mid-1970s, and accounts for the disaffection with which his work is now viewed by those who believe in photography as an instrument of social critique. More recently, Friedlander has come under fire for his on-the-job portraits of industrial workers, published in 1982 in the book *Factory Valleys*. These vigorous and innovative images, in which man and machine share equal space and visual weight, are in the eyes of some critics too much inflected by the Friedlander "style" to function as documents—as if using a style other than that of traditional social documentary practice were tantamount to disrespect.

What Friedlander is, of course, is a matter of what he chooses to show us, and our judgments always are based on the evidence at hand. Still, it may come as a surprise to the photographer's critics that the commonly held belief in Friedlander-as-formalist has little relation to the facts. Yet this is the indisputable message of the pictures in the book *Lee Friedlander: Portraits*. They are frequently witty and occasionally satiric, but on the whole they are sympathetic, accepting documents. It is clear that Friedlander sees the human

condition as a human comedy, but his viewpoint is genial, unpretentious, and even humane. Moreover—and this is what most surprises—this viewpoint seems to go back to the very beginnings of his career.

So, in fact, do his portraits. Although Friedlander has long included people within the fabric of his complex, visually syncopated compositions, one would not have thought of him as a portraitist. If anything, he has always seemed to be a landscape photographer, albeit one frustrated by the seemingly unavoidable interventions of buildings, highways, and telephone poles within the environment. Yet his earliest work after setting out as a photographer in 1955 was to portray jazz musicians, in New York and New Orleans. The examples of his jazz portraits in the show are direct, empathetic images of individuals who for the most part remained outside the mainstream of American music their entire lives. They have an elegiac quality also found in the photographer's more recent work, including the portraits and landscapes in *Factory Valleys*. His 1958 picture of Sweet Emma Barrett, sitting at an old upright piano in an empty bandstand, looks as sweet and nostalgic as any picture from the turn of the century.

Since then Friedlander has continued to portray people in their settings, usually with a casualness that makes the images seem offhand. Many of his subjects are friends or acquaintances, which contributes to the air of relaxed informality. The painter Jim Dine sticks his bare foot into the lens in a picture from 1969; a young woman named Mary Kelly sprawls across a divan in a pose approximating that of André Kertész's *Satyric Dancer* (except that Miss Kelly wears braces on her teeth). Some of the subjects are photographers or persons known within the photography world—the Museum of Modern Art's John Szarkowski, balancing a baby on his knees; Garry Winogrand in 1957, looking like a cross between James Dean and Wally Cleaver; the late Walker Evans smiling mischievously from a hospital bed. Compared to most portrait exhibitions there are relatively few other sorts of celebrities to be seen here, and those that are—Jean Genet, for example—are not Friedlander's most fully felt pictures.

As is true of all his work, however, the appearance of casualness belies the underlying intelligence and virtuosity of the photographer's formal repertory. Time and again he catches our eye with the "accidents" of photographic vision—unusual juxtapositions, strange perspectives, the tonal vagaries of direct-flash lighting. His 1970 portrait of a woman named Helen Costa is typical; seated in a kitchen, wearing a bathing suit and wrapped in a towel, she seems like a specimen of suburban housewifedom pinned to the refrigerator behind her. The refrigerator's

white rectangle frames her face in the manner of a pre-Renaissance painting, an effect reinforced by the halo of shadow surrounding her hair, which was produced by the photographer's flash. It is a portrait of such stark immediacy that we cannot help but be reminded of Friedlander's series called "Gatherings," which consisted of flash-lit pictures of partygoers taken in a similar unflinching style. (In 1970 the photographer was in the midst of shooting the "Gatherings" pictures.)

His portraits of women tend to be scrutinizing, with an almost palpable curiosity, while his pictures of men emphasize their camaraderie and emotional self-confidence. The most compelling pictures, however, are of children; they are also Friedlander's most sentimental images. There is a sweet and slightly nostalgic atmosphere in his image of a girl standing alone on a Cincinnati street, or of a black child in Newark nestled between his father's knees, or of a Spanish boy dressed up in a white shirt. Especially touching is a 1962 image titled *North Carolina,* which shows a girl in her Sunday-best dress kneeling next to a pulpit and singing (or shouting) her heart out into a microphone that is several feet over her head. It is the kind of picture one associates with 1930s social documentary photography, yet its gentle humor marks it as Friedlander's own.

All of this is in stark contrast to his 1966 self-portrait, which shows the artist at the wheel of a car, his eyelids half closed and his mouth fixed in the kind of dopey, brain-damaged expression of one of Disney's dwarfs. It is an expression thoroughly familiar to anyone who has seen Friedlander's 1970 book *Self Portrait,* an anti-narcissistic tract which portrayed the artist as shadow, reflection, and cipher. Why, we might ask, is there such a difference between the way he has portrayed himself and the way he here portrays others? A tentative answer may be that in the 1960s he was almost compulsively concerned with debunking the myth of artist-as-hero, a rebellion shared by many artists of the post-abstract expressionist generation. One can even speculate that his devotion to the camera as his artistic means—and subsequent adherence to a "straight," nonmanipulative camera practice—was partly a revolt against the romantic excesses of the art world of that time. Yet just as Robert Frank's cynicism is grounded in romanticism, Friedlander's satire contains a component of sentimentality, and—according to this evidence, at least— always has. He only refuses to extend it to himself.

Thus the conventional belief that sees Friedlander's career as split in half, between angry young man and soft-hearted bucolic, would seem to be as much a myth of our own making as the notion that he is "merely" a formalist. A more accurate accounting would have to concede that even his most alienated "street" photography of the 1960s carried a playfulness

rooted in an affection for human foibles. Conversely, of course, the recent photographs of flora and fauna are not without at least an implicit sense of distance and emotional archness. What is "new" about Friedlander's work in portraiture is our sense of his achievement, which now seems more unified, capacious and emotionally expressive than heretofore.

Published in the *New York Times,* November 6, 1983, in response to the publication of *Lee Friedlander: Portraits* by the New York Graphic Society, and an accompanying exhibition at the Virginia Zabriskie Gallery in New York.

Robert Adams's Pathetic Frontier

ALTHOUGH THEY SHARE THE SAME last name and a similar reverence for the American West, one would be hard pressed to find two more dissimilar landscape photographers than Ansel Adams and Robert Adams. The widespread popularity of Ansel Adams's pictures is rooted in a purposeful exclusion: he photographed primarily in wilderness preserves and eliminated all signs of human presence. Robert Adams's images, however, show us what the land looks like once it has become inhabited, focusing on the frontier between the human and natural worlds. Consequently, they are both more convincing and more disturbing.

Robert Adams's black-and-white landscapes strive for inclusion. They show us divided highways, telephone poles, suburban developments and discarded beer cans cutting heedlessly through the once-seamless splendors of the West. In this, Adams is kin to Walker Evans, whose book *American Photographs* opened the doors to a critical and uniquely American brand of landscape photography.

Walker Evans once said he wanted his pictures to be "literate, authoritative, transcendent." Adams aims for much the same effects, avoiding the grandiloquence of conventional "artistic" landscapes but sharing their implicit romanticism. He also asks his photographs to do something that visual images are rarely asked to do: to bring into being an awareness that is as much ethical as it is visual. It is a goal that is seldom achieved, but part of the complex pleasure of looking at his work lies in seeing how close the pictures come to this self-imposed ideal. Adams's pictures are not designed to be overtly political, but like any deeply felt images they are capable of reorganizing how we perceive the world.

The typical Robert Adams photograph is filled with a bright, almost searing light. Three-quarters of the image may consist of sky, with the foreground leading back to a shining sliver of distant mountains. What occupies the foreground is usually a combination of lackluster architecture, paved roads and bare ground, often in the company of isolated, half-starved vegetation. In *Colorado Springs, Colorado,* 1969 for example, the frame is divided from left to right by the blank wall of a ranch house, a stop sign, a slender tree, and the screen of a drive-in movie theater.

11. Robert Adams, *Boulder County*, 1983

Throughout his career Adams has varied the proportions of man-made and natural elements in his pictures. In the 1970s, when the books *The New West*[21] and *Denver*[22] brought his work to public attention and earned him a place in the influential *New Topographics* exhibition, he focused mainly on tract homes, suburban sprawl, and other evidence of impending conformity. Starting with his 1980 book *From the Missouri West,*[23] however, he has increasingly sought out patches of unsullied scenery. Although he still includes signs of human habitation, from graffiti-covered rocks to cattle fences, these pictures seem to seek some solace from nature's dogged persistence in the face of our depredations of it.

Adams's landscape style is essentially classical, and within the spectrum of today's photography he might be considered a purist. But within his oeuvre there are significant, and surprisingly daring, aberrations. One is a penchant for night photography, where the usually bright surfaces of his prints reverse to become almost totally black. Rather than being somber, however, these pictures seem rapturous and dreamy, as if dusk had laid a healing blanket over the damages revealed by daylight.

Considering the large-format precision of most of his pictures, Adams also is remarkably accepting of blur. This partial loss of detail occurs frequently in his pictures of people, a subject for which he has an overlooked talent. The images from his 1984 book *Our Lives, Our Children,*[24] which seek to intimate the dangers of the Rocky Flats, Colorado nuclear plant near Adams's home, are especially vivid, in part because the expressions are sufficiently generalized to become suggestive of an undefined malaise. Blurred or not, the people in these photographs seem imbued with both grace and sadness.

Adams's penchant for trespassing the conventions on which his photography depends, which also includes a propensity for tilting the horizon as wildly as Garry Winogrand once did, at times gives his work a risky, hallucinatory edge. It also serves to balance its didactic qualities, which might otherwise seem programmatic. There is a progression here as well: the exhibition leads the viewer gradually from the small, compacted and angry pictures of *The New West* and *Denver* toward the larger and more transcendentalist images of *From the Missouri West* and the 1986 series *Los Angeles Spring*.

Some of the more recent pictures—a suite of photographs of the artist's dog and backyard, for example—might better have been left unhung. In the best of the recent pictures, however, scraggly cottonwood trees are made to seem like tragic figures, acquiring a human presence. They suggest, for the first time in Adams's work, that the natural and human worlds are in some sense compatible, or at least interdependent.

Adams's enduring faith in the restorative powers of landscape photography, and his own reformist zeal, set his work apart from much contemporary photography—especially the sort to be encountered in the downtown precincts

of New York. It is instructive, for example, to compare his pictures with the
recent landscapes of Ellen Brooks. Brooks casts off almost all the specificity of
traditional photography in panoramic color images that extend to eight feet.
Bearing generalized titles like *Course* and *Falls,* and marked by a kind of pointil-
list screen that blurs all detail, these pictures propose that all landscapes—or
at least our experiences of them—have become generic. In a world full of
stereotype, the specifics no longer matter.

Brooks's approach is thoroughly postmodern, in that it accepts (and, to some
minds, endorses) the notion that we can no longer respond to images with any
degree of innocence. Adams's work, on the other hand, represents a position of
hope, refusing to abandon the belief that individuals can still respond to images
in fresh, individual ways. This may make his photography seem old-fashioned,
and even unfashionable, but it accounts for its continued appeal and its ultimate
importance. Until we become thoroughly complacent about the idea that all
experience of the world is mediated and thus corrupted by photographic images,
his pictures will retain their originality and complexity.

Written in response to *Robert Adams: To Make It Home—Photographs of the American West,*
a retrospective exhibition organized by the Philadelphia Museum of Art, and published in the
New York Times, March 5, 1989.

Joel Sternfeld

THE ITINERANT VISION

It is not then, merely to satisfy a curiosity, however legitimate, that I have examined America; my wish has been to find there instruction by which we may ourselves profit. ALEXIS DE TOCQUEVILLE, *Democracy in America*

WHY IS THERE SUCH AN URGE to encompass America—or at least that part of the North American continent that is the United States? Why this drive to swallow the country whole, to know it as one knows a lover, to reveal its innermost essence, when it was born of many parts, a federation of different states of place and mind? Perhaps it is the vastness of the undertaking that draws us in, the great immensity of the task. Perhaps it is the ineffability of the place, its significance so great that it invites description even while it defies it. Or perhaps it is because America is really a mirror, and in the process of describing it we cannot help but describe ourselves. If this is the case, what is at issue in books about America is not just the quality of observation, but the construction of history.

When Tocqueville disembarked in New York in May 1831, he was by no means the first foreigner to come to America seeking to discern its meaning through direct observation. He was merely more perceptive than his predecessors, and in the nine months that he and his companion, Gustave de Beaumont, journeyed across the breadth of the adolescent United States, he observed its character and prospects with an uncanny prescience. So keen, detailed and balanced is his report, ambitiously titled *Democracy in America,* that it seems at times almost photographic.

Photography, of course, was yet to be born, so we have no snapshots by Tocqueville to compare his view with what we, more than 150 years later, can record today. But we know that from the moment he set foot in this country, the young French nobleman was made aware that in America things are not what they seem:

> When I arrived for the first time at New York, by that part of the Atlantic Ocean which is called the East River, I was surprised to perceive along the shore, at some distance from the city, a number of little palaces of white marble, several of which were of classic architecture. When I went the next day to inspect more closely one which had particularly attracted my notice, I found that its walls were of whitewashed brick, and its columns of painted wood. All the edifices that I had admired the night before were of the same kind.

Thus did Tocqueville learn, early on, about the American penchant for putting up fronts, for keeping the best face on things, for disguising our own rudeness and cultural naiveté. This is true not only in our architecture, which again today borrows from classical models, but also in our social fabric. Thus the challenge for photographers who would picture the true face of America: how to unmask the superficial appearance of the thing, revealing not only what its people have taken such pains to conceal, but also why.

The surreal tingle that Tocqueville experienced in his first deep breath of the United States reappears in Joel Sternfeld's photographs, which take up the issue of appearance and reality in American life from a vastly different perspective. Sternfeld's photographs, for one, provide a native-born American view. Yet they sometimes seem so wide-eyed and ingenuous they could have been taken by a visitor from another country, if not another planet. (Then again, what distinguishes a New Yorker's view from a Frenchman's in, say, North Platte, Nebraska, is a matter for semioticians.) Sternfeld's pictures explicitly address the surface of things, not their underlying structure, although they certainly have much to tell about what *Reader's Digest* calls "life in these United States." And they survey a different present—not an early nineteenth-century society poised on the cusp of industrialization, but a postindustrial, service-oriented society devoted to technology, consumer spending, personal narcissism and increasing unemployment, which masquerades as leisure time. Of such materials are surrealist ironies made.

To discover the truth about America, the pilgrimages made in the name of this unquenchable thirst are legion, and account for a whole genre of American art, both visual and literary. It is in this tradition that Sternfeld's photographic prospectus stands—the tradition of wanderers like Huckleberry Finn and Sal Paradise. It means, both literally and figuratively, being on the road. "Whither goest thou, America, in thy shiny car in the night?" Carlo Marx says to Sal and Dean Moriarity in Kerouac's picaresque novel *On The Road*. "But I reckon I got to light out for the territory ahead of the rest, because Aunt Sally she's going to adopt me and sivilize me, and I can't stand it. I been there before," Huck Finn concludes in Twain's classic. To discover America is to discover oneself.

In American photography, the tradition owes a debt to the exploration of the western territories in the years following the Civil War, when government-sponsored surveys saw the virtue of employing a picture man to supply evidence of what the West looked like. These adventurer/photographers—Timothy O'Sullivan, Carleton Watkins, William Henry Jackson, William Bell, A. J. Russell—brought back dramatic landscapes, to be sure, but they had little of the endearing effects of Hudson River School paintings. Their nature was raw, rugged, and unforgiving, and their pictures amazed contemporary audiences

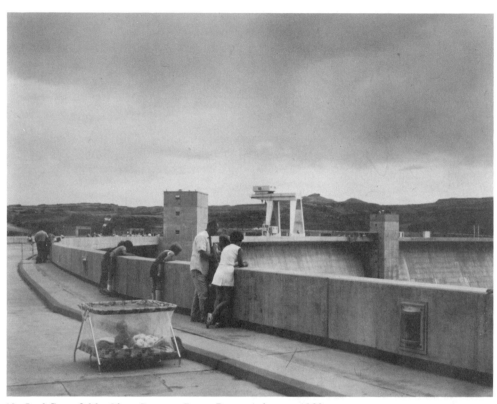

12. Joel Sternfeld, *Glen Canyon Dam,* Page, Arizona, 1982

largely because of the unhospitable vastnesses they depicted. The West, in photographs, was not what it seemed when described in words or paint.

"You road I enter upon and look around, I believe you are not all that is here, I believe that much unseen is also here," Walt Whitman sang in his grand ode to America, *Leaves of Grass*. With the railroad, and soon highways, the continent lost some of its forbidding quality, but the lanes crossing the country whetted ever larger appetites for adventure. As automobiles, billboards and Coca-Cola signs became commonplace in the twentieth century, photographers taking to the road could no longer ignore them. It was Walker Evans, in *American Photographs*, who first demonstrated that the elements of roadside America—signs, telephone wires, even the road itself—could be transformed by the camera into a coherent, meaningful visual amalgam. Even more significantly, Evans changed the key of the American experience from major to minor. *American Photographs* is a fond, measured and ultimately bittersweet elegy to pre-Interstate, pre-suburban, pre-agribusiness America. Hard on Evans's heels came others, Edward Weston and Wright Morris among them, eager to sift nostalgia from the shards of American innocence.

Even more bleak is Robert Frank's *The Americans,* a masterpiece that charts the face of postwar American society. Frank, a Swiss, did not come to this country to charm us, and the eighty photographs that constitute his journal of cross-country travels home in on the tenderest of our sore spots: racism, alienation, the substitution of media-generated images for reality. Where Tocqueville saw America as the model for the future, Frank saw it as a dead end. "A sad poem for sick people," one critic called the book,[25] perhaps not realizing what he was saying. Today's territorial surveys are no less sad, if more sympathetic: Robert Adams's *From the Missouri West,* Lewis Baltz's *Park City,* Lee Friedlander's *The American Monument,* Stephen Shore's *Uncommon Places.*

Such is the company in which Sternfeld's *American Prospects* finds itself, a prisoner, like the rest, of the historical moment in which it is born. But it is more than just another sad poem, I think, for like the best of its peers and parents it fights hard to balance indignation and consolation. Those rusted coal cars, that basketball hoop poised on the brink of the Grand Canyon, the streaked faces of the rainbow chasers whose pots came up empty outside of Houston—for all that these speak of malaise, they also speak of endurance. Like the seasons, which provide a counterpoint to Sternfeld's prevailing discourse of dissipation, the relations of Man to nature and Man to Man seem subject to renewal. That, at least, is the promise of these pictures, and their solace.

Sternfeld's photographs can be funny, in a way that photographs seldom are, especially photographs taken on the road with a sense of mission and urgency. Perhaps it is a humor born of despair, a catch-22 sense of the absurd, but nevertheless it serves to entice the eye to engage the images' complex meanings.

What seems so amusing at first glance—an elephant in the middle of a road, being tugged by Lilliputian-sized humans—resolves into the focus of the picture's poignancy: a wild spirit, yearning to be free, is ensnared by civilization, like Huck Finn in the grasp of Aunt Sally. Elsewhere, much is folly: firemen shop for pumpkins while a house burns. The jokes are false fronts, marble made of brick and wood. Yet in such discontinuities, Sternfeld's pictures suggest, lies the essence of America's present.

No wonder, then, that evidence of America's rural and industrial past leaks into his photographs, as well as the signs of its technological future. They are connected by the thread of their incursions on the landscape of today. As views in the nineteenth-century tradition, the images contain such a diversity of information and feeling that we can overlook their inherent didactic qualities. The photographer's eye is generous, understanding and forgiving, but it is also critically aware, intelligent and unblinking. Fortunately, this combination has created a suite of pictures as dense and meaningful as they are beautiful.

In the future, no doubt, these images will seem suffused with nostalgia, much as we now see Walker Evans's photographs of the 1930s. They will seem less ironic and more totemic, and their sometimes acid social commentary will lose much of its bite. But for now they speak of a time when progress lost its sense of inevitability, when the land lost its last pretense to innocence, when the spirit of individualism flickered for want of fresh air. They also speak of nature's restorative powers, of human goodness, of men and women seeking to accommodate their primal needs to the imperatives of technological society. It is a tricky business, balancing these messages, and it does not make for ideological simplicity or political instrumentality. However, in these photographs Sternfeld manages to eke a measure of harmony out of an assortment of follies, which makes *American Prospects* a metonym for the state of our times.

Introduction to *American Prospects: Photographs by Joel Sternfeld,*
New York: Times Books, 1987.

Richard Avedon's Portraits

INVERTED FASHION, FASHIONABLE MUD

RICHARD AVEDON IS THE RINGMASTER of twentieth-century spectacle, our most visible connoisseur of upscale/downscale, insider/outsider voyeurism. He stares his hard stare—as intractable as the flawless glass of his camera lens—into the face of Susan Sontag's observation that as a medium photography is obsessed, alternately, with the upper crust and the dispossessed. "Traveling between degraded and glamorous realities is part of the very momentum of the photographic enterprise," she wrote in *On Photography*.[26] And no one in our time is a more accomplished traveler than the veteran Avedon.

But Avedon always has been eager to disperse the glamorous, to rent the seams of fashion, to reveal the pretenses of public images. He photographs politicians, writers, musicians, artists, and fashion designers as if they were moths masquerading as butterflies. He pins their wings and displays them in pristine showcases, edged in funereal black. Andy Warhol's Factory, the Chicago Seven, the Vietnam Mission Council—these groups are all parts of the power he sees arranged around him, and he is eager to disabuse us of any romantic notions we may harbor about its standard-bearers. The polished media images are stripped away, replaced with seemingly stolen scenes of visages in dissolution, faces decaying before our eyes. This is the "documentary" content of Avedon's portraiture, the opposite of the fashion photography he does for a living. Thanatos fills in for Eros. As Sontag remarks in discussing his 1972 portraits of his dying father, "There is a perfect complementarity between Avedon's fashion photography, which flatters, and the work in which he comes on as The One Who Refuses to Flatter."[27]

But are these portraits any less media images for being inverted? This is the question that makes Avedon's portraiture so tantalizing, so problematic. Dwight David Eisenhower, hero of the Normandy invasion and grandfatherly leader of cold-war United States government, is made to appear at once old and infantile, his benevolence a convenient mask for incompetence. (In the 1950s and 1960s in the United States, babies were often said to look like Eisenhower, and Avedon's picture shows us why.) Yet to see Eisenhower in reverse, as the flip

side of his commanding public image, is a substitution of media effects, not a deconstruction of them. Avedon's project is not to demystify the power of portraiture, it would seem, but to reinvigorate its most atavistic myths.

In the American West takes the obverse of the American dream and shoves its face in our faces, in the form of larger-than-life prints that loom over our heads like so many parental rebukes. To see these icons of disillusionment on display in a gallery or museum, we have to lift our eyes; the exhibition takes the architectonic form of a cathedral, inviting a perverse kind of worship. In the book of the same title this effect of scale is blunted, but we are subjected instead to a numbing, overdetermined sequentiality. There are no writers or artists or fashion designers to be found here, no one eligible for the *Vogue* treatment. Instead, we find blackjack dealers, coal miners, waitresses, convicts, drifters—a representative cross-section of the American West, perhaps, in the cinematic or tabloid imagination, but hardly paradigmatic.

As in Bill Brandt's *The English at Home* (1936), Avedon's incorporation of upper and lower classes within the overall rubric of his portraiture has a leveling effect. An unemployed Las Vegas man looks disheveled and grotesque, but no more so than do the Duke and Duchess of Windsor in Avedon's earliest collection of portraits, *Observations* (1959), a collaboration with society novelist Truman Capote. Like a paranoiac, Avedon sees no difference; to him we are all equally specimens for the camera's cold desire. Celebrity is not a sign of stature in his world, but of attention; it is subject to the winds of fashion and the whims of fashionable minds.

For Avedon is, at heart, a man of fashion—something not to be overlooked in considering the dynamic of his hunger to record both the highs and the lows. His profound indifference to the parameters of conventional taste was nurtured by his mentor, Alexey Brodovitch, the legendary art director of the magazine *Harper's Bazaar.* As a cynical cosmopolite Brodovitch loved surprise, shock, and surrealism, and it followed that he loved photography, that most machinelike and unconscious of image makers. Brodovitch discovered Avedon at the end of World War II, insisted that he use his primitive instincts as his working tools, and gave his protégé, an erstwhile merchant seaman, page after page of prime display. Avedon cut his teeth on junior dresses by American designers and soon was traveling to Paris to do haute couture on the streets, complete with sidewalk vendors and circus performers.

But no doubt Avedon felt an ache to be serious, to graduate from fashion to culture. He accomplished this by becoming a portraitist, photographing the literati as well as the glitterati. Whereas he broadly sketched the models and society women he portrayed, bathing them in ethereal light that removed any flaws, he limned the authors, actors, painters, and politicians mercilessly. His lights became weapons, guardians of the barbed-wire edges of fashion's

enclosure. These early portraits, done for *Harper's Bazaar* and collected in *Observations* and *Nothing Personal* (1964), both shock and surprise—the two elements Brodovitch always required of a picture.

Then as now, Avedon loves to take fashion and turn it on its head. Once that is done, he turns squalor into fashion. The cycle is self-completing and infinity regressive. As a result there is no arguing with Avedon's world; there is only denial. Many of his critics have adopted this stance, refusing to treat his work as a construction of the imagination. Instead, they waste their time arguing that life is neither as grim nor as glamorous as he makes it seem, as if his portraits were transcriptions of the real. They fail to see that Avedon is merely creating a showplace that is designed not to please but to energize. Ennui is his greatest opponent and biggest fear.

If, as Roland Barthes suggested in *Camera Lucida*, the arena in which photography performs is triangulated by the three terms of subject, photographer and viewer, then Richard Avedon's portraiture finds its substantial power closest to the third, most obtuse angle, that of the viewer. His work, despite its alternating currents of notoriety and obscurity in terms of whom he chooses to depict, has meaning only in relation to the sensibilities and sensitivities of those who look at it. He is not cataloguing the types of American life, in a reprise of August Sander's *Man in the Twentieth Century,* but playing to the responses of his wide and presumably sophisticated audience.

We are meant, I think, to be astounded by the bald man who wears a swarm of bees in lieu of clothes, or by the two Texas prison inmates whose scars are more deeply incised than their sentimental tattoos. And we are meant to be offended by the insistent grime that adheres to the subjects of *In the American West,* whether they wear it on their sleeves, as the coal miners do, or inside, where it diminishes the capacity of their hearts. Those who rise up to complain that there are no God-fearing, upright, financially comfortable accountants, school teachers and bank presidents in this sociological sample are like fish rising to perfectly prepared bait. Avedon's hook wears an irresistible lure, and it is dangerously sharp.

One could even go so far as to say this: To detest Avedon's manipulation of our responses is to admire the underlying spirit of his portraiture.

Art Press (Paris), December 1987.

Nan Goldin's Grim "Ballad"

WHAT ROBERT FRANK'S *THE AMERICANS* was to the 1950s, Nan Goldin's *The Ballad of Sexual Dependency* was to the 1980s. The 800-image "ballad"—a sweeping, diaristic and critical account of life within the photographer's own artistic, urban subculture—reflects the same dissatisfaction with contemporary life evident in *The Americans* and extends the narrative potentials of still photography that Frank's book revealed. At the same time, it serves to gauge the distance between the Existential angst of Frank's time and today's sense of social and cultural atomization. Goldin, at the age of thirty-three has created an artistic masterwork that tells us not only about the attitudes of her generation, but also about the times in which we live.

The Ballad of Sexual Dependency originated as a rudimentary rock-club entertainment, with Goldin's slides accompanied by taped rock-and-roll music. (It was first shown at the Mudd Club in lower Manhattan in 1979.) But while its format has remained the same, it has grown in size and artistic ambition as its creator has continued to photograph her immediate milieu, which could be described as East Village bohemian. The work's underground reputation has grown along with it, to the point that in 1985 it was included in the Whitney Biennial. Later it became available in an altogether different form: a selection of 130 of its photographs were gathered together and published in book form (*The Ballad of Sexual Dependency*, Aperture, 1986).

As a slide show, *The Ballad of Sexual Dependency* attacks the senses with visual and aural information. The images cross the screen in rapid-fire succession, as mood-setting rock songs—ranging in style from The Supremes to the Velvet Underground—come and go. The guiding theme may be the destructive aspects of relationships between men and women, but the pictures examine nearly all permutations of human interactions with an obsessive attention. Women with women friends, men with men friends, parents with their children—Goldin's seemingly omnivorous camera records them all.

Her camera also records moments seldom portrayed in photographs, or any other kind of picture; the resulting images seem not so much intimate as indelicate.

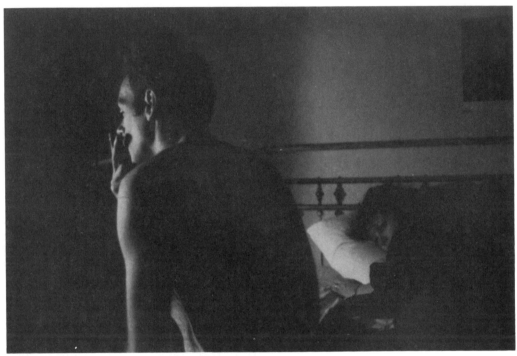

13. Nan Goldin, *Nan and Brian in Bed*, New York City, 1983

Goldin's photographs perhaps are no more explicit than Brassaï's classic pictures of Parisian brothels, but they certainly could be deemed unsuitable for family viewing. There is a great deal of nudity in the pictures, both male and female, and there are explicit scenes in bedrooms and bathrooms. What makes Goldin's unquenchable desire to depict such things palatable is, in part, her willingness to turn the camera on herself with equal candor. She is as unsparing of her own privacy as she is of that of her other subjects.

These subjects usually come from her immediate circle of friends, and as the slide show progresses we come to recognize and, to some extent, identify with them. (With the significant exception of her parents, almost all of Goldin's subjects appear to be in their twenties or thirties.) Most seem oblivious to the presence of the camera as it surveys them in their dingy, unkempt apartments, giving the pictures an almost uncanny you-are-there feeling. The young women lounge on beds, put on makeup in front of mirrors, embrace their men friends, display the markings of sexual abuse, and dissolve in tears. The young men are shown in similar situations, although they wear tattoos instead of makeup, they seldom cry, and they do not show signs of sexual abuse.

For all the photographer's catholicity of subject, however, and despite the snapshot-like formlessness of many of her pictures, *The Ballad of Sexual Dependency* as a whole is tightly organized. Besides sections devoted to pictures of the men and women in Goldin's milieu, shown singly, as couples and in groups, there are diversions into the subcultures of English skinheads and male transvestites, where Goldin examines exaggerated maleness and its travesty. In the end, the focus shifts from sex to death, a Freudian coda that further reinforces the undercurrent of despair that haunts these sometimes carefree, sometimes poignant images.

Clearly *The Ballad of Sexual Dependency* is about much more than sexuality and dependency—or more precisely, women's dependency on men. Its underlying theme, which unifies what otherwise might be an inchoate diversity of subject matter and tone, is the insufficiency of intimacy—sexual or otherwise—as a cure for what seems, from Goldin's point of view, a pervasive sense of individual isolation. This is a grim message, and it is conveyed in a manner that is, despite the entertaining qualities of the presentation, quite harrowing. There is, for example, an unforgettable self-portrait that shows the photographer's face bruised and swollen, her eye filled with blood; it is titled *Nan After Being Battered*.

This may seem like distant territory to those acquainted with Frank's photographs in *The Americans*, but the comparison is interesting. Both artists position themselves outside conventional society, refusing bourgeois values and comfort, and both portray others in similar outsider positions. Frank's favorite subjects were the poor, children, and blacks—the powerless. Goldin focuses on a

disaffected class of young whites whose powerlessness may be more apparent than real, but who nevertheless have rejected the urge to become Yuppies. In both their pictures, much attention is paid to how people present themselves as images, in their choice of clothing and in photographs. Many of Goldin's subjects appear in exaggerated outfits that seem like costumes designed for dolls; appearances, it would seem, are as cherished as reality, if not more so.

In terms of style, both artists favor the candid and unplanned over the technically polished and precise—which is not to say that either is incapable of remarkable images. Both approach photography from the perspective of film, seeking to open the medium's gates to narrative through sequencing and editing. As a book *The Americans* is cinematic in structure, and Goldin's slide show, with its screen and sound, closely replicates the experience of moviegoing. But the most profound similarity between the two artists is their emotional immediacy, and the degree to which they express torment and pain. Frank's book, being such a strong assertion of his disaffection with the prevailing social condition, was broadly criticized at the time it appeared. It would not be especially surprising if Goldin's work suffers a similar reaction.

New York Times, November 30, 1986.

IV. A New Kind of Art: Camera Culture in the 1980s

MUCH OF THE ART OF THE 1980s, and especially that which we know as postmodernist, consciously sought to undercut and displace the aesthetic standards and aspirations of its immediate antecedents. This rejection of the immediate past has, of course, a long history; rebellious sons have savaged their painterly forefathers with Oedipal regularity for centuries. (Never mind that such a rejection frequently proves illusory, a convenient fiction that allows art and artists room to breathe.) It is characteristic of modernist art, just as it is of postmodernist art. But what makes the art of the 1980s different is that it seems to stand in opposition not only to the modernist art that is its immediate forebear but also to the entire longstanding tradition of high culture, and its institutions. It challenges not only the style of art, but also its domain.

What we call popular or mass culture was long excluded from serious aesthetic consideration. Whenever it threatened to enter the artistic discourse, terms like kitsch were employed to neutralize and marginalize it. Photographs, for familiar reasons, suffered a similar fate. But beginning in the 1960s, thanks to artists like Andy Warhol, popular culture became a subject of considerable currency in contemporary art. Not surprisingly, photography has come to play an increasing role in this arena, since it is both symptomatic and symbolic of the superabundance of images in our mass-media, mass-produced, mass-reproduced culture.

What now fascinates artists and critics is photography's complex ability to represent and reveal the stereotypes of our visual world, to make us aware of a coded visual experience that we ordinarily take for granted. Thus we find emphasis in recent discourse on the concepts of "criticality" and "deconstruction"— the latter a word invented to describe the process of unmasking or decoding conventionalized meanings. Without this oppositional function—opposed, some would say, to a dead or dying modernism—the photographic borrowings of postmodernism would seem merely to be a naive, myopic recycling of pop art.

All postmodernist photography, and all postmodernist art, has an adversarial relationship to conventional notions of aesthetic value. For many, it is irritating; for others, it is obscure. Postmodernist uses of photography also stand outside of, and in opposition to, the conventions of fine-art photography. The traditions of art photography elaborated by Alfred Stieglitz, Minor White, and John Szarkowski mean little to artists interested in photographic images as cultural representations. Instead, they take their cues from Walter Benjamin, Roland Barthes, Jacques Derrida, Jacques Lacan, and Jean Baudrillard. The marked theatricality, artificiality, and conceptual density of 1980s art photography are merely symptoms of a deeper difference: photographs are no longer seen as transparent windows on the world, but as intricate webs spun by culture. These essays attempt to shed light on the ramifications of this realization.

Photographic Culture
in a Drawn World

THERE WAS ONCE A TIME, and not so very long ago, when seeing was believing. But our faith in the superficial availability of reality, in its obviousness, has dwindled dramatically—thanks to the influence of, among others, Marx, Freud, and Saussure—and with it much of our faith in the camera as witness. Today we recognize not only the spatial and temporal arbitrariness of photographic representation, but also its role in mediating our experience of the world. If the art of the mid-1980s—and drawings, in particular—can be seen as "after photography," one meaning of that phrase is that they evidence our loss of belief in the innocence of lenticular experience.

The long and largely covert use of photography by the more established mediums of painting and drawing has been chronicled so exhaustively it scarcely needs repeating.[1] Courbet, Delacroix, Manet, Degas, Cézanne—all rifled photography in search of new means of depiction, suspecting that its optical vagaries were entirely appropriate for an age of increasing industrialism, urbanism, and fragmentation. With photography's invention (announced by Daguerre in 1839) the scientific ideal of single-point perspective was fully realized. Artists could choose to play second fiddle to the camera (not a pleasant thought, presumably, at least until the photo realists arrived) or, freed of much of the burden of "objective" representation, they could pursue direct observation—which became, with the impressionists, the *sine qua non* of art. This, at least, is the prevailing notion of photography's effect on painting and drawing, one that explains very well the apotheosis of abstract painting in the twentieth century but which seems totally inadequate to the task of explaining the overtly photographic drawings of Troy Brauntuch, Nancy Dwyer, Eric Fischl, Mike Glier, Jack Goldstein, Sherrie Levine, Robert Longo, Walter Robinson, and other like-minded artists.

Short of asking the artists, we have no way of knowing whether all or any of their drawings are based on actual photographs. But it seems inconceivable that they could have been made without the *existence* of photography and, more to the point, of what we might call photographic culture. By photographic culture I do

not mean the tradition of fine-art photography, as it has been conceived by art historians, critics, and collectors; rather, I mean everything *but* that tradition—not the photographs of Stieglitz, Strand, and Weston, that is, but news, advertising, billboard, greeting card, calendar, postcard, publicity, and pin-up photographs. These are the kinds of images that impinge on us every day, a network of popular-culture imagery every bit as omnipresent, ingratiating, and ultimately seductive as television's. And these are the kinds of images, it seems to me, that have served to inspire these artists.

Their drawings are "after" photography in several ways. They not only "take off" from photographic sources, being as indebted to them as Picasso's *Las Meninas* is to Velázquez, they also "take off" *on* photography—they seem to parody the medium or, to put the matter more precisely, they use pastiche to reawaken our sense of photography's peculiarity.[2] Sometimes this strategy has the capacity to amuse and sometimes it does not, but it always calls our attention back to photographic culture—which is to say, to the representational conventions that dominate (and, to some degree, determine) the texture of today's world.

More than a hundred years after Manet took photography seriously, Mark Tansey—an avid collector of photographic ephemera in the form of magazine reproductions—is able to poke fun at it. I am thinking of his ironically titled *Action Paintings*. In one, a Sunday easel painter is seen contemplating a race car careening out of control; as if by supernatural sleight of hand, the painter's canvas contains the scene exactly as we see it, complete with crashing car—as if photography's "decisive moment" school had infiltrated *plein air* painting. In *Action Painting II,* the situation is roughly the same, but what is being painted (and what appears both in the distance beyond a group of some ten easel painters and on their canvases) is the fiery takeoff of the space shuttle rocket.

One aspect of the joke, of course, is that painting and drawing cannot in any full sense "take after" photography, and yet Tansey's painting depends on visual knowledge—the arrested, fractional instant, lenticular perspective, disjunctive framing—that is absolutely indebted to photography. After all, before Eadweard Muybridge photographed the split seconds of a horse's trot, painters blithely painted the beasts with all four legs splayed out at once. In addition, there is a sense in which the *subjects* of these paintings are indebted to photography, for they mirror to an uncanny degree the preferences of certain types of vernacular photography—the car crashes and rocket launches of newspaper photojournalism, the group pastorals of the snapshot. What makes us laugh in these paintings is that the amateur artists are carrying brushes—not, as we would expect, cameras.

As I said, such art mines photographic culture but excludes photography's own art tradition. This is, I would hazard, a purposeful decision on the part of artists now making use of photographs. For what photographic culture in their eyes epitomizes, and in a sense is coincident with, is popular culture—life as lived

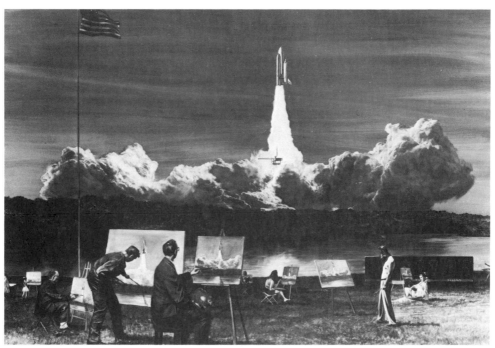

14. Mark Tansey, *Action Painting II*, 1984

through the mediation of advertising, mass magazines, television, and movies, and not by any direct contact with the "natural world." (Indeed, their work denies the existence of a natural world, the very world most art photography insists on.) To put it another way, it seems to me that in our times, and for many people, photography has come to represent the demise of "high" culture. Instead of enlarging the audience for the traditions of fine-art practice— something widely expected; for a time photography was a kind of privileged "expansion art" at the National Endowment for the Arts—it has helped to create an unsettled and unsettling situation in which advertising, entertainment, propaganda, and art are conflated, their distinctions nullified.

Insofar as it has become a replacement for direct experience, photography's presence in the world today is both compelling and troubling. Its system of perspective is so taken for granted that we can fail to take note of its conse-quences. We can imagine that we know someone simply because we have seen his or her image. Worse, we can imagine we understand, say, the situation in El Salvador, simply because we have seen pictures of El Salvador. That artists should become at once fascinated by, dependent on, and wary of photographic culture is not surprising. For many of them, what is directly observable in the world is that which is already depicted. In poststructuralist terms, *all* that we observe is the depicted, and all that we know are the cultural models for what we see, not—as Edward Weston would have had it—"the thing itself."

These observations put us squarely into the arena of postmodernism, for it is contemporary art's fascination with the déjà vu quality of experience that marks its departure from modernism, with its belief in originality, progress, and radical individualism. Postmodernist art clearly conceives of the visual universe as finite and conventionalized, and it does so without tears, without deploring that condition. But there is something more to be said about this art. It is not simply convention that fascinates it, but convention of a particularly degraded sort. Drawings like those of David Salle, Richard Prince, Walter Robinson, and Nancy Dwyer enter into the representational discourse of cheap tabloids, slick skin magazines, romance and movie gazettes. The smell of newsstands, checkout counters, and barbershops adheres to their lines. Photographic culture and popular mass culture are seen as synonymous.

Such drawings consequently implicate photography as an agent in the devolution of picture making. They suggest that photography is not only a democratic medium, but also an entropic one. They accept Susan Sontag's argument that our experience of photography tends to level our experience of both art and life—everything becomes "interesting," but no more. "Photography," Sontag says in *On Photography,* echoing Walter Benjamin, "has decisively transformed the traditional fine arts and the traditional norms of taste, including the very idea of the work of art. Less and less does the work of art depend on

being a unique object, an original made by an individual artist." She concludes: "Now all art aspires to the condition of photography."[3]

I am not sure that this message—that photography has helped degrade the picture-making tradition that dates back to the Renaissance—is intended pejoratively by the artists I have mentioned. In fact, I suspect that these artists harbor a certain fondness for photography, despite a preference for its most anti-aesthetic manifestations. Today's widespread use of images derived from photographic culture seems as much a symptom of the apparent cul de sac reached by the hand-dependent picture-making media as it is a sign of photography's culpability. In any case, these pictures hold a distorting mirror before the already distorted images of photographic culture, at once denaturalizing them and demystifying the painterly realm of the unique, the original, the "artist's" hand. Their aim, it would seem, is to use the aura-less artifacts of photographic culture to strip the aura from fine-art representation.[4]

But *is* picture making at a dead end? Has originality really been used up? If so, we might expect to find such drawings irrelevant, *retardataire,* lifeless— simply because they are drawn. Yet what makes them most interesting is their existence as drawings, replete with formal invention and marks made by individual hands, and the way in which this conflicts with their insistence on a predetermined, pre-imaged universe. One might say that their form and content exist in a state of tension that approaches contradiction. Such pictures may mirror a crisis in the world of representation, but they also are evidence of the continuing power of the image. Like those in photography who continue to believe in their medium's ability to describe the world with some degree of certitude, and to find new means of description within it, these artists retain an attachment to the aesthetic persuasiveness of drawing. Their pictures offer consolation to our overdetermined eyesight even as they testify to the delicious ineffability of photographs.

Published in *Drawings: After Photography,* the catalog to an exhibition organized in 1984 by William Olander and circulated by Independent Curators, Inc. This essay is dedicated to the memory of William Olander.

Andy Warhol

PRESENTATION WITHOUT REPRESENTATION

FOR MANY, ANDY WARHOL WAS the quintessential pop artist of the 1960s. Certainly he became the most journalistically celebrated, since his Campbell soup cans and Brillo boxes readily lent themselves to spectacle and ridicule. If in the public mind a five-year-old could make a painting that looked like a Picasso, it didn't even take an infant to make a Warhol. Warhol's paintings looked like they had been done by a machine.

In a way, they were. Warhol liked the idea of mass production, and he tried his best to imitate its qualities in his work. As a result, one of the tools that entered his repertory at an early stage in his career was the camera. The camera made negatives that, like his silk screens, could produce endless repetitions of a single image. Unlike the painters of an earlier generation, Warhol was not interested in unique objects; rather, like Robert Rauschenberg, he sought to open art to commonplace experience and to acknowledge the influence of the mass media, including camera-based reproduction. Besides producing paintings, then, Warhol and his "Factory" made films, published a magazine, promoted a rock band, and, of course, took photographs.

Most of these photographs were transformed into facsimiles of themselves through Warhol's silk-screen process, making them more like reproductions and less like the rarified products of contemporaneous creative photography, from which Warhol always kept his distance. But in the years since his relationship to photography began, the field of photography has changed considerably. No longer is there a hard distinction to be made between photographers who consider their pictures art and artists who use photography in their work. Given such a climate, it is not too surprising that Warhol, following Rauschenberg's lead, should leave the silk-screen mode and finally reveal himself as a photographer, pure and simple.

Or almost simple. The black-and-white photographic works he made in 1985 are complicated by the stitches that join them together into grids of from four to twelve prints each. The images, which are linked together by sewing machine, are invariably identical, so that each work consists of one image repeated several

15. Andy Warhol, Untitled (*Brooke Shields*), 1976–86

times. One sees, for example, Brooke Shields four times, a station wagon four times, a tea kettle on a stove four times—often with a length of loose thread hanging from the center. In addition to making the images approximate the size of paintings, these gridlike arrangements disrupt our conventional way of looking at an image. Instead of magnifying the effect of whatever is depicted, the repetition diminishes it. Warhol used the same strategy in the 1960s, most memorably in his "Disaster" series, in which he used silk-screens to transfer newspaper photographs of auto accidents, executions, and other scenes of violence onto canvases dozens of times apiece.

Characteristically, the artist pursues no single formal idea in the new photographs, no one compositional device. In some, the single image is centered in the frame, so that the whole reads as four discrete pictures. In others, the elements within the frame are such that an overall pattern is created. A fragmentary view of Manhattan skyscrapers, when stitched to others like it, becomes part of a bilevel panoramic skyline. A piece of a tulip bed is repeated to create an overall field of flowers. Elsewhere, the interest is on where the edges of the frames meet, as when the rear half of one horse leaps the stitching and joins up with the front half of another. (The humor here, as well as the juxtaposition, brings to mind William Wegman's photographs of the 1970s.)

It is clear, in short, that as much as Warhol enjoys the formal combinations and coincidences possible in this sort of photocollage, he is devoted to none of them. His subject matter is equally diverse, encompassing portraits, window displays, room interiors, urban architecture, and even a flushing toilet. One can draw several possible conclusions from this superabundance of subject and approach. Perhaps Warhol is demonstrating his virtuosity, showing himself to be at least as much a connoisseur of chaos (poet Wallace Stevens's words) as Rauschenberg, whose career has traversed photography in much the same manner. Or perhaps Warhol is as yet uncertain about what these photographs should focus on, what their message should be. Or—and this I think is the most tempting possibility—perhaps these photographs are meant to be as subversive of art today as his soup cans were of the art of the 1960s.

To understand the relationship, we can refer to another significant body of Warhol works, early hand-painted images from 1960 to 1962, which belong to the Dia Art Foundation and were shown at its gallery in Soho in 1985. They are called hand-painted because they predate Warhol's adoption of his silkscreen method, and they contain somewhat sketchy and slightly crude recapitulations of mass imagery drawn from magazine advertisements, comic books, and matchbook covers—icons, that is, of popular culture. Looking at their impudent but still painterly demeanor, one can see how radically important it was when Warhol made the shift to a more mechanical means of producing images— via the camera and the silkscreen process.

Just as Warhol's repetitive, mechanically-reproduced images in paint challenged the dogma of artistic creativity twenty years ago, his recent multiple-image photographs challenge the ideas of creative photography today. By rendering subject matter irrelevant through repetition and variety, and by exploiting a wide variety of formal devices without an allegiance to any of them, he negates the conventional notion of an artistic "eye." There is no point of view in these pictures; instead, the point of view is all in the presentation.

Thus Warhol's photographs are very much of the moment in today's art world, since presentation seems well on the way to replacing style as the means by which art (photography included) is recognized and appreciated. Warhol, of course, is the one artist to have foreseen this tendency long ago, and to have fashioned a career based on it. What Warhol does in his art is to present representations, making us face them for what they are, devoid of sentimentality and beyond the reach of irony. As Stephen Koch writes in a book that accompanied the exhibition at Robert Miller Gallery, Warhol's art has an aesthetic distance "just beyond the reach of either passion or resolution." If this essential quality of Warhol's aesthetic has seemed diminished by repetition since the 1960s—as if it were simply another serialized image in the artist's repertory—with these photographs he has found a way to restore its currency.

Published in the *New York Times,* January 11, 1986, in conjunction with an exhibition of Warhol's latest—and, as it turned out, last—photographic works at the Robert Miller Gallery, New York.

Chuck Close's Hyperbolic Verisimilitude

THE RISE IN THE LATE 1960s of the painting style known as photorealism seemed, for anyone devoted to photography, quite inexplicable. Why, given the availability of photographic technology and the ubiquity of photographs themselves, go to all the trouble of painting something to look like a photograph? For many photographers, the products of photorealism were an affront to the integrity of their medium. And for many painters, photorealist paintings were lame hybrids, debased by their uncritical acceptance of photographic appearances.

Today it is clear that the relationship between camera-based images and painted images is more complex and resonant than what most photorealists championed and their critics disdained. Among the artists to convince us of this is Chuck Close, whose painted-from-photographs portraits of the 1970s combine a painter's concern for scale and surface with a photographer's penchant for representation and detail. Although pigeonholed early on as a photorealist, Close has continued to find new visual territory in which to operate, and new formal issues to explore.

His exploration of large-scale mark-making, and the limits of representational information led him from the start to work from photographs. He used them as "working drawings" for his huge portrait "heads." These paintings are marvels of technical ingenuity and patience, being built up from as many as 160,000 dots or marks, applied one at a time within a meticulous grid structure. Some were done with a brush, some with an air brush, some with the artist's thumb dipped in paint.

By 1980, however, his attention had turned to photographs themselves. Inspired by the Polaroid Corporation's 20-by-24-inch "instant" camera and film, which is capable of making larger-than-life-size prints directly, he began a series of multi-part images that took advantage of the process's unmatched powers of description. This fascination with the representational potentials of large-format photography has culminated in a breathtaking group of mural-sized works.

Five pieces made in 1984 and shown at the Pace/MacGill Gallery, New York, in 1985—two full-length nudes, posed in a manner suggestive of Manet's *Olympia,* and three torsos—are as striking as any large photographs yet made. At almost seven feet high and up to sixteen feet long, they are unequaled in overall impact

16. Chuck Close, *Maquette for "Francesco,"* 1987

except perhaps by Richard Avedon's black-and-white blow-ups of groups such as the Vietnam Mission Council and the Chicago Seven, done in the 1970s. But Close's pictures are in lifelike color, and since they are direct positives and not enlargements they are disconcertingly detailed. Not only does every wrinkle show on his subjects' skin, but also every pore, hair follicle, eyelash and hangnail. Their clarity is overwhelming, and it was emphasized by an installation that made viewers crane their necks to take the pictures in.

The full-length, reclining nudes—one male, one female, each formed of five abutting vertical "panels"—were hung opposite each other on walls not much farther apart than a good-sized hallway's. The torsos—two female triptychs and a male diptych—were given a bit more breathing space in another room, but the scale of the bodies and their towering height made the space seem almost as confining. The figures are all bigger than life-size, attaining a monumentality that is kin to traditional heroic sculpture. Yet the men and women depicted are far from idealized. The camera's unrelenting gaze fixes everything dispassionately, from the palm-tree pendant dangling on one woman's neck to a loose flake of skin on a man's hand.

The result, for the viewer, is an enforced intimacy so precipitous and inescapable that the act of looking comes to feel rude or embarrassing. Only the limited plane of sharpness in the images (an unavoidable aspect of the process) offers the eye some relief. While one cannot help but focus on certain formal qualities—the slightly skewed perspective from one panel to the next, for example, which makes the torsos look flattened and the full-length figures elongated—it is impossible to consider these pictures merely as exercises about issues of representation. Their psychological impact is as calculated as in any of Close's paintings, and even more aggressive.

From the start Close's painting has been involved in technical virtuosity and mastery; his art seems motivated by a grand obsession with the process of creation. This spirit also can be found in these photographs. Where in the paintings he puts repetitive marks on canvas, challenging the physical limits of his abilities and attention, here his feat is technological. The "camera" he used is a 12-by-16-foot room, constructed by Polaroid inside the Museum of Fine Arts, Boston, with a lens affixed to one side. His models were posed on a platform attached to a forklift truck, which positioned them in front of the lens. The exposure required several banks of electronic flash. Polaroid technicians inside the camera helped handle the 40-by-80-inch film and its subsequent development.

But the images this complex collaborative effort produced are more than a testament to the artist's persistence and craft. The heightened verisimilitude and density of photographic information color our reactions to the subject matter being presented. One consequence is that these seem not so much nudes in the

aestheticized sense but naked individuals, heroic in size but terribly mortal in their appearance. Remarkably, they seem totally devoid of self-consciousness, a state the average viewer is not likely to obtain while looking at them.

Indeed, there are no doubt Puritans among us who could find Close's close scrutiny obscene, if for no other reason than the proportions involved. The artist became aware of this problem as long ago as 1967, when he first painted a larger-than-life nude. He quickly switched to portraits in an effort to not distract attention from his painterly concerns. But here he seems to court distraction, creating a tension between form and verisimilitude that, like the installation itself, leaves his audience little room for dispassionate reflection. At a time when much photography is proud to point out how distanced it is from reality, Close's monumental, hyperbolic nudes seem all the more innovative and compelling.

New York Times, February 2, 1985.

Lucas Samaras's Photographs
SLICED, STABBED, AND CUBED POLAROIDS

THERE IS ART that is ordered, thoughtful, and intellectual, and there is art that is
unruly, impulsive, and emotional. Lucas Samaras's work clearly clings to the latter
pole. His sculptures built of mirror shards and nails, his sewn-fabric "paintings,"
his Polaroid photographs, his anti-utilitarian furniture, and his Rorschach-blot
drawings add up to a byzantine catalog of myth, perversity and creative self-
indulgence. And yet there is a touch of self-consciousness about it all, the barest
hint that Samaras knows exactly the effects his primitivist sensibility provokes.
This trait of self-consciousness is not without virtue: it tempers the self-indulgence
and narcissism, giving his compulsiveness an air of calculation.

In his photographs, especially, one finds his obsessive expressionism in league
with a detached sense of the work as theatrical flourish. To a large extent these
Polaroid images—self-portraits, mostly—are the keystone of his art, inasmuch as
they enable him to be both the observer and the observed. Samaras began making
photographs in 1969, well in advance of the horde of artists-making-photographs
that was to overrun the art world by the end of the 1970s. His earliest pictures—
which he called "AutoPolaroids"—showed him in various costumes and guises,
mugging for the camera, kneading the flesh of his stomach, wearing a repro-
duction of Leonardo's *Last Supper* as a loincloth.

At first such images befuddled fans of his spiked, aggressive sculpture, but
they fit perfectly with the legacy of Samaras's involvement with "body art" and
"happenings." They also fit perfectly into the photographic climate of the day.
Les Krims was photographing make-believe murder scenes with naked female
"victims"; Duane Michals was using sequences to chronicle surreal, suggestive
reveries; Diane Arbus was at the peak of her fascination with the freakish and
forbidden. Samaras merely made himself the side show's central attraction.

He also displayed the images in combination, in the form of grids. Since the
grid constituted a sign of artistic seriousness at the time, obviously Samaras
wanted these photographs taken seriously. But in retrospect it is clear that the
grids also function to cage the wild, loony expressionism of the pictures, to put a
rein on their perversity and a limit on their outrageousness. As a result, we read

17. Lucas Samaras, *Sittings (8×10)*, 1979

them differently than we read, for example, an Arbus picture; for all their flirtation with the bizarre (and Samaras's poses and guises are nothing if not bizarre) they permit us to retain our bearings, to believe that the world remains under control.

One grid in particular deserves attention, for it is as close as we might come to a Rosetta Stone for Samaras's art. Alternating with color close-ups of the artist's thumb are black-and-white images of a razor blade, a paper punch, a safety pin, and a pair of scissors. Besides being functional implements for the artist, these objects define quite succinctly the motifs of his work. That is to say, they slice, pierce, stab and cut—or, to put it more gently, they penetrate. Penetration, replete with overtones of sex, wounding, surgical excision, psychological healing and even the process of art-making, is so much an underlying theme that we can hardly fail to notice it. We see it in his chair that has a sharpened shaft jutting up from the middle of the seat. And we see it in his sculptural boxes bristling with nails.

We also have evidence of his fascination with razor blades and scissors in the photographs that followed the AutoPolaroids, called "Splits," and in a more recent series called "Panoramas." Each of the "Splits," done in 1973, is made from the diagonally sliced halves of two photographs, rejoined to make one. The "Panoramas" are portraits or interior views formed from a multitude of thin strips cut from large-format Polaroid photographs, intermingled to create a contiguous but perspectively skewed space. In the ten years between these two bodies of work, however, Samaras generally forsook slicing his photographs. What penetration there is in those photographs—the well-known SX-70 self-portrait series called "Photo-Transformations," a series of still lifes done in the artist's cramped apartment, and "Sittings," a series of portraits of naked culturati— is psychological rather than physical.

In the "Photo-Transformations" we see Samaras nude, bathed in bilious green and purple light, apparently undergoing a series of agonizing transformations that make Gregor Samsa's plight seem like a mere hangover. His face and body are contorted in ways undreamed of by the painter Edvard Munch. To achieve such gruesome effects, the artist learned to manipulate the surface of the SX-70 print while it was developing, allowing him to rearrange his teeth, mouth, eyes, arms and other bodily parts at will. Kept to an intimate scale by the constraints of the Polaroid print, and filled with the signs of emotional catharsis, these are Samaras's most compelling photographs to date.

The portraits of naked art-world notables and the still lifes are relatively tame by comparison, yet they have the humor, audacity and scorn for conventional standards of "good taste" that mark the artist's best work. The portraits are discomfiting as well, for lurking in the corner of each, beside the strobe lights and fabric backdrops that clutter the frame, is the portraitist himself.

This insistence on including himself in the scene is more than an attempt at candor on Samaras's part (more, that is, than a modernist poker player showing his hand); it makes explicit the inherent voyeurism of the situation and underscores the photographer's domination of the interchange. In every case he appears self-possessed and in control, while his subjects seem awkward and embarrassed, stripped of more than just their clothes.

If Samaras intends to penetrate and disassemble the conventions of photography to get at something else, we need to ask what that something else might be. There are, for example, numerous allusions to ancient mythology, to the history of art, to his childhood, and the disruptions that accompanied it (he was born in Greece in 1936 and was displaced by World War II), to deepseated ambiguities about his identity and sexuality. These give us a sense of the psyche responsible for the art, and its place in art history, but nowhere do we sense that the art's instinctual expressionism is capable of resolving the psyche's fundamental conflicts and anxieties.

This is a problem with Samaras's photography, as it is with all obsessional art: However clearly the artist conveys the elements of his complex personality, and however much his self-absorption is moderated by artistic sophistication, the images retain a claustrophobic feeling. One yearns for his art to connect more with the world at large, to have therapeutic value for the audience as well as the artist. In his photographs, at least, that yearning—which stems from a desire that art have a liberating function for the viewer—has yet to be satisfied.

Written in response to the exhibition *Lucas Samaras: Polaroid Photographs 1969–1983,* which opened at the Centre Georges Pompidou in Paris and later appeared at the International Center of Photography in New York. *New York Times,* July 15, 1984.

Cindy Sherman

A PLAYFUL AND POLITICAL POSTMODERNIST

WHEN PHOTOGRAPHY ENTERED the discourse and marketplace of the art world in the 1970s it did so largely on the basis of its modernist momentum. Photographers took pains to stress their interest in the formal properties of their medium, investigating "problems" of time, tone, space, and framing in the Bauhaus spirit of Moholy-Nagy. At about the same time, paradoxically, artists outside the photographic tradition were taking up the camera for radically different reasons. It was used to furnish visual documentation of relatively inaccessible or ephemeral art works, such as Robert Smithson's *Spiral Jetty* or Christo's *Valley Curtain,* or as a source of predigested imagery for certain representational painters, such as Chuck Close, or as a kind of shorthand notebook for conceptual artists on the order of John Baldessari, Robert Cumming, and William Wegman. In short, while photographers were involved with photographic form, artists in revolt against abstract and minimalist art became enamored of photography for its content.

Today it is clear that photography's isolationist preoccupation with its unique formal properties—its reflexive urge to prove itself a fully modernist art—has run its course. Why worry over modernism when modernism itself is in such disarray throughout the arts? Painters have turned to representation and realist styles despite photography's presence; architects have taken to decorating their edifices with columns and curlicues culled from the past; dancers have left the lofts and sidewalks to return to the proscenium stage. We are, many believe, in the throes of a postmodernist age, which entails not only a passage beyond modernism, but also an active rejection of its historical imperatives.

Cindy Sherman's photographs—essentially *tableaux* in which the artist herself, bewigged, costumed, and heavily made up is the sole protagonist—may infuriate photographic purists and annoy painters still devoted to the canvas, but they are no doubt exemplary of what photography is coming to resemble in an era of postmodernism in the arts and postformalism in photography. Sherman does not attempt self-revelation in her self-consciously stylized pictures of herself; instead—dressed as a Hollywood film starlet, a suburban housewife, a pubescent

18. Cindy Sherman, Untitled # 155, 1985

bobby-soxer—she creates a series of dramatic personae (or, in Jung's psycho-
logical version of the word's plural, personas), each with its own aura, its
own particular presence. Appearance is all, she seems to say, yet she also
demonstrates how conventionalized and delimited appearances ultimately are.

Such pictures could be called postmodern both in the sense that they reach
back into the past and in the sense that they constitute a rebuke of modernism.
The props, costumes, and makeup they employ are consciously borrowed from
the 1950s and 1960s. The photographs refer to, and comment on, preexisting
categories of imagery. Significantly, their source—what Sherman "quotes"—
is outside the high-art tradition; the early pictures were called "Untitled Film
Stills," the subsequent work looks like illustrations for *Modern Romance*.
By focusing exclusively on conventionalized, almost stereotypical forms of
representation, Sherman seems to question our assumptions about originality in
art. By borrowing from popular culture rather than high culture, she questions
the vitality of the fine-art tradition. By fragmenting her own identity into a
series of performing personae, she deflates our image of the artist as a
glamorized Nietzschean super-hero. And, in photographic terms, she moves
past the investigation of formal syntax to take up questions of content.

Compared to the black-and-white "Film Stills" of the 1970s and her first
color pictures, shown in 1980, Sherman has been concentrating more on the
figure and less on locale, implied narrative and nostalgia. The large and
elongated (24-by-48-inch) color photographs of 1981 mark a watershed: they
eliminate much of the background and some of the more outlandish costuming.
Gone, too, is the starlet veneer of the film stills. Sherman has pared her
vocabulary to the extent that all but the lady vanishes; consequently,
psychological tension takes the place of situational theater.

The pictures grew out of a project for the journal *Artforum,* for which
Sherman proposed to produce a Playboy-style centerfold. (The project, which
accounts for the pictures' proportions, was never published.) Thus, we find
Sherman on the floor in five of the photographs and in bed in three others,
usually recumbent and often supine. There is no nudity, but a limpid sexuality is
certainly implied: her skirt is hiked up above her knees; a slice of bare skin
peeks out between jeans and blouse. In addition, due to Sherman's proximity to
the camera and to the larger-than-life scale she assumes in the prints, her
corporeal presence is emphasized; as viewers we are thrust into an almost
embarrassing intimacy.

However, these are no ordinary pinup poses. Sherman obviously means to
play off against the centerfold conventions. Sweat drenches cheeks, damp bangs
are plastered to foreheads, hands clutch bedcovers or newspaper clippings
("Know Yourself/Know Your Future," says one classified ad). Instead of
projecting allure, the expressions Sherman's personae assume are remote and

ambiguous. In one photograph she seems to have an eye on someone outside the frame, but for the rest her gaze stays within the picture boundaries. Despite the initial message of come-hither availability, the pictures ultimately close the viewer off; the women depicted are isolated within the photograph's field of reference by the stilted, mannered method of their representations.

The net effect is a nonspecific characterization that tempts one to speculate about the situation and mood of the female protagonist. Given this inducement we are likely to see the model (Sherman) as a generic model for certain emotions. By simultaneously utilizing and undermining the conventions of commercial mass-culture representation, she gives us glimpses of vulnerability, suffering, anticipation, desire. If there is any overriding theme, it is a diffuse yet pervasive anxiety. Like Laurie Simmons, Eileen Cowin, and Ellen Brooks—all of whose photographs involve models and ambiguously presented mise-en-scènes—Sherman is at once playful and political.

There are, I would argue, two major tensions that charge this work: one that pits the determined stylization of her references to popular imagery against the immediacy of her own presence, and one that pits woman-as-temptress against woman-as-victim. The first, pointing as it does to the difficulties of creating and containing meaning in today's image-conscious world, places Sherman's photographs squarely among the postmoderns. The second, more compelling tension places them in the world at large, far beyond the circumscribed realm of ideas about art.

New York Times, November 22, 1981.

Cindy Sherman, Continued

GRIMM, BUT STILL PLAYFUL

CINDY SHERMAN'S PHOTOGRAPHS—all of which portray the artist in various guises—have received an extraordinarily enthusiastic reception virtually from the time the artist arrived in New York in 1977. They apparently strike a cultural chord of widespread resonance. In one sense narcissistic, in another sense self-abnegating, they suggest that the decline of first-hand, unmediated experience that is a consequence of today's image-saturated world is not without compensation. Look, they say, at the possibilities. Why not enjoy ourselves, trying on an endless chain of chameleon-like identities the way we try on clothes?

There are those who say that the show cannot go on indefinitely, that Sherman's closet will sooner or later be depleted—thus confirming the traditional faith in the unity and independence of the self. But Sherman seems to have more resources than even her most ardent admirers originally suspected. Indeed, her work suggests that she is growing ever more confident and accomplished. Far from being at the end of her rope, she still seems to be climbing toward the peak of her powers.

Except for her first mature series of photographs, the "Untitled Film Stills" of 1977–80, Sherman's most engaging images have been inspired by projects assigned to her by others. This was the case with her panorama-format color "centerfolds" of 1981, originally commissioned by *Artforum,* which multiplied exponentially her then-budding reputation, and again with a more recent project in which she tried to upstage the designer fashions of Dianne B. and Issey Miyake. Her pictures of 1985 are no exception: they were occasioned by an assignment from *Vanity Fair* to illustrate children's fairy tales.

As happened with the *Artforum* assignment, Sherman's new pictures failed to make their way into print as intended. But whatever the editors' needs, there is no question of the quality of the photographs she has produced. Not that they are easy to like: they are darker in spirit, more mythic and more monstrous than anything she conceived before, and they convey—like a surprising number of fairy tales—a nightmarish view of the world. The life-size prints, which stand six feet tall, are large enough to menace the viewer, yet technically they are Sherman's most inviting work to date. Both the lighting and the color are handled

with sophisticated assurance, convincingly simulating moonlight, firelight and twilight—all in the confines of the artist's studio.

As for Sherman, she appears scarred, pockmarked and otherwise disfigured. In one image she seems to have been beheaded; in another she sticks out a tongue as large as a slice of bread; in still another she sports prosthetic breasts. It is as if she discovered a Hollywood makeup kit and became intent on using all the props and pieces as quickly as possible. Her ingenious guises and disguises also include a witch's warty chin, a pig's snout, a bald head and a plastic derriere. Gone are the glamour, vulnerability and calculated allure of the Shermans of four years ago; in their place is an earthy primitivism, formed by an eerie amalgam of references to Teutonic myths, Oriental legends, art history, and transformative horror films on the order of *I Was a Teen-Age Werewolf.*

One cannot help but notice the extent to which these photographs seem to play off the artist's earlier pictures—or, more precisely, the reception often afforded them. The scars and sores and whisker stubble that appear on Sherman's face undercut the sexual suggestiveness that has either tantalized or distressed observers of her career. There is still a good deal of suggestive moisture oozing from the foreheads of her protagonists, and a smattering of decolletage, so their erotic appeal is not totally blunted. But it coexists with signs of infection, putrefaction, amputation or worse. In three of the images, the character we see appears to be dead. If photographs were discernible by smell, no one would venture within intimate range of these images, which more than ever deny the label "self portraits."

Clearly Sherman has moved away from her early reliance on popular culture as a source for her re-creations. The new pictures look deeper into history, verging on a unsettling synthesis of tribal ritual, genetic instinct, and Jungian archetype—albeit from a post-Disney perspective. Rather than evoke exclusively twentieth-century precedents, she now ranges over territory that, in its narrative thrust, recalls not only *Hansel and Gretel* and *The Arabian Nights* but also *Taras Bulba* and Jerzy Kosinski's *The Painted Bird.* In purely visual terms the images have echoes both of movies on late-night television and of the "high culture" of artists like Rembrandt, Ingres and the surrealist Hans Bellmer.

What this transition does to Sherman's status as the major avatar of postmodernist photography is not so clear. Her work originally was championed by those who subscribe to the notion of "deconstruction"; in their eyes, her pictures are valuable because they unmask cultural messages the rest of us ordinarily take for granted, and make the world seem less grounded in certainty than we would like to admit. The images now on view still remind us that our view of reality has a certain friable quality, to be sure, but they are less directed at contemporary culture and certainly less adamant about identifying the camera as the primary source of our cultural inheritance.

On the other hand, they remain preeminently postmodernist in the sense that the term is used in architecture. Sherman appropriates images from whatever arena she pleases, with the same breadth and abandon that the architect Michael Graves displays in choosing styles of ornamentation. By doing so she confronts us with an admixture of cultural myth that, while disconcerting to our present-day eyes, serves to reacquaint us with the power of images buried in our collective past. This act of revivification stands in marvelous contradiction to the postmodernist idea that all the world—including all we see—exists in a state of depletion. Instead of depletion, the photographs give us abundance.

These are, then, bellwether pictures in relation to Sherman's ability to create new territory within the rather limited means she allows herself. Like much neo-expressionist painting, their evocations of a primitive past are not theoretical conceits; they imply a deep longing for a connection to more innocent times. But more than most painters, and unique among photographers, Sherman makes this longing palpable.

New York Times, October 20, 1985.

Laurie Simmons

WATER BUOYED

THERE IS NO FASHIONABLE IRONY in Laurie Simmons's photographs of swimming figures, no shiny veneer to distance us from the images they contain. Unlike Richard Prince and Troy Brauntuch, two other "picture" artists using photographs in their work, Simmons isn't arctic in temperament, but tropical. Her pictures are warm, lush, and sexy.

Taken underwater, the photographs depict human figures swimming in chlorinated pools or clear Caribbean waters. Well, swimming is not quite the word: her youthful subjects drift, dive, and hover against what seem to be—save for clues like bubbles or a pool drain—monochromatic blue backgrounds. If Matisse had signed on as Jacques Cousteau's photographer, his pictures wouldn't be much different from these. (Matisse, it should be said, kept his figures separate from his grounds; here, the marine blue spills over onto flesh.)

Most of Simmons's swimmers are skinny-dipping, but a few wear strange bathing costumes. A man sports a red leotard, which provides relief against the blue; a woman appears in a tutu with particolored fringe. The suits are evocative, but it is difficult to say of what era—they may, in fact, point toward the future. The world of these pictures, then, is not only weightless but also timeless.

The world of these pictures is also *valueless,* at least superficially. By choosing an environment without distinguishing features and costumes outside fashion, Simmons avoids lending any cultural context to these images. As much as the swimmers, we viewers are at sea. It wouldn't be altogether fair, though, to say that the pictures have no meaning.

For one thing, they take on meaning when placed in the context of her earlier photographs. Simmons once set up plastic frogmen in an aquarium, with colorful and pseudo-*naif* results. Before that she placed miniature figures in dollhouse-sized environments, suggesting human-sized psychological dilemmas. Most recently, she tried scenes similar to her miniatures but using full-scale props and real people. The pictures of swimmers obviously represent a solution to her need to work with larger objects, while they remain visually tied to the aquarium series.

19. Laurie Simmons, *Family Flying*, 1981

The pictures also create an atmosphere uniquely their own—a molasses brew at once soporific and ecstatic. Looking at the work, it is possible to feel free of city hassles, to daydream of vacations to come, to recall the best sex of one's life. It is an atmosphere less hermetic and less defined than that of Simmons's earlier work. Like the swimmers, meaning floats free within the frames.

The unabashed manner in which Simmons celebrates the human figure recalls the films of Leni Riefenstahl, whose lens salivated whenever it crossed the biceps of a proud Aryan youth. Riefenstahl presented the human form without any wider meaning intended, yet she felt compelled to heroicize it to an absurd extent.

We know, of course, that Riefenstahl's films of the 1930s were intended to be paradigms of their culture, and thus were exploited by the Nazis. That Riefenstahl later rehabilitated herself largely through photographing Nuba warriors in Africa—the Aryan hero turned upside down—only adds a note of irony. (It's ironic, too, that Riefenstahl now photographs under water.) How, then, can we be sure that Simmons's seductive pictures aren't just as dangerous?

The answer, I think, is that whereas Riefenstahl's films collaborated in the process of confirming cultural stereotypes, Simmons's photographs actively deny our attempts to ascribe values to them. Rather than heroicize the figure, Simmons deflates it. Water pressure squeezes cheeks and breasts into curious proportions, pushing flesh toward the bottom of the frame. The beauty of this effect is that its beauty is unconventional; that is, it resists the very cultural conventions to which Riefenstahl fell prey. And, as I suggested earlier, the lack of any sure sense of place and period in Simmons's pictures also puts them beyond cultural appropriation.

Thus there is a final meaning to these apparently meaningless photographs— one that is paradoxical and difficult but nevertheless essential to an understanding of what this sort of art is about. By freeing an image (in this case, the human figure) from its conventional usage, the artist liberates it from its conventional meanings. We see it with fresh eyes—not as it *really* is (a poststructuralist impossibility), but as it *could* be. Simmons's ability to focus on this issue with photographs that are tantalizing and accessible is rare and wonderful.

Soho Weekly News, May 6, 1981. This was the last column I wrote for the late-lamented paper, which published its last issue a few months later.

Barbara Kruger

PHOTOMONTAGE WITH DIFFERENCE

WALKING INTO A BARBARA KRUGER SHOW is like walking into a lecture ten minutes late: you immediately feel engulfed by reprobation. The photographs—montages, really, with words built into them—chasten you with an imperious voice. "You are giving us the evil eye," they say, "Your money talks," "You are the cost of living." With these didactic, remonstrative messages come images culled from the past, their half-tone dots enlarged to the size of thumbnails. Behind the blocked-in type that says "Your money talks," a man leaps from an exploding house. In a vertically disposed triptych with the words "Money can't buy me," the visage of a youthful J. Edgar Hoover shares space with an outsized revolver.

At heights of six feet or more, hung so they tower over the average-sized viewer, these black-and-white pictures with red enamel frames have a powerful effect that is exponentially greater than that of traditional photographs, which often seem to huddle for comfort on gallery walls. Their power is not unlike that of Soviet propaganda posters, and they have the "look" of constructivism—Alexander Rodchenko's posters for Sergei Eisenstein's film *Battleship Potemkin,* say, or his covers for the magazine *Lef,* both dating from the 1920s.

But besides resembling classic political photomontage of the 1920s and 1930s (John Heartfield's name also ought to be mentioned here), Kruger's pictures partake of a more recent and commercial style—namely, the type of graphic design one can find in trendsetting magazines, from the West Coast funk of *Wet* to the New York slick of *Self,* and in fashion advertising. (The artist's biography notes that she has worked for Condé Nast publications as a graphic designer.) The recourse to graphic modes that are linked to the design vocabularies of both persuasion and propaganda is not coincidental on Kruger's part, because these pictures not only have the *look* of power, they *are* about power. Although at first one may take the artist's accusations personally, it is soon enough apparent that the "you" being chided in the texts is in the second person plural.

Kruger's pictures have two subjects. One is economic power; some have the word "money" inscribed in them, and in others money is at least implied. Also implied is the connection between money and power—the message that economics

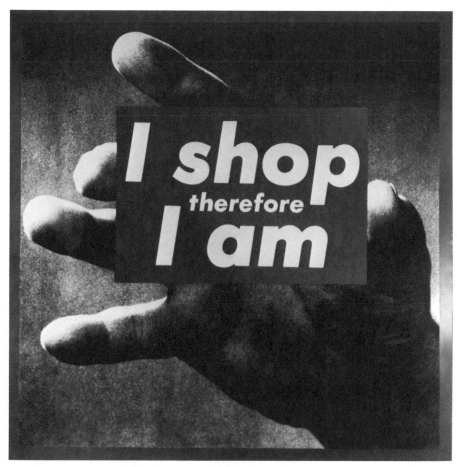

20. Barbara Kruger, Untitled *(I shop therefore I am)*, 1987

is also politics comes through loud and clear. A picture of what looks to be a puppet in the form of a duck comes with the message "Buy me. I'll change your life," a claim so overblown, and so much in contrast to the "product" on display, that we can't help but feel the incongruity between what advertising promises and what reality delivers. Here Kruger functions as a kind of guerrilla Federal Trade Commission.

At the same time, there is another kind of politics being pursued in Kruger's work: the politics of male/female relations as seen from the perspective of feminism. It's clear enough that the "you" of the texts is associated with men, and the "we" with women. In two works featuring images of women— *Our time is your money* and *You are the cost of living*—the women seem to be victims of a consumer economy controlled by men; one wears a crown of ball bearings, another has tweezers aimed at her cheek. And yet there is an ambiguity about just who is doing what to whom, and why—an ambiguity the viewer can't help but feel in trying to decide whether to identify with the camp labeled "we" or "you." Presumably this ambiguity is intentional, intended to make us think, to make us place ourselves on the spectrum of economic and sexual relations.

The undercurrent of male/female opposition carries over to her pieces in which the overt subject is matters of sight. A man peers ominously through a loupe (*Surveillance is your busy work*), fingers scan pages of braille text (*What you see is what you get*) and a pair of glasses magnifies and refracts the words of a book on impressionism (*You are giving us the evil eye*). In one of Kruger's few images to include the presence of both a man and a woman, the words "Your seeing is believing" are inscribed next to the man, and both characters stare into the distance, not at each other. Seeing, the message seems to be, is not a neutral act; it is bound up with (male) power politics.

In combining words and images, Kruger is by no means unique; the supplementing of photographs with text is a widespread tendency in today's photography, spurred in large part by a dissatisfaction with the photograph's native ability to deliver messages of aesthetic or social import. Nor is the combination especially unique to our times: documentarians since Jacob Riis have written texts to accompany their pictures, and artists using photocollage in the 1920s and 1930s (including Rodchenko and Heartfield) liberally mixed in literary elements with fragments of images. But Kruger's work stands out all the same, not only because of its graphic force (which is substantial) but also in its use of language. She renders political statements ambiguous, twistis clichés, throws out aggressive exhortations in a flat, almost detached style. The closest equivalent to her syntax is found not in photography but in the work of the artist Jenny Holzer, who strings imperative sentences together with the grace of a poet and exhibits them in forms that range from brass plaques to bumper stickers.

As does Holzer, Kruger uses words in a way that leaves them suspended in mid-air, at least partly ripped from their moorings. They are, it would seem, intended to be more than agitprop for certain fashionable ideologies, although to convincingly explain the mechanisms by which this transformation occurs would take much more space than is available here. (The critic Craig Owens has given it a go in an article in *Art in America,* concluding with the quite mystifying assertion that her art "engages in neither social commentary nor ideological critique" and "has no moralistic or didactic ambition."[5]) Suffice it to say that the impact of these pictures is due both to the power of the advertising and propagandistic devices they adopt and to the artist's sardonic commentary on those devices. If Kruger harbors no didactic intentions (which I doubt), her pictures certainly possess them.

Pictures like *Surveillance is your busy work* and *Your seeing is believing* seem more resonant than most, partly because they avoid the obvious visual/verbal puns to which the artist occasionally falls prey. (In one piece, the words "Put your money where your mouth is" accompany an image of a set of false teeth with a banana stuck between the uppers and lowers.) But it is also because they focus on matters having to do with images and image making (i.e., art), not money and economics (i.e., the art market). They are about perception, not consumption, and they seem happier for it.

A review of a Barbara Kruger show at Annina Nosei Gallery, published in the *New York Times,* April 1, 1984.

Richard Prince, Rephotographer

RICHARD PRINCE'S PHOTOGRAPHY of the late 1970s and early 1980s—or, in his terminology, his "rephotography"—seems intentionally designed to straight-arm the viewer. Like a great deal of minimal and conceptual art of the 1970s, it is reticent about providing pleasure, preferring to err on the side of the cerebral for fear of the sentimental. Indeed, his images can hardly even be called his own: they are photographs of others' photographs, slightly altered recapitulations of pictures he clips from magazines and other mass-media sources. One is hard pressed to imagine a less accessible, more obdurate form of art, and there is little need to wonder why the artist has not yet achieved the public celebrity and national recognition of some of his peers.

Yet for all this Prince is a respected, seminal figure in the vanguard art scene. Of all the new breed of New York-based artist/photographers, he has acquired the largest following and has had the greatest influence on young downtown artists— if we judge by the number of imitators he has attracted. The concept of "appropriating" and remaking imagery in lieu of attempting to create one's own apparently has struck a nerve among some members of the artist's generation, not only for practical reasons—one could say that there is a certain ecological economy in recycling imagery—but also for its rebellious, antimodernist overtones.

The typical Prince picture looks like a glossy blow-up of a fashion photograph, copied well enough that we might at first wonder whether it isn't the advertising photographer's original handiwork. But something about it—the presence of enlarged half-tone dots, the strange scale, the slightly displaced color and contrast— clues us that it is not quite what it seems to be. These shifts from the well-crafted, purportedly authentic "originals" are relatively minuscule, given the range of creative intervention the photographic process allows, but they are enough to give the work an eerie, unlikely presence. Coupled with the often hyperstylized, clichéd and blatantly consumerist subject matter of his prototypes, Prince's otherwise low-key re-presentations have an unsettling resonance.

They are at once mute reminders of the syntax of advertising and critical challenges to the art marketplace's orthodoxy of inventiveness. For advocates of

postmodernism—especially those critics seeped in the ideologies of post-structuralism, such as Douglas Crimp—Prince's photographs do more: they "deconstruct" or lay bare the very premises of modernist art—for example, the notions of originality and authorship. Whether one hews to this belief or not, it does seem fair to say that Prince sticks a pin in the balloon of art photography, which exists by virtue of our faith in the possibility of an endless image-making frontier. His art is troubling because it implies the exhaustion of the image universe; it suggests that a photographer can find more than enough pictures already present in the world without the bother of making new ones. Prince's response to this condition is to substitute selection for creation as the primary process of art making. It is a strategy with a wide appeal to a generation brought up in an environment saturated with images.

One might imagine that he would face his historical situation with a certain amount of regret or sense of loss, but he accepts his fate as a latecomer to the world of visual possibility with great (and disconcerting) equanimity. In a book of fiction called *Why I Go to the Movies Alone,* he summarizes his aesthetic ethos through the agency of an unnamed protagonist: "His own desires had very little to do with what came from himself because what he put out (at least in part) had already been out. His way to make it new was *make it again*, and making it again was enough for him"[6] This is as close as anyone has yet come to formulating a creed for postmodernist art.

There has been only one flaw in Prince's style, however: initially, it did very little to recommend itself to our eyes. One can attribute this primarily to its lack of inflection; that is, the artist as a rule has refused to make anything but the most subtle changes in the "original" image. As a result, the re-presentation of the "original" can be only as interesting to look at as its predecessor. (One early exception to this rule was the "Holiday" series of 1982, which was imbued with sunset hues.) Whereas a like-minded artist, Sherrie Levine, in her copies of famous art photographs, at least had the built-in advantage of eye-catching originals, Prince's choices tend to the obviously stilted, if not banal.

In the mid-1980s, however, with his untitled "gangs" and other sculptural-style works, Prince began to reconcile his strategy of transforming unpromising materials by the most minimal of means with the necessity of attracting and holding the attention of an audience. His focus shifted to installations instead of discrete photographs, creating an impact greater than the sum of the parts.

His 1984 show at Baskerville & Watson in New York marked the start of this shift. On entering the gallery a visitor first confronted a larger-than-life-size color picture of a woman's face, mounted on a wall painted shiny black. The pink tint of her hair, the outsized half-tone dots speckling her skin, and the title (*Plastique,* which is said to be the subject's name) all served as signs that one had left behind the territory of photographic realism and entered the realm of artifice.

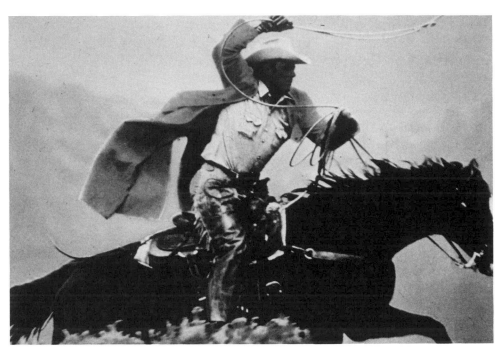

21. Richard Prince, Untitled *(Cowboy)*, 1980–84

Leaning against a nearby wall were four floor-to-ceiling black panels, on each of which was mounted an artificially hued portrait accompanied by abstractionist dots, bars, and reels. Like sandwich boards, these panels seemed to advertise their contents, and it is no surprise to learn that the subjects of Prince's attention are entertainers. At least they are entertainers of a sort, since from their reconstituted publicity headshots they appear much more likely to be found in Times Square than Las Vegas. (They have names like "Fay" and "Luanne.") Indeed, an atmosphere of Times Square tawdriness hung over this part of the exhibition so heavily that one could be sure it was calculated.

The rest of the show, consisting of portrait photographs hung in groups or on panels, was not devoted to the tailings of the entertainment business, but the tawdry atmosphere carried over. There were two multi-image panels of "gangs," one consisting of pictures of women with motorcycles and one of pictures of fashion models with their eyes covered. Here Prince combined his strong nose for what is absurd or ambiguous about commonplace representations with a method of presentation that highlights their absurdity and ambiguity. There was also, for the first time, a palpable sense of humor at work.

Finally, there were nine more-or-less-straight portraits of young and trendy types, some of whom are Prince's art-world friends and some of whom are rock stars on the Warner Brothers label. They are, like all of Prince's work, photographs of photographs, but what makes them interesting is that it is impossible to distinguish the art-world types from the rock stars. This is, to my knowledge, the closest to home he has come as a student of the conventions of media representation. As with the "gangs" panels, the portrait grouping provides a context (and content) to what might otherwise be taken to be an idiosyncratic, wayward, and recondite approach to image making.

New York Times, October 14, 1984. Since this was written, Prince has gone on to make paintings, and he has made humor an explicit issue by reproducing jokes within them.

Robert Cumming, Conflationist

THOSE IN SEARCH OF A MODEL postmodernist artist need look no further than Robert Cumming. His work oversteps the traditional boundaries between visual media, relies on verbal as well as visual cues, refers to theater in its use of illusionism, and serves to undermine our faith in the veracity of representation. These are precisely the qualities advanced by today's theoretical critics as the criteria for postmodernist art—art, that is, which actively seeks to throw off our modernist inheritance. The photographs, drawings, sculptures, books, and permutations thereof that Cumming produces, although refined in appearance, are not really the locus of his art; they are more like artifactual evidence of it.

The work for which Cumming is best known began in the 1970s, when he adopted the camera as his primary working tool (even though he insisted at the time on being identified as a sculptor, not a photographer). Many of his archly humorous and prop-laden black-and-white photographs of that decade were used, together with his often hilarious narratives, in a series of books Cumming created, starting with *Picture Fictions* in 1971. The photograph *Mosquito Field* (1974) is typical of his ingenuity and wit: it is an 8-by-10 contact print of what seems to be an evenly dispersed array of insects, which close inspection reveals to be artificial. In fact, Cumming designed and manufactured the "mosquitoes" (in his role as sculptor), arranged and photographed them (as photographer) and later reproduced the image in his 1975 book *A Discourse on Domestic Disorder* (as illustrator/author/publisher). Obviously his is an art that does not lend itself to categorization.

Since the 1980s began, Cumming's work has been changing shape, although its direction remains the same. Consisting of equal parts photographs, drawings, and cut-paper silhouettes, it displays his abiding taste for technological improbabilities and his delightfully obsessive urge to fantasize. But rather than construct improbable objects for the camera's benefit, as he did for ten years, Cumming seems content to draw them; his photographs—now in color—are focused almost entirely on *objets trouvés,* which seem to come with their absurdities built in.

Cumming has long sketched his ideas for photographs and sculptures, but the drawings signal a new commitment to craft and polish. Done either with charcoal

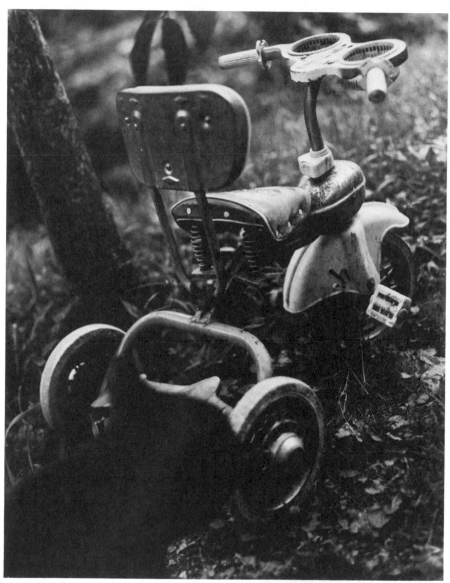

22. Robert Cumming, *Tricycle and Cat*, 1981

on white paper or with white conte crayon on black paper, they are rendered with an illustrator's facility, and they include within their borders titles that have been meticulously hand-lettered in various serif type styles. Despite their coloration they resemble nothing so much as blueprints of a mad architect's isometric drawings. In one, a funnel eats mysterious hieroglyphic-like symbols and, in the drawing beneath it, squirts them out as straight black lines. In another, matchsticks have acquired joints that make them look like penknives. The silhouettes are just as madcap: inside the profile of a woman's head one finds a seesaw with a bullet on one end and a beehive on the other.

His color photographs capture the same sense of mystery and disarray in the physical world without resorting to the imagination. Cumming merely points his camera like a finger, centering on the object of his attention and imbuing it with an iconic presence. He shows us a tree with a black line painted around its trunk, a Japanese tricycle complete with a dashboard, a newspaper on which snow has fallen, and other curious ephemera. Many of the objects he depicts are broken—road signs, a birdhouse, a watchband. Entropy seems to be ruling the universe in these photographs, so much so that the world of the imagination displayed in the drawings seems much more felicitous.

Unlike most photographers who seek to present themselves as artists, Cumming does not endeavor to be formally innovative in these pictures. His interest, certainly, is with the objects they describe; to the extent that when he adopts a style it is a transparent one, one that pretends to invisibility. Occasionally, though, he takes pains to remind his viewers that they are looking at a picture, not at the thing itself, as when he includes an out-of-focus cat in a foreground corner of the tricycle picture. This device seems similar to that used in his earlier staged photographs, in which, for example, he would include his light sources within the frame, much like a magician revealing a sleight of hand. What unites all of Cumming's work, it seems, is this purposeful blurring of the distinction between what is illusory and what is real. As a result, in any confrontation with his pictures we are likely to get the feeling that we have lost our bearings.

This condition of conflation is characteristic of the current art we call postmodernist (and of the poststructuralist thought that dominates contemporary criticism); however, it also is characteristic of other kinds of art. Cumming's work is directly related to the conceptual and narrative art modes of the 1970s, of course; more significantly, it seems related to the surrealism of the 1920s and 1930s. Cumming's commitment to displacing the familiar, his emphasis on the disjunction between the appearance of an object and its function, the distortions of scale, time, and situation he introduces and, lately, his affection for the found object all are evocative of surrealist aesthetics. It is possible while perusing Cumming's pictures to think of René Magritte's painting of a train steaming out

of a fireplace, or of Salvador Dali's melting watch. Susan Sontag has called photography "the only art natively Surreal,"[7] but the surrealism in Cumming's photographs is doubled by the artist's interventions.

I do not mean to suggest by this comparison that Cumming attempts to recapitulate surrealism in the way that architects are recapitulating neoclassicism, painters expressionism, and fashion designers the styles of every decade of this century. Photographers who have tried to imitate the effects of surrealist painting are generally a dour lot, their pictures infected with an all-too-high seriousness, whereas Cumming is a cosmic comedian. If anything, he satirizes surrealism (especially in the drawings and in the staged photographs) by including the evidence of his hand within his conceits, thereby diffusing their potential for making us shiver.

What I do mean to suggest is that for all the postmodernist attributes Cumming's work possesses, it does not necessarily represent the radical art-historical rupture that postmodernist critics seem to require. This in turn suggests that there is something problematic about the perception of postmodernism as antimodernist. After all, the surrealists, too, believed that they were making a clean break with the art-historical past.

A review of Cumming's exhibition at Castelli Graphics, New York, in the spring of 1982, published in the *New York Times,* May 30, 1982.

Jan Groover

CONSCIOUSNESS AS CONTENT

JAN GROOVER'S ARTISTIC CAREER has been a barometer of the fortunes of photography within the art world of recent times. In the mid-1970s her poetically condensed, visually syncopated triptychs of truck traffic and suburban houses caught just the right note of seriousness when photography was itself beginning to be taken seriously in art precincts. In 1978 an exhibition of her dramatic color still-life photographs, taken in her kitchen sink, caused a sensation; when one appeared on the cover of *Artforum* magazine, it was a clear signal that photography had arrived in the art world—complete with a marketplace to support it. Her still-life photographs looked smashing on the wall, and their voluptuous colors were as impressive as their prices.

When the photography "boom" turned to something like bust at the start of the 1980s, Groover seemingly dropped from the art-world horizon. In a self-willed retreat from trendiness and visibility, she embarked on a period in which she recapitulated most of photographic modernism's styles and much of its subject matter, substituting the restricted hues of old-fashioned platinum/palladium printing for her earlier wealth of color. She made landscapes, portraits, pictures of knees and elbows, and still more still lifes, but this profusion of subjects seemed to indicate a lack of direction, a frustration with her own momentum. At the time of her 1983 retrospective at the Neuberger Museum in Purchase, New York, it was unclear where her image making was leading.

Groover has stayed on her own track, however, a message that her 1987 retrospective exhibition at the Museum of Modern Art conveyed convincingly. The retrospective's account of the progress of her career was virtually identical to that given by the Neuberger exhibition, but the sense of accomplishment and successful risk-taking extended through the black-and-white pictures. Working primarily with insignificant objects arrayed on a tabletop in her studio, Groover now is able to fashion breathtaking images from what appears to be little more than thin air.

More than any other photographer I can think of, Groover imbues her work with a knowledge of the history of photography. Besides using a view camera

and printing with turn-of-the-century materials, she liberally "quotes" from the work of Alfred Stieglitz, Edward Steichen, and other first-generation modernist photographers. But her penchant for pastiche, and her awareness of aesthetic issues regarding representation, extends equally to painting and sculpture. Her earliest pictures, the triptychs, use a systematic approach typical of conceptual art to render visible interrelations of time and space. The color still lifes not only draw from the cubism of Picasso and Braque but also reflect ironically on contemporaneous "Pattern and Decoration" painting. The black-and-white images shown at the Modern shuffle surrealism with traditional *nature morte* painting. In their investigatory spirit, however, these latest works most recall the still lifes of Cézanne.

As with the work of Cézanne, as well as David Salle, Groover's pictures are interesting not so much for the things they show us as for how they show us those things. Depiction, in short, is the name of the game. The critic Alan Trachtenberg has noted the artist's insistence that "a photograph must be understood as representing no more than its own activity."[8] This is a position the Museum of Modern Art's photography department understands and endorses, and Susan Kismaric, the exhibition's curator, has done an estimable job in revealing how Groover has consistently put theory into practice.[9]

But can photographs truly dispense with the world of material things— "content," if you will—to concentrate solely on matters of form? Groover is not the first photographer to raise the issue; the very modernists from whose photographs she draws inspiration were leaders in the attempt to sunder photography from its conventional materialist base. But where Stieglitz, Strand, and Weston fought their battles on the ground of abstraction, photographing clouds and shadows and sand as metaphors for human existence, Groover stakes her claim squarely within the world of objects. The knives, fruit, plants, cooking molds, and *objets trouvés* we see in her photographs are at once there and not there; they are represented clearly enough, but in a way that empties them of their functional meanings. As Kismaric says in the catalog to the show, "The drama in Groover's pictures arises from the tension between the form of the picture and the things we know to exist in the world."[10]

But if the main tension in Groover's work is between form and content, as Kismaric argues, it is not the only one. As I already have suggested, the historical and the contemporary also do battle in Groover's pictures, and in this sense the work is "about" something more than their own construction. This is especially clear in Groover's suite of images of Greek statuary, done for an artist's book titled *Greeks,* a collaboration with Bruce Boice and Ann Lauterbach. Like Boice's prose and Lauterbach's poetry, the pictures mix past and present— they were taken at the Metropolitan Museum of Art in New York, not in Greece. The result is too elegiac to qualify as postmodernism.

23. Jan Groover, Untitled, 1983

Another tension in the work pits order against its opposite, chaos. This is especially clear in the black-and-white tabletop pictures, where the line between compositional intention and mere accident is honed sharper than any of the kitchen knives Groover is fond of photographing. In a 1985 print, the black rectangle of the image is dotted with such disparate items as a cake tin, a butcher's knife, a vase of small flowers, tin funnels, a mushroom, a spoon—and, in the midst of it all, a sleeping cat. The cat—what Roland Barthes would call the photograph's *punctum,* or point of surprise—at once unites the disparate agglomeration of objects and, by being "real," renders the rest of the image unreal. Being asleep, it mimics the *memento mori* of the traditional still life and at the same time suggests that the picture itself is a dream.

The dreamy quality of Groover's recent work perhaps accounts for the aura of immateriality that pervaded the show as a whole; it lets us for a minute forget that her pictures are drawn from observable and unruly reality. We also are able to forget unruly reality itself. As long as we are in the pictures' grasp, Groover's quest to make form independent and sufficient succeeds. Her pictures may seem insubstantial, but her artistry is not.

New York Times, March 15, 1987.

The Photograph as Art Object

IT IS NO LONGER ENOUGH for a photograph to be a picture of something. For a photograph to succeed in the art world, all the signs now suggest, it needs to be an object. And the more elaborate the better.

Robert Mapplethorpe's 1987 photographs are a case in point. Printed on linen cloth using the archaic platinum process, they are mounted on stretchers, like paintings, and float within frames of thick black wood. More often than not they are flanked by a panel (sometimes two) of understated but luxurious fabric. The resulting diptychs and triptychs recall minimalist painting more than anything else.

And what are the images set off by this treatment? For Mapplethorpe, who first earned his reputation with shocking subject matter, they are relatively mild: faces, flowers, muscular torsos and a bust of Mercury, the messenger of the gods. All are bathed in the gorgeous light characteristic of the photographer's best work. A few of the torsos may be "PG" fare, but none seem calculated to set the teeth on edge. If anything, Mapplethorpe's longterm devotion to the classical ideal emerges with a new and surprisingly Platonic clarity. His desire for refinement is so fiercely reductive that the subjects seem disembodied and ethereal. Classicizing style and minimalist presentation mate perfectly.

Mapplethorpe is by no means alone in striving to enhance the physical presence of his photographs. The Starn twins were represented in the 1987 Whitney Biennial with a floor-to-ceiling installation consisting of purposefully creased, stained, and otherwise battered prints, which were casually stapled to the walls. In most cases the Starns used several prints to make up a single image, in the manner of a cubist collage. This is how they have fashioned one of their most striking images—a life-sized, stretched-out Christ figure that lies horizontally in a vitrine. Insouciant if not outrageous, the work harks back to F. Holland Day's turn-of-the-century series of Christ's Passion, in which the photographer himself assumed the leading role.

The resuscitation of religious imagery is perhaps as much a trend as the photographic object. The most bizarre photographic image of recent years has to be Joel-Peter Witkin's photo sculpture of the Crucifixion, again with a Christ

24. Annette Lemieux, *Broken Parts,* 1989

figure of life-size proportions. The sculpture consists of a large wood cross, at the tips of which are mounted examples of Witkin's customarily freakish photographs. On the cross itself is the three-dimensional figure of a man, formed from hundreds of tiny contact prints of the man's body, which were printed onto foil and overlapped to create a continuous image.

It is unlikely that the appearance of images of Christ in the work of Witkin and the Starn twins was intended simply to coincide with the Easter season. A better explanation, given the penchant of these photographers for expressionist gesture and Romantic excess, is that the figure of Christ is meant as a symbol for the artist, in the traditional sense of a personage who is misunderstood and even tormented for possessing a profound, sensitive vision of human life.

The urge to romanticize the artist and the urge to make photographs look like painting and sculpture are merely two aspects of a single enterprise, which is to reassert the notion that the artist/photographer is an independent, self-sustaining creative force who works outside the restraints of society. This is a view that also seeks to restore the authority of photographs as autonomous, original creations. In short, the mission of works such as these would seem to be to contradict the lessons of postmodernism, which holds that all artists and all works of art are beholden to their historical conditions. Since the 1980s began, the art of photography has been under the spell of this postmodernist ideology, resulting in a spate of images acutely self-conscious of their cultural indebtedness and explicitly critical of photography's place in the formation of cultural symbols.

Now, perhaps, as the decade grinds to a close, the tide is turning, and photographers are seeking to return to the very "myths" so stridently decried by the postmoderns. It is not just in photography that these signs are appearing. The 1987 Whitney Biennial as a whole suggested that painters and sculptors, as well as photographers, have been turning to more psychological and idiosyncratic modes of working, forgetting—if only for a moment—the intrusions of the mass media on their cerebral cortexes.

At the same time, however, the urge to make photographs into objects of considerable physical presence is not limited to artists like Mapplethorpe, Witkin and the Starns, whose work seems intent on revitalizing tradition. The New York downtown scene is rife with exhibitions in which photographs are both object-oriented and antitraditional, witness the recent work of Annette Lemieux, Sarah Charlesworth, and Cindy Sherman. Their imagery concerns cultural myth, as conveyed by media-oriented photography, but their pictures are presented with a high-tech gloss and sheen. Here, too, the sculptural impact of minimalism is felt.

Barbara Kruger's recent montaged images have the same traits. Formed of fragments of found images and bannerlike pronouncements ("I shop therefore I am"), they rise more than ten feet tall. They re-use pictures published in

magazines and the like, reminding us of the impingements of advertising and mass media generally, but at the same time they impress us as objects designed to fill both the room and the eyes.

Ultimately, then, the trend toward making photographs into something other than flat pieces of paper is not so much evidence of a postmodernist backlash as it is an expression of dissatisfaction with the limitations of the conventional means of photographic display—its two-dimensionality. In part this dissatisfaction stems from a need to compete for attention with paintings and sculpture, and in part it comes from an urge to trespass beyond the strictures of the medium's veristic, documentary traditions.

New York Times, May 2, 1987.

Robert Mapplethorpe

THE SUBJECT IS STYLE

THERE IS A WIDESPREAD BELIEF that style is replacing substance in
contemporary life. This attitude is not simply rampant among fundamentalists
and philistines; it also can be found in the rather sophisticated precincts of the
art world. Indeed, some visual artists, reacting to the way style has become a
kind of trademark guaranteeing one's success in the art marketplace, have made
style the very subject of their art.

If style and its permutations, fashionability and taste, are major topics of the
art of the late 1980s, then Robert Mapplethorpe is perhaps the most topical
artist of the times. Less than twenty years since he first decided to make art
with a camera, his elegant but often provocative photographs are being heralded
as exemplars of the new stylish sensibility.

Most of Mapplethorpe's work is in the form of photographs, but in some
cases—a 1987 portrait of Andy Warhol, funereally framed in the shape of a
cross, for example—the photographs are bit players in a more complex
sculptural installation. This is especially true of his earliest works, which are
sculptural treatments of Polaroids and found photographic imagery. These are
often self-referential in the way they make a fuss about their frames. Pop art
is a major influence, and there are echoes of the kind of constructions Lucas
Samaras once made. But mostly they serve to anticipate Mapplethorpe's
subsequent preoccupation, once he became committed to photography in
1973–74, with presentation and framing. His 1987 pictures on sensitized
linen, flanked by panels of silk and other luxe fabrics and framed with
expensive woods, are simply Hollywood versions of the early low-budget
productions.

But Mapplethorpe's work first came to public attention, and gained consid-
erable notoriety, in the second half of the 1970s. It did so not on the basis of
its presentation, but because of its sensational subject matter. Like scores of
photographers before him—Lewis Hine, Brassaï, Weegee—Mapplethorpe chose
to depict a subculture seldom photographed before, or at least seldom seen
in the contexts of fine-art photography. In his case, the subculture is a sado-

masochistic, male homosexual one. While his compulsive, unabashed and carefully staged chronicle of this particularly strident variety of homo-eroticism. may not be everyone's cup of tea, it has proven irresistibly fascinating to much of the art world.

These pictures represent only the beginnings of the artist's mature career, however. Since the late 1970s he also has become known for his elegant portraits of cultural celebrities and of friends, and for portraitlike images of flowers. Curiously, this less explicitly eroticized work has proven equally fascinating—perhaps because, in all of Mapplethorpe's pictures, the act of looking (and, by implication, the act of photographing) is akin to being seduced.

Partly we are seduced by the surfaces of his prints, which revel in the infinitesimal gradations of blacks and of whites that photography is capable of producing. Partly we are seduced by the way he presents his subjects, as idealized as any classical sculpture, if a touch more ethereal. The conjunction of perfect technique and perfect form gives his photography a rarefied beauty that would seem anachronistic, were it not for its obvious contemporary appeal.

Seeing how he manages to apply this rarefied beauty to *outré,* outlaw subject matter, as well as to conventional portraits and still lifes, goes a long way toward explaining why his work provokes such avid curiosity. The major source of the public's curiosity, however, may lie in the extremes of response to Mapplethorpe's art. Roundly condemned ten years ago as unsuitable viewing for adults, much less children, it has since been admired, collected, and valorized by Susan Sontag, Holly Solomon, the late Sam Wagstaff, and other influential cultural figures.

Taking the work as a whole, however, it proves difficult to place a label on Mapplethorpe and have it stick. Throughout his career, he has concentrated on not one subject but several, photographing male and female nudes, flowers, and faces (including his own) almost simultaneously. He even has photographed a U.S. Navy battleship, and a bunch of grapes. Determining what unites the diverse arenas of his attention is no simple task.

There are three essays in *Robert Mapplethorpe,*[11] a book that served as a catalog for Mapplethorpe's 1988 retrospective exhibition at the Whitney Museum of American Art, and they offer three different versions of Mapplethorpe's "vision." In his contribution, Whitney curator Richard Marshall suggests that it is the combination of "abstract, formal considerations" and idealized beauty that gives Mapplethorpe's photographs their charge. Ingrid Sischy, the former editor of *Artforum*, argues that his pictures "gut clichés" and "transgress borders"—in effect, that they dismantle the conventional while creating new openings for previously "renegade" subject matter.

25. Robert Mapplethorpe, *Thomas & Dovanna*, 1986

Poet and translator Richard Howard perhaps comes closest to enveloping the work's diversity when he speaks of the pictures as "emblems of contested mortality." Arguing that "flowers are the sexual organs of plants," he sees them, together with the faces and figure studies, as part of a single continuum balanced between the forces of uplift and gravity. (Or, one might say, between eros and thanatos.) Hence the focus on male genitals, flower stamens, and, in the portraits, on intense physical beauty.

One could argue, of course, that all great photographs create a sense of timeless perfection, one which we as human beings can comprehend only temporally. They have that poignant sense of "having been there" that Roland Barthes remarks on in his book *Camera Lucida*. But in Mapplethorpe's photographs, the poignancy of this apprehension of Man's mortality is especially vivid, since it is so at odds with the physical perfection the photographer courts.

At the same time, however, one cannot dispute Sischy's observations on the disruptive power of Mapplethorpe's work. While not precisely postmodernist, his pictures do serve to rupture the conventions of polite aesthetic discourse (even though some, including Marshall, can manage to talk about pictures of men bound in leather and chains in purely formalist terms). What is contested in his homoerotic images is not just mortality, but conventional morality.

"Mapplethorpe's meat and potatoes come from the subjects that have been forced by our culture to be hidden like secrets," Sischy writes, applauding the candor of his most unsettling pictures. Moreover, she believes his photographs have a heightened relevancy now, in the time of AIDS, when "any image of sex, especially of male homosexual sex, filters into the culture through the screen of death."

But one can admire candor without necessarily subscribing to all its consequences. In Mapplethorpe's case, one consequence is the virtual elimination of distinctions. This is true not only of relatively harmless ones, such as the distinction between photography and sculpture, or between the genres of portraiture and still life, but also of those that are crucial to any understanding of our culture. For example, the mix in Mapplethorpe's portrait pantheon of well-known celebrities (Richard Gere, Paloma Picasso) with individuals drawn from the male gay subculture obscures the fact that the dominant culture, which supports the notion of celebrity, functions in a way that marginalizes such subcultures.

Because Mapplethorpe's photography fails to make distinctions—he seems willing to turn anything into an idealized icon—one could also argue that it has no center, no moral gravity that would lend the pictures weight. This, ultimately, is why his images seem to be about style rather than substance.

For Mapplethorpe, however, style and substance are not opposites but components of each other. His work reveals that style has its own substance—one that says that beauty is essentially the same as art, that appearances are tantamount to knowledge, that the world is comprehensible through the mediation of taste but not by the imposition of moral values. This is the real and quite remarkable message of his pictures, and it makes them central to the issues of our times.

New York Times, July 31, 1988. This was published before Mapplethorpe's death and before a second retrospective, organized by the Philadelphia Institute of Contemporary Art, came to the attention of Senator Jesse Helms. Since then, the subject of Mapplethorpe's art has become politicized in the most primitive sense.

Now Starring the Starn Twins

TO SOMEONE OUTSIDE THE ORBIT of Soho, reputations in contemporary art can seem based as much on manipulation as on merit. There is a widely held but seldom-voiced suspicion that a cabal of New York dealers, curators, and critics periodically conspires to put certain names on the artistic map regardless of the ultimate merit of the work involved. Even within the contemporary scene, one can find skeptics who believe that the "hot" artists of any given moment are merely a creation of the marketplace, propelled to public attention by that calculated, artificial, and blatant form of stimulation known as hype.

Not surprisingly, the whispers about hype surface most often when the artist involved is relatively young. When a young artist's work is embraced by a powerful dealer, the whispers suddenly become audible. And when two or more dealers arrange to present concurrent exhibitions, the noise amounts to a din. In the fall of 1988, there were two artists at the center of precisely this kind of pandemonium: Mike and Doug Starn.

With simultaneous shows at the Stux and Leo Castelli galleries in New York, the Starns, who are identical twins, have become art-world phenomena. Their joint career began to take off when the Stux Gallery, then based in Boston, started to show their fractured, multipart photographic images in 1985—the same year the twins left art school.

In the first eight months of 1988, the Starns' work was featured in one-man shows at the Museum of Contemporary Art in Chicago, the Wadsworth Atheneum in Hartford, and the San Francisco Museum of Modern Art. One of their images could be seen in London, where it is part of the trend-setting Saatchi Collection. During the same period the gallery sold a work called *Double Mona Lisa with Self Portrait* for a reported $50,000. And readers of *Vogue* could find a portrait of the artists in their September 1988 issue, where the Starns (and several other artists) revealed what clothes they like to wear to openings. Were it not for the obvious vigor, ambition, and virtuosity of their work, one might wonder whether the forces of hype had triumphed at last.

26. Doug and Mike Starn, *Double Rembrandt with Steps*, 1987–88

The Starns are true prodigies. They began making photographs together when they were thirteen, and throughout their art-school years they collaborated on experiments in stitching, pasting, and dry mounting separate sheets of photographic paper to form one continuous image. In 1985, the year they left school and began to exhibit their work, they discovered the practical and aesthetic qualities of transparent tape, which they now use to join the fifty or more separate segments that go to make up one of their images.

They are also hardworking, professing to spend as many as seven days a week together in the studio. Because of their diligence and high energy, their output is remarkable. At Castelli, they showed seven large pieces and an installation consisting of forty single images; at Stux, the count was nine large pieces and a score of smaller works. Almost all of them were dated 1988.

Such rampant production is possible because the Starns' work is not so much finished as cobbled together into permanently fixed positions. This is true of the photographs, which are stained, folded, and overlapped, and also of their frames, which are hand-made by the artists from rough lumber. Even the plexiglass covering the framed pieces has been fashioned into a form of self-consciousness; sometimes it is cut in two, and it often is glued by the artists directly to the surface of the picture, via wooden spacer blocks. Overall, the pictures give the appearance of an overeager rush to get on to the next piece.

However, the Starns' approach to image making is also capable of producing pictures of a considerable (and surprising) sublimity. *Double Rembrandt with Steps,* a nine-foot square work of 1988, is one example of how they can transform their materials. Framed in wood and plexiglass, and combining paper photographs with translucent ones on film, *Double Rembrandt* depicts a Rembrandt portrait of a man as if it were a playing card, with the face appearing both upright and flipped upside down. Surrounding this image are what look to be rays, as if they emanated from the man, although in actuality they are images of stone stairs.

Like much of the Starns' work, *Double Rembrandt* is done on the scale of contemporary painting, and it makes asides to painting by appropriating images from the canon of art history. (The Starns photograph the paintings during their frequent visits to museums, or they "rephotograph" them from reproductions.) The piece also refers to architecture, and it uses photography as the glue that simultaneously fixes and dissolves the distinctions between the three mediums. Their replication of the Rembrandt figure in *Double Rembrandt* is in one sense a postmodernist aside, but it is at least as important as an icon of twinship, an aesthetic identity that the Starns have not merely reproduced, but doubled.

Other pieces seem more concerned with the state of the world. *Copley's Watson with Blue,* based on John Singleton Copley's painting of a shark attack, conveys a sense of terror even though it omits the shark in favor of sheets of

blue-toned photo paper that lack any discernible image. *Film Seascape with Woman* picks up the watery subtext, while *Film Tunnel with Man* suggests the kind of Stygian space found in underground parking garages. *Crucifixion* continues the Starns' fascination with the figure of Christ, using five columns of unframed photographs, plus pushpins, wire, and ribbons, to depict its subject.

The growing dimensionality and sculptural quality of the Starns' pictures is made explicit in a forty-photograph series called "Lack of Compassion." In the aggregate, the images depict individuals who were killed or persecuted because of who they were or what they believed. Some of the figures are readily identifiable (the Kennedys, Anne Frank, Gandhi) while others represent peoples or races (a gypsy boy, a lynching victim, a Brazilian Indian). Such a pantheon cannot help but seem sentimentalized, but the way the images are presented—glued to unstained, 2-by-8-inch boards eight feet high, which lean against the wall—gives them a somber weight. The feeling is akin to being in a cemetery where Man's best intentions have been buried.

Taken together, these two exhibitions were a tour de force of formal, technical, and material virtuosity, which is something of a problem. The Starns seem able to stretch art in any direction they desire, to leap the divisions between neo-expressionism and postmodernism with a single bound, and to collapse any and all distinctions between painting, sculpture, and photography. But without a clear focus to their activity, their facility can come to seem facile. They are not alone in this regard—Robert Rauschenberg comes to mind—and not every piece is guilty of seeming arbitrary. Their art may deepen as it matures.

This leads to another, more central issue raised by the work, which is the degree to which it lacks a critical point of view. Looking at it, one can almost forget the theoretical infighting of neo-geo, simulation, and other forms of contemporary art that seek to relate aesthetic practice to cultural reality. Even the "Lack of Compassion" series, which represents the Starns' most concentrated foray into social commentary to date, seems oddly disconnected from the so-called political art of our day. Is the work intended as an antidote to "critical art," as a reassertion of the primacy of self-expression? Is its main focus the breaking of boundaries between photography and art? Is it, in its use of segmentation and appropriated paintings, seeking to critique the very act of representation? These are questions the Starns' work raises but, as yet, does not answer.

To ask whether it is hype is another question, and one that is ultimately less interesting. Hype is finally a measure of the disparity between the attention given to an artist and the quality of his or her art. Judged by this standard, the fuss made over the Starns is as warranted as that made over a great many other

artists who have been acclaimed early in their careers, from Frank Stella to Cindy Sherman. The acid test for the Starns—as it has been for Stella and Sherman—is whether they can keep getting better. If they can, then all the attention they are receiving now will seem not only prescient, but also well deserved.

New York Times, October 2, 1988.

The Representation of Abstraction/
The Abstraction of Representation

THROUGHOUT ITS 150-YEAR HISTORY, photography has been allied
with representation of a particular sort. The camera's issue has been over-
whelmingly descriptive and detailed, to the point of being overdetermined.
Photographs not only depict people, places, and possessions, they seem to do
so with a flawless fidelity. As a result, they are thought to provide more reliable
evidence and contain more factual truth than paintings, drawings, and other
forms of image making. One might say that the medium of photography has
come to represent representation, not only to the art world but to all of
Western culture.

It is only a slight oversimplification to say that the development of abstraction
in painting is predicated on photography's interruption of painting's narrative,
depictive tradition. Whether the painter Paul Delaroche, on hearing of photogra-
phy's invention, said, "From today, painting is dead"—a wonderful line, even if
apocryphal—we have been taught that painting survived by finding new tasks
for itself. These tasks have been understood in a fundamentally modernist
context: as the elucidation of the boundary between surface and volume, as the
freeing of paint from line, as the discovery of essential forms that lie behind
everyday reality. Such tasks are generally understood to be the motivating drives
of twentieth-century abstract painting, but behind them lies the weight of
thousands, even millions of photographs.

There is another sense in which photography has been allied with representa-
tion and painting with abstraction in this century. Photography, the progeny of
progressivism and the Industrial Revolution, represents a rational, materialistic
practice, while painting, with its atavistic, cave-dweller roots, represents the
possibility of transcendence and the survival of the spirit. This alignment remains
true today: photography is associated with a broad range of critical, conceptual
art practices, including those called postmodernist, while painting remains
associated in many minds with emotional immediacy and self-expression.

Thus the appearance of a strain of abstractionist photography in the late
1980s—of camera images that are purposefully nondescriptive, nonfigurative

27. Adam Fuss, Untitled, 1990

and, at first glance, nonrepresentational—seems to fly into the face of the modernist conception of art history. These camera abstractions, which invoke imaginative and associative responses, also do not seem to fit into the rubric of modernist photography history, which assumes that photography's role is to describe things in all their infinite detail and tonality. Detail, and all the other conventional attributes of so-called fine-art photography derived from modernist ideas about "the photographic," have been jettisoned by a young and ambitious new generation of camera image-makers.

Photography's current flirtation with abstraction is not unprecedented, however. Embedded within the modernist practice of photography are not one but two traditions of abstractionist practice and theory, which together are responsible for much of the photography that was admired as art in the forty years between 1920 and 1960. On one shore we have the insistent purism of Alfred Stieglitz, who asserted that photographs, to be art, must reach the plane of metaphor even while adhering to strict ideas about photographic appearances. On the other shore we have the example of European photography as practiced in the 1920s and 1930s in Germany at the Bauhaus, in France by the surrealists, and in the Soviet Union by the constructivists. To make a complex story simple, artists such as Alexander Rodchenko, László Moholy-Nagy, and Man Ray treated photography as an experimental probe, using it to refashion optical experience in thoroughly "modern" terms.

In retrospect, it seems obvious that these two traditions, which joined together in the United States after World War II, were inherently incompatible. But both pushed photography in the direction of abstraction. Stieglitz, in what is commonly considered his most radical act, took photographs of clouds that he titled "Equivalents." These unearthly, dematerialized images represent the same kind of yearning for spiritual enlightenment (they are literally "heavenly") one finds later in the paintings of Mark Rothko and the other abstract expressionists; their only problem as great art is that they are small and monochromatic.

For Moholy and Man Ray, who independently began exposing sensitized photographic paper directly to light in the early 1920s, the tenebrous shapes recorded by their photograms and Rayographs were not so much records of spiritual encounters as records of the performance of light (and, in Man Ray's case, the workings of the subconscious mind). Moholy's claims for his photography were primarily formal and political. Like Rodchenko, whose influence he surely felt, Moholy conceived of his images as capable of restructuring human perception. The apparently "abstracted" bird's-eye and worm's-eye perspectives used almost reflexively in constructivist and Bauhaus photographs of the 1920s supply further evidence of this belief in the power of the camera to revamp society by making it "see" in new ways. That the camera was a machine, and therefore putatively objective, only enhanced its appeal.

28. James Welling, Untitled, 1981

In the postwar years, an expressive, formally based abstractionist style became the dominant mode of fine-art photography. Conflating the metaphoric qualities of Stieglitz with the experimental, aleatory tradition of Moholy, photographers such as Minor White, Aaron Siskind, Harry Callahan, Gyorgy Kepes, and Henry Holmes Smith created images in which the real-world contexts or referents were eliminated, disguised, or dissipated. Their images, by being simultaneously of the world and apart from it, seemed to exemplify photography's aspirations as a form of art. The art world took them seriously; in 1951 the Museum of Modern Art mounted an exhibition with the title *Abstraction in Photography*. The 103-print show included work by Ansel Adams and Walker Evans, among many others.

Today, of course, these attempts at creating an abstract photography—as well as the parallel paths of abstraction in painting and sculpture—wear only the shredded rags of their original convictions. In photography, one could date this unraveling to 1953, when *Life* ran a photo essay by Ernst Haas consisting of color "abstractions" of New York City as seen reflected in puddles, shop windows, and other surfaces. This popularization of abstract expressionist style in the tradition of the *objet trouvé* signaled the end of Stieglitz's "Equivalent" as a serious, rarefied concept. Appropriated by the mass media, it could no longer be taken seriously—any more than could Moholy's claim, brought to Chicago in 1937, that formal innovation could result in social betterment and reform. But the decline of abstraction's innocence is a much broader phenomenon, one which is linked to the growing pervasiveness of camera images in postwar society and the growing influence of the media in shaping that society's public and personal perceptions.

A number of artists born into this camera-happy, mediated society are today resurrecting the idea of photographic abstraction, but not in the name of self-expression or social reformation. Rather, they are largely bent on critiquing the practice of abstraction, on revealing it to be as culturally coded and conflicted as any other type of image. They understand abstraction as a style, not as a spiritual pursuit, which often gives their work an art-historical, déjà vu quality. Abstraction, no longer viewed as an innocent, edenic island apart from the conditions of history, the marketplace, and mass culture, is revealed to be yet another brand or model of cultural representation.

Thus it is no longer appropriate to speak of abstraction and representation, or of abstraction versus representation, but of a range of representational practices that includes abstraction, along with such culturally loaded styles as figurative realism, cartoonish stylization, and reified stereotype. No longer can we assume that an early Frank Stella stripe painting is categorically distinguishable from, say, designer Saul Bass's circular blue logo for AT&T. Today they both appear to us as stereotypes—which is to say they no longer represent themselves. Instead, they represent the uses of abstraction as containers for culture and as symbols of power and control.

In terms of photography, the conceptualization of abstraction as a form of representation produces some unsettling effects. In Allan McCollum's series "Perpetual Photo," for example, the apparently abstract array of each image is in fact a totally accurate representation of what appeared, framed as art, on television. McCollum simply photographed TV images in which domestic "art" appeared on the walls and then enlarged the background sections bounded by frames. The result is part commentary on the degraded quality of the images television presents (and, by extension, the inadequacies of popular culture) and part demonstration of how eagerly we as viewers seek to read abstraction as meaningful.

James Welling, in his pictures of aluminum foil, gelatin, and drapery, and Cindy Bernard, in her close-up pictures of Kool-Aid and of the linings of corporate billing envelopes, reprocess pictorial information of the most mundane sort to produce a level of simulated abstraction. In Welling's case, the goal seems always to be a deflation of abstraction's pretensions; at the same time that he evokes the metaphoric possibilities of the photographic image, he provokes us to recognize its material insignificance. Bernard's microscopic images of packaged food mixes are in the same vein, while her pictures of repetitive business logos point quite economically to the power relations of abstraction.

Welling and Bernard do not hesitate to re-present modernist modes of abstraction, even as they empty it of its claims to expressiveness and autonomy. Adam Fuss's color photograms go even further, actually replicating the methodology of Man Ray and Moholy using present-day materials. Fuss seems drawn to the innocent demeanor of early abstraction even as he shows it to be redundant. There is a tension in his nearly blank photograms, and throughout the work of late 1980s abstractionists, between a nostalgia for a prelapsarian modernist past and an awareness of how postmodern experience is subsumed by the overabundance and overdetermination of all images.

But if some artists note how abstraction tends toward stereotype, others show how stereotypes tend toward abstraction. That is the message of the work of Ellen Brooks, James Casebere, David Levinthal, Cindy Sherman, and Laurie Simmons, among others. By reducing depiction to its barest, most telling details, or by reproducing such depictions *in vitro,* these artists match steps with technology, which thanks to the computer and video is gradually reducing the definition of everyday life. Their focus—or lack of it—seems atuned to the hazy, suggestive quality of memory and, increasingly, perception itself.

To some minds, the tendency toward abstraction in recent art represents a reaction to the masses of information that saturate our culture. To others, it reflects the manner in which that very cultural information is itself becoming more abstract, and hence simplified, in an effort to grab and keep our attention. Undoubtedly both these ideas are at work in contemporary culture; artists, no

more than the rest of us, reflect and respond to them. What is paradoxical, however, is the extent to which photography has been enlisted as an agent in the questioning of abstraction's domain. This may be because photography, the most representational of visual media, is ultimately unable to become abstract. Instead, it serves to represent the *idea* of abstraction, which at the end of the twentieth century is all that really matters.

This is an abridged version of my catalog essay for the exhibition *Abstraction in Contemporary Photography*, organized by Jimmy DeSana for the Emerson Gallery of Hamilton College and the Anderson Gallery of Virginia Commonwealth University in 1988.

V. Documentary Dilemmas

AS PHOTOGRAPHY BECAME increasingly aestheticized in the 1980s—that is, as photographs of all sorts came under the spell of "museumization," to use Hilton Kramer's term—the disjunctions and disparities between artistic meaning and social meaning were exacerbated. At the same time, the increasing influence of television and other forms of electronic imagery has challenged some of the traditional cultural uses of the medium. These developments demanded that old assumptions about social-documentary photography and photojournalism had to be reexamined, not only by critics but also by their practitioners.

Recent art criticism directed at photography has benefited enormously from the theoretical understandings of representation forged by deconstructionists, feminists, and social activists. With the knowledge that no image, no matter how reportorial or well-intended, is without cultural inflection, critics and historians have been able to reveal many of the hidden codes and assumptions lurking behind photography's descriptive veneer. Photographers, meanwhile, have begun to use the same knowledge to create hybrid styles of imagery.

Terms like "new photojournalism" and "new documentary," if they mean anything, indicate the need to discover new ways of making photographs tell stories—new rhetorics, new forms, new presentational formats. Color, captions, collage, sequencing, rephotography—these are only a few of the strategies developed in response to the awareness of photographs as cultural messages and to the crisis in documentary practice that this awareness has provoked. The following essays attempt to demonstrate how photographs have been used rhetorically in the context of the mass media and examine the efforts that have been made to revive photojournalism in particular and documentary practices as a whole.

What Kind of Art is It?
Connoisseurs Versus Contextualists

THE FIELD OF PHOTOGRAPHY has never been one big happy family—to -
start with, it has never been that big—but increasingly it seems to consist of
two families, and feuding ones at that. The issue that both divides and frames
current photographic thinking is not (blessed relief) whether photography can
be considered an art, but what kind of an art it is. Is it an art like painting or
drawing, with the same aesthetic claims and standards, or is it art form unto
itself, so inextricably interconnected with social and political values that to call
it "art" in the conventional sense requires quotation marks?

The lines are drawn between those who think of photography as a relatively
new and largely virgin branch of art history, and those who rebel at the very
notion of photography being "aestheticized." The former welcome the medium's
elevation to the realm of the museum, the marketplace, and traditional art-histori-
cal scholarship, while the latter argue that photography's "museumization" robs
it of its real importance—that is, its social meanings. Never mind that one finds
the antagonists of photography's aesthetization performing essentially the same
tasks as its proponents, teaching art history, curating exhibitions, and writing
criticism; the split is real and the rhetoric is fierce.

For the sake of convenience we might call these two camps the connoisseurs
and the contextualists. The connoisseurs delight in the beauty of the original
print, seek to know its place in the oeuvre of its author, and appreciate its stylis-
tic niceties much as one might appreciate those of a painting. Curator Weston
Naef's 1982 show *Counterparts: Form and Emotion in Photographs* at the
Metropolitan Museum of Art is a classic example of this approach. The exhibi-
tion paired some of the medium's most revered images according to similarities
of subject matter and form, but without regard for their chronology, content, or
intended uses. For example, a 1937 Margaret Bourke-White picture of a Nazi
rally in Czechoslovakia was matched with Weegee's well-known 1945 image of
an endless Coney Island beach crowd. Both pictures depict masses of people, as
Naef pointed out, but one also has to notice—as Naef apparently did not—that
their intended meanings are radically different.

Another example of connoisseurship at work in the 1980s can be found in the spate of exhibitions and books devoted to paper-negative practice in the medium's early years. The art historians and curators responsible for this vogue in calotypes (the art-historically proper name for images made from paper negatives) have chosen to emphasize its stylistic distinctions. Art historian Eugenia Parry Janis, co-author of the book *The Art of French Calotype,* a collaboration with the collector André Jammes, makes no bones about her desire to have us see calotypes primarily as artistic objects. The early French calotypists, she says, "did more than exploit a process; they originated an art."[1] The art they originated, moreover, fits perfectly into her conception of the history of mid-nineteenth-century French painting, with its controversies over "line" and "color" and the infant style of realism.

This is exactly the sort of thing the contextualist camp hates to hear, and the reaction was not long in coming. In the summer issue of the magazine *Afterimage,* in an article called "Calotypomania," Abigail Solomon-Godeau called *The Art of French Calotype* "less a work of scholarship than a pedantic work of public relations, an elaborate gloss on the patrician sensibility of Jammes, and an upholstered exercise in photographic *gourmandise.*"[2] What apparently prompted Solomon-Godeau's savaging prose was her annoyance with any art-historical account that seeks merely to certify objects (in this case photographs) as art. "Janis's relentless pursuit of the aesthetic—at the expense of any other consideration of the uses, functions, and discourses of nineteenth-century photography—leads her inevitably into error as well as significant omission," she writes, later adding, "Aestheticism is an ideology, whatever fantasies art and photography historians may have about it."[3]

The contextualists have an ideology of their own, of course, which is fashionably called poststructuralism but which finds its roots, directly or indirectly, in Marx's conception of the world as totally politicized and purposefully mystified. The contextualist critics of photography—beside Solomon-Godeau, I would include Douglas Crimp, Rosalind Krauss, Sally Stein, Allan Sekula, and Carol Squiers, to name only a few—are devoted to a history of photography that includes its functioning and uses within the culture. On the whole they believe that our notion of originality in art is a myth, that "authorship" and "genius" are merely mystifications inflicted by ruling-class culture on the rest of us, and that, per Walter Benjamin (without Benjamin these critics would still be on the ground), photographs are important precisely because they evade the "aura" of the rare (and thus valuable) artwork.

To make this all clearer one has only to consult examples of contextualist criticism, such as Crimp's "The Museum's Old/The Library's New Subject,"[4] Sekula's "On the Invention of Photographic Meaning,"[5] or Stein's "Making Connections with the Camera," a quite cynical critique of Jacob Riis's motives

29. Lewis Hine, *Italian Immigrant, Eastside*, New York, ca. 1910

for making reformist photographs during the 1880s.[6] The contextualist approach has made inroads into the exhibition circuit as well, starting with the exhibitions Squiers mounted in the early 1980s at P.S. 1 in Long Island City. These shows frequently consisted of photographic reproductions torn from publications such as *Life* and the *New York Times*.

Although they conceive of themselves as underdogs, arrayed against the forces of the museum world, the art market, and the prevailing cultural climate, the contextualists seem of late to be flexing a great deal of muscle. Their influence apparently now extends even to traditionally minded curatorial enterprises, if the New York Public Library's 1983 exhibition of Lewis Hine photographs is any indication. Actually, I should not say "Lewis Hine photographs" in this instance, since although the images were unmistakably Hine's, the library insisted on the term "blow-ups" for these pictures.

And "blow-ups" is exactly what they were. While they were quite modest in terms of today's "big pictures," you can bet that Hine never imagined his prints at this scale. Hine, however, would have had considerable sympathy for the exhibition's intention, which was to convey a sense of the immigrant experience to a large and general public. (The show, called *Lewis W. Hine: Fellow Immigrants*, also included copies of immigrant newspapers and magazines, dating from the nineteenth century to today.) But in the name of vivifying what is indisputably a contextualist curatorial notion, the organizers felt moved to eliminate any trace of Hine's real production—that is, his own photographs.

A text accompanying the show explained the decision. It said that Hine's photographs embody both a "social message" and an "aesthetic sense"—an undeniable observation—and that moreover "the two elements in the photographs sometimes seem to work against one another" to the detriment of the social content. "To lessen this effect, the photographs have been enlarged and tinted in the hope that content rather than style will be the viewer's focus." Surely this must count as some of the most bizarre reasoning yet encountered in a photography exhibition.

One could begin taking issue by disputing the assumption that style in a picture is an antagonist of content. Doesn't our willingness to look at Hine's pictures of Ellis Island newcomers and child laborers depend first of all on style, inasmuch as it attracts our eyes to the subject matter? And what is it about Hine's style, which is as unobtrusive as any social documentarian's, that makes it so offensive to the causes of empathy and understanding—causes to which Hine was particularly devoted? The most important objection to be lodged, however, is that the work itself has been removed, replaced, shunted aside, and a coffee-colored surrogate put before us. Can this be a means of coming to grips with the social functioning of photographs? Can we better understand Hine's record of the immigrant experience in the early years of this century by distorting his imagery in this way?

Obviously neither the connoisseurs nor the contextualists enjoy a monopoly on intelligence, which in the final analysis is how we can judge their contributions. What is especially ironic about the Public Library's misguided effort to give Hine's work a context, though, is that the selfsame library was roundly chastized in Crimp's essay "The Museum's Old/The Library's New Subject" for adhering to the viewpoint of connoisseurship. Crimp objected to the recent establishment of a separate photography collection within the library, arguing that it had the effect of removing the pictures from their original contexts (what was once "Colorado" might become "William Henry Jackson," for example) and thus changing their meanings. The Hine exhibition was not mounted by the division that supervises the library's photography collection, but the feeling remains that here is a case of the pendulum swinging too far in the other direction.

Where will the debate between photographs-as-aesthetic-objects and photographs-as-social-instruments lead? If we follow the contextualist camp's own dialectical logic, it is the contextualists who will wither away. This is because photography, as a mode of cultural production, has been supplanted by more advanced technology—starting with motion pictures, and now electronic media. The degree to which photography is no longer our culture's primary means of imaging the world is the degree to which it is an artifact. Thus the adoption of the medium by museums, libraries, and art-history departments is not part of a late capitalist conspiracy aimed at blinding us to the real meaning of photographs, but merely a reflection of photography's devalued functional currency.

In practice, however, I suspect that the contextualist way of thinking will continue to exert a strong oppositional influence as long as the impulse remains to convert photography into an adjunct of painting, drawing, and sculpture. Photography's distinction has always been its connection to the world outside the imagination, and it traditionally has been practiced not in the artist's garret but on the streets or battlefields or mountaintops. A photograph traces something real, and it is the mission of the contextualists to open our ideas about art to accommodate this fact.

New York Times, August 14, 1983.

Decoding National Geographic

IT WOULD BE DIFFICULT TO OVERESTIMATE the impact that *National Geographic* magazine had on the formative years of someone raised in postwar America. From the perspective of small-town U.S.A., the wild animals, tribal cultures, and mountain vistas pictured on its pages seemed utterly foreign and completely fascinating. They were far off but, with the magazine nestled in my lap, they were also tantalizingly near. Together with the then-infant medium of television, *National Geographic* made the world shrink before my eyes.

I am not alone in having had my budding view of the world outside my ken shaped by what I saw in *National Geographic*. Since early in the century, the influence of its photography on Americans' perceptions of other places, peoples, and species has been enormous. The magazine currently has a circulation of more than 10 million copies a month. Not only has it reflected a quintessentially American view of the world throughout our century; it has also created and refined a persuasive and pervasive photographic aesthetic.

The pictorial genre known as "*National Geographic* photography" was the subject of the exhibition *Odyssey: The Art of Photography at National Geographic,* which was organized by the Corcoran Gallery of Art in Washington, D.C., as part of the National Geographic Society's celebration of its 100th anniversary, in 1988. It was an exhibition of considerable interest, not only for its wealth of nostalgic, curious, and sometimes astonishing pictures but also for what it told us about how the magazine's photographers and editors have chosen to represent their subject: "the world and all that is in it."

Selected from the magazine's archive of several hundred thousand pictures, the images in the show had an imposing diversity. There were portraits of haggard, glassy-eyed polar explorers, vignettes of African cats munching on their prey, close-ups of insects and fish, and brightly colored scenes of exotic customs and costumes. There was even an occasional portrait of the kind for which *National Geographic* was once slightly notorious: dark-skinned, bare-breasted women, in their customary dress, looking at the camera without any awareness of their impending status as spectacles for adolescent Western eyes.

30. *National Geographic*, Photographer unknown, first published in 1896

For many photographers today, as well as for many who simply look at pictures in magazines and books, the photographs found in *National Geographic* represent the apotheosis of the picturesque. That is, they embody many of the same conventions of color and form as *plein air* painting. They aim to please the eye, not to rattle it. As a result of their naturalism and apparent effortlessness, they have the capacity to lull us into believing that they are evidence of an impartial, uninflected point of view. Nothing could be further from the truth.

As a rule, *National Geographic* photography is the visual equivalent of what James Clifford, in *Writing Culture,* calls the "ethnographic pastoral" mode.[7] Like much of the writing found on the magazine's pages—and in the accounts of travelers generally—it tends to verge on the rhapsodic, depicting foreign lands and cultures as exotic and alluring. In some cases, non-Western peoples are portrayed as childlike, and animals are anthropomorphized shamelessly. A "portrait" of a star-nosed mole, taken by Lynwood M. Chace around 1930, is fairly typical of the latter failing; the mole is "posed" with its claws on a table, and its snout is lifted up as if it were a face.

Besides presenting our culture's attitudes and preconceptions as if they were universal, or even nonexistent, the photography of the *National Geographic* produces a pictorial iconography that tends to reduce experience to a simple, common denominator. Take, for example, a Luis Marden image of a gaily decorated oxcart, taken in Costa Rica and published in 1946. Marden was among the first and most insistent advocates of Kodachrome film, and this image seems designed to emphasize the colorful emulsion's most vivid qualities. Its primary hue is red, a color that rivets the eye. It describes the patterns of the painted cart accurately enough, but its main mission seems not so much to tell us something about life in Costa Rica than to fashion an artistic image emblematic of the faraway. That it appeared in a story titled "Land of the Painted Oxcarts" suggests how much the editorial content of the magazine was defined by pictorial values; the photographs, in effect, became the signifiers of Costa Rican culture.

Even as apparently innocent an image as David Doubilet's underwater photograph of a 400-pound "bump head wrasse"—a sea creature doubtlessly invented by Dr. Seuss—seems less involved in conveying information about its subject (one is left wondering what exactly a bump head wrasse might be) than in self-consciously fashioning itself to be experienced pictorially. Sam Abell's 1983 view of Red Square is much more explicit about this pictorial urge. The Moscow plaza is seen through the frame of a hotel window, at the bottom of which is a row of incongruous, colorful, and totally irrelevant lemons.

The tendency to subjugate the mission of gathering evidence to the demands of pictorial appeal becomes especially obvious in the pictures taken by the magazine's staff and freelance photographers within the past several years. But it is also an inevitable consequence of the *Geographic*'s modern definition of itself

as a magazine of mass appeal. The impetus for turning what had been a dry, scholarly nineteenth-century journal for geographers into a popular mass magazine came, curiously enough, from Alexander Graham Bell. Bell's son-in-law, Gilbert Grosvenor, was the editor responsible for transforming the *Geographic* into a popular, predominantly illustrated magazine. The great inventor urged Grosvenor to write stories to relate to photographs already in hand, instead of using pictures merely as post facto illustrations.

With this simple suggestion, the entire texture and tone of the magazine began to change. By 1908 more than half the magazine's pages were given over to photography, according to C. D. B. Bryan, whose book, *The National Geographic: 100 Years of Adventure and Discovery,*[8] represents the best history of the society and its magazine we have. Color—today the hallmark of *Geographic* photography—appeared slightly later, and flourished after the introduction of Kodachrome in the 1930s. By the 1950s, when Grosvenor retired, photography had become the *sine qua non* of the *National Geographic*.

The exhibition contained pictures from both the "old" *Geographic* and from its modern incarnation. Unfortunately, since the pictures were not arranged by date, and we were not given any clues as to how they were reproduced, there was no easy way of distinguishing what changes, if any, Grosvenor's editorial shift produced. (In addition, about half the images in the show were never published in the magazine.) Nevertheless, there is evidence to suggest that since Grosvenor's retirement little has changed in the *Geographic*'s conception of photography, which is why the show lacked both a sense of progression and a strong finish.

One is left wondering whether the show's curators intended this message, or any message at all. Rather than approach the *Geographic* archive as a resource that required decoding and contextualization, they apparently settled for connoisseurship. But picking pictures to hang on museum walls because they resemble pictures on museum walls does not illuminate an archive like that of *National Geographic*. For that, what is required is a critical point of view.

New York Times, September 18, 1988.

Oliver North, Fawn Hall, and the View of Life from Life

THE JANUARY 1988 ISSUE of *Life* magazine, devoted to "The Year in Pictures" for 1987, features a remarkable portrait of Lt. Col. Oliver North. Taken by the photojournalist Harry Benson, it shows the star of the Iran-Contra hearings in full dress uniform, standing at attention next to an American flag. The camera's position, roughly waist-high, causes him to loom larger than life. The background adds to the heroic, even mythic effect of the pose; its polished marble looks like a night sky during a thunderstorm. One could say that Lt. Col. North appears to be impersonating Charleton Heston impersonating Moses on the mountaintop.

This carefully lit and calculated image seems aimed at encapsulating the popular impression of Lt. Col. North as a kind of folk hero, and in this respect it succeeds quite well. But it is not by any stretch of the imagination a report on what went on during the congressional inquiry. For that we have to turn the page, where we can find a less rhetorical, and less interesting, news picture of Lt. Col. North being sworn in before a full house of Congressmen, aides, and—needless to say—press photographers.

The portrait and the news picture raise an important question: What kind of history do photographs make? Is the aggregate visual record they produce a fairly faithful, albeit condensed, reflection of the events and spirit of our times, a kind of Cliff's Notes for the future? Or is it something more ambiguous, selective, and slippery, the still equivalent of a television docudrama?

One would assume that photographs are more reliable representations of historical events than, say, cave drawings or hieroglyphics. Those alive 150 years ago certainly thought so, since the invention of photography ended the practice of history painting virtually overnight. Surely our image of the Napoleonic era would be more precise and accurate if we were to see it through the lens of a camera rather than through the embellishing eye of the painter Jacques-Louis David.

But the camera's status as a mechanical recording instrument does not mean that its images are necessarily any more innocent of bias than David's pigments. This is especially obvious today, when everyone from politicians to postmodernists is acutely aware of how media images can be fabricated to serve specific ends. In our century, the camera's ability to refashion the world is a given.

Still, it is significant that *Life*, which has long been considered the spiritual home of American photojournalism, should choose to use a plainly artificial, posed portrait of Lt. Col. North rather than one of the thousands of "head shots" taken in the course of his testimony. It suggests that a symbolic photograph can supersede in importance a picture that purports to represent an event as it happens. It suggests that photojournalism is as much artifice as actuality. It even suggests that in terms of representing history, photography is better at reproducing preconceptions than it is at revealing behind-the-scenes truths.

But there is a more profound lesson to be gleaned from *Life*'s "The Year in Pictures" issue, which is that photography lends credence to the belief that history is a matter of individuals and their actions. Those who believe otherwise— that economic, environmental, social, and other factors are the motivating forces of history—will look in vain for photographs to serve as evidence. Photography deals in appearances, although appearances are not everyone's idea of history.

What picture might illustrate the impact of the nuclear-arms reduction pact, which to many minds was the most significant event of 1987? An image of missile silos, or of the warheads themselves? The editors of *Life* have opted for a photograph of a smiling Gorbachev and a laughing Reagan, culled from the two leaders' recent summit. What picture might best sum up the contra insurrection in Nicaragua? *Life* tells the story with a shot of Nicaraguan President Daniel Ortega carrying a coffin. These are symbolic solutions to a real dilemma.

Photography seems eager to confirm Ralph Waldo Emerson's observation that "all history revolves itself very easily into the biography of a few stout and earnest persons." But photography's affinity for individuals is not necessarily bad. Consider Alon Reininger's harrowing photographs of AIDS patients in the same issue of *Life:* What better way to bring home the devastating toll of the disease than to particularize its victims?

There is a flip side to this, however. Events without human faces tend to be left out of the pictorial record. In reporting on the October stockmarket plunge, for example, *Life* resorts to drawings. At other times, faces take the place of the real problem. Fifty years ago the Farm Security Administration essayed to photograph the nation's agricultural crisis; what we remember best today is Dorothea Lange's poignant portrait of a migrant mother and her children, not Walker Evans's powerful but unpeopled images of the land itself.

The tendency of pictures to reduce history to personality frequently leads to the equation of celebrity with significance. In *Life*'s case, eight pages of the "Year in Pictures" issue are devoted to publicity portraits of Hollywood stars, including Bette Midler, Cher, and the male leads of television's "L.A. Law." These are not especially interesting photographs, much less pictures that help to explain the year just past.

31. Francesco Scavullo, *Fawn Hall,* 1989

The reverse can happen just as easily. *Life*'s issue closes with three curious, glamorized portraits of Fawn Hall, Jessica Hahn, and Donna Rice—in the editors' words, "the girls of summer." The three women have nothing in common except roles in the careers of prominent men, but on *Life*'s pages they are transformed from historical footnotes to full-fledged celebrities. In makeup and designer clothes, they literally become models of notoriety.

This is not to take anything away from the photographers involved, who have done their best to give *Life* and its readers memorable images. Francesco Scavullo's picture of Miss Hall, in particular, is a convincing simulacrum of a *Cosmopolitan*-style fashion photograph, and I doubt that Miss Hall has ever looked more dashing. But if we compare this image with an earlier, thumbnail-size portrait that shows her testifying before Congress, the gulf between image and reality seems to widen beneath our feet. (There is one more image of Miss Hall in the issue. She appears on the cover, lean and leggy in a mini-dress, in almost the same spot that the singer Whitney Houston, lean and leggy in a mini-dress, appeared on the cover of the 1986 version of the "Pictures" issue.)

One wonders: Is this the same *Life* magazine that gave us Robert Capa's D-Day photographs, W. Eugene Smith's "Country Doctor" and "Spanish Village" photo essays, and countless other classics of photojournalism? In a way, it isn't; the *Life* that nurtured the genre was a weekly, not the monthly we have now. But in another way it is, for if one looks back at the old weekly *Life* one will find it as full of calculated portraits and celebrity fluff as the current incarnation. Even Gene Smith, whose credo was "Let truth be the prejudice," took liberties with what was in front of his camera. Photojournalism has never subscribed to Joe Friday's notion of "Just the facts, ma'am," even though for some reason that is what we still expect of it.

New York Times, January 10, 1988.

The Foreign and the Fabulous

PHOTOGRAPHY IS LIKE LANGUAGE. It can be employed in the service of the sublime, the ridiculous, or the desultory; it can reveal truth or distort it. But, despite Edward Steichen's hortation that the goal of photography is to explain man to his fellow man, the fact is that photographs suggest much but explain very little.

Nicaragua by Susan Meiselas[9] and *Visions of China* by Marc Riboud,[10] photographic books that purport to document societies in a state of upheaval, are cases in point. *Visions of China* traces the People's Republic over twenty-three years; *Nicaragua* encompasses a much smaller time—thirteen months—but focuses on a much more visual event, armed combat. Both books, it should be said, contain a number of striking and admirable pictures. But what these pictures tell us about the transitions they attempt to decipher is naggingly incomplete—even compared to what can be learned in a sixty-second television news report. Worse, what they do manage to tell us about radical change tends toward the sentimental and heroicized.

If one needed visual confirmation of what Yeats meant by "a terrible beauty" being born of insurrection, *Nicaragua* supplies it in spades. Not since Vietnam and the original incarnation of *Life* magazine has there been war photography this graphic and drenching. Bodies are everywhere, blown to stumps, swollen in the sun, burning under a blanket of tires. The sights are not pleasant during any revolution, and the Sandinista-led popular uprising against Nicaragua's Somoza regime in 1978–79 was no exception. Susan Meiselas's color photographs, however, are often intensely beautiful. *Nicaragua* becomes haunting precisely because of the precarious balance between the beauty of its pictures and the horror of what they depict.

Meiselas's photographs also create the appearance of objectivity. She photographs mostly from an uninflected middle distance, eschewing close-up details and long views. Yet clearly the photographer is on the side of the insurrectionists; she even rides with them into Managua after Somoza's defeat. The dead, some of them children, are always victims of Somoza's National Guard, although presumably the rebels did a share of the killing. (Like Riboud, Meiselas is a member of Magnum, a photo agency that traditionally has taken a critical view of entrenched power and a sympathetic one of the downtrodden and oppressed.)

What is odd, then, is that by themselves the photographs are completely ambiguous. The book separates the pictures from their captions, which are lumped in the back. This has an unsettling consequence: looking at the photographs alone, it is impossible to tell who is fighting whom, or why. What are we to make of a photograph midway through the book that shows uniformed soldiers firing automatic rifles from behind a wall of sandbags? Has Meiselas switched her allegiance without telling us? The caption later explains that these well-equipped "soldiers" are indeed rebels; from another caption we learn that they have appropriated their materiel from a captured garrison. Such pictures suggest that without language, the meaning of a photograph is inherently ambiguous.

The ideology of *Visions of China* is more obvious but less well defined. Marc Riboud took photographs in the People's Republic for four months in 1957, and again in 1965, 1971, 1979, and 1980, so we might expect him to be a heavy-handed apologist for the powers that favored him with admission. This is not quite the case. Ironically, though, Riboud's pictures dote on evidence of the increasing materialization of China—television sets, tractors, sunglasses—as if these were markers of progress. Since more Chinese now wear Western clothes than before, Riboud seems to say, conditions have improved. The way in which these "improvements" are shown is often as blunt as a Mao poster. A 1965 picture of a peasant couple carrying a sow to market is paired with a 1979 photo of a stylish couple carrying a television set down a Peking boulevard.

Riboud's is not the first report from China (Eve Arnold, Inge Morath, and other photographers have weighed in with China books of their own), but because Riboud visited China over a wide span of years his book has a unique historical opportunity. Despite its title, it is no mere monograph testifying to Riboud's "vision." Rather, as Orville Schell's introduction suggests, it seeks to engage history while still paying homage to Riboud's poetic sense of black-and-white composition. The expectable result is compromise. Instead of being arranged in the order in which they were taken, the photographs are placed in sequences that often are visually superficial and glib. (Old men in traditional costumes on one page, young children reading comics on the next.) Likewise (and like *Nicaragua*), the explanations of what the pictures show are saved until the end. On the other hand, the quality of the photographs varies so widely—some equal Henri Cartier-Bresson's; others could have come from a tourist bureau—that obviously art had to make some concessions to political history.

Ultimately, *Visions of China* explains little more about modern China than any other China book available. Nor does *Nicaragua* explain the overthrow of Somoza. Partly this is the fault of the photographers, both of whom seem to rely unquestioningly on the familiar habits of photojournalism, and partly it is a result of the structure of their books. But the deeper problem lies with the kind

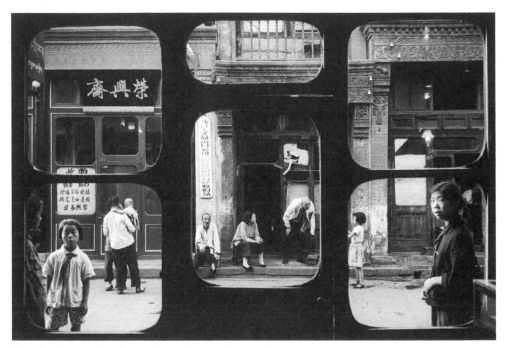

32. Marc Riboud, *The Antique Dealers Street,* 1965

of work photographs are asked to do in books of this sort, and with photo-journalism as a photographic genre. How is it that we expect an outsider—the ambulatory photojournalist, a glorified tourist—to deliver essential insights into a foreign culture? Too often style is all that the photographer brings to the subject—that, and preconceptions. Isn't it, after all, too much to ask for explanations when the photographer is only paying a visit?

New York Times Book Review, June 14, 1981. Since that time, despite the reservations expressed here, I have come to regard Meiselas's *Nicaragua* as a watershed in postmodern photojournalism or, as the next piece suggests, in New Photojournalism. It is one of the first books of combat photographs to use ambiguity as a rhetorical device. The same cannot be said, unfortunately, of *Visions of China.*

The "New Photojournalism" and the Old

FIFTEEN YEARS AFTER THE DEMISE of *Life* as a weekly magazine, photojournalism is reclaiming its former glamorous, legendary status. Pictures that were taken on assignments for magazines and newspapers now regularly reappear—in frames—on the walls of museums and galleries. The photojournalists of yesteryear are being enshrined in biographies and celebrated with retrospective exhibitions. Today's photojournalists are big draws on the photography lecture-and-symposium circuit. Meanwhile, college-level programs designed to produce the photojournalists of tomorrow are growing at a rapid rate.

The signs of photojournalism's new cachet extend to the book stores, where the patriotic anthology *A Day in the Life of America* climbed into the bestseller lists, and to the movies, where photojournalists have become the newest breed of Hollywood protagonist. In Oliver Stone's *Salvador,* James Woods plays the role with considerable panache and a sliver of accuracy; he is a dissolute, macho, reckless, and conniving Quixote. But when he sees government brutality against the peasantry, he is filled with moral indignation. Woods's photojournalist is the modern-day, male equivalent of the hooker with the heart of gold.

The resurgence of interest in photojournalism as a genre, and in photo-journalists as moral actors on the stage of world events, coincides with the development of a new breed of photojournalism itself—what is being called the New Photojournalism. This notion of newness has been the subject, explicitly or implicitly, of a number of recent exhibitions and accompanying symposia, from *On the Line: The New Color Photojournalism,* organized by the Walker Art Center in Minneapolis, to *Contact: Photojournalism since Vietnam,* which appeared at the ICP/Midtown Gallery in New York.

To some minds, what is new about the New Photojournalism is a matter of its style or, in the case of the show *On the Line,* its choice of film. Be that as it may, a fresh and experimental spirit now prevails in the genre, fueled by a

generation of photographers in their thirties and early forties who are dissatisfied with the conventions they inherited from such patron-saint figures as Robert Capa and W. Eugene Smith. They want their pictures to convey more complex and sophisticated meanings, of both a social and personal sort, and to this end they want to control the contexts in which their images are presented. They also want to receive credence as creative photographers.

Curiously, however, the New Photojournalism has arisen without any new vehicles for its propagation. If anything, the number of magazines and newspapers willing to run committed, hard-hitting photo essays in the tradition of Smith and Capa has declined in the United States. This change in the marketplace has had an effect on both the form and presentation of photographic reportage. One of the most obvious and ironic characteristics of the New Photojournalism is that it is to be found in books and exhibitions as frequently as it is reproduced as news.

Perhaps the most significant token of this shift from journalistic to aesthetic presentation was the establishment, in 1986, of the *Life* Gallery of Photography in the Time-Life building. That the long-preeminent magazine devoted to the photo essay should market photographs as works of art worth buying and collecting on their own merits surely says something important about its current relationship to photojournalism, and about photojournalism's relationship to the medium as a whole.

One could date the emergence of the New Photojournalism to the publication of *Nicaragua,* Susan Meiselas's 1981 book of photographs chronicling the Sandinista revolution. Not only did Meiselas's pictures lack captions underneath them to guide the viewer's responses (explanations were provided only at the end of the book), they were in color. They were not the first war pictures in color, nor even the first in which the color actively served to heighten our emotional responses to war—that honor belongs to the Vietnam pictures of Larry Burrows and John Olson, which were published in *Life.* But they used the vivid, saturated qualities of the Kodak rainbow in a way that struck some observers as artistic, if not decorative. Even their compositions seemed aesthetically premeditated.

As a consequence, Meiselas's book had an unsettling effect. The pictures looked like art—and especially like the color art photographs of William Eggleston, whose work the Museum of Modern Art had exhibited five years earlier. But they were of distinctly non-art subjects; indeed, they were highly charged politically, having been taken from the point of view of a rebel cause that our government has consistently opposed. Because of this combination, the pictures seemed to float away from the established

moorings of photojournalism. Instead of condensing an event in a way that explained it, *Nicaragua* made the Sandinista revolution seem complicated and ineffable.

Nicaragua has since been joined by Gilles Peress's *Telex: Iran* (1984), a book which describes the Iranian revolution of Ayatollah Khomeini essentially in terms of the photographer's own confusion over the events he was recording, and Alex Webb's *Hot Light/Half-Made Worlds* (1986), consisting of supersaturated color photographs taken in tropical locales. Both books have problems—Peress's because its invocation of confusion skirts close to incomprehensibility, Webb's because it uses the Third World almost as a prop in a formalist exercise—but both are representative of the new attitude in photojournalism. Significantly, Peress's Iran pictures were first published in *Afterimage,* a small-circulation journal published in Rochester, New York, not in any mass-market venue.

Like these three photographers, today's most stimulating photojournalists seem more interested in the complexity of issues and events, and in conveying the flavor of their experience of them, than in producing easily digested, simple-to-understand images. Disaffected with most magazines (even though they continue to sell their work to them), they gravitate toward the book form, which allows them greater control and more space in which to get their messages across. Mary Ellen Mark, Eugene Richards, and Miguel Rio Branco are among the photojournalists whose images achieve their ultimate expression in books. Richards's *Exploding into Life,* an illustrated journal of a cancer patient, is an example of the New Photojournalism's penchant for personal points of view; his co-author, Dorothea Lynch, was both the subject of the book and Richards's girlfriend.

But the current generation of photojournalists is not the first to seek to expand their genre with personal points of view, or to adopt the formal syntax of art photography in their work. Bruce Davidson, Charles Harbutt, and Abigail Heyman, for example, independently developed a hybrid form of photojournalism in the early 1970s, choosing to display their work in books and galleries. Davidson's *East 100th Street,* Harbutt's *Travelog,* and Heyman's *Growing Up Female* tested the line between reportage and personal expression, and they were widely influential among today's younger photojournalists.

Within the last year all three photographers have produced long-awaited follow-ups. Harbutt's *Progreso,* depicting a town in Mexico's Yucatan, is as psychologically allusive as *Travelog*; Davidson's *Subway* examines another metaphor of urban life, and Heyman's *Dreams and Schemes*, subtitled "Love and Marriage in Modern Times," again uses a first-person narrative

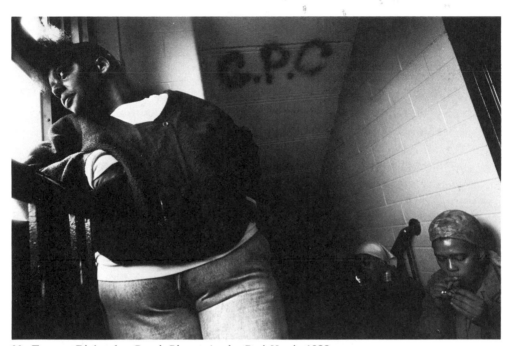

33. Eugene Richards, *Crack Plague in the Red Hook,* 1988

to help pierce another social fantasy. What separates these photographers from their younger colleagues is less a matter of style than of content: they still seem to believe that a well-organized photograph automatically communicates a certain meaning about its subject. Meiselas, Peress, and Webb seem more acutely and self-consciously aware of the abyss between photographic appearances and the events they portray.

Not surprisingly, much of the New Photojournalism is of little use to the magazines that depend on photography to explain the world to their readers. In the realm of news, clarity, brevity, and objectivity are held to be the guiding virtues, and images that express overtly personal points of view are unwelcome. At least that is the way it has always been. But just as the New Journalism of the late 1960s injected first-person narratives into the bloodstream of American journalism—as in the "gonzo journalism" of Hunter Thompson in *Rolling Stone*—the New Photojournalism may succeed in infiltrating magazines and newspapers. In both cases, the aim is a higher truth than conventional objectivity is thought to provide.

Contact: Photojournalism since Vietnam, while essentially an uncritical celebration of the tenth anniversary of a commercial picture agency, served as a ready gauge of how far the New Photojournalism has extended its influence into the world of reportage. By the evidence, the influence is substantial, at least in terms of style. For one, the pictures were in color. Indeed, thanks to the Cibachrome materials on which the prints were made, color was the show's main attraction, and it helped make the mostly newsworthy events depicted unnaturally vivid. In many cases it was used with a skill and sophistication more in keeping with *National Geographic*-style travel pictures than breaking news stories. On occasion, it even resembled art photography. Of the photographers represented in the show, David Burnett stood out as the most refined colorist of the group, and his compositions often were equally vibrant.

The pictures included were also exceedingly, and sometimes excruciatingly, explicit. We are shown the disfigured skin of men with AIDS, the exhumation of four nuns slain in EI Salvador, stages in the slow death of a Colombian girl trapped by debris. Such graphic frankness would be unusual in many publications, which tend to spare their readers from some of the world's worst horrors. But on the gallery walls, photographers can set their own standards of propriety and taste.

Additionally, the pictures suggest a renewal of "concerned" photojournalism's traditional advocacy role, and a willingness to risk sentimentality in the name of humanist, liberal values. Like James Woods in *Salvador,* photographers such as Burnett apparently manage to dispel any symptoms of

worldly cynicism—a disease often thought to be an occupational hazard—
when confronted by suffering and injustice. Judging from the evidence, if
photojournalism since Vietnam has a subject, it is precisely suffering and
injustice.

Yet for all their other merits, the pictures by Contact's photographers are
only superficially new. Unlike the best New Photojournalism, they reflect no
individual points of view, no sense of complexity about world events, no self-
consciousness about the role of the photographer in shaping those events for
public consumption. They are colorful, explicit, and humanist in spirit, but
they lack any critical sense of themselves. Not surprisingly, these are the
kinds of pictures that are widely published in the traditional venues of
photojournalism, because they still adhere to photojournalism's traditional
subjects and functions. Their style is merely new icing on old cake.

What is new about photojournalism since Vietnam is not to be found in the
pictures in the exhibition but, paradoxically, in the very fact of the exhibition
itself. By virtue of its name, photojournalism has long defined itself
according to what appears in organs of the press. What can we make, then,
of pictures calling themselves photojournalism that appear in an exhibition
setting? Or, more to the point, why is it that, in the 1980s, photojournalism
is increasingly seen in contexts other than magazines and newspapers?

It would be easy to blame the magazines and newspapers themselves, to
criticize them for a reliance on images of a sensational sort, for preferring
pictures that are big, graphic, and easy to understand—"stoppers," in the
jargon of the fifties picture magazines. Even in the hands of practitioners like
Capa and Smith, who were partisans of social change and to an extent rebels
against the publishing system, photojournalism boiled down to the need to
produce clear and immediate images that the average reader could readily
grasp. Limitations such as these are precisely what today's highly educated
photojournalists aim to challenge, so it is not surprising that they have to go
outside the system.

Yet it may be that photojournalism's turn to less ephemeral and more
aesthetic ways of being seen has little to do with the desires of magazines
and newspapers and everything to do with their archrival, television. More
and more, the news remains news only until the next network news update;
television cameras exhaust the image potentials of a subject long before
photographers get their film back to their offices. As still-video cameras
reach the marketplace, news photography will have to be redefined.

The specter of television's usurpation of photojournalism's conventional
functions may account for the brutal explicitness of the pictures shown at
ICP/ Midtown. As the critic Max Kozloff wrote in the catalog to yet another

show about contemporary photojournalism, called *Photojournalism in the 80s,*
"Still photographs cannot compete with network television in massiveness of
audience, but they can be more concentrated and dramatic in their revelations."
But the competition, such as it is, may already be over. The current interest in
photojournalism could be a sign not of vitality but of its new status as an artifact.
Taken off the page and folded into the museum, the New Photojournalism
becomes simply another genre in the realm of art, dysfunctional but beautiful.

New York Times, April 12, 1987.

Magnum's Postwar Paradox

PHOTOJOURNALISM, as it has been defined by its most ambitious practition-
ers and mythologized by their admirers, is an activity that combines aspects of
social reform, individual heroism, and emotional compassion. It also aspires to
be received as art. But like photography as a whole, photojournalism does not
slip seamlessly into the realm of the aesthetic.

The exhibition *In Our Time: The World as Seen by Magnum Photographers,*
which in two simultaneous identical versions toured the United States and
Europe starting in 1989, presents as works of art images by Robert Capa, Henri
Cartier-Bresson, and some sixty other photojournalists.[11] But it also raises
questions: What kind of art do these images represent? And how does photo-
journalism relate to the less functional kinds of photographs commonly found in
art galleries and museums?

By definition, photojournalism is directed toward a large audience.
Consequently, a photojournalist's pictures must always be accessible, eye-catch-
ing, and even provocative. They compete with words and other images for our
attention, so they need to engage us almost viscerally. They commonly accom-
plish this in two ways: they appeal to the eye, and they tell a story. They work
visually and emotionally.

From an American perspective, postwar photojournalism has had two primary
exponents: *Life* magazine and Magnum Photos. *Life*, organized on the corporate
model, long represented the conformist urges of the profession, trimming
photographers' individual visions to suit the upbeat, gee-whiz, ain't-America-
great philosophy of Henry Luce's media empire. *Life* popularized the photo
essay and emphasized pictures that tell stories.

Magnum, a photographers' cooperative formed in 1947, has nourished the
opposite: "personal" points of view, idiosyncracy, and the possibility that art
and politics could be made to coincide. It also has emphasized the purely
visual component of photography, giving Magnum claim to photojournalism's
aesthetic high ground.

Of course Magnum was more than a neat alternative to *Life*. It was itself torn between two conflicting ideas about the mission of photojournalism. Its two minds were those of Capa and Cartier-Bresson, who with the less celebrated photographer David Seymour (whose pictures were credited to "Chim") were the guiding lights of Magnum's formative years. The differences between the two men define both the strength and weaknesses of Magnum's more than forty years of activity.

As photographers, Capa and Cartier-Bresson were like oil and water. Capa was fired by events, chasing down wars and other cataclysms like a news hound. His pictures remain memorable in large part because of their political significance: here is the Spanish Civil War from the Loyalist point of view; here the throes of Israel's first days as a nation. Cartier-Bresson was more the boulevardier, the stroller with a camera who, under the spell of surrealism, cast his net for surprising juxtapositions and momentary happenstance. Ultimately, his photographs endure because of their complex compositions, not on the merits of their subject matter. "The anecdote is the enemy of photography," he often has remarked.

Because of his emphasis on compositional form, Cartier-Bresson is almost universally admired in the museum world, where he is viewed as an important influence on Garry Winogrand, Lee Friedlander, and all other postwar " street" photographers. But museums have an easier time dealing with the compositional innovations of his pictures than with their reportorial tendencies. For example, the 1987 exhibition *Henri Cartier-Bresson: The Early Work,* organized at the Museum of Modern Art by Peter Galassi, concentrated exclusively on the years before Magnum began.

Galassi argued persuasively that Cartier-Bresson's prime achievements lay in the arena of surrealism and that, by implication, they ended when he began functioning as a photojournalist. But, as Dan Hofstadter observed in an exhaustive *New Yorker* profile of the photographer, "Surrealism and photoreportage, far from being inherently opposed, actually had an affinity for each other." [12]

That affinity provides much of the fuel for the exhibition *In Our Time,* and also accounts for much of its waywardness. What are we to think, for example, of an exhibition that includes (and makes no distinctions between) an amusing picture by Richard Kalvar of a dog sitting on a Paris sidewalk and a horrific Chris Steele-Perkins image of a shrunken, starved Ugandan child kneeling beside three men with painfully thin bare legs? How are we to compare Ernst Haas's blurred color abstraction of street traffic with Eugene Richards's shot of teenage crack users, or Leonard Freed's picture of a dead man lying in a Harlem hallway?

To the extent that these pictures ask to be seen as works of art, it is clear that they are competing on different terms. The Steele-Perkins, Richards, and Freed images are emotionally immediate, wrenching photographs with no-frills compositions. The Kalvar and the Haas pictures appeal to us on quite different

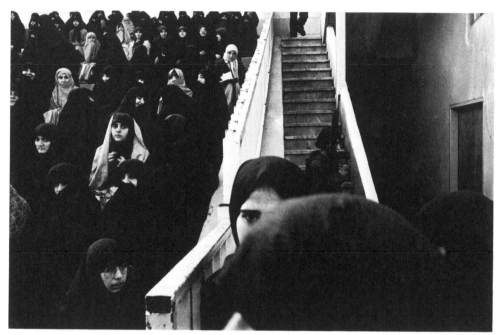

34. Gilles Peress, *Demonstration in a Stadium,* Tabriz, 1979

terms. The Kalvar is unexpected, beguiling, and as inherently surrealist as
Cartier-Bresson's early work. Haas's picture, taken in 1963, is decorative,
colorful, and atuned to then-current painting styles.

The tensions that divide these pictures—between powerful reportage and
artistic license, between anecdote and artifice—account for much of the
incoherence of *In of Our Time.* Yet there is reason to argue that these differences
can never truly be resolved but only acknowledged. Facts cling to photographs
like dust, and even everyday snapshots aspire to some formal coherence.

This may explain why the best Magnum photographers of our day are also
the most aware of the problematic nature of their activity. Gilles Peress's pic-
tures from the Iranian revolution, for example, are compositionally sophisticated
in a way that even Winogrand might have admired, and they depict an event of
considerable importance on the world stage.

What makes Peress's pictures radically different from those of Capa, however,
is their implicit abandonment of any moral position. A picture like *Tabriz, Iran,
1980* is chock-full of visual information precisely because Peress wants us to
know that he could not sort it all out for us. As an outsider he found the events
in Iran incomprehensible, and the pictures he made there (collected in the book
Telex: Iran) are documents of that incomprehension.

Similarly, Susan Meiselas's coverage of the Sandinista revolution in
Nicaragua (in the book *Nicaragua*) does not predigest the story for us. Working
in color, she made sophisticated pictures of scenes that do not always reveal
themselves on their surfaces. The story of Nicaragua, she seems to say, involves
more than appearances. The same could be said of Alex Webb's photographs
from Haiti, which are gorgeous in their color but lack a clear editorial focus.
(Webb's work can be seen in his book *Under a Grudging Sun: Photographs
from Haiti Libéré,* 1986–1989.)

In pictures like these, Peress, Meiselas, and Webb are attempting to avoid
another photojournalistic pitfall, that of Western privilege. Most photojournal-
ists, after all, come from comfortable backgrounds in the West, and their efforts
to describe the Third World can be criticized as a kind of visual imperialism.
Cartier-Bresson, who specialized in coverage of India, China, and the Far East,
has characterized himself as "a natural hunter."[13] Does that make his subjects
equivalent to prey?

The vast difference between subject and photographer was built into
Magnum's beginnings, too. Its founding meeting in 1947 was held in the
penthouse of the Museum of Modern Art; its name is the word for a large bottle
of champagne. But Magnum's subjects, in large part, have never been to a
museum or tasted champagne.

Peress, Meiselas, and Webb try to circumvent this tradition by resisting the
urge to overinterpret what they record; their pictures are often ambiguous and

sometimes blank. This strategy, which is very much of the 1980s, has its own drawbacks, of course; there is a difference between a photograph of a confusing situation and a confusing photograph.

Compositionally complex, nonjudgmental pictures are not always what magazines and newspapers need; consequently, much of what is being called "the new photojournalism" now appears in book form or—the ultimate turn of fate—in museums. This suggests that the days are over when a single image— one of Cartier-Bresson's, for example—could serve the purposes of both the editors of *Life* magazine and the curators of the Museum of Modern Art. When "new photojournalists" like Peress, Meiselas, and Webb start making pictures for museum walls, however, one has to wonder whether photojournalism has left its roots behind.

Published, in a slightly different form, in the *New York Times*, November 26, 1989.

Subject and Style

PROSPECTS FOR A NEW DOCUMENTARY

IT'S NO SECRET that documentary photography is in a state of disrepair. Facing public indifference on one side and the attacks of deconstructive critical theory on the other, it has come to seem more and more a vestige of an earlier, less cynical time—a time when seeing was tantamount to believing. Now there is talk about a "new documentary," although no one seems terribly sure what that means. For the documentary photographer today, there are at least two problems: to find a subject matter that has not already been exhausted by previous photographs, and to find a style that can maintain at least a modicum of documentary authority without merely repeating the conventions of the documentary tradition.

The difficulties of the documentary are especially visible within its more traditional practice. Take, for example, the photographs in the book *El Salvador*.[14] Even with the benefit of captions to tell us what we are seeing, something remains insufficient about the experience of these pictures. The problems of subject matter and style interlock: the images are so much in the style of conventional black-and-white photojournalism that they are largely indistinguishable from previous reportages of war and revolution, from Cyprus to Vietnam. Their immediacy depends largely on our awareness that the situation they describe is ongoing.

The best chance of curing the documentary's blues may lie with a radical reexamination of its premises. One of these is an obsession with what one might call the Other. In the nineteenth century, pioneer practitioners such as John Thomson and Jacob Riis photographed the poor, people on the margins of the societies in which the photographers themselves flourished. Other photographers, sent to survey the American West, viewed the land as hostile territory (much of it was, of course). In short, the tendency of documentary photography has always been to define its subject matter as whatever is foreign to the photographer. This is true not only of the photojournalists represented in *El Salvador*—most of whom carry United States passports—but also of most recent social documentary projects (Mary Ellen Mark's essay on Indian prostitutes, say). One direction contemporary documentary practice might take, then, is toward recording the "I"

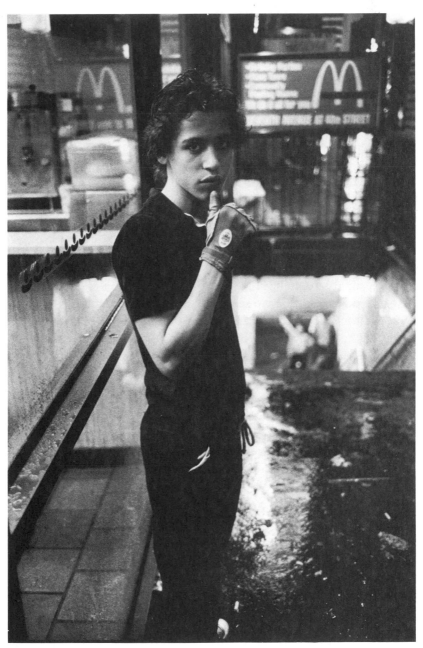

35. Larry Clark, Untitled *(from 42nd Street Series)*, 1979

instead of the "Other," centering itself on what the photographer's life is rather than on what it is not, and acknowledging the crucial presence of the photographer on the scene.

Larry Clark's book *Teenage Lust*[15] mines exactly this territory. A collection of eighty-three black-and-white pictures made between 1963 and 1980, it takes up much the same themes as Clark's underground classic *Tulsa* (1971) and recasts them in autobiographical terms. Whereas *Tulsa* only hinted at the photographer's involvement in the netherworld of drugs, guns, and casual sex that it depicted, *Teenage Lust* makes it explicit. Besides the pictures of Clark's macho pals, occasional sleep-in female friends, and boy prostitutes in Times Square, there are a number of portraits of the photographer in a variety of guises—a naked nature boy coated with mud, an acid-era rock drummer in the East Village, a convict in an Oklahoma penitentiary, a heavy-lidded drug user. The overall portrait that emerges is of a wild child who through the medium of photography escapes his milieu but not his past.

Although the photographs are often self-explanatory, Clark's autobiographical text supplements them, placing him even more squarely at the center of the piece. In a sense, he simply has redone *Tulsa* by other means—it is much the same seamy, seedy world that we see, but now the photographer is its core. This makes for a compelling document, although it is substantively flawed. The candor of Clark's soul-baring narrative collapses at those moments when he tries to account for his criminal behavior. ("I was getting down and I was drinking, and this was a period where I was getting pretty catatonic, man.... I don't known what happened. I just lost it.") While the photographs from his Tulsa days are frequently riveting in their immediacy, his more recent Times Square pictures seem more distanced; instead of reading as experience, they read as metaphors of Clark's unhappy youth. *Teenage Lust* is a work that has all the self-indulgent flaws of *A Loud Song,* Danny Seymour's seminal 1971 photographic autobiography that Clark credits as an inspiration, but no one can quarrel with its documentary authenticity.

A personal document of quite another order can be found in Mark Klett's landscapes from the West and Southwest. Klett prefers to depict the face of the land rather than the conditions of society, finding his antecedents in nineteenth-century photographers of the American West such as Timothy O'Sullivan and William Henry Jackson. Nonetheless, he is similar to Clark in that he puts himself at the center of his documentation—something of a feat considering that his subject matter consists mainly of mountains and deserts.

To be accurate, Klett's presence in his delicate and beautiful landscape pictures is more allusive than actual. Mostly it is a matter of (once again) the written word; in silver ink he writes captions directly on the surface of the prints, providing details not only of date and locale but also of occasion. In *First day of*

summer, evening of solstice—a color print—the poignancy of the year's longest day is deftly captured. In *Pausing to drink*, the shadow of someone swigging from a canteen coincides with a view of Arizona mountains. Other pictures show the photographer's friends or fellow photographers. In essence, the photographer adopts the style of nineteenth-century survey photography—which he learned while working on the Rephotographic Survey, a modern project to duplicate certain vintage Jackson and O'Sullivan pictures—and overlays it with a twentieth-century self-consciousness. As one consequence, we are forced to question any faith we may still have in the disinterestedness of survey photography in particular and landscape photography in general. Unlike the calculated objectivity of "New Topographics"–style photographs, these landscapes have all the intimacy of a diary.

Like John Pfahl, whose *Altered Landscapes* of the late 1970s toyed with optical vagaries of space and scale, Klett records the natural world with a capacious spirit that partakes of both humor and reverence. He wants to make us aware of looking at a photograph, going so far as to include the edges of his Polaroid negatives in his black-and-white prints, yet he never undercuts the experience of the landscape itself. He obviously holds the land in great respect, and is able to recapture some of the sense of awe that it once inspired—without, however, pretending that it still exists in virginal, majestic solitude. He admits not only to the depredations of man—as in a picture of a bullet-riddled cactus—but also to his own less damaging presence. By placing the "I" of the photographer in equilibrium with the "Other" of the landscape, he manages to reduce our postmodern sense of estrangement from the natural. While his work occasionally veers in the direction of Marlboro Man–style frontier nostalgia, it offers the promise of a revivified documentary genre.

This essay, written in 1984, was published for the first time in the first edition of *Crisis of the Real.*

Portraits, Real and Recycled

MORE THAN HALFWAY THROUGH a decade of photography largely given over to appropriation and tableaux, portraiture has acquired a renewed sense of currency. What is the source of this fascination with the human face as recorded by the camera? There are two likely explanations. For one, portrait photography may represent a reaction to the skepticism inherent in postmodernist thinking. Dealing as it does with what seems an irreducible essence of individuality, it can be seen as the last frontier of the genuine, a border of resistance to the depredations of the déjà vu. More than any other kind of images today, portrait photographs seem able to speak to us directly, without any interference from our accumulated cultural baggage.

Perhaps for this same reason, however, they appeal equally to those artists who believe that what we know as reality is merely a culturally coated shell. The function of portraiture in shaping public celebrity—viz. *Vanity Fair* and *People* magazines—is perhaps too obvious to need elaboration, but portraits are so seductive they still manage to fool us into thinking that seeing is believing. So postmodernist and "simulationist" artists may be doubly eager to demonstrate that even the most innocent-looking portrait images serve to reinforce cultural stereotypes and conventional hierarchies.

Real Faces, an exhibition organized by Max Kozloff for the Whitney Museum of American Art at Philip Morris, offered an alternative to what Kozloff sees as the recent depredations of stylization. The show's four photographers—Bill Burke, Nan Goldin, Birney Imes, and Judith Joy Ross— remain convinced that outside the walls of the studio something like real life remains available to the camera. Eschewing staging and props, they manage to bring back pictures that have a bracing emotional immediacy. In Kozloff's words, their "absence of presumption makes for freshness of contact and transparency of effect."

By "transparency of effect" the curator presumably means that the photographers he has selected share both a distaste for artifice and a fondness for the tradition of Walker Evans, whose 1936 pictures of tenant farmers in *Let Us*

36. Judith Joy Ross, Untitled (*Eurana Park,* Weatherly, Pennsylvania), 1982

Now Praise Famous Men are the benchmarks of their documentary-style portrai-
ture. Like Evans, they all rely on the camera's inherent ability to hold our
attention, and like him they seem to prefer to focus on the inhabitants of society's
margins. Burke concentrates on Kentucky mountain folk, Goldin on her own
post-punk milieu, and Imes on blacks in the rural South. Ross—whose pictures
are the most delicate—divides her attention between pubescent children in
Pennsylvania and visitors to the Vietnam Memorial in Washington. (Vietnam, it
could be argued, was the most marginal of America's wars.)

Given their reliance on the tradition of Evans, the participants in *Real Faces*
could not be said to be inventing a new direction for portraiture. Instead they, and
Kozloff, are attempting to rehabilitate the genre, to restore some of its former
power by returning to a style akin to naturalism. Imes, for instance, pictures the
participants in a river baptism with an old-fashioned sincerity, as if the scene
were new not only to him but also to photography. There is, however, something
appealing about such an earnest approach, and it is hard to dislike either the
photographs or the photographer because of it.

The subjects of Ross's pictures capture our sympathies in much the same way,
although there is a world of difference between Imes's often candid approach and
Ross's almost grave formality. Burke and Goldin, however, take the risk of
showing us people we may not like. Burke cuts through the nobility routinely
ascribed to Appalachian whites, making them seem alternately threatening and
frightened. Goldin's subjects are even more daunting—a tattooed man straddling
a pool table is not someone this writer would particularly like to meet—even
though they often are bathed in beautiful light and warm colors. Just as Burke
seems to stand halfway between us and his subjects, not quite at home with
either, Goldin straddles the line between mythologizing bohemian existence and
stripping it of its pretensions.

Such ambivalence, which is produced by the interaction of portrait subject and
portrait taker, enlivened *Real Faces* and, paradoxically, lent credibility to its claim
to represent a way out of what Kozloff calls "the rhetorical impasses" of more
calculated portraiture. But ambivalence is not always a saving grace. In the case
of Rosalind Solomon's pictures of people with AIDs (collected as *Portraits in the
Time of AIDS,* and shown at the Grey Art Gallery of New York University) it
merely clouds the issue.

Solomon has photographed a wide range of AIDs patients, including represen-
tatives of different ages, races, ethnic backgrounds, and genders. Some have
symptoms that are unmistakable and others show no outward signs of the dis-
ease. Some are seen in hospital beds, with intravenous hookups installed; others
are shown at home, often surrounded by mementos. One man holds up a snap-
shot of himself and his lover from what obviously were happier times. The
awareness that all the people pictured suffer from AIDs, even when no evidence

of the disease is presented visually, gives all of Solomon's photographs a gut-wrenching immediacy.

If one has ever wanted to see the horrifying physical consequences of the disease close up, these portraits will more than satiate one's curiosity. As viewers we are made into voyeurs, seeing (as we do in Diane Arbus's or Joel-Peter Witkin's pictures) what might be too frightening or upsetting to peruse in the flesh. However, all this evidence is presented without any written explanation or visual context, giving the exhibition—not to mention the disease itself—an unfortunate quality of sensationalism. Indeed, given that these were among the first explicit AIDS pictures to appear in a gallery context, sensationalism seems a risk inherent in the very nature of the project. Although perhaps unintended, it surely could have been anticipated.

The problem does not lie with the photographer's motives, or with her commitment to a form of social-documentary photography that aims to alert us to conditions that need urgent attention. But with such loaded subject matter, the decision to approximate a cross-section of AIDS sufferers seems calculated more to forestall political criticism than to enforce a point of view. Even the show's title, *Portraits in the Time of AIDS,* promises something larger and more coherent than this collection of pictures delivers. Despite having a pronounced style, the photographs lack a consistent vision, much less a sense of comprehension. As a result, they seem vulnerable to one of sensationalism's side effects, exploitation.

One suspects that the show's curator, Thomas Sokolowski, was aware of the pictures' potential for controversy, since his essay in the show's catalog makes a point of connecting Solomon's pictures to the histories of art and photography. Goya and Géricault are mentioned, of course, as are August Sander and Walker Evans. More anomalously, Sokolowski cites a similarity of composition between a Solomon portrait and a Watteau painting. This kind of formalist comparison is more irritating than enlightening, and ultimately leads us to wonder whether the assault these pictures make on our emotions has to do with art rather than life. And if we find ourselves aestheticizing AIDS, we have more than a virus to worry about.

One cannot, in short, consider Solomon's photographs simply as portraits of individual faces, any one of which may be more or less interesting. Like all portraits, including those in *Real Faces,* they have to be read in terms of their social function and the relative positions of their subjects and their makers. In both shows, the emotional charge of the image is implicitly linked to its subject, and that subject—as has been true throughout photography's history—is located at society's margins. Southern blacks, Appalachian whites, people with AIDS— all are made to seem "real" by the camera's attention.

At the same time that it fills in the social margins, however, the camera also functions to empty the substance of reality from those at its center, and from

those who aspire to it. This paradox is the message of artists like Robert Mapplethorpe, Richard Prince, Jeff Wall, and Thomas Ruff, whose work appeared together in June 1988 at the Barbara Gladstone Gallery. They confront the issue of cultural stereotyping through portraiture directly. Mapplethorpe, for example, has transformed the actress Isabella Rossellini into a monochrome goddess; her skin glows an almost featureless white against a rich black backdrop. Since Rossellini is already a media celebrity, Mapplethorpe goes a step further: he mythologizes her. The result is an extreme, if not total, stylization, a friezelike pictorial container that is simultaneously pristine and flat.

Prince's manipulated "Portraits," on the other hand, are merely echoes of Mapplethorpe's essentially narcissistic extreme. Playing the field of celebrity, from rock and roll (Tina Weymouth, Brian Eno) to downtown art world (Meyer Vaisman), Prince has emptied out and then revamped the messages of existing images, taken by others, by the mere act of photographing them over again. Grouped together, these "rephotographed" portraits catalog a variety of responses to the camera's gaze, from confrontational to self-absorbed, but such differences are nearly canceled out by their overriding sense of stylistic sameness. This challenge to the portrait's autonomy and self-sufficiency puts Prince's pictures at the opposite extreme from those in *Real Faces*. The same could be said of Wall's *Double Self-Portrait* from 1979, a vintage example of the kind of portraiture that cancels out any claims to uniqueness.

The most startling and confounding images in the gallery, however, were by the German photographer Thomas Ruff. His imposing, larger-than-life color portraits—of young German artists who are his contemporaries—are almost interchangeable. The subjects are shown at head-and-shoulders distance, looking straight ahead, with the camera perfectly level. Their faces are practically expressionless; at most they seem absorbed with the mechanisms of the camera. Like Bernd and Hilla Becher's typecast collections of industrial architecture, Ruff's portraits maintain that dissimilarity is only a matter of details.

As Kozloff astutely observes in the catalog of *Real Faces*, "it seems utterly quaint and useless to wonder about who the person portrayed is or was" in portraits like these. Individuality, obviously, is not the point. "If the viewer is led to anything, it could only be to that which has replaced personality," he concludes. But the search for personality's replacement, however dreary the idea might sound, is not without interest, and pictures like Ruff's may reflect the present dilemma of portraiture even more poignantly than those attempting to revive the genre's endangered authenticity.

New York Times, June 26, 1988.

Nicholas Nixon's People, with AIDS

THERE ARE TWO APPARENTLY POLAR but equally valid ways of looking at Nicholas Nixon's photographs. His images are remarkable demonstrations of how the traditional (and by now archaic) tools of the medium—a view camera, black-and-white film, contact prints—can be used to venture into uncharted artistic territory. At the same time, they concentrate on subjects—the poor, the elderly, the mortally ill—that align the work with photography's tradition of socially concerned documentation.

Within the aesthetic debates of the last several years, formal concerns in art have often been seen as separate from, if not antithetical to, social consciousness. But Nixon, more than any other photographer of our time, forces us to consider that the two approaches are more interconnected than one might suspect. As Peter Galassi, the curator of *Nicholas Nixon: Pictures of People,* an exhibition of ten years of Nixon's work that appeared at the Museum of Modern Art in the fall of 1988, says of the photographer's activity, "Making pictures has become a way of finding a path to the heart."

Nixon's photographs do not aspire to revamp the essential assumptions of documentary photography. As did Lewis Hine, Dorothea Lange, and countless other socially concerned photographers of this century, he relies on the photographic image's ability to convince us that what we are seeing is the truth. Like them, he assumes that seeing is enough to provoke indignation and action. But Nixon's faith in the photograph's powers of persuasion goes even further; unlike Hine or Lange, he feels no need to provide captions to tell us what we are seeing. At a time when many critics have concluded that the social-documentary tradition is exhausted, its efficacy worn down by bathos and repetition, Nixon's ability to make images that move us is all the more remarkable.

Nixon's earliest "pictures of people" date from the late 1970s and early 1980s and depict groups of children, teenagers, and adults at leisure, lying on the beach or standing in front of their homes. Several show us families gathered on porches. Judging from the meagerness of the clothes they wear and the houses they inhabit, most live in poverty. More than half of them are children, and the

37. Nicholas Nixon, *Tom Moran and His Mother, Catherine Moran*, August 1987

contrast between the open faces of the young and the often downcast visages of their parents and grandparents gives the photographs much of their poignancy.

At the same time, however, these images are astonishing for the complexity of their pictorial organization. As many as a dozen people may be arrayed within their borders—close to the camera and behaving as candidly as they might in common snapshots. But the photographer gives them a sense of shape and proportion that makes what is fortuitous seem inevitable. The formal grace and ease is all the more remarkable inasmuch as Nixon made the photographs with an 8-by-10-inch view camera, an imposing instrument that one would think to be too bulky, slow, and conspicuous for such an approach.

Moreover, and despite their wealth of descriptive detail, Nixon's contact prints are not beautiful in any conventional sense. Their unprepossessing black-and-white hues are without any seductive tint or tone. Their range of grays is not as consistent or as dramatically crafted as one finds in the prints of Ansel Adams. But their relative roughness turns out to be an advantage. They have an immediacy and ingenuousness quite removed from the sense of calculation characteristic of Adams's images.

In his essay for the show's catalog, Galassi has written that the photographer's "pictorial innovations, although masterful and even breathtaking, seem less to open a new territory for others to explore than to realize an opportunity created by earlier work. Photographic tradition, in its headlong, spendthrift course, had forged a consensus that the opportunity was used up." The wonder of Nixon's pictures, the curator concludes, is that they prove this consensus wrong.

From dealing with people in public spaces in a way that redefined "street photography," Nixon moved inside. From 1983 to 1985 he photographed in a nursing home, recording the elderly residents there in portraits that scrutinize each one individually. Isolated in the frame, seemingly heedless of the photographer's presence (although Nixon again used his large, conspicuous camera), the subjects seem to mirror the conditions of their lives. But as unlike the group portraits as these pictures are, the two series have one thing in common: they depict their subjects without prejudice. They neither flatter them nor disdain them; they indulge in neither sentiment nor irony.

This refusal to take sides is perhaps the major source of tension in Nixon's photography, what gives it its "edge," so that a viewer is forced to feel uncomfortable in its presence. The sense of pictorial implacability—evident in Nixon's earlier pictures of city buildings, which the museum exhibited in a 1976 one-man show—can seem a virtue at a time when sentimentality and romanticization threaten to pervert the possibilities of meaning in photographs. This surely was true in the mid-1970s, when Nixon wrote one of the most striking single-sentence artist's statements ever published: "The world is infinitely more interesting than any of my opinions about it."

Yet the refusal to give in to what curator Galassi calls "pictorial and moral cliché" should not be mistaken for a lack of concern or care—an error that critics of Nixon's "formalism" may finally be forced to admit when they see his most recent body of work, sequences of pictures of people with AIDS. These images are the most searing, sobering, and unforgettable photographs of Nixon's career. They may also be the most powerful images yet taken of the tragedy that is AIDS.

The subjects of these serial pictures include gay men, a woman, and a male hemophiliac. The photographs, taken over a period of months, chronicle both the visible signs of the progress of the disease and the inner torment it creates. The result is overwhelming, since one sees not only the wasting away of the flesh (in photographs, emaciation has become emblematic of AIDS), but also the gradual dimming of the subjects' ability to compose themselves for the camera. What in each series begins as a conventional effort to pose for a picture ends in a kind of abandon; as the subjects' self-consciousness disappears, the camera seems to become invisible, and consequently there is almost no boundary between the image and ourselves.

In the case of Thomas Moran, whom Nixon photographed from August 1987 until shortly before his death in February 1988, the progression from posed portrait to tacit acceptance of the camera's presence is especially vivid. In the sequence's first image, mother and son look out at us, embracing and apparently consoling each other. At the sequence's end, the young man's eyes again look in our direction, but they seem focused on infinity. Here, and in the other sequences, Nixon fashions complex meanings from one of the most basic elements of photographic portraiture: the subject's gaze.

In their openness to the emotional qualities of photographs, Nixon's portraits of people with AIDS show the influence of another side of his picture-taking— that involved with his family. Since the mid-1970s, he has taken yearly group portraits of his wife and her three sisters, and in the mid-1980s he made a number of images of his two infant children. These images, which serve to temper the otherwise sobering tenor of the exhibition, are filled with vitality and a sense of the future. They also represent the nearest the photographer gets to expressing conventional sentiment.

The family photographs provide a precedent for the AIDS portraits, in terms of both their methodology and their emotional resonance. The much-published series of yearly group portraits, for example, may have inspired Nixon to work in sequence in his AIDS images, as a way of showing the passage of time. Like the pictures of his children, the AIDS portraits are essentially private moments made public, but with a difference: the family pictures have no wider social consequences. As a result, they seem less significant—and surely less demanding— than Nixon's pictures of the poor, the aged, and the ill.

Compared to other attempts to photograph current social problems—Rosalind Solomon's *Portraits in the Time of AIDS,* for example—Nixon's pictures seem to be translucent. They are largely without any obvious stylistic inflections that would divert our attention from the subject to the photograph itself. Nor do they aim for dramatic effects of the kind W. Eugene Smith felt necessary to capture the public's attention. Despite Galassi's remark at the close of his catalog essay that "As the work has matured it has grown closer in spirit to [Diane] Arbus's work," the more obvious precedent for Nixon's approach is Walker Evans— specifically the Evans who took the portraits found in *Let Us Now Praise Famous Men.* Like Evans, Nixon has perfected a style that seems to be no style at all, so that for a brief and magical moment what he shows us, and how he chooses to show it, appear synonymous.

New York Times, September 11, 1988. Since then, Nixon's photographs have been attacked by some AIDS activists on the basis that they depict people with AIDS as victims and imply that the disease is inevitably fatal (see, for example, *October* 43, "AIDS: Cultural Analysis/Cultural Activism," edited by Douglas Crimp). Admittedly, Nixon has not shown people with AIDS in an upbeat or positive fashion—as, in fact, Rosalind Solomon endeavored to do—but this hardly invalidates the integrity of the pictures he has made.

Displaced Sympathies
A READING OF BILL BURKE'S PORTRAITS

THERE IS AN EPISODE of *The Twilight Zone*—a television series remembered for the intelligence of its writing—in which a frightened old woman alone in an isolated cabin is tormented by tiny extraterrestrial creatures who have landed in her backyard and infiltrated her house. They sting her with miniature ray guns in an attempt to subdue her, but in the end she manages to kill them with a broom, as if they were mice. As the camera pans away from the cabin, we are shown the spacecraft in which the creatures arrived; on its side is a familiar flag and the words "United States of America."

This program is lodged in the memory bank of my formative years because it was such a provocative example of how slippery sympathy can be. Having spent a half hour rooting for the old woman, we discover in the last few seconds that we have essentially betrayed our species. Appearances have proved deceiving, just as they do in still photographs. Photographic images give us the comfort of an apparently fixed rendition of the world, but when we examine them closely we find that they are no more reliable than memory. The eyes that conceive and receive them—the photographer's, and ours—provide their own inflections. In looking at photographic images, especially portraits of strangers, we cannot help but place our sympathies somewhere.

Bill Burke's portraits make sympathy a primary issue—or, perhaps more precisely, they make problematic the question of where our sympathies should be placed. Are the individuals we find in his pictures members of our own kind, victimized by some larger force, like the old woman with the broom, or do they represent some Other, a foreign species that exists in a world apart from ourselves?

The question is raised because a sort of genetic entropy is evident in his photographs, a misfeasance of the genes that manifests itself in the eyes. Some are blackened by abuse, some are pinched by toil, some are as innocent as a cherub's. Burke's subjects look at the camera differently than urbanites, more naively and more expectantly, as if the lens were capable of transforming them into something glamorous, something larger than the experience of their own lives. Most of them

38. Bill Burke, *Lewis Vote Cool,* Valley View, Kentucky, 1975

are what city slickers once called hillbillies—mountain people, farmers, miners, truck drivers. They have none of the sheen of cosmopolitan experience, and none of its hard veneer of distrust.

Half the faces we meet in his pictures seem alien, if not lurid. They belong to adults whose bodies often show what their minds must know: that the economy of existence is in a prolonged slump. For solace these people apparently rely on friendship, on family ties, on the children. When all else fails, the men look to animals, as pets and as prey. Presumably the barely controlled vitality of their hunting birds and guard dogs cheers them, as does their mastery of snakes and snappers. For others there is music, an outlet for the spirit, a Grand Ole Opry of the imagination. But whatever their consolation, it seems insufficient compared to the harshness and bleakness of their subsistence-level social economy.

The other share of Burke's subjects, the children, seem almost angelic. They hold themselves as if poised for ascension. A boy whose mother's head is swathed in hair rollers spreads his hands in a gesture of blessing; behind him a spout of water makes a halo in the river. A slip of a girl wearing stylish sunglasses holds up globes of fruit as if they were talismans. Others would be angelic except for the nascent promise of their pubescent bodies, their seemingly premature physicality. The men who grasp them with big, blunt-fingered hands seem like snake handlers, their expressions a curious mix of possession and trepidation. In all these children there is an element of wildness that sets them apart from their parents but unites them with the animals we see. Cavorting behind their parents with no consciousness of registering on film, or flirting ostentatiously with the camera's attention, they seem still rooted to a state of grace.

Allied with the children are the feeble-minded and disabled. The former remind us of childhood innocence carried beyond its prime, while the latter serve as literal examples of aging's losses. Such is the almost biblical cast in Burke's portrait theater, in which the signs of a bedrock, blue-collar America are assembled for what seems a final curtain call.

Burke encountered many of his subjects on behalf of the Kentucky Documentary Project, one of a score of literal-minded, earnest and well-intended photographic surveys intended to give creative photographers a social function. Not all these surveys succeeded in ways that were anticipated; usually, their products were more aesthetic than social. But for Burke, who lives in Boston, working in Kentucky provided an opportunity for uniting his aesthetic with a wider social aim. Burke also finds his subjects on trips to distant locales, such as Brazil, where he mimics the role of photojournalist as a cover for his more personal mission. Yet if Burke's rendition is accurate, Brazil is merely another Appalachia, another American vestige inhabited by the dispossessed and the disheartened. But no matter where they live, his subjects eke out a slim thread of poignancy from their circumstances.

Perhaps this is because all the subjects in Burke's pantheon, from circus performers to nightclubbers, seem aware that they are presenting themselves to the camera but unaware of how they might appear to it. As a consequence the pictures often seem to be revealing intimate secrets. There is an irony here: Burke has used Polaroid positive/negative film, giving him and his subjects the possibility of on-the-spot feedback. To make us aware of his forthrightness, or to enhance the illusion of it, he prints the negatives whole, complete with unevenly developed edges and the occasional imperfections of his technique. The Polaroid process functions for Burke as a signifier of honesty, on the part of both the photographer and the subject.

The wonder then becomes, how does he get away with it? What might the man in a sleeveless T-shirt, arching his enormous belly toward the lens, think of a Polaroid positive that, like an unreversed mirror, reveals his composure so unabashedly? Did the woman with the enormous rollers in her hair see herself as a parody of the Madonna, or did she complain that the lens made her hips seem too large? Did fistfights break out over others of these unflinching images? We have to admire Burke's nerve, but what, we might well ask, were his motives?

Surely they were not the motives of a photojournalist, who aims for the illusion of transparency, or of a traditional social documentarian, who aims to educate and improve. Burke's pictures are too tightly knit to pass as the former, and insufficiently sentimentalized to suggest the latter. His motives are more like those of a portraitist who answers first to his own sense of what is just. Viewed against photographic tradition, his pictures recall most strikingly Walker Evans's pictures of the Ricketts, Woods and Gudgers, reproduced in *Let Us Now Praise Famous Men*. But whereas Evans's camera and James Agee's words supplied those poverty-stricken Southern tenant farmers with a certain nobility, here it is largely missing. Instead, a slightly Freudian shiver prevails, especially in the images of brawny men with their arms wrapped around fragile, fair-skinned young girls.

One might also think of Mike Disfarmer's collection of Ozark faces wearing the looks of dirt-farm poverty and wartime anxiety. Something about Disfarmer's lack of guile, his ability to let his subjects seem to make their portraits on their own, without the photographer's intervention, informs Burke's work. On the other hand, as a collection that speaks to the state of the American people, the territory here is not too far removed from Richard Avedon's *In the American West*. Like Avedon, Burke depicts a society gone sour. But both Burke's Appalachia and Avedon's West are located in the minds of their makers. So, perhaps, was Disfarmer's Heber Springs.

That the people pictured in Burke's theater are playing roles secondary to the photographer's sense of devolution is suggested by the portraits taken far from Kentucky. Geography doesn't matter. Burke's eye is so strong it creates an

Appalachia of the mind wherever it alights. Since he hails from Boston, and has been to art school (and occasionally teaches photography in an art school), one might be tempted to call these travel pictures—or worse, carpetbagger pictures, one more in a line of visitations by the haves to the have-nots. But unlike carpet-bagging photographers, who do damage to individual dignity in the course of imposing their own vision of the world, Burke lets his subjects breathe to a remarkable extent. Instead of stripping away the environment and isolating them, like chloroformed specimens kept in a drawer, he includes enough detail for us to place them in a context. Despite the harshness and bleakness that the pictures describe, Burke's portraits have an eloquence about them, and it makes us want to admire them as the truth.

Part of that truth is bitter, part sweet. There is a sadness about the pictures as a whole that stems from the contrast between the way children appear and how the adults do. Perhaps this is why the most striking images often show us children in the grasp of adults, or adults acting like children, and why Burke finds adolescents especially fascinating. The young solicit our sympathy; they, more than the adults, are like us. We do not need a psychologist to see a psychological dimension in the work, or to speculate how this dimension corresponds to the photographer's vision. But Burke, like all artists doing something important, makes his individual responses resonate with the external world, so that the psychological and the sociological coincide. Bill Burke's portraits also reveal Bill Burke's portrait. Using a distinctive but economic style, he delivers a message about both the texture of American life and the tensions lurking in its subconscious.

Published in slightly different form in *Bill Burke: Portraits* (Ecco Press, 1987.)

VI. Photography at the
End of the Millennium

Photography in Its 150th Year

IT ALREADY HAS BEEN 150 YEARS since photography, that most literal of image-making media, appeared on the scene. To say that photography has changed the way we view the world and ourselves is perhaps an understatement; photography has transformed our essential understanding of reality and, in the process, transformed itself. No longer are photographic images regarded as innocent "mirrors with a memory,"[1] merely reflecting the world back at us in a simple one-to-one translation. Rather, they construct the world for us, helping to create the comforting illusions by which we live.

The recognition that photographs are constructions and not reflections of reality is the basis for the medium's presence within the art world. It defines photography as both personally and culturally expressive. It tells us that photography, like painting, reflects the artistic climate of the day—that it has had its abstract moments as well as periods of social-documentary descriptiveness. And as the work of artists like Anselm Kiefer makes clear, photography and painting have both interacted with and reacted to each other.

Within the precincts of today's photography world the medium's 150th anniversary has been an occasion for celebration. Two massive survey exhibitions—*On the Art of Fixing a Shadow: 150 Years of Photography,* at the National Gallery of Art, and *The Art of Photography, 1839–1989,* at the Museum of Fine Arts, Houston—have been organized, along with scores of less comprehensive but equally congratulatory commemorative shows at museums here and abroad.[2] At the same time, the marketplace for photographs is flourishing; in 1989 an Edward Weston image of a shell, which twenty years ago could have been bought for $100, sold at auction for more than $100,000. More art galleries than ever before have included photographs in their schedules of shows. Little wonder, then, that photographers and their supporting casts are feeling proud of themselves.

But photography's presence in the world obviously is not as unalloyed as the festive observation of its anniversary might suggest. At the same time that it has brought visions of faraway places and famous faces into our living-rooms, it has helped erase the traditional distinctions between what is real and what is merely an

39. Larry Johnson, Untitled *(Black Box),* 1987

image, between first- and second-hand experience, between observation and voyeurism. Susan Sontag, in her book *On Photography,* made precisely this argument, stating that photographs diminish and ultimately exhaust reality by rendering everything surreal, in the process creating an audience of alienated image consumers.[3]

Traces of pervasive uneasiness about photography remain in today's art world. For some, it is to blame for all that has gone bad with contemporary art—starting with Andy Warhol and culminating with postmodernism. Not only do photographic prints lack any of the painterly attributes of the artist's "hand," but photographic images also come from (and often represent) the arena of popular culture. Snapshots, fashion photography, and advertising images partake of everyday life, not the rarefied realm of existence to which art traditionally has been addressed.

The idea that reality has been replaced by its simulacrum—a fashionable notion advanced most adamantly by Baudrillard[4]—depends above all on the hyperabundant presence of photographic images in Western culture. (Whether they are mechanically reproduced or electronically transmitted, as in the case of television, is of relatively little importance to the theory.) Followers of Baudrillard and Roland Barthes, his perceptive predecessor, view photographs not as scenes taken from the world, but as cultural representations.[5] As representations, they are subject to (and examples of) the biases of the cultures from which they come. This view, more than anything else, explains why photographs have become so fascinating to artists who have little interest in the traditions of fine-art photography but a great deal of interest in representation.

One might assume that today's photographers are more interested in having their pictures viewed as works of art than their nineteenth-century counterparts. But photography has had an ambivalent relationship to "art"—meaning the realm of painting, sculpture, and drawing—for most of its existence. At the same time that the Impressionists were trying to put as much distance as possible between their canvases and images made by the camera, photographers such as Julia Margaret Cameron and Peter Henry Emerson were trying to mimic the atmospheric effects of nineteenth-century painting. It remained for "modern" photographers of this century, Alfred Stieglitz and Paul Strand among them, to erect an aesthetic based on the uniqueness of photographic representation. Their insistence on photography as a medium with its own unique mission inadvertently reinforced its separation from "art," and is primarily responsible for the way photography's history has been written.

According to the modernist art-historical gloss, fine-art photography has traditions, styles, and a momentum all its own. Thus art-history books have been free to ignore photography's role in the development of painting, and photohistory texts have all but ignored the impact of painting styles on photographers.

While photography's history, like painting's, has been constructed as a series of masterpieces and masters, which together create a lineage of influence, photography's aesthetic development has also been tied to technology; the introduction of dry plates in the late 1800s, for example, is assumed to have led to new pictorial forms, as did the introduction of the Leica camera in the 1920s. Times change, however, and the linkage of photographic images with progress, technology, and an independent fine-art tradition of its own is precisely what is under attack in contemporary photography and its criticism.

It would have been gratifying if *On the Art of Fixing a Shadow, The Art of Photography, 1839–1989,* and the other anniversary shows reevaluated the modernist notion of photography's history.[6] Unfortunately, they are more symptoms of what's wrong with our prevailing ideas about photography than attempts at repairing these notions. Although their curators enjoyed the advantage of fifty years of hindsight on Beaumont Newhall's landmark *History of Photography* exhibition at the Museum of Modern Art, they seemed content merely to fill in the blanks in the historian's venerable pattern. These shows approach photography as if its practices were largely autonomous and self-generating. Neither challenges the art-historical trappings in which photography has become ensnared. Consequently, they have a lugubrious air, seeming more *fin d'epoque* than *fin du siècle*.

Behind the apparently seamless facade of such efforts to create a canon of fine-art photographs lies an unspoken anxiety that photography, as we have long known it, is fading away like an old snapshot. Its feared replacement? Electronic imagery, generated by a combination of video and computer technology. But the worry that electronic imagemaking may soon supersede photography's traditional silver-based processes masks a crucial shift that has already taken place: in the 1960s, television replaced photography as the major message-bearer of Western culture. The consequences have been profound. For one, photography has come to function less as a report on real-world events and more as a subjective, interpretative medium. And, like most cultural artifacts, it has found refuge in the museum and the art world.

But despite the widespread creation of departments devoted to collecting and exhibiting photographs, museums remain somewhat puzzled by them. The Whitney Museum of American Art's 1989 Biennial, for example, included only one artist (Cindy Bernard) whose work consists entirely of photographs. Although the museum has a curator who specializes in independent film and video, it so far has not created a position for a specialist in American photography. The ostensible reason is that photographs now swim in the same seas as painting and sculpture and therefore do not need special curatorial attention. But the virtual exclusion of photographers from the Biennial suggests that in the curators' minds, at least, photography remains separate and unequal.

The shift in photography's relation to the world of art was obvious, if implicit, at the National Gallery's installation of *On the Art of Fixing a Shadow*. The first room of the exhibition, devoted to photography's version of incunabula, was like a sanctuary, dim and intimate. Some of the pictures were covered with drapes, which one had to lift to see fragile, seemingly evanescent images. How different an environment this was compared to the show's final room, which was made as open, bright, and spacious as a Soho gallery. The difference is instructive, because it suggests that what is considered the art of photography today is radically at odds with the treasured images from the medium's beginnings.

One way of describing the shift would be to say that the act of looking at photographs has been transformed from a private to a public experience. But the change has as much to do with the picture maker as it does with the observer. All we need do is compare a nineteenth-century landscape from the National Gallery exhibition, like Carleton Watkins's *Cape Horn near Celilo,* which precisely describes the poetic relation of rock, sky, and railroad track, with Hockney's *Pearblossom Hwy.*, a 1986 collage of snapshots that creates a totally imaginary perspective, more cubist than renaissance. Since the Hockney was the last image in the show, we don't have to wonder about which direction photography is headed.

For further evidence, there was *The Photography of Invention: American Pictures of the 1980s,* an exhibition of 172 plainly postmodernist pictures that appeared at the National Museum of American Art at roughly the same time as *On the Art of Fixing a Shadow.*[7] If the work of Barbara Kruger, Sherrie Levine, Cindy Sherman, and the Starn Twins—all of whom were represented in *The Photography of Invention*—means anything, it is that photography's impact on contemporary consciousness has not been limited to the practices encompassed by photography's version of art history. Clearly it is the medium's broad public presence—including images of glamour, news, politics, and pornography—that inspires (and in some cases irritates) today's artists.

A work like David Robbins's *Talent* (1986) exemplifies the radical approach to photography found in today's art world: it consists of eighteen commercially made "head shots," commissioned by Robbins, of artists who are his friends and peers. By treating artists like aspiring performers—the usual customers for such 8-by-10 glossies—he wryly emphasizes the extra-aesthetic aspects of the art world. A more chilling example is Larry Johnson's 1987 Untitled *(Black Box)*; on a shiny color photograph are printed the last words of a commercial airline pilot, taken from his plane's "black box" recorder after it crashed. Works like these plainly have no relation to the mainstream fine-art traditions of photography, referring instead to the medium's role in mass communications.

The message of this new approach is significant, if disconcerting. It suggests that we live in a society thoroughly encoded by photographic images. And it

suggests that these images are not the innocent, natural products of an objective lens, but vestiges of human consciousness. As such, they can be exhumed and examined like archaeological shards—"appropriated" is the artworld term—to yield evidence of the culture from which they came. For today's artists, the ever-expanding world of photographic images is a more important subject, and a more meaningful one, than the world we experience first-hand.

This explains why so few art photographers now bother to go out into the world to find their subject matter, and why the tradition of Henri Cartier-Bresson, W. Eugene Smith, and Robert Frank, which was carefully traced in the National Gallery exhibition, seems to have lost its emotional credibility. A picture like Smith's untitled image of a street sign that reads *Dream,* taken in the 1950s, seems up to date because of its implicit skepticism but hopelessly old fashioned because of its faith in the expressive powers of the "found" image.

Given the current fascination with mass-media photographs as cultural signs, and the widespread dissatisfaction with the traditions of fine-art photography inherited from fifty years ago, one has to wonder whether the celebration of the medium's sesquicentennial might better have been conceived as a wake. For if photography survives into the next century, it will be as something more overtly fabricated, manipulative, artifactual, and self-conscious than the photography we have come to know. It will, in short, look less like the world and more like art.

New York Times, May 22, 1989.

Photography in the Age
of Electronic Simulation

WHEN I WAS TEN YEARS OLD I set out to design the automobile of the future. At first it bore an uncanny resemblance to my father's 1957 Plymouth sedan, but after several days of crumpled paper and resharpened colored pencils it evolved into a streamlined, road-hugging, fire-belching rocket with a grill that approximated a tiger's snarl—an impossible, overelaborate vehicle, to be sure, but one thoroughly convincing to the boundless imagination of a boy. In my best lettering I proudly labeled it "Car of the 20th Century." It was more than a little deflating when my mother pointed out that the twentieth century wasn't the future, but the century in which we were living.

My childhood blunder is repeated constantly, incessantly, in the adult world. We can't help but model the future on the present. The future is our dream, but it consists of fragments and extrapolations of who we already are. Lately it has become more than that: in this age of rapid technological progress, we worship the future so much it has begun to dictate our daily lives. To a large extent, it defines us, fixes us in our ever-changing state of now. One might even say that the future has slid so far into the present that it has become the present. This is what makes the predictions of soothsayers like Jeanne Dixon so comforting: they tell us what we already expect.

So it is when we look into the crystal ball of photography. What to the nineteenth century seemed a mirror of nature, and what to this century has seemed an instrument of personal expression, now promises to become a subsidiary of technological advancement, an appendage to a larger enterprise that carries all our bets for the future. This seems new, but isn't. Photography has been allied with technology from the moment it was invented. Then, it heralded a new industrial age and epitomized the progressive spirit new to its time. Today, the industrial age has rusted shut, but the progressive spirit that fueled it lives on. What has changed dramatically in the interim isn't so much the spirit that motivates photographs, or even the look of photographic images themselves, but what we make of them. They can no longer purport to be innocent witnesses devoid of intentions, and we no longer can pretend to be innocent bystanders in the path of their endless procession.

40. Nancy Burson with Richard Carling and David Kramlich,
Three Major Races, 1982

When the real is no longer what it used to be, nostalgia assumes its full meaning. There is a proliferation of myths of origin and signs of reality; of second-hand truth, objectivity and authenticity.[8]

The prefix "post" is currently enjoying a widespread vogue in cultural circles. We speak of our times and world view as variously postmodern, postindustrial, post-Freudian, post-capitalist, post-Marxist, poststructuralist. We seem to want to be beyond the past, to leap out across some imagined barrier into a brave new world. Instead, we find ourselves without absolutes, without standards of reference by which to make judgments. This is precisely what French philosopher Jean Baudrillard has called the simulacrum, a socially constructed hall of mirrors with no external points of reference. For many, history has become entertainment instead of instruction, and the future is whatever we care to make it. Alas, cry these Chicken Littles, the real is no longer what it used to be. We return to Plato's cave and do not pass go.

However captivating this notion may be to the young, however, it appears inadequate to anyone with a modicum of experience in actual life. The social world may be constructed arbitrarily, but our experience of it is inarguably authentic. Or at least we would like to think of it that way. For part of the impulse of photography—part of its widespread popularity—is that it confirms and authenticates our experience. It is what "hard copy" is to the computer, a tangible record of neural excitement, a transubstantiation of our impressions and intuitions. Never mind that the transparent realism of camera images is only a stylized container, one choice made from an infinite wealth of possibilities; photography remains convincing in a way that no other visual image can be.

Because it is convincing, because it has an evidentiary value in the courtroom of reality, photography has prospered and multiplied. With technological advances that have made the process of picture taking easier and faster ("You push the button, we do the rest"; "A color picture in 60 seconds") and with marketing advances that have put cameras in the hands of Everyman, the number of images existing in the world has become incalculable and unimaginable. This wealth of pictures is not without its problems, however.

In his 1936 essay "The Work of Art in the Age of Mechanical Reproduction," Walter Benjamin sagely foresaw some of the consequences of a cultural superabundance of imagery predicated on photography.[9] As he sensed, the "aura" of originality has been dissipated; what we have in its place are reproductions, impressed on notecards, posters, silk scarves, and jigsaw puzzles, all available at your local museum shop. But Benjamin's critique can be extended beyond the arena of art. What has been dissipated by the reproductive onslaught of photography is not just the aura of art, but reality itself. Photography is no longer simply the litmus of reality; it has become reality's replacement.

What has happened in and to photography in the more than fifty years since Benjamin's essay only reinforces this displacement. The Xerox machine and the one-hour "minilab" processing laboratory make reproduction a casual, largely unremarked affair. Printing-press capabilities recently have become accessible to anyone with a personal computer. We have grown used to the idea that images and texts should exist, at minimum, in duplicate and triplicate. So-called "limited editions" of popular artworks, photographically reproduced, are manufactured and marketed in thousands of copies. We now can upload and download images via the telephone lines, outside the traditional systems for disseminating pictures. To capture and view these images, no camera is required, only the requisite software. This is André Malraux's "museum without walls" and more; we now live in a museum without limits.

Today, a half century after Benjamin, we find ourselves on the edge of a new age: not of mechanical reproduction, but of electronic simulation. Photography's trespass on reality is no longer at issue. With electronic imagemaking and receiving equipment insinuating itself into every home and office—we have our choice of video cassette cameras and recorders, still video cameras and playback devices, image-capture and "paint" programs for personal computers, computer publishing programs and laser printers—the notion of a crisis between reality and its image is rendered moot. Just as Harold Edgerton's electronic flash sliced life into increasingly narrow sections, and just as Edwin Land's Polaroid sliced the time between photographic stimulus and response to a hair's thinness, today's electronics have the capability of transforming every action into an instantaneous raster pattern. "Real time" is a vestigial idea, left over from when there wasn't any.

The important distinctions between traditional photography and the largely untapped potentials of electronic imagemaking are not a matter of whether pixels will replace silver grains, or whether electronic cameras will capture market share from mechanical cameras. What is at issue for the future is how much of the increasingly complex technology will filter down to the level of the general public. All the evidence today points to an increase in the disparity between the scientific (engineering, medical, architectural, et al.) and casual uses of what we now call photography. (The name may have to be changed shortly, since "writing with light" seems less central to the electronic enterprise.) The gap will most likely also widen between the "professional" and "amateur" user, and between the realms of evidentiary and aesthetic intentions.

In the past, all these functions and purposes were consumed under a single umbrella. One practiced photography, whether it was meant to serve an insurance investigation or an individual's personal idiosyncrasies. Today, the spokes of photography's umbrella are pulling apart. This can be felt most acutely, perhaps, within the arena of education, where photography teachers are struggling

to define both what they are teaching, and why. Does it make sense any longer to teach the craft of film developing and print making, if those skills are not needed in the industrial marketplace? Does it make better sense to teach aspiring photographers computer programming, on the theory that the new frontiers of the medium lie with image manipulation?

Paradoxically, as the function of traditional silver-based photographs as carriers and conveyers of cultural messages decreases, their value increases. Stripped of their use value, they become commodities instead. They are rarefied and fetishized, treasured by art collectors and museums, who subject them to the traditional discourse of connoisseurship. For photography as an art form, this transition has certain benefits: it frees the medium from any obligation to depict the world and report on world events, opening the gates to new practices divorced from documentary expectations. (This is precisely what happened to painting when photography was invented.)

But there are losses as well. Ask any photojournalist who thinks seriously about what he or she does. Photojournalists know that photographic reportage is no longer taken at face value; they have to find ways to reinvigorate their genre. They have begun to mimic the styles of art photography as a way of capturing our attention, and they increasingly are turning to the exhibition and publishing systems of art photography to disseminate the results. This shift is symptomatic of our loss of innocence regarding photographs, and also of their new existence as artifacts.

Meanwhile, computer scientists march machines closer to us, and us closer to machines. At MIT's Media Laboratory—a five-million-a-year research center funded by corporations and the federal government—holograms have been developed to show us human X-rays and car designs in three dimensions—as real, one might say, as life. At the California Institute of Technology, computer chips that "see" like the human eye are in the works. "Scientists envision one day building robots or vehicles that can steer by themselves, read handwritten documents and recognize faces," the *New York Times* has reported.[10]

"Machine vision," as computer object recognition is being called, reinforces the notion that human sight is itself computerlike. Already Canon, Kodak, Nikon, Sony, and others have introduced one-frame-at-a-time "still video" cameras for the news market, albeit in analog form. Once a scene is scanned, it can be played back at any time—or erased. The magnetic code that encapsulates the image can be altered, and the image itself can be compressed or magnified, its resolution enhanced or degraded, its contents rearranged or deleted. Soon enough, electronic photography will be primarily a digital system, since that will allow images to be more easily transformed. The "faithful witness," the "mirror with a memory," will soon seem even less reliable than it does now, as we approach the demise of the relatively crude, but effective, airbrush.

Of course, advancing technology does more than spoil our faith in the innocence of photographs—if indeed we have any left. It opens up a wide new field of possibilities. Computer scientists, working with architects, can now "install" skyscrapers at their sites before they are built—using a kind of onscreen sleight of hand that has enormous potential benefits, since it gives city planners a chance to preview the effects of developers' plans in three dimensions. Laser scanning of color negatives produces sharper prints than otherwise possible; for even better detail, definition can be enhanced by a process developed for the space program. Holograms, once thought to be a marvelous invention without a *raison d'être,* are now embedded in credit cards to help prevent duplication and fraud. And these are relatively mundane examples of future technology alive in the present; one can be sure the Pentagon has much more dramatic ones under lock and key.

To some, electronic imaging *is* the future. They see pixels in the same way that George Eastman saw roll film, as the tidal wave of technology that will overwhelm the competition—in this case, conventional silver-based photography. But it is more likely that electronic imaging will function like Edwin Land's Polaroid process, as a supplement to the community of image-making media. Even the head of Eastman Kodak's electronics division—a recently established corporate entity designed to take the future's high ground—believes that traditional photography's "hard copy" role will not be usurped by electronics. "The natural domain of electronic photography is a video signal on a video monitor," he told a group of photographic scientists recently. "We see electronic imaging as enhancing silver halide photography, not replacing it."

It will be interesting to see, however, whether the new electronic technology develops its own pictorial style, in the way that photography is often said to have done. Or will it simply produce more of the same kinds of images, only with less definition, less reliability, less courtroom veracity? Personally, I lean toward the latter, more skeptical view. One can notice, for instance, that video cameras, still and otherwise, rely on the same kinds of lenses as cameras that record images on silver-based emulsions, and they therefore might be expected to produce similar perspectival effects. One also can notice that the American tourists who have taken to carrying portable video cameras on their vacations tend to use them exactly as one would use a 35-millimeter camera. They line up their families in front of the scenery, direct them to hold still, and then "'film" them from a discreet distance. Click. In this sense, the amateur's use (or misuse) of video is indistinguishable from that of its immediate predecessor, Super 8 movies.

Even in expert hands, however, the difference between film and video already has proven to be based on production values, not on any pictorial qualities inherent to those mediums. True, there is a difference between seeing a movie in a theater full of popcorn-chomping couples and watching television alone

at home. The material may be the same, but the scale is not. Neither is the ambiance. But it does not follow from this that the pictorial territory of the two mediums is fundamentally distinct. In fact they overlap, with video increasingly favored for reasons of economy. Based on this precedent, it seems unlikely that still images formed of pixels will prove *sui generis,* a category unto themselves.

At the same time, however, there is afoot something called "computer art." The claims for it are grandiose. A book called *Digital Visions* starts out by saying, "Computers are making unprecedented aesthetic experiences possible and revolutionizing the way art is conceived, created, and perceived."[11] There are full-time computer artists and innumerable computer-art museum exhibitions. In short, we are being asked to believe that computer-generated video images *are* a new art form, with their own aesthetic precepts, practitioners, and possibilities. Once again the long-sought union of art and science seems close at hand.

A less sanguine view might hold that computers are yet another tool of the artist, capable of results quite banal or quite startling depending on the sensibility of the person using them. To date, banality has been the rule, but who is to say what possibilities there are? To these eyes, the problem with much of today's computer imagery is that it attempts to duplicate the visual tropes of painting and photography. There are swooping landscapes formed from fractal equations, and there are surrealistic conjunctions of incongruous elements. But none of this is truly revolutionary: the genre of landscape was invented in the sixteenth century, and surrealism has been a staple of fine-art photography since the 1920s. When someone finds a way to convince us that computer images can be beautiful on their own terms, the term computer art may take on meaning.

On the other hand, the computer and its associated image-making technology may have a profound effect on the sociological status of artists in our culture. Artists will have to stand on one side of the line or the other. They either can be bohemian *refuseniks,* working outside the structure with vestigial materials (silver-based films and papers) and equipment (conventional cameras), or they can join the revolution at its vanguard, immersing themselves in the new technologies. In the former case, they run the risk of becoming irrelevant, producing artifacts that speak of their increasingly precarious free will and tenuous independence. In the latter, they face the unhappy possibility of becoming dependents of the technology they embrace, in the same way that children are dependents of their parents.

The critic A. D. Coleman, in a 1981 address titled "Fiche and Chips," put the division somewhat differently:

> Is the challenge which now faces the image-maker that of taking commonplace means for the rapid production and dissemination of economically insignificant multiples and reestablishing hegemony over them by converting them into personalized vehicles for the creation of marketable artworks? Or is the challenge

instead that of teacher-poets claiming for the citizenry a set of tools devised for the furtherance of the corporate/bureaucratic elite, humanizing those devices and revealing them to the polity as a birthright?[12]

The idea of "teacher-poets" notwithstanding, Coleman's formulation clearly appeals to the instincts of social reformers.

But social reform is not high on the agenda for most artists today. Instead, they are becoming professionals in the industry of producing art. A professional artists' advisor recently wrote in *Art New England*—presumably with a straight face—that "Artistic talent is not enough for an artist to succeed professionally; the ability to manage the business aspects of being an artist is also necessary."[13] Here, perhaps, is where the initial interface of art and computers will take place: in the artist's spreadsheet of capital gains, and in his data base of influential curators, critics, and collectors.

Meanwhile, on the frontiers of the new technology, aesthetic concerns will take a back seat to innovation—as indeed they always have. The disciples of Edwin Land will be busy finding ways to bring the twenty-first century into our lives a few years early, and their inventions are sure to captivate us. Certain traditional forms and displays of photographic imagery will succumb to the same fate as the dinosaurs as new forms take their place. Nevertheless, those anticipating a big bang of radically altered electronic consciousness will be sorely disappointed. There won't be a revolution because it's all part of a familiar historical evolution; the Old will go gently into the good night as the New tiptoes into prominence. It doesn't do any good to blame technology, since photography wouldn't exist without it. The electronic future is as inevitable as our loss of faith in the integrity of photographic images.

This essay was written for Polaroid's *Close-Up* magazine in 1988, but was published for the first time in the first edition of *Crisis of the Real*.

41. Robert Heinecken, *Connie Chung/Bill Kurtis*, 1985

Looking at Television

The danger of television is not that it presents entertaining subject matter but that all subject matter is presented as entertaining. NEIL POSTMAN[14]

AS THE AGE OF MECHANICAL REPRODUCTION has given way to the age of electronic simulation, artists have had to seek new means for maintaining a critical stance toward commonplace culture. It no longer suffices to regard broadcast television and "the media" in general simply as anathema to the artistic pursuit, or as extraneous to the processes by which art is conceived and perceived. Such stances have the effect of denying what is now the most prolific and influential source of visual material in the Western world. As was true of photographs and comic strips during the heyday of mechanical reproduction, television images have come to represent the territory in which contemporary life and art intermingle.

Like it or not (and many don't), the media have disrupted and dissolved our conventional conceptions of art and artists. Since pop art, and arguably back as far as the Zürich dadaists, pre-TV art's claim to high-mindedness has been under attack. Today every image, every artistic gesture, seems to be instantly co-opted and transmuted into a form of spectacle, a vehicle for entertainment. Artists become celebrities and stock-market investors. Works of art become commodities in the exchange of fashionability.

Artists have reacted to this situation in different ways. Keith Haring's paintings openly aspire to popularity and mass-culture status, using the iconography of the cartoon show. Julian Schnabel, a painter who seeks old-fashioned redemption in heroic scale and classical motifs, nevertheless feels compelled to utilize such detritus of kitsch culture as black velvet and palomino hide. One shudders to think that for some of today's artists, the first model of their profession was Jon Nagy, host of an early television learn-to-draw show. All this is a far cry from the bohemian-style spirituality and artist-as-seer poses that characterized art when television was in its infancy.

Television has done more than open the world of art to commonplace imagery and everyday life; it has forced artists to reinvent what art is. This process has coincided with a renewed engagement with the conditions and assumptions under which art is produced. What was previously implicit—

art's role in creating images of desire and diversion, its complicity with the status quo—has, in the age of television, become explicit.

For photography, a medium that has seemed especially suited to addressing the conditions of mechanical reproduction, the shift to an electronic-image culture has several consequences. One is that the interest in "the photographic," that supposedly natural style of camera description which characterized modernist fine-art photography for most of this century, has declined to the point of invisibility. Postmodernist artists are interested in photography not as a distinct means of describing the world but as an embodiment or metonym of how the culture represents itself. This urge to present the activity of representation is, above all else, the distinguishing feature of much contemporary photography.

If we use the term "the photographic" to signify those traits of an image seemingly dictated by the camera's inherent picture-making traits, what does it mean to speak separately, and more broadly, of representation? In essence, one could say that the content of images is now seen to be the network of their cultural relationships rather than either their nominal subject matter or the mechanics of their fabrication. Anyone familiar with the writings of Roland Barthes—in *Mythologies,* for example—has been made aware that images are never divorced from, or innocent of, a nexus of culturally determined meanings. It follows from Barthes that what is represented, as opposed to what is imaged, is no less than the dominant ideology of a culture. Representation, in short, entails ideology—most often veiled or implicit—and this ideology can be either accepted or questioned.

Why, we might wonder, should artists choose to dramatize the ontological and cultural tensions of television by using photography? They could be accused of anachronism, of tackling a new form of representational engineering with the tools of an outmoded one. But even if this is the case, the tactic is not without merit. Challenging the new technology with the old, the simulative with the reproductive, serves to distance us from the fascination with technique that is one of video technology's most beguiling features. Photography offers a kind of Brechtian awareness of the picturing process that television tries to dissipate. Once considered transparent itself, photography now serves to unmask the transparency of TV. This is a deconstructive process only a few video artists— Nam June Paik, early on, and Dara Birnbaum more recently—have managed to achieve.

"With regard to the screen," Walter Benjamin wrote, speaking of movies, "the critical and the receptive attitudes of the public coincide."[15] Today this seems like wishful thinking at best—certainly if we think of the television screen. The current critical debate about television focuses on whether its enormous influence can be wrested from the powers that be and made more democratic. Marxists

are battling it out with structuralist theorists over whether it is in the nature of television to force-feed its audience a diet of "acceptable entertainment."

To some, such as Marshall McLuhan, the most influential media theorist of the 1960s, television reduces the sense of difference in the world—it is an all-encompassing, inherently "cool" medium, universal in reach, that brings us together in a "global village." (McLuhan saw this reduction of difference as a good thing.) To others, such as Hans Magnus Enzensberger, the tendency to see television as an inescapably monolithic source of information stands in the way of its redemption. Analyzing the medium from a Marxist point of view, Enzensberger has argued that its "repressive uses" are not inevitable but a result of its control by the "bourgeois-capitalist" class. As a result, he contends, there exists the possibility of an "emancipatory" practice of television, grounded in local transmissions controlled by the working class. "By producing aggressive forms of publicity which were their own, the masses could secure evidence of their daily experiences and draw effective lessons from them," he states in his 1974 book *The Consciousness Industry.*[16]

Baudrillard, however, in responding to Enzensberger's ideas, declares flatly that "There is no theory of media. The 'media revolution' has remained empiri-cal and mystical."[17] Defending McLuhan, he claims that the media are not something onto which ideology is imposed, but that they create their own ideol-ogy. Because the product of television is immaterial, he says, the materialist theory of Marx is insufficient. Baudrillard's structuralist-based analysis of the media concludes that *they are what always prevents response,* making all processes of exchange impossible. . . . This is the real abstraction of the media. And the system of social control and power is rooted in it." Television, to Baudrillard, is simulation, and simulation is the structure that rules our lives.

What seems clear, however, is that artists *have* been able to respond to tele-vision. Through the use of photography, they have transformed its messages into something more skeptical, more reflective, and more entertaining than they were originally intended to be. Their interventions may not be on the order of a revolution in consciousness, or a socialist uprising, but they are fully compatible with, and analogous to, the operations performed by pop and postmodernist artists on mechanically reproduced imagery.

No one better suggests the transition from the modernist idea of "the photo-graphic" to the current fascination with representation than Harry Callahan. Callahan, who came to photography via the Detroit Camera Club and whose early hero was Ansel Adams, is in many respects the model of a formalist photographer. His career can be read as a cyclical reworking of the "themes" of chiaroscuro, figure and ground, surface and depth, and other "visual ideas" common to the discourse of painting. But as his doubled-exposed color images from 1984 suggest, his interest in formal experimentation has co-existed with an

interest in the differences between media representations (of women, mostly) and their real-life counterparts. As early as 1956 he photographed collages of women's faces that he cut from magazines; in the 1984 images he uses television images as automatic collaging devices. The dialectical relationships established by the two overlapping exposures—between inside and outside, ideal and real, mediated and experienced—give these otherwise experimental images an unexpected currency.

If Callahan represents the transition from the old to the new, John Baldessari represents the new in its infancy. Working outside the photographic tradition from the very beginnings of his career in the 1960s, Baldessari always has treated images as representations, albeit representations prone to radical shifts in context and meaning. His skepticism about their ability to convey meaning free of cultural baggage has carried over into television-derived works such as the *Blasted Allegories* series of 1978. By "parsing" TV images as if they possessed a grammatical syntax or mathematical structure, and by pairing them with words in an arbitrary, ambiguous manner, he allows them to float free of their original contexts. His approach to images, like that of conceptualist artist Douglas Huebler, has greatly influenced the current, media-attuned generation.

The issues of reproduction first raised by Walter Benjamin in his 1936 essay "The Work of Art in the Age of Mechanical Reproduction" do not disappear in an electronic age, of course. They are simply subsumed, incorporated in new technologies, and reflected back in a new light—usually the light of the glowing box in the corner of the room. The box, that ungainly piece of high-tech furniture that interrupts so many French Provincial interiors, is as much an inescapable feature of modern life as the images that issue from it. It is not surprising that artists such as Philip Lorca DiCorcia, Anne Turyn, Tim Maul, and George Legrady have made it a character in their foreshortened, fictive narratives, where it competes for our interest with fragments of memory, text, and human presence. And in Daniel Faust's pictures, it enters the museum; instead of seeing the furniture of television, we see television characters who have assumed to status of furniture. Cast in wax, they possess the predatory pathos of taxidermy.

But more than being an environment for today's artists, television is a site for the image-making process and a fertile source of its images. John Pfahl's *Shock of the New,* for example, shows us a video image of Ansel Adams's famous scenic view of the Yosemite valley, "appropriated" from Robert Hughes's art-education TV series of the title. Pfahl has reproduced this inadequate blur as a "precious" platinum print—a nod to the art market in which Adams's prints once played a major role. Even more television-referential is Allan McCollum's series "Perpetual Photos." By focusing in on the framed images seen in the background of network broadcasts, McCollum reproduces exactly what "art" is on television. As definition is lost, generic forms take the place of individuality.

Most of today's artists, though, use the television image less as a "ready-made" than as source material for a kind of electronic synthesis or collage. In some cases—works by Callahan, Paul Berger, and Thomas Barrow, for example—the television image exists in relation to an external reality; that is, it is framed by references to the world outside of media culture. In other pictures—Bonnie Donohue's poignant *Mary Decker* sequence is one outstanding example—the television image is all there is. As a result, the simultaneous intimacy and distance of television are isolated and reflected back. The effect is not so much hermetic as it is discomfiting, although discomfort here may only be a sign of an unwillingness to concede the future to electronic images.

Today, it has become almost impossible to distinguish between images that are manipulated electronically, as are Nancy Burson's computer-generated composite portraits, and those manipulated by more traditional means, such as Robert Heinecken's TV-newscaster composites and Frank Majore's swank cocktail-hour interiors. It is even becoming impossible to detect what has been manipulated and what is (or might claim to be) genuine. The ultimate point of pictures like these may be that it doesn't matter. Within our image-saturated society, the old standards of reality no longer apply.

If our accustomed ways of interpreting lenticular images—those supplied by both traditional photography and the electronic media—are no longer as secure as they once seemed, what remains? Something slippery, elusive, and spectral, perhaps. In the simulacrum in which we now live, according to Baudrillard and other critics of our day, there is no point of reference that can be fixed and called "real." Even the familiar AT&T logo, as refashioned by Gretchen Bender, slips out of its symbolic skin. And in Sandra Haber's untitled composite panoramas, one sign slides into another until their sums equal zero. Meaning becomes tenuous, friable, provisional.

Obviously television is more than the source material in these pictures; it is also the subject. Its blandishments come, in Paul Laster and Renée Riccardo's apt phrase, in the form of "acceptable entertainment." The term implies a certain resignation. On the one hand, we can live with it; on the other, it barely meets our standards, much less our dreams. It seems safe to say that the work collected here does not attempt to reconcile this paradox, but to dramatize it. What remains to be seen is whether this art is the last breath of resistance to the enveloping dominion of the electronic age, or the first tiny crack in its armor, a path to participatory involvement with a medium that has always seemed more happy to give than to receive.

Written in 1988 and published in *Acceptable Entertainment,* the catalog for an exhibition organized by Paul Laster and Renée Riccardo and sponsored by Independent Curators Incorporated, New York.

Photographic Memory and the News in "Real Time"

WHILE THE PHOTOGRAPHY WORLD WAS BUSY congratulating itself on the 150th anniversary of the medium in 1989, and while photojournalism was being recognized as an art in several touring museum exhibitions, the public territory of still photography was quietly eroding. World events, which still photography has long memorialized, rushed by so rapidly at decade's end that cameras seemed for once unable to keep up.

At least this was true of cameras that use film, the traditional bearer of the news images that become etched in the public mind. But another kind of camera, one capable of sending its electronic signals around the world in what has come to be called "real time," relished the rush of events. It was television that captured most of the memorable images of 1989.

Think, for example, of the aborted democracy movement in China, and the nearly incomprehensible massacre in Tiananmen Square that brought it to an end. Yes, there are photographs of the incredible moment when a lone protestor stopped a column of tanks out of sheer desperation and grief; you can see one on the cover of *Life*'s "The Year in Pictures" issue. But the television pictures of the incident, shown on the network news the same day that it occurred, had an emotional immediacy that still burns in the mind. So what if they were blurred and shaky; the feverish quality of video images can give them an added clout.

Perhaps the Tiananmen Square tragedy conditioned some of us to maintain a vigil around the television set whenever news was breaking. Or perhaps it was coincidence, as when all of America's baseball fans tuned in to watch a World Series game and were greeted with live coverage of the San Francisco earthquake instead. Once again television's video images had the advantage, thanks in part to the circling presence of a camera-equipped blimp.

Conventional photographers managed some vivid shots of the scene, and all of America could see them in newspapers over the course of the next several days. But none conveyed the scope of the disaster as well as the live video images from the blimp, which surveyed from on high the crippled Bay Bridge, the collapsed Nimitz Freeway, and the burning houses of the Marina District. Television cameras

42. NASA, *Exploding Challenger*, 1986

were able to do what still cameras cannot: to sweep from place to place, taking in the enormity of the event without needing to condense or abridge its magnitude.

As for history, nothing seemed more unforgettable in 1989 than the sight of the Berlin Wall being breached while Tom Brokaw stood in front of it, delivering the NBC evening news. The idea that history can happen in front of one's eyes is one of television's most radical contributions to twentieth-century consciousness, and no doubt it has helped fuel popular dissent of the kind that spread through Eastern Europe this fall like spilled gasoline.

Because of its immediacy and pervasiveness, television is now widely perceived to have been an instrumental agent in the toppling of the authoritarian communist regimes in East Germany, Czechoslovakia, Bulgaria, Hungary, and Rumania. The East Germans, in particular, were tuned in not to their state-run television but to West German stations that fed them consumerist messages and shows like *Dallas* and *Miami Vice*. Who can blame them for wanting to join the ranks of capitalism? And who would have thought that Don Johnson's speedboat would become a political instrument?

The view that television is powerful in political terms is held not only by media analysts but also by despots and revolutionaries. In Rumania, the center of the intense fighting between the Army and Nicolae Ceausescu's holdout loyalists was the Bucharest television station. For a time, the new government was actually in residence there. No wonder, then, that photojournalists today feel like an embattled breed, and that photographs sometimes seem more like museum pieces than a part of contemporary life.

The influence of television images raises the question of whether photographs can still render memorable images, and, if not, whether the world is the better or poorer for it. Though especially germane now, when history seems to have suddenly increased its speed exponentially, the question has been lingering in the margins of journalism at least since 1963. It was in that year, on a Saturday morning, that much of the nation saw the murder of Lee Harvey Oswald, President Kennedy's assassin, on live television. Robert H. Jackson's photograph of the killing appeared in newspapers the next day—and later earned the photographer a Pulitzer Prize—but to those who had witnessed it on television, the still picture was only an artifact of the emotional experience from the day before.

Since then, the photograph has slipped further from its erstwhile role of giving events their primary emotional contours. Today, still images function largely to confirm what we have already seen, to serve as mnemonic triggers of visual experience that has already been filtered through the omnipresent lens of the video camera. As images twice removed—at least in terms of our memory of events—they take on the quality of snapshots in a family album, with the distinction that the memories they call up are of things seen, not lived.

News photographs also have begun to take on aesthetic qualities, borrowing freely from the formal innovations of artists in an attempt not only to seize the eye but also to hold it. What used to be called "stoppers"—pictures that made page-turners pause—have been replaced by more complex and self-conscious images intended to be "keepers." Color, which not too long ago was thought to get in the way of bringing home the news, is now nearly universal. Photojournalists such as James Nachtway use colors like nails to hold their pictures in our minds; the color red reads as blood red before it registers as blood.

As a result, some still photographs achieve a kind of emotional parity with television images. The photograph of the wrecked space shuttle Challenger falling to Earth in a sad blossom of twisted contrails sticks in the mind with all the vividness of the footage seen on the network news. Photographs may even have a built-in advantage in some cases; because they are still, they are easier to remember. (This no doubt explains why we see more and more use of "freeze frames" on television, in commercials and also on the news.) But memory is weighted by more than visual stimuli, and television usually cues more of those other associations. I remember where I was when I saw the Challenger disaster on television, but I do not recall where or when I first saw a photograph of it.

What are the gains and losses of having television usurp photography's role in preserving events and making them history? To a degree, there is little difference. The kinds of stories that make for sensational still pictures also make for sensational (and sometimes sensationalized) television. The kinds of stories that seem to elude the 35-millimeter camera—the AIDS epidemic, acid rain, the ozone layer, drug smuggling—also are resistant to videotape. As the coverage of the San Francisco earthquake reminded us, television images need to be supplemented with verbal commentary just as much as still images need captions.

Television does have one unmatched advantage, though: it is on all the time. For those with cable television, news is now a twenty-four-hour-a-day proposition, not a morning read. Coupled with the television camera's ability to sweep across a scene, and its newfound mobility, this unceasing presence gives us a view of events that is less edited and less premeditated than photographs published in magazines and newspapers. But it is also less organized and usually less coherent. Only news events of a certain magnitude are guaranteed to get the attention that would make them stick in our minds.

Unfortunately, television also tends to lower the threshold that distinguishes real events from entertainment. On one hand we get a TV movie of the murder of Jennifer Levin, and on the other we are treated to "dramatizations" of the news—such as the one that showed a spy-style briefcase exchange that was only alleged to have taken place. Certainly still pictures can be manipulated and made to look almost real, but they seem more resistant than television to the conventions of prime-time entertainment.

Television imagery is also inherently commercial, whether it shows commercials or not. If it is not selling the products of the Western world, it is selling itself. To those who credit television with creating unrest in the Communist world, this may seem all to the good, but even as an instrument of liberation television remains essentially consumerist. As viewers, we consume not just the products we see advertised on the screen but also Hollywood's idea of the good life. In addition, news, entertainment, and advertising mix and mingle with an abandon that may inspire East Germans but that ultimately diminishes all hierarchies of visual experience. Everything comes to seem equally interesting and equally a part of history.

If this seems a bit farfetched, consider a commercial that aired over the holidays. An East German soldier, putting a flower in a buttonhole of his uniform, appeared to be celebrating the new liberalization of his country. Then, superimposed on the screen, came the words "Peace on Earth" and, next to them, "Pepsi-Cola." For the world, and especially for Western culture, this may prove the ultimate historic visual image of 1989.

Published in slightly different form in the *New York Times*, January 14, 1990.

Art Under Attack:
Who Dares Say That It's No Good?

ONE CONSEQUENCE OF THE UPROAR over art labeled obscene, blasphemous or otherwise offensive is that the careers of the creative artists whose work is at issue have been given a rocket-powered boost. This was surely not intended by those who have taken the artists and the National Endowment for the Arts to task, but it should not have surprised them. In today's culture, notoriety often equals fame, and fame passes for success.

Unfortunately, the increased attention these artists and performers have gained makes it nearly impossible to evaluate their work. The prevailing critical response has been to circle the wagons. Instead of arguing about aesthetics, critics now spend their time defending the notion that artists can do and say whatever they please. To argue about the merits of artists who have been attacked is, in certain circles, tantamount to heresy, no matter how mediocre their work.

In an era when "political correctness" has become a criterion for judging art, this response is doubly dangerous. For one thing, it plays into the hands of those who equate the outer edges of art with a radical political agenda. And it encourages artists of limited talent to take a shortcut to success by cultivating outrageousness for its own sake.

Two years ago, the names Karen Finley, Holly Hughes, Andres Serrano, and Jock Sturges were little known; and 2 Live Crew was just another rap-group-come-lately. But in becoming the focus of controversy, these artists are now in the enviable position of having their every move watched with intense interest. Even those who already enjoy celebrity benefit from such limelight. One such example is the novelist Brett Easton Ellis; Simon & Schuster abruptly canceled plans to publish his violence-filled new work, creating invaluable publicity.

For the most part, the artists whose work is at the center of controversy are by no means representative of the best talents in their fields. Karen Finley, who wears chocolate as a costume as part of her performance art, is not in the same league as Laurie Anderson or Spaulding Gray, who have honed their individual gifts into unmistakable styles. The photographs by Serrano, who specializes in images of bodily fluids, and Sturges, whose subjects are nude teenagers, have

yet to inhabit the distinctive and personal terrain of Cindy Sherman or William Wegman. The group 2 Live Crew has not shown the talent for musical innovation exhibited by other rappers of equally disputable taste, like the Geto Boys.

Robert Mapplethorpe's sexually explicit photographs, which seem like the first spark in a fire now raging out of control, at least provoked arguments about his importance as an artist. To some his work embodies the essence of contemporary beauty; to others it is simply fashion photography extended to new territory. Once Senator Jesse Helms rendered an opinion about it, however, disputes about the value of Mapplethorpe's work all but stopped. It seemed essential to protect all art, not just unarguably good art, from heathen attackers.

Only recently have critics broken the silence and begun to examine the photographer's artistic legacy with some reasonableness. One such critic is Ben Lifson, a writer and photographer, who takes a dim view of Mapplethorpe's contributions in the fall issue of a newsletter published by Curatorial Assistance Inc., an exhibition service based in Los Angeles. Lifson sums up the situation quite neatly by saying "In this climate, whatever is said about Mapplethorpe largely, if not entirely, degenerates into propaganda."

Propaganda is hardly a form of art criticism, and it does nothing to reconcile the growing tensions between those who believe that cultural life is the ultimate measure of a society and those who feel threatened by what they see as culture's increasingly political agenda. Nor can propaganda make distinctions that can stimulate the emotions and the mind, which is what the arts and criticism are ultimately all about. What is needed at this moment is aesthetic judgments, not political ones.

Suspicions about the agenda of the arts and attempts to limit artistic expression are not unique to our time, of course. Works like James Joyce's *Ulysses* and D. H. Lawrence's *Lady Chatterley's Lover* were kept out of circulation in the United States for much of the first half of the century because of their erotic content. In the 1950's anti-communist ardor resulted in the blacklisting of several screenwriters and authors, effectively halting their careers.

(Paradoxically, controversy often pays for today's artists. In the case of Mapplethorpe's photographs, which were the focus of a much publicized obscenity trial in Cincinnati, more people entered the museums where the exhibition was shown in a month than normally pass thorough their gates in a year. Sales of the 2 Live Crew album that led to the obscenity conviction of a record store owner in Florida have surpassed two million copies.)

One could argue that the urge to suppress artistic expression is a cyclical part of American life, as predictable as artists' urges to violate conventional taste. What makes it different now—as well as surprising—is that it comes after twenty-five years of governmental advocacy for the arts. The National Endowment for the Arts has been more than a grant-making agency, after all; its

mission, and the mission of local and regional arts councils, has been to spread the word that the arts are good and good for America.

Today this supposition is under attack, and cultural life consequently needs to be defended with passion and political savvy. But this should not mean that every artistic utterance that defies convention merits praise, or that art that raises hackles is necessarily more vital than work that does not.

Notoriety not only impairs our ability to judge art on its merits. As the case of Andres Serrano suggests, it can also befuddle an artist. Serrano is best known for his image of a plastic crucifix in a tank of urine, and has become something of an art-world hero for having provoked considerable ire from Christian fundamentalists, among others. But his most recent work marks a radical departure from the images that brought him to public attention, which featured combinations of milk, blood, urine and other naturally occurring fluids.

The artist's most recent pictures are portraits of homeless men and women (a series he calls "Nomads") and of members of the Ku Klux Klan—subjects that seem to reek of chic. The subjects are as fixed and monumental as the New Guinea tribesmen found in Irving Penn's series "Worlds in a Small Room" and no less exotic. The homeless seem like figures from a far-off land, and the Klansmen, in their hoods and gowns, resemble a perverse version of Vatican fashions. If Serrano's subject was once the irreconcilability of the spirit and the flesh, his new photographs seem to be about the mutability of cultural representation. There's nothing inherently wrong with changing artistic direction. But Serrano's present preoccupations seem fueled by a desire to prompt the kind of controversy that his earlier work caused.

For all the interest of their openly "political" subject matter, though, Serrano's new pictures are not always as beautiful to behold as they could be. His large prints are sharp enough, but their colors are acidic and their tonalities are unpleasantly contrasty; in some places, the blank surface of the paper is all that one sees. This is especially true of the Klan pictures, which are the most recent, suggesting that the artist took too little time in the darkroom supervising their production.

Jock Sturges, the San Francisco photographer of nude adolescents, is another artist who has acquired a major reputation despite his relatively minor work. In May, the Federal Bureau of Investigation raided his San Francisco studio and confiscated its contents. The F.B.I. acted after being contacted by a photo processing lab, which suspected that the Sturges pictures it was developing were pornographic.

(The F.B.I. has urged processing labs to report to the police the names of customers whose pictures might be pornographic; under California law, such labs are legally obligated to do so.)

The abrupt seizure of the photographer's work set off shock waves in

California and across the country. Although Sturges's work was not widely known—in addition to making pictures intended to be seen as art, he does commercial photography for a living—the implications for artists were clear, as was the specter of Big Brother.

The pictures that sounded the alarm at the processing lab in San Francisco have not been seen publicly, but some inkling of what the fuss might be about could be gleaned from Mr. Sturges's exhibition at the Vision Gallery in San Francisco.

The more than fifty images in the show were exquisitely printed enlargements, made from large-format black-and-white negatives, of naked young women and a few naked young men. These subjects have been photographed in a direct, candid portrait style that suggests the influence of Jack Welpott and Judy Dater, at places like northern California communes and French nudist colonies. They have names like Danielle, Marine, and Misty Dawn.

In a sympathetic review in the San Francisco Chronicle, the art critic Kenneth Baker concentrated on responding to allegations that Sturges's pictures constituted pornography. "What decisively absolves this work of the suspicion of pornographic intent is its absence of shame," Baker concluded, as if intention were the bone of contention.

But if the work is not child pornography, neither is it good art. Sturges seems too caught up in the Lolita-like qualities of his subjects to be able to fashion an original picture; as a result, the work seems to be one long leer. The history of photography is full of pictures that document the male urge to possess what is otherwise forbidden or untouchable—Bellocq's portraits of New Orleans prostitutes come immediately to mind—and Sturges's pictures certainly fit into this tradition. But whatever the forces of moral rectitude make of them is ultimately less important than the tired way they repeat a thoroughly discredited genre.

As was true in the controversies surrounding Mapplethorpe's and Serrano's pictures, the defenders of Sturges's First Amendment freedoms seem reluctant to discuss artistic values. Perhaps this is because those artistic values are so meager, or perhaps it is because no one wants to be seen as a supporter of Humbert Humbert. In any case, the result is an uneasy silence about the very issues that would be at the center of discussion in a healthy, less politicized, cultural climate.

Artistic freedom should always be defended. But abandoning aesthetic discourse means capitulating to the very forces that seek to politicize, and thus control, all artistic activity.

Published in the *New York Times*, November 25, 1990, and subsequently reprinted in *Culture Wars*, edited by Richard Bolton (New Press, 1992). While the culture wars of the early nineties have since receded from view, the need for a critical visual-arts discourse outside of politics remains an issue in the United States. As might be expected, my assessments of the work of Andres Serrano and Karen Finley have been mitigated in the years since this was written.

Points of Entry: Tracing Cultures

TRACING CULTURES was an exhibition of recent work by artists who employ photography to address issues of cross-cultural adjustment, displacement, and loss from the perspective of their own lives. While several of these artists are first- or second-generation immigrants to the United States, their work is not specifically about immigration, at least as that word is conventionally understood. Nor is it about what immigration "looks like" in the late twentieth century. Rather, it is about the simultaneously personal and political experience of cultural migration and cultural difference, and in particular the frequent conflict between one's culture of origin and an adopted American culture that, while in some respects hegemonic, is at root a medley of diverse, often contradictory cultural influences and impulses.

The idea of cultural migration and difference seems best suited to discussing the work of the artists in the exhibition because of the peculiar history of our national discourse about immigration. As we understand it today, immigration has meaning only in the context of governmental regulation of borders and population, but this was not always the case in the United States. In its first hundred years, our government was more concerned with the issue of citizenship than with immigration; until 1882, the United States had no laws that restricted the flow of immigrants to its shores. For much of our history, immigration was welcomed and encouraged. Only with federal regulation did immigration take on its current, politicized connotations of control, exclusion, and marginalization. Cultural migration as it is used here implies an experience that goes well beyond the crossing of national borders, having to do with a much more profound and long-lasting process of relocation of the very essence of one's community and identity.

Unlike many exhibitions that group artists together, *Tracing Cultures* is not intended to illustrate one curatorial thesis or master narrative. Instead, it reflects a faith that works of art, being products of their makers' intentions, speak for themselves. The twelve artists in the show, two of whom work as a team, take a variety of approaches to the subject of what it means to come from cultures outside of the United States and to confront what is, in effect, a complicated but

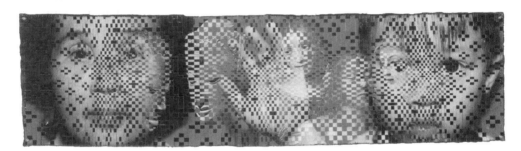

43. Dinh Q. Le, *Crossing Paths*, 1997

well-enforced master narrative that defines who belongs here, who does not, and who decides. Their work reflects a widespread preoccupation with this topic within contemporary art; many more artists are working in this vein than could be included here.

The reasons that artists today are concentrating on the terms of their cultural identity and status within the larger culture of the United States are not difficult to discern. As Ronald Takaki points out in his essay "A Different Mirror," demographic changes are causing us to reconsider what it means to be an American.[18] No longer does the picture of a society made up of European descendants and "others" describe with any accuracy the texture of our increasingly diverse national makeup (in fact, it never did, given the history of Native and African Americans). One could argue that "otherness" is merely a construction created by those seeking to form (or, more recently, to shore up) a simple, coherent version of our national identity. While the Other may be a necessary term in the definition of individual identity, in sociological terms it places artificial boundaries between us. The artists in this exhibition do not represent the Other in American life—or, for that matter, the Other in contemporary art. They do, however, represent a compelling current in the art of our day that embodies new aesthetic and critical concepts, new subject matter and new moral imperatives.

Photographs play a key role in the work of these artists because camera images are tokens of people, times, and places that cannot be recaptured except in terms of the photographic image. Many of the photographs in the exhibition are mementos of the existence of an earlier generation and, in some cases, evidence of the changes that have made the past irretrievable. Memory, and the persistence of cultural heritage despite the intrusions of contemporary American popular culture, are subjects addressed implicitly and explicitly within the context of reusing family photographs from the past. Photographs also are used because they have the cultural status of witness: as testimony, they ground the work in a reality that is assertive, melancholy, nostalgic, and impassioned.

The exhibition includes artists of many backgrounds and cultural origins, but *Tracing Cultures* is not meant to be either a demographic catalog or a representative sampling of artists working in the United Stated today. One might, however, think of the show as a survey of the many possible relationships to what has been called the immigrant experience. While it is fair to say that everyone in the United States comes from somewhere, the hows and whys of our arrival vary radically. The native people of Lewis de Soto's work, "Tahualtapa (Hill of the Ravens)," migrated across the Bering Strait thousands of years before the Spanish, French, Dutch, English, and other Europeans finally arrived on these shores. The Africans brought here in chains from slave ports like the one shown in Carrie Mae Weems's work were immigrants only in the most charitable construction of the term.

Even in the heyday of immigration from northern and southern Europe at the end of the nineteenth century, the experience of arrival was far from uniform. Ships sailing into New York harbor disgorged their first- and second-class passengers directly onto Manhattan Island; only steerage or third-class passengers were then ferried to Ellis Island to pass the rigorous inspections for admission to the United States. But, as Rebecca Solnit suggests in a poetic and profound meditation on her own family's past, memories of where we come from and how we got to these shores can be as much a fabrication as the myth of the melting pot itself.

Artists like Albert Chong, Young Kim, Dinh Q. Le, Komar & Melamid, and Maria Martinez-Canas have experienced firsthand the enduring fracture of moving from the countries in which they were born to this one. Gavin Lee and Kim Yasuda are among an even larger number of artists today whose work tries to come to terms with the decisive cultural journeys of their parents, grandparents, or more distant ancestors. And I. T. O. (whose given name is Shigeki Ito) and Ruben Ortiz Torres bring to the show the perspective of visitors who, in an increasingly frequent pattern, cross borders as readily as their work is able to cross cultures. Like all artists in the show, they draw artistic power by foregrounding their status as cultural migrants.

That cultural migration, diversity, and displacement have become powerful and popular subjects for contemporary artists using photography is hardly surprising; what *is* surprising, however, is how new this work seems in the context of photography's artistic, commercial, and vernacular functions of the past one hundred years. Images through which immigrants to this country addressed their complex, reformed identities (and, one imagines, their marginalized existence as so-called hyphenated Americans) were undoubtedly made, but such photographs have by and large been hidden away in thousands and thousands of family albums passed on from one generation to the next. And photographers seeking to make art did not, until recently, make their own cultural backgrounds the dominant theme of their work.

One likely reason for this lacuna in photography's broad panorama of American life is that for many years there was a widely held belief in the virtue of fitting in; images that classified one as exotic and alien were not tickets to artistic or even material success. At the same time, photography seems to have been harnessed to the task of documenting the many cultures that constitute American culture only in moments of severe political controversy and strife. Lewis Hine photographed new arrivals on Ellis Island, for example, in the context of widespread anger over the economic impact of immigrant labor, and not merely because of an abstract admiration for their inherent dignity. Similarly, the many photographers working today along the border between Mexico and the United States may be motivated by principle, but their work gets its meaning from the politics of immigration in our own historical moment.

Photography often has been called a "universal language," capable of transcending differences of language and of culture. Like anthropology and ethnography, it was thought to have its roots in a scientific, empirical point of view that gave it universal credence. But photography's claim to represent other cultures impartially and fairly is no more accepted today than that of the social sciences; the notion of observation and description outside of culture has been discredited in both theory and practice. This perhaps explains why the artists in *Tracing Cultures* insist on contextualizing the photographic image by fragmenting it, displacing it, and juxtaposing it with painted, sculptural, and other materials—all in the name of a kind of Brechtian awareness of its conventionally-framed meanings. Photography, in their work, is less authoritative and more amenable to individual, idiosyncratic meaning.

What remains for us today is the belief that photographs, in the right hands, can speak not only for those descended from the European culture that developed Renaissance perspective and invented the camera, but also for those who, for much of the medium's history, were consigned to be its subjects. Now, at a time in which cultural identity is being challenged by yet another great universalizer, the computer, the subject of the camera has fundamentally changed. *Tracing Cultures* is about a photography in which subjectivity has replaced subjecthood, and in which the power of representation ultimately rests with those who are represented.

This essay served as the introduction to an exhibition I organized for the Ansel Adams Center for Photography in 1995, as part of a collaborative series of photography exhibitions on the subject of immigration. The catalog also contained an essay by Rebecca Solnit, to which I refer.

Photography's Dark Side: The Work of Sophie Calle

PHOTOGRAPHY'S HISTORY as a form of art has been much discussed and widely documented. What remains less well known and largely unrecorded is the medium's history as an instrument of observation, oppression, titillation and social control. Yet this shadowy, second history of camera pictures has become a significant presence within the discourse and marketplace of contemporary art. Photographs are crucial to art today not merely because they possess distinctive aesthetic qualities but because artists have come to recognize their enormous power to define and maintain social reality.

Sophie Calle is one of these artists. Her mysterious and tantalizing works locate photography in a discourse of voyeurism, surveillance, seduction, classification, and identification—a discourse, in short, of power relations. Combined with staccato quasi-objective verbal commentaries, her photographs seem like documents of a bizarre sociological experiment or, at their most detached, like the issue of a robotic bank camera. But taken together, the work has an unsettling, emotional effect that dislodges the positivist assumptions of the scientific worldview on which photography is based.

Calle's ongoing artistic concern about the social impact of photography as an agent and instrument of power, and specifically its associations with identity, criminality and eroticism, is analogous to critical concerns of theorists such as Roland Barthes, Walter Benjamin, and Michel Foucault. These writers—all of them French with the exception of Benjamin, a German who lived in France—are largely responsible for implicating photography as an historical agent of oppression and control.

Benjamin, the twentieth-century critic who has revised our understanding of photographs more profoundly than anyone else, remarked in 1936 that Eugène Atget's photographs bore comparison to crime scenes. Benjamin was thinking not only of the peculiar sense of absence that the photographs produce—the partly nostalgic, partly anxiety-producing quality that Barthes would later call "photography's *noeme:* That-has-been"—but also of its function as evidence. "With Atget," Benjamin wrote, "photographs become standard evidence for historical

occurrences and acquire a hidden political significance."[19] By linking photography to social deviance and the policing techniques intended to control it, he placed the medium in a political context divorced from any artistic meanings.

In our day the critic who has done more to elaborate the less sanguine aspects of photography is Allan Sekula, who in his essay "The Traffic in Photographs" has written that "... every work of photographic art has its lurking, objectifying inverse in the archives of the police ... every proper portrait of a 'man of genius' made by a 'man of genius' has its counterpart in a mug shot ... every romantic landscape finds its deadly echo in the aerial view of a targeted terrain. And to the extent that modern sexuality has been invented and channeled by organized medicine, every eroticized view of the body bears a covert relation to the clinical depiction of anatomy."[20]

In Calle's work the photograph is both a reflection of political forces outside the artist's control and the means by which she asserts her own power. As a woman, she is eager to claim her own identity from within the confines of conventional social definition—in the terms of Jacques Lacan, she redefines herself by recasting the social relationship of self to "Other." As an artist interested in risk, Calle is eager to assert control in social situations that always contain the possibility of spinning out of control. Her tactical interventions seem designed to test Foucault's observation that "the exercise of power consists in guiding the possibility of conduct and putting in order the possible outcome."[21]

One way of looking at Calle's work is that she makes explicit her complicity as a social actor—she is neither innocent nor objective. More than an observer, she is an active participant in the scenes she records. In "La Filature, (The shadow)" (1981), for instance, she became the quarry of a camera-toting private detective whom, unbeknownst to him, she has hired to follow her. Like most of her work of the 1980s, "La Filature" is presented as a document of an actual experience, backed up with photographs utterly lacking in artistic grace and with words that purport to record what took place during her days as an object of intense scrutiny.

Part of Calle's interest in surveillance is in the disguised mutuality of the observer and the observed. In "La Filature" both are at risk—not just the risk of discovery, which is what we might most anticipate, but the risk of transgression. In other works she flirts more overtly with the dangers of female existence: in "The Sleepers" (1979), she invited strangers to sleep for eight hours in her bed while she stayed in the room to photograph them; at least one participant admitted to having consented to the experiment because he was expecting a sexual encounter. In "The Bronx" (1980), she accompanied men she encountered in one of New York's worst neighborhoods to unknown destinations of their choosing. In "Anatol" (1983), she recorded a trans-Siberian train ride in which she shared a sleeping compartment with a Soviet official (and possible KGB agent).

When not risking physical confrontation or assault, Calle deliberately exposes herself to possible public outrage and humiliation. In *L'Hotel* (1981), she rummaged through the suitcases of hotel guests and listened to their coital conversations while employed as a chambermaid. In *L'Homme au carnet* (1983), she collaborated with the Parisian newspaper *La Libération* in publicly describing the life of a man whose address book she purported to have found. Surprisingly, these fraught adventures have rarely become misadventures. The man who was exposed to her detective work in *L'Homme au carnet* objected to his unwitting participation in the artist's conceptual schemes, demanding and getting an article of his own in *La Libération*, but otherwise she has escaped retribution.

"The transgressive nature of Sophie Calle's work, the curious impoliteness with which she provokes and targets her inquiries is, in a strange way, comforting," Deborah Irmas has remarked recently. "Perhaps it is the understanding that her search is ultimately about what we all seek—knowledge of ourselves." [22] The notion that her subject is "knowledge of ourselves" may explain the direction Calle's work has taken in the 1990s. It has become more psychological, meta-phoric and reflective and at the same time less confrontative, narrative and event-specific. Like Christian Boltanski—an artist whose work seems especially akin to hers—she now uses photographs in an ambiguous but emotionally charged way that seems to capture inner truths rather than explicit reality.

This is certainly true of the focus of her more recent series of large-scale photographs and groups of photographs called *Les Tombes* (Graves, 1990/1991). Lacking the contextualizing frame that we have come to expect for her work, and dependent to an unprecedented degree on the photographs' ability to speak for themselves, *Les Tombes* forsakes the conceptual, "Story Art" heritage of artists like Jean LeGac and Douglas Huebler for an almost minimalist concentration on presentation values. The power of the piece is largely site-specific, and it is less amenable to reproduction than her previous endeavors.

One writer has observed of *Les Tombes* that for the first time in Calle's work, texts are absent. This ignores, of course, the rather weighty presence of words within the photographs themselves. "Father" and "Mother," "Brother" and "Baby," when inscribed in granite, are not incidental notations. What is different in this piece is that the words are not ancillary devices used to frame or contextualize documentary-style photographs, but integral and largely self-explanatory elements of a wholly pictoral presentation. We cannot know whether these gravestones are in any way related to the artist, other than that she has appropriated their images with a camera. (In fact, we are told, the gravestones are in a cemetery in Bolinas, California, which Calle visited for the first time a few years ago.) But this ambiguity lends *Les Tombes* its intrigue and emotional power.

These "found" images move Calle a step closer to forsaking the overtly conceptual, process-art orientation of her work of the 1980s—with its overtones

of LeGac, Huebler, Vito Acconci, Gordon Matta-Clark and, most obviously, Joseph Beuys. Rather, like Barbara Bloom, Barbara Kruger, Dennis McAdams, Alfredo Jaar and many other artists in their thirties and forties, she seems to have adopted an installation style that emphasizes physical presence and materiality or, conversely and perhaps more accurately, absence and immateriality.

She also is no longer the protagonist or antagonist of her pieces; indeed, the narrative function that required her presence has largely vanished. This is true not only of *Les Tombes,* but also of her recent contribution to the exhibition *Dislocations*, a 1991 survey of installations-oriented art organized by Robert Storr at the Museum of Modern Art. Calle's "installation" was a form of subtractive interconnection in the museum's painting galleries: she removed several popular canvases from the walls and replaced them with descriptions of the paintings furnished from memory by museum staff members. The piece was called *Fantômes* (Ghosts); in France, *fantôme* is the name given the labels that explain why a painting has been removed from exhibition.

Likewise, Calle's piece in the 1991 Carnegie International in Pittsburgh emphasized what might be called the presence of absence. In this case, Calle photographed the galleries of the Isabella Stewart Gardner Museum in Boston, where a much publicized art theft took place two years ago; her pictures show the empty spaces, still marked with labels, where the stolen pictures once hung.

While *Les Tombes* is about stones that are etched to memorialize the dead, and not fine art canvases and their display, there are several similarities among these three recent works that are worth noting. All are focused on rectangular containers that are meant to mark, if only in a metaphoric way, the removal or absence of what once was present. In addition, the physical nature of the work itself—sheets of paper, photographic or otherwise—is insignificant compared to its subject. Calle's photographs of gravestones are immaterial compared to the gravestones themselves, which in turn are lifeless slabs compared to what they represent, actual human lives.

The family relationships that these gravestones signal but do not explicate give *Les Tombes* a weighty, fraught overtone that is not far removed from that produced by Christian Boltanski's accumulations of tin boxes, children's clothing and blurry portrait photographs, which together serve to suggest involuntary death on a massive scale. But with Calle one has to suspect that the true subject is not death but how death is represented. Her unadorned, straightforward photographs can be seen as part of a chain of representations that begins in complex human presence and ends in a gallery space where we, as viewers, struggle with the poverty of our aesthetic responses. Once again Calle, with a brilliant economy, has made us uneasy voyeurs.

Mills College Art Gallery Bulletin, Vol. II, 1991–1992.

Sweet Illusion: Vik Muniz's Sigmund

VIK MUNIZ'S *SIGMUND*, 1997, is a 5-by-4-foot color photograph of a drawing made with chocolate syrup on a 5-by-4-inch piece of white plastic. Muniz used a view camera mounted on a copy stand to take the photograph, a straight pin to draw the portrait, and Bosco brand syrup as his medium. When he finished, he licked the plastic clean.

Such dislocations of scale, medium, and aesthetic expectation are a source of pleasure to this thirty-five-year-old, Brazilian-born, New York-based polymath; more to the point, they're his artistic stock-in-trade. Muniz calls himself a "low-tech illusionist"—"more in the tradition of Ricky Jay than Siegfried and Roy"—and his legerdemain has the virtue of being both witty and challenging. Photography, with its claim to verisimilitude, plays a large part in the illusions he creates, but the more traditional mediums of drawing and sculpture are essential as well. In the last seven years he has produced drawings based on his memory of famous photographs; photographs of sculptural "drawings" constructed from wire, thread, and cotton balls; a series of bogus newspaper articles incorporating his own bogus photographs; and other conundrums of materiality and appearance.

In an age when the notion of "the original" seems all but overwhelmed by a flood tide of digital technologies and Derridian-do, Muniz might seem the proverbial Dutch boy with his finger in the dike. Yet for all his work's material uniqueness, "originality" is less a claim than a foil. In the case of *Sigmund*, the skill and conceptual audacity involved in drawing a portrait with chocolate sauce is mediated by the final product: a photograph. The painstakingly con-structed drawing is erased with a swipe of the tongue; all that remains is a second-order representation, a convincing but nonetheless approximate simula-tion that is somehow stranger and more affecting than the chocolate original.

Muniz taught himself to draw with chocolate syrup not long after mastering the process of drawing with sugar. In both cases, his aim was to stretch the norms of what constitutes artmaking, to produce work that "revolves around the principle of translation." In *Sigmund*, which is part of his ongoing "Pictures

of Chocolate Series," the act of translating a drawing into a photo-
graph that recalls a painting opens a gap in the formal and syntactical chain that
we construct whenever we attempt to decipher a work of art. This image is, in
its own peculiar way, as degraded as a painting on black velvet, but Muniz's
ingenuity in choosing his materials and his ability to turn those materials into
willing servants of his adaptive draftsmanship enable the picture to comment on
the very devices of representation it employs. *Sigmund* is at once a
demonstration of Muniz's mastery over his quirky medium and a reminder of
how readily the codes of our common visual experience can slide into travesty.

Of course *Sigmund* is not only a fascinating translation of means and
materials—pin for pen, syrup for ink, plastic for paper—but also a portrait of
the founder of psychoanalysis, whose distinctive visage is not only readily
recognizable but immediately conjures the whole history of this century-
defining discovery. "The chocolate pictures started with the material and then
progressed toward the search for suitable subjects. Freud was very appropriate
because the piece dealt plainly with desire and representation. Everyone I
know loves chocolate, but it is difficult to explain why you love the taste of
something. Psychoanalysis was set up to tackle problems of this nature, to give
a 'meaning' to emotions, instincts, and sensations," Muniz explains.

Other pictures in the chocolate series include near-photographic images of a
couple locked in a Hollywood-style embrace; a woman rowing a boat in a
river; another woman dropping a plate on the floor; and a portrait of
Napoleon. "I believe all the images in the series to be descriptions of dreams
or delusions," Muniz notes, adding that his next undertaking in chocolate
syrup will be a re-creation of a famous Hans Namuth photograph of Jackson
Pollock making a drip painting.

Muniz's scrambled but apt references to history, and particularly to art his-
tory, are as characteristic of his work as they are of Mark Tansey's. In *16,000
yards (After the 1854 cliché-verre by J. B. C. Corot, Le Songeur)* from the
"Pictures of Thread Series," 1995–96, the artist essentially duplicated Corot's
experimental photographic drawing of a landscape using an enormous quantity
of black sewing thread (the 16,000 yards of the title). In exhibition, Muniz's
black and white photographic print is hung near a pedestal displaying a tangled
ball of thread used to make it. The image alludes to the impact of photogra-
phy's invention on nineteenth-century artists and, with admirable economy,
demonstrates the medium's current ubiquity.

Muniz's sense of play sets his work apart from most recent conceptually
based artistic practice, which has often treated the overlap of content and
form with painful seriousness. Much as William Wegman and Robert
Cumming did in the 1970s, Muniz demonstrates that serious conceptions are
sometimes best expressed with wit. Coming from a country where the

functions of poets and philosophers often overlap, Muniz is fully aware of the
meanings of his manipulations and of their relationship to a state of linguistic
indeterminacy. It is as if he were illustrating the sensibility of writers like
Borges, Calvino, García Márquez, Nabokov, and Pynchon, who are able to
convey the contingency of meaning even as they construct elaborate chains of
signification. As Calvino once put it, "I play the game, in other words, the
game of pretending there's an order in the dust, a regularity in the system, or an
interpenetration of different systems, incongruous but still measurable, so that
every graininess of disorder coincides with the faceting of an order which
promptly crumbles."

Muniz's penchant for setting up a gamelike arena for his art, complete with
rules and boundaries, is evident in one of his best-known bodies of work, the
"memory renderings" of 1990. Sometimes referred to as "The Best of *Life*,"
these black and white photographs document pencil drawings Muniz made
from his memories of *Life* magazine's most iconic images. *Memory Rendering
of Tram Bang* is a passable (and, more to the point, recognizable) rendition of
Nick Ut's prizewinning picture of a naked Vietnamese girl fleeing an American
napalm attack. Published in *Life* in 1972, the picture helped crystallize the
country's broad-based antiwar sentiment; redrawn and rephotographed by
Muniz, the image is a container emptied of its historical horror—a new kind of
"life drawing," one appropriate to a postmodern world.

Muniz himself sees his work as analogous to crossword puzzles, which
different people solve via different routes:

> The nature of every game is to provide a conventional structure where people can
> sense their individual capacities. In my structures, everything that is general,
> conventional, common sense, folk psychology, grammatical, etcetera, is taken
> into consideration and carefully measured to force the player to assume a
> dynamic attitude toward it. Some are games of attention, when the
> representational systems are very similar, and some are games of association,
> when the representational systems are either very different or open.

Muniz's "Cloud Pictures" of 1993 (aka the "Equivalents" series) are an
example of the latter. These photographs depict cotton-ball sculptures that
mimic fluffy clouds which assume the shape of recognizable objects—a pair of
praying hands, in one case. The pictures are easily referenced to Alfred
Stieglitz's own series of cloud pictures produced mostly in the 1920s, but with-
out the aspiration to metaphorical transcendence. Instead, Muniz provides an
easy (and perversely dopey) reference for his "clouds," while also letting you
know they aren't clouds at all, but cotton. Here again, the "low-tech illusionist"
revels in the unstable territory between object and image, material and repre-
sentation, fact and metaphor.

The chocolate series followed immediately on the heels of a 1996 series "The Sugar Children," a group of six portraits drawn with sugar on a sheet of black paper and then photographed. (Each portrait was "erased" by clearing the paper of granules before starting on the next one.) When he exhibited these in New York last December, Muniz included, as part of the installation, jars of the sugar he used to make the drawing. Whereas the sugar had a strong sociopolitical connotation—the portraits were of plantation workers' children, whom Muniz had photographed on St. Kitts—the chocolate gave rise to more elusive associations. Muniz notes:

> I usually pick materials based on the potential for association they offer. I could do still lifes with wire, but I needed thread to do landscapes and powder to do portraits. I guess that since I had covered most of the genres of Western art I started to explore different ways of rendering them.
>
> Basically, at first I was working with the formal properties of these materials, but recently I became curious about associations that occur outside the realm of vision. The use of chocolate, for example, appeals to other senses, forcing the amount of cognitive play involved with the apprehension of the image to become even more complex. My choices of material have something to do with my choices of subjects, but the opposite is also true. Sometimes, as in the case of "The Sugar Children," the subject inspires and influences the material.

Using chocolate upped the sensory ante of Muniz's work, and it also led to two changes in presentation: large scale and color. *Sigmund* and its companion pieces are Muniz's biggest photographs to date, and in this respect they mimic painting more than conventional drawing. In part the resemblance was inevitable: chocolate syrup looks like paint and, as Muniz points out, even behaves somewhat like it. "The chocolate pieces have the 'feeling' of painting because they are larger than life and deal with physical pleasure, but the reason I made them at first was to try to make a drawing that required a certain amount of speed—chocolate either spreads or dries, depending on the amount of time between the drawing and the photo. In any case, I had a lot of physical pleasure executing those drawings—not to mention that I ended up eating a lot of the chocolate."

And while he had rarely used color photography before, Muniz found that color was necessary to render chocolate as chocolate. "Black-and-white chocolate is not chocolate; it's blood," he says, insisting that Alfred Hitchcock used chocolate syrup in *Psycho's* shower scene. Besides providing the requisite chocolate-brown tones, color film also emphasizes the specular highlights and prismatic effects produced when the liquid is photographed—effects that give the final image its tantalizing, faux-finish look.

For Muniz, drawing and painting are allied but syntactically different means of imagemaking: drawing is closer to language and more numeric, he declares,

while painting is "totally analog." Fittingly, he believes that his virtuosity as a draftsman stems from a childhood inability to cope with language. "When I was a kid I suffered from attention-deficit syndrome, and I could hardly finish a sentence I started," he remembers. "I would jump from subject to subject, making it very difficult for people to follow what I was trying to say. I always had to draw pictures and diagrams to illustrate my arguments." But it is photography that both inspires and makes possible his navigations between the syntactical and the pictorial. Of his photographic turn, Muniz says:

> I became more involved with the medium after I was working as a sculptor and had my pieces photographed for documentation. It was then that I realized I was after the images of those objects more than I was after the objects themselves.
>
> What really fascinates me about the photographic process is that it endorses the existence of things. A chocolate puddle with the likeness of Freud becomes a part of the same history as its notable subject. It did exist sometime and somewhere as an object in the world. Photography objectifies even flat representations. It reveals their real identity as objects.

The verisimilitude, essential to Muniz's illusions, that is made possible by the camera allows him to consider not only how photographic representation reflects cultural and social norms but also its means of production—the materiality of the two-dimensional image. Despite his fascination with photographs, Muniz remains a happy materialist. "A visual artist who isolates himself from contact with the material is putting himself in the position of the spectator. It's an enjoyable position, but unfortunately not a very ambitious one."

Published in *Artforum* 36 (September 1997).

J. John Priola: The Photograph as Index

IF WE ACCEPT THE NOTION that the major preoccupation of artists using photography in the 1980s was to demonstrate that photographic images are mere representations, as artificial and as subject to the codes of culture as paintings and drawings (albeit in many ways more functional and influential), then the task taken up by J. John Priola's generation of photographic artists is to reestablish our faith in the medium's essential connectedness to its subject.

Perhaps this long and complex opening sentence needs elaboration, although I would hope that the images in *Once Removed*, Priola's first book, are ultimately sufficient to make its meaning perfectly clear. Suffice it to say that at least since Cindy Sherman's "Untitled Film Stills" series of the late 1970s (and let us also remember Andy Warhol's silkscreen "Disaster paintings" of 1963–64), critics and artists have focused on photography as a mediating agent within contemporary life. Pictures, especially camera pictures, are seen to stand in the way of our experience of the "real thing"—or, worst-case scenario, to obliterate and thus obviate the very notion of the real. Instead of living in a world that can be portrayed by images, that is to say, we live in a world of images, one that betrays our own contingency through the infinite regress of the production and reproduction of camera pictures. Photographers of the 1980s sought to mobilize their art in recognition of this condition through a variety of now-familiar postmodernist devices: appropriation, montage, fracture, simulation, tableau.

By the end of that decade, however, there were signs not only of postmodernism's own regressive contingency but also of photography's resistance to its theoretical stereotype. The work of Mike and Doug Starn, for example, urged viewers to consider the photograph not as a reproductive artifact but as a material presence: as a thing itself. In the late 1980s, English artists Susan Derges and Adam Fuss, among others, began returning photography to its primitive, camera-less state as a means of teasing out its representational authenticity devoid of cultural interpolation. Their photograms are essentially

44. J. John Priola, *Vince*, 1995

records of the presence of objects made directly by the action of light on sensitized paper—as unmediated as photography can get.

Looking back, one might wonder whether Roland Barthes's book *Camera Lucida,* in which he asserted that the essential message of the photograph is "That-has-been," was published not in 1981 but in 1991. For photography as an art spent most of the decade of the 1980s assiduously denying the camera's ability to capture anything as concrete and poignant as traces of the past. Not only was reality obviated by the camera but history as well, and the object in front of the lens therefore could be said to exist in a kind of permanent purgatory. Only recently have we returned to consider Barthes's astonishing but nearly forgotten statement "What I intentionalize in a photograph . . . is neither Art nor Communication, it is Reference, which is the founding order of photography."

J. John Priola's concise, precise and utterly poignant pictures reassert Barthes's contention that Reference is the founding order of photography. Employing simple objects to evoke complex associations and feelings, his images reject the ahistorical limbo to which the photographic subject was consigned fifteen years earlier. They do this in a way that is extremely simple and ingenious: they show us what we are to look at and no more, and, in their composition and presentation, they become as much objects as the objects they describe.

In "Paradise," which is where we and the book begin, Priola's photographs function like spotlights, round and revealing. Some of the pictures in the series seem to wish us luck; others suggest that chance encompasses danger as well. In one, a diamond-shaped portrait of a man stands as testimony to both memory and mortality, self-reflexively doubling the photograph's message. In the series "Saved," the now-rectangular but still iconic pictures bring us closer to the subjective condition of the artifact. Images appear that are like objects, and these objects are then described in images—a process that collapses their differences. Yet who would be so insensitive as to not notice that the subjects of the pictures are creased, torn, tattered and otherwise marked by the passage of time, whereas the photographs themselves are as pristine as a freshly laundered shirt?

The pictures in the book's final section, "Residual," give themselves up more slowly, as a gradual shift in Priola's attention from presence to absence becomes more acutely felt. The subject recedes and becomes ephemeral: a puff of smoke, a spiders web, the trace on a wall showing where a picture once hung. In the end, the insistently concrete directness of Priola's gaze—which may explain why I continue to think of these pictures as portraits, not still lifes—encompasses not only material objects but also their nearly immaterial remains.

The notion of the photograph as a physical trace of its subject is one that can be traced through twentieth-century thought from C. S. Peirce's pioneering study

of signs to Rosalind Krauss's seminal 1977 essay "Notes on the Index." As
Peirce theorized and Krauss seconded, photographs "are in certain respects
exactly like the objects they represent" and thus are less metaphorical than
indexical.[23] One can think of this indexical functioning in Priola's work almost
literally—in the pictures of two-dimensional photographs and drawings, for
instance, the change in thickness from original to reproduction is nearly negligi-
ble—but also, and probably more profitably, associatively. For what is traced in
these photographs is not merely the object, or the sign of its residual physical
presence avant the photograph, but the echo of its historical resonances and place
in time. As a result, *Once Removed* is tinged with a sense of loss and regret ap-
propriate to our age and to the circumstances of our culture. Its consolation is
that J. John Priola has refreshed our faith in photography as an instrument of
undiminished versatility and veracity.

Published as the introduction to *Once Removed, Portraits by J. John Priola* (Arena Editions, 1998.)

Photography Beside Itself

WE NOW FIND OURSELVES in a predominately visual culture in which
camera-based images have become the common coin of representation and the
means by which we receive most of our information about workings of the
world. It is not surprising, then, that photographs have become central to visual
artists and have themselves become subjects of intense artistic investigation.
Whether they are abstract or minutely descriptive, single or multiple, straightfor-
ward or painted over, photographs now reflect not only on the world but also on
themselves. This self-reflexive condition, much more than the medium's status
within the art market, is what gives photography its important and engagingly
problematic status within contemporary culture.

This is not to say that the medium has been adequately recognized for its
central place in twentieth-century modernist art. Photography remained largely
on the margins of art-world consciousness until the late 1960s and early 1970s,
when the existing hierarchies gradually and grudgingly began to give way.
Yet by the 1980s, photography was recognizably essential and inescapable in the
contemporary art world. Painters and sculptors, no less than curators, critics and
collectors, had to account for its powerful presence, either by defining
themselves in opposition to it or by facing the challenges it makes to
conventional notions about art and aesthetics.

The story of this unfolding and flowering of photography's promise has been
told elsewhere, but its irony is seldom fully appreciated. For photography's
triumph as an art to be taken seriously came just at that moment when
modernism's insistence on the primacy of medium—painting as painting,
sculpture as sculpture, photography as photography—was being trundled off to
long-term storage. Photography *qua* photography, whether in the form of the
hand-camera dexterity of Robert Frank and Garry Winogrand or the carefully
crafted landscape "visualizations" of Ansel Adams, became accepted as a
collectable realm, but it held little interest for an art world introduced to
photographs as documents of performances, earthworks, and a variety of
conceptual maneuvers. Artists who early on adopted photography as part of

their work—Robert Smithson, Bruce Nauman, Ed Ruscha—had scant relationship to the tradition of photography as a self-conscious art, which as it happened was the very tradition on which the nascent photography market relied. In effect, the art world's adoption of photography was predicated on a covenant that it drop its claims to uniqueness as an art form and adopt the postmodern premise of a world in which all images are equally grist for the artistic mill.

This did not stop artists such as Sherrie Levine and Richard Prince from using photographs specifically to challenge the paternalistic tenets of the oiled and bronzed modernist past, but it did cause profound consternation among those to whom photography was a deliciously different kind of art.[24] Throughout most of the twentieth century, those who cared about the medium had labored intently to erect independent traditions of artistic practice, criticism, and scholarship. The resulting canon of the art of photography, first voiced in a modernist context by Beaumont Newhall in 1939,[25] allowed for the creation of masters and masterpieces and for individual and museum collections to claim to represent "the history of photography." But just as these collections were celebrating their preeminence with exhibitions occasioned by the 150th anniversary of photography's first public announcement, the canon on which they were based was being emptied of its authority. In the context of contemporary art, photography's sesquicentennial bash was a well-disguised bust.[26]

One reason the anniversary celebrations wore such a lugubrious air is that contemporary practices involving photography seem at first to have little to do with the grand traditions inscribed in the existing histories of photography. Certainly none of the anniversary exhibitions managed to make a coherent connection between, say, Alfred Stieglitz and John Baldessari. Whether this was a fault of the scholarship on which they were based or a failure of curatorial imagination is difficult to say, but it is clear that there are precious few collections now in existence capable of shedding light on the crucial transition between photography's historical traditions and its contemporary practices.

This is why *After Art: Rethinking 150 Years of Photography,* selected from the collection of Joseph and Elaine Monsen, represents much more than merely a recognition of individual connoisseurship and finely tuned acquisitions. Like the recent exhibition *The Waking Dream,* a breathtaking survey of the medium's first 100 years from the collection of the Gilman Paper Company,[27] *After Art* attempts to reconsider and hence revitalize our way of looking at photographs. Unlike the Gilman exhibition, which limited itself to the nineteenth century and the early decades of the twentieth, *After Art* concerns itself with the connections between the past and the present forged over the last 150 years.

In some ways the exhibition is a radical assertion, a risky business at best. Just as no one was willing to admit photography to the larger history of art until

recently (as recently as the last update of Jansen's *History of Art!*), few are especially sanguine about the notion that the innovative practices of contemporary artists making use of photography are in some way tied to the traditional view of photography's history. But the connections are there. Smithson was fascinated by Muybridge; Bernd and Hilla Becher are able students of August Sander. The aspects of photography scorned by an earlier generation of artists—its veracity, its facility, its descriptive mode of representation, its social instrumentality, its use in popular culture—may have seemed irrelevant to the project of abstract painting, but these aspects are precisely why the medium became privileged by artists of the last quarter-century. Today there is little sense of a gap between art and photographic practice, but a nagging sense of a missing narrative to explain how the transition from frog to prince was accomplished.

The interconnections revealed by the exhibition are tentative, to be sure, but they are a needed first step on the road to reimagining photographic practice not as a discrete enterprise but as an integral outgrowth of the conditions, cultural and social, that govern art making as a whole. What one can learn from looking at photography in this way, paradoxically, is that it does indeed have unique attributes, in terms of both its representational system and its social functioning. These idiosyncrasies were once portrayed as the sole province of photographers, but they have been appropriated by contemporary artists to convey in particularly telling fashion the major themes of late twentieth-century art.

One of the most available ways of seeing the connections between the traditional history of photography and contemporary practices is in the genre of landscape. The relationship between nature and human beings is a subject as old as art itself, and one that is inscribed as one of the history of photography's most notable features. Some of the most impressive and engaging pictures ever taken are nineteenth-century views of places as far apart in place and sensibility as the Egyptian pyramids and Cape Horn on the Columbia River. These landscapes share an almost tangible sense of discovery, as if the photographer were forming the landscape purely on the basis of his spontaneous reaction to an unexpected, edenic vista. This conceit—that the earliest photography is a kind of visual primitivism, linked to raw, innocent seeing—retains its appeal today amongst a broad public, but it also is being challenged by contemporary artists interested not only in the scenic possibilities of the landscape but also in its functional and instrumental discourses.

Lewis Baltz's views of the construction of Park City, Utah, for example, bear more resemblance to the Martian landscape portrayed by an unmanned NASA space probe than to the romantic, accommodating Nature of Roger Fenton's views of England's Lake District or even the Bisson brothers' potentially hazardous scene of Alpine climbers. Baltz's project, like that of Robert Adams,

Joe Deal, Frank Gohlke and Richard Misrach, has been to demythologize the landscape by purging it of any sign of hospitality toward humanity. This reified, topographic practice struggles to balance beauty and despair, looking to nineteenth-century precedents like Timothy H. O'Sullivan and Carleton Watkins for a style rooted in seeming objectivity and calculated distance.

What Baltz and the others bring to the table that O'Sullivan and Watkins do not, however, is irony and disappointment (and, particularly in Baltz's "New Industrial Parks" series, a sense of Minimalist aesthetics). Their natural world is not a display for human benefit but a reflection of human failure, a failure of the imagination that allows the land to be altered, undermined and abused to provide for our needs for comfort, recreation and profit. Their photographs are rooted in our late-twentieth-century awareness of the distance between ourselves and the rest of the natural world.

This distance may seem irremediable in the context of Baltz's adamant stance, but others of his generation are attempting to bridge the gap. Mark Klett, whose pictures of the West are suffused by a profound understanding of nine-teenth-century exploration photographs of the same territory, has found ways to personalize the landscape and at the same time acknowledge his presence in it. Klett's pictures focus attention on incidental, intimate and transitory aspects within nature's domain, like his party's campsite, suggesting that human pres-ence does not automatically defile the grand aspirations of the landscape. In this sense his work is less like that of the exploration photographers and more like the matter-of-fact, unglamorous views of Darius Kinsey, William Rau and, closer to the present day, Wright Morris.

Like Klett, the British artist Hamish Fulton inscribes his own presence in the landscape, documenting his various treks and walks with pictures that are as eloquent as they are remote. His emphasis on his own experience displaces the traditional photographer's assumption that the image is the main event; Fulton's pictures, like James Turrell's images of his Rodin Crater earthwork, stem from a need to document artistic processes, not natural ones. Still, the ambivalent, sometimes longing relationship with the nineteenth-century sublime of Turner and Ruskin links their work to that of photographers like Paul Caponigro and Linda Connor, as well as to the modernist landscapes of Ansel Adams and Edward Weston, for whom the sublime was less an issue than a much-desired goal.

The contemporary ambivalence about how human beings fit in the world is especially obvious in photographs of the built environment. Unlike the American West, where one can presume to experience untrammeled nature, cities and towns offer the photographer evidence only of the human effort of their making. For photographers of the nineteenth and early twentieth centuries, this evidence was magnificent and inspiring; it was as if the sight of Rouen Cathedral or the New York Central's rail yards was recognition of the worth of

the human species and, ultimately, of the human spirit's connection to God. For nineteenth- and early twentieth-century photographers, photography, progress and industrial capitalism were directly connected by an uncritical, positivist faith. The pride evident in Berenice Abbott's view of Wall Street was already an anachronism by the time she took the picture in 1938, since during that decade most pictures of urban life came to be marked by a deep, Depression-induced pessimism. For photographers, this pessimism has lingered throughout the rest of the century.

Pessimism about the character of modern life has not been limited to photography, of course, but photographers have conveyed that spirit with particular skill. From Russell Lee's Depression-era *Unemployed Workers in Front of Shack with Xmas Tree, East 12th Street, New York City* to Robert Frank's and William Klein's caustic surveys of a dyspeptic America in the 1950s, the premise of our social organization has been graphically undercut. More recent assays of urban existence, such as those by Lee Friedlander, have stepped back from the declarative tone of the social documentary tradition, preferring a more open-ended outlook as a means of engaging the viewer. Stephen Shore and Thomas Struth seem stubbornly neutral compared to Baldus and Atget; Jan Groover seems more interested in the vagaries of urban display than in the actual experience of city life.

Whether one talks about photographing wilderness or the city, there is now an overriding reluctance to glorify the subject for its own sake. This may explain why some of the most interesting young camera artists, like Adam Fuss and Mike and Doug Starn, seem to forgo descriptive representation in favor of a more direct, expressive relationship with the materials of photography themselves. Fuss's photograms, and the Starns' collaged and stained pictures, focus attention not so much on *what the photograph is of* but on *how photographic meaning is constructed*. Similarly, the figurines used in the work of David Levinthal and Laurie Simmons and the full-scale models and costumes lately used by Cindy Sherman suggest a displacement in the subject's importance, or at least in the importance of the subject's being perceived as real.

This is not to say that subject matter has ceased to matter in contemporary photography, only that long-held assumptions about its inherent significance and its role in determining the meaning of photographic images are being questioned. In James Welling's photograph *Untitled,* 1989, for example, the drapery that constitutes the entire subject matter of the picture is an ironic commentary on its own status; forced from its conventional position in the background, it reveals itself to be a mute but nonetheless evocative container of symbolic meaning. Welling, in this picture and in all his work, forces us to reconsider the ontology of photographic meaning and, in the process, to recognize that the photograph's subject is not identical to (or simultaneous with) its content.

At best, artists today seem intent on reaching an accommodation between their lives and the diminished sense of possibility offered by a world enmeshed in environmental, social, and geopolitical disarray. Behind this attitude is a particularly postmodern sensibility that has had to confront not only a super-abundance of images produced by the camera but also the discourse of stereo-typicality that these images create. This "image world,"[28] which suffuses contemporary culture and shapes it and us in ways only just beginning to be understood, has profoundly changed the role photography plays in the overall arena of art, widening its aesthetic territory and attracting artists from outside its traditions and past practices. It has also made photography itself an issue, at the same time that the medium's representational and instrumental functions have become central topics in current critical theory.

In the nineteenth century, heroic stature and individual genius were taken for granted, as the epic cataloguers of greatness, Julia Margaret Cameron, Nadar, and Hill and Adamson among them, ably demonstrate. Nadar's pantheon of the great was more than an index of Second Empire French society; it established the notion that celebrity and stature were coincident. Cameron's Pre-Raphaelite portraits gave Renaissance men like Sir John Herschel an aura of saintliness oddly commensurate with their Victorian pragmatism. This sort of portraiture, carried over into the twentieth century by *Vanity Fair* (in its original incarnation) and later by fashion magazines like *Harper's Bazaar* and *Vogue*, helped sell the idea that history was the story of great men and their actions. Marx's view of history, so central to shaping the central conflict of our times, remained invisible.

The notions of greatness, genius, and mastery on which portraiture has always depended have been challenged by postmodern theory and practice, as roles replace identity, stereotypes replace individuality, and repetition replaces uniqueness. We can see these shifts most obviously in the work of Cindy Sherman, but they also are major currents in the photographs of Tina Barney, Louise Lawler, Sherrie Levine, David Levinthal, Frank Majore, Richard Prince, and William Wegman. All of these artists have taken as their subject photographic reality, not the world itself. Richard Prince has even argued that the world of the already photographed is now the only reality available to us.[29] To some (especially to some traditional photographers) this may seem a repugnant and sorry conclusion, ruling out any spontaneous, direct contact with the natural world, but to Prince and other post-moderns the déja vu condition of contemporary life opens up new and valuable territory for the visual arts. Besides, regret is not likely to change it.

Any survey of the terrain of contemporary art activity needs to account for this fundamental change in the prospects for photography. It lies at the heart of the work of John Baldessari and Robert Heinecken, which focuses on the sub-liminal and not so subliminal messages of the media, of the discomfiting, staged self-portraits of Robert Mapplethorpe and Bruce Nauman, of the bizarrely plot-

ted procedures of Vito Acconci, Sophie Calle, and Robert Cumming, and of the casual records of sybaritic pleasures found in the photographs of Jack Pierson and David Salle. It also helps explain a current fascination with trespassing on the innocence of photographic information, with revealing the typological orders that create stereotypes in the first place, and with stripping away the subject and reducing representation to its essentials.

The urge to elaborate on the conventions of photographic appearance, often in ways that disregard or obliterate lenticular information, can be traced to early modernists like May Ray and Herbert Bayer. Their lack of allegiance to the givens of the camera, as exemplified by their use of cameraless photograms, collage and multiple imagery, provided a legacy for later artists, like Clarence John Laughlin, Arthur Siegel, Jerry Uelsmann and Duane Michals, who strayed from the "straight" photographic aesthetic of their respective eras. Today, this essentially Surrealist tradition can be located in the work of Joel-Peter Witkin and other artists for whom the encounter between lens and subject is merely a staging ground for their own fantasies.

What the European Surrealists also discovered—and what has been truly appreciated only recently—was that photographs did not have to be manipulated or combined to appear fantastic, eerie, otherworldly or bizarre. Indeed, the camera sometimes seems to leak subconscious information unintentionally, and to catch the everyday world at moments when its seams are most exposed. Diane Arbus, with pictures like *A Family on Their Lawn One Sunday in Westchester, New York,* 1968, revealed a wonderful aptitude for finding Surrealist tableaux even within the banal fields of everyday life. It was Arbus, more than any other photographer, who led Susan Sontag to conclude, in *On Photography,* that "Surrealism lies at the heart of the photographic enterprise: in the very creation of a duplicate world, of a reality in the second degree, narrower but far more dramatic than the one perceived by natural vision."[30]

The last essay in Sontag's *On Photography,* it should be remembered, is titled "The Image-World." But Sontag is no postmodern; her enduring and repeated complaint about photography is that it displaces and thus devalues first-degree reality. One consequence, for her, is that we become prisoners of the image world and adopt the manner of autistic consumers: "Despite the illusion of giving understanding, what seeing through photographs really invites is an acquisitive relation to the world that nourishes aesthetic awareness and invites emotional detachment."[31] Ironically, however, her complaint was made just as art photographers were recognizing how to exploit the difference between photographic reality and reality itself, to make that difference visually clear and, as a result, inviting us to critically examine the ways in which photographs (commercial, vernacular, historical) shape our perceptions. These were images that gave themselves up to fiction, not fictive masks of reality.

This emphasis on the fictive qualities of the photographic image has become pervasive in contemporary photography and, not surprisingly, can be found in the work of artists with no particular allegiance to the medium. In Europe, artists working in the tradition of Joseph Beuys and primarily identified with the resurgence of Expressionist painting, including Anselm Kiefer, Gerhard Richter, and Sigmar Polke, have employed photographs or photographic information in startlingly original ways. Kiefer has produced photographic books featuring images of model warships floating in a large tub, as well as large paintings in which mural-sized photographs are embedded. Richter's painting style encompasses photorealist reprises of notorious news photographs, and Polke makes photographic notebooks as adjuncts to his large-scale oil paintings.

This dialogue between photograph and canvas, which is also characteristic of U.S. artists like Chuck Close, Eric Fischl, and Lucas Samaras, suggests how influential the photograph has become as a index of social reality. These artists acknowledge the photograph's influence but, by transforming and dislocating their pictures by various means, they subvert its indexical status. Close divides his portrait *Linda* into gridded squares and transfers the data to canvas; Fischl paints figures from his beach scenes into new tableaux; Samaras pushes and pokes the emulsion of his self-portrait Polaroids until a new image emerges from the surface.

To a great extent, the veracity and integrity of the photographic image now matter less than its flexibility and capacity to be transformed. The work of Mike and Doug Starn is exemplary of the current urge to surpass the givens not only of the camera and its lens but also of the usually seamless photographic surface. The Starns' work purposely subverts the image provided by the camera and the conventional print, turning what would be a flat surface into an object of sculptural dimensions. While remaining true to the medium in terms of the prints themselves—their effects come from chemical development, not from painting—the collaborative brothers recontextualize the way in which pho-tographs are read and displayed. And while they take their own pictures, their usual subjects are appropriations of icons of art history.

If photographic information is no longer considered to be innocent within contemporary artistic practice, it still serves artists whose work is based on conceptual modes. For them, the photograph is both a social sign and a means of documenting social orders that otherwise would remain hidden. Bernd and Hilla Becher are probably the best known artists working today for whom photographs serve as instruments of cataloguing and classification. In their series of studies of architecture from the immediate industrial past, from steel blast furnaces to coal tipples, they reverse the notion that differences mask a common stereotype; in their work, the stereotype, which is a given, reveals differences that are fascinating and reassuring. By presenting their work in

groupings of images of similar industrial forms (and, in their books, as catalogs of functionally similar objects), they invite us to locate our sensibilities at the point where convention ends and individual invention begins.

The Bechers' influence is both direct and indirect. As teachers in their native Germany, they have passed on their unvarnished, monotone style and inventorying approach to a generation that includes Thomas Ruff, Thomas Struth and Andreas Gursky. In the United States, artists like Lewis Baltz and Dan Graham have produced catalogs of suburban houses and industrial parks that mine the Bechers' approach. Jim Dow's series of panoramic pictures of major-league baseball stadiums and Neil Winokur's multiple-image portraits show how pervasive this essentially documentary attitude has become. In addition to the Bechers, there is the influence of Andy Warhol, whose catalog of Polaroid portraits of celebrities and socialites was used as the basis for many of his silk-screened paintings.

Practices of classification and cataloguing have direct precedents in early photography, some of them benign and some not. The nineteenth century's pragmatic positivism and headlong rush to adopt scientific methodologies led to projects like Anna Atkins's early publication of images of ferns, as well as to ambitious projects like the *Missions Heliographiques,* in which five photographers, including Henri Le Secq, Gustave Le Gray and Edouard-Denis Baldus, were commissioned to inventory the architectural splendors of France.[32] Another, more problematic assay was undertaken by Hugh Welch Diamond, who tried to study mental illness through a catalog of portraits of asylum patients. Diamond's photography was part of an attempt to establish a scientific basis through which physiognomy could become predictive of social behaviors, medical conditions and ethnic categories, a project that finds its uneasy twentieth- century equivalent in the work of the German photographer August Sander.[33]

No matter how one views the early tradition of classification practices, however, its premises are distinct from those of present-day artists who, like Sol LeWitt, seem more interested in demonstrating the peculiarities of the physical world than in comprehending it through photographs. The world of images now seems too great to allow photographs, singly or in aggregate, to serve as simple evidence of scientific truth; instead, they reflect the dizzying diversity of information available to us, and the difficulties of organizing that information in any coherent, universal system. The more pictures the Bechers take, that is to say, the more infinite the possibilities of meaning seem.

Perhaps the most radical artistic response to our postmodern condition is the decentering of the photographic subject. While much of the world still looks at photographs as containers of reality—"Look, here's Aunt Jane at Disney World!"— it has become clear that no such one-to-one correspondence exists. The belief in the veracity of photographic information is a cultural convention, not a fact, which today is being amply demonstrated by the development of new

electronic means for invisibly altering photographic information. But our impending loss of faith in photographic images was recognized by artists long before computers began to threaten the evidentiary order of photographs.

By reducing the importance of a recognizable subject and vectoring the photograph's content in the direction of abstraction, artists have moved photography toward painting and sculpture and away from the medium's traditional functions. While in some sense all photographs are abstract, being two-dimensional records of three-dimensional scenes, and while one can find nineteenth-century images in which light and shadow function independently of the subject matter, the self-conscious, purposeful use of abstraction in photography really began early in this century, among European artists intent on investigating the formal first principles of the medium. The need to demonstrate photography's uniqueness as a medium of art, so palpable in the American images of Alfred Stieglitz, Paul Strand and Edward Weston, informs much of what we consider abstract photography. Other episodes of abstraction coincide with the flourishing of abstract painting: Aaron Siskind's and Ralston Crawford's pictures, for example.

Today's abstract photography is different inasmuch as it is occasioned not by a need to promote the medium as an art but by a recognition of the limits of photographic information. If all representations are in some sense clichés, then what about representations that appear to have no referents? Could abstraction itself be a kind of representation, as thoroughly encoded as any other image? Are abstraction's claims to spirituality and freedom of expression compatible with the conventions of the camera? These are the kinds of questions raised by the recent pictures of James Welling, Adam Fuss, Christopher Bucklow, and others.

In Welling's case, the tendency toward abstraction has a clear connection to postmodernist practices of the 1980s. While most of his contemporaries were raising issues about the influence of mass media on the photographic subject, and often appropriating mass-media stereotypes outright, Welling put the question differently: If all representation is based on stereotype, where is the stereotype located? In the subject? Or in the representational system itself? By forming images from wrinkled aluminum foil, chunks of gelatin and draped cloth, he suggested that it is possible to evoke subjective responses regardless of the putative content or subject matter.

This proposition has opened a new and vital territory for today's photographers, many of whom have returned to venerable modernist techniques like the photogram (or what Man Ray modestly called the Rayograph). By directly imprinting the image with the subject, as Adam Fuss does in his unique and uniquely beautiful prints, they also eliminate the stereotyping mediation of the camera lens. But as much as these pictures restore a sense of immediacy and directness to the photographic medium, they also seem imbued with a sense of

their own limitations. The aura of transcendence that characterizes most abstract painting is defused by the simple fact that the photographic print is, in the final analysis, a picture *of* something. One cannot escape from representation, the message reads, only dramatize its omnipresence.

The recognition that there is no escape from representation, only an accommodation to its beauty and its ambiguities, is fundamental to the contemporary practice of photography—in the art world, obviously, but even in unexpected realms like photojournalism. This has profoundly changed not only the kinds of photographic images that are being made but also the way we look at and respond to them. No longer is there an unbridgeable gulf between images created by artists and images found in magazines, newspapers or family albums; all partake of the codes of representation embodied by the medium of photography.

At the same time that the art of photography has been redefining itself, the development of computerized means of producing and altering photographic (or apparently photographic) imagery has profoundly altered the climate in which photographs are received, and the prospects for photography's future. The computer, however, is less a threat to photography than it is often made to seem, simply because its fictional devices ultimately are not that different from the camera's. Computer images, like camera images today, will be seen as representations of a simulated, second-degree reality with little or no connection to the unmediated world. This is one lesson we can learn from photographs, and especially from those of the last twenty five years: images exist not to be believed, but to be interrogated.

Published in *After Art: Rethinking 150 Years of Photography* (University of Washington Press, 1994), the catalog to an exhibition organized by Chris Bruce of the Henry Art Gallery and selected from the collection of Joseph and Elaine Monsen.

Notes

PART ONE

1. Jean Baudrillard, *Simulations,* translated by Paul Foss, Paul Patton and Philip Beitchman (New York: Foreign Agents Series/Semiotext(e), 1983), 25.

2. In his classic text, *The History of Photography from 1839 to the Present,* Newhall uses the technological development of the medium as a model for describing its aesthetic tradition. In other words, by his account the artistic practice of photography progresses in an ascending curve from its primitive beginnings to an apotheosis in the high modernism of the 1930s. As a result, in his 1982 revision of the history (New York: Museum of Modern Art) Newhall is unable to coherently account for photography's path since. Anything after Weston and Cartier-Bresson is, in his eyes, *prima facie* "post."

3. 1 have been unable to ascertain a "first use" of the term "Post Modern," which is also encountered as "Postmodern" or "postmodern," but it almost certainly dates from the late 1960s. In architecture, it is most often associated with Robert Venturi, the advocate of vernacular forms. In "On the Museum's Ruins" (*October* 13). Douglas Crimp cites the usage of "postmodernism" by the art critic Leo Steinberg in 1968, in Steinberg's analysis of the paintings of Robert Rauschenberg. But the term's popularity in the art world came much later; as late as 1982 John Russell of the *New York Times* could call Post-Modernism "the big new flower on diction's dungheap" (August 22, 1982, Section 2, page 1).

4. Charles Jencks, *The Language of Postmodern Architecture* (New York: Rizzoli International Publishers, 1981), 5.

5. See Sally Banes, *Terpsichore in Sneakers: Postmodern Dance* (New York: Houghton Mifflin, 1980), 1–19.

6. Douglas Crimp, "The Museum's Old/The Library's New Subject," *Parachute* 22 (spring 1981), 37.

7. See Derrida's seminal work, *Writing and Difference* (Chicago: University of Chicago Press, 1978), a collection of eleven essays written between 1959 and 1966.

8. Terry Eagleton, *Literary Theory: An Introduction* (Minneapolis: University of Minnesota Press, 1983), 96.

9. Ibid., 108.

10. Ibid., 129–130.

11. Rosalind Krauss, "Sculpture in the Expanded Field," *October* 8 (spring 1979), 42.

12. "If we are to ask what the art of the 70s has to do with all of this, we could summarize it very briefly by pointing to the pervasiveness of the photograph as a means of representation. It is not only there in the obvious case of photo-realism, but in all those forms which depend on documentation—earthworks..., body art, story art—and of course in video. But it is not just the heightened presence of the photograph itself that is significant. Rather it is the photograph combined with the explicit terms of the index." Rosalind Krauss, "Notes on the Index: Part 1," *October* 3 (spring 1970), 78.

13. Frederic Jameson, "Postmodernism and Consumer Society," in *The Anti-Aesthetic. Essays on Postmodern Culture,* ed. Hal Foster (Port Townsend, WA: Bay Press, 1983), 114.

14. See, for example, Douglas Crimp's essay "Appropriating Appropriation," in the catalog *Image Scavengers* (Philadelphia: Institute of Contemporary Art, 1982), 33.

15. Richard Prince, *Why I Go to the Movies Alone* (New York: Tanam Press, 1983), 63 and 69–70.

16. A more elaborated and political view of art photography's waning dominion can be found in Abigail Solomon-Godeau's "Winning the Game When the Rules Have Been Changed: Art Photography and Postmodernism," *New Mexico Studies in the Fine Arts,* reprinted in *Exposure,* 23:1 (spring 1985), 5–15.

17. Baudrillard, *Simulations,* 51.

18. For further evidence of photographic imagery's impact on pop and concurrent movements see the

catalog to the show *Blam, The Explosion of Pop, Minimalism, and Performance, 1958–1964,* organized by Barbara Haskell of the Whitney Museum of American Art in 1984, which surveyed the art of the 1960s.

19. Douglas Crimp, "The Photographic Activity of Postmodernism," *October* 15 (winter 1980), 91.

20. Jean-François Lyotard, *The Postmodern Condition: A Report on Knowledge,* translated by Geoff Bennington and Brian Massumi (Minneapolis: The University of Minnesota Press, 1984), 79. The emphasis is mine.

PART TWO

1. Sarah Greenough, "Alfred Stieglitz and 'The Idea Photography,'" *Alfred Stieglitz: Photographs and Writings,* Sarah Greenough and Juan Hamilton, eds. (Callaway Editions/National Gallery of Art, 1983), 12–13.

2. Stieglitz's portraits of Dorothy Norman were conspicuously absent from the 1983 National Gallery exhibition of his work, no doubt a reflection of O'Keeffe's lingering antipathy toward her.

3. Reprinted in *Edward Weston: On Photography,* edited and with an introduction by Peter C. Bunnell (Salt Lake City: Peregrine Smith Books, 1983), 88.

4. See the contents page and textual organization generally of Ben Maddow, *Edward Weston: His Life and Photographs* (Millerton, NY: Aperture, 1979). Maddow, the "official" Weston biographer after Nancy Newhall, does not account for the period from 1902, when Weston first took up the camera, to 1918.

5. For example, Peter C. Bunnell observes in his anthology of Weston's writings (see note 3 above, page xviii) that the years 1927 to 1934 constitute "the most significant of [Weston's] periods."

6. See my article "Edward Weston Rethought," *Art in America* (July–August 1975), for a discussion that broaches the psychoanalytic dimensions of Weston's oeuvre and couches its division in the Freudian terms of eros and thanatos.

7. Edward Weston, *California and the West* (New York: Duell, Sloan and Pierce, 1940; reprinted by Aperture, Millerton, NY, 1978).

8. Robert Adams, *From the Missouri West* (Millerton, NY: Aperture, 1980).

9. John Szarkowski, *American Landscapes* (New York: Museum of Modern Art, 1981), 11.

10. Walt Whitman, *Leaves of Grass* (New York: Limited Editions Club, 1942); reprinted by Paddington Press, New York, 1976, as *Edward Weston: Leaves of Grass.*

11. Amy Conger, *Edward Weston in Mexico, 1923–1926* (Albuquerque: Univ. of New Mexico Press, 1983), 7.

12. Ibid.

13. See Weston's article "Of the West/A Guggenheim Portrait," *U.S. Camera Annual,* 37 (1940), reprinted in Bunnell, 114.

14. Bunnell, 78.

15. Ibid., 79.

16. Maddow, 268–269; See also Richard Ehrlich's introduction to *Edward Weston: Leaves of Grass,* iii.

17. Ibid., 268.

18. Weston, *California and the West,* 181.

19. Letter from Charis Wilson to Peter Bunnell, April 25, 1981, quoted in Bunnell, xx.

20. These references and the biographical information used throughout this article can be found in *Ansel Adams: The Eloquent Light* by Nancy Newhall (San Francisco: The Sierra Club, 1963; reprinted by Aperture, 1980). A more recent source for details on Adams's life and beliefs can be found in the posthumously published *Ansel Adams: An Autobiography* (New York: New York Graphic Society, 1985).

21. Nancy Newhall, *The Eloquent Light,* 39.

22. Beaumont Newhall, *The History of Photography, from 1839 to the Present* (New York: Museum of Modern Art, 1964), 192.

23. This statement appeared in a publication of the Friends of Photography, the organization Adams helped found, so Bunnell might be excused. James Alinder, ed., *Untitled 37: Ansel Adams, 1902–1984* (Carmel, CA: The Friends of Photography, 1984), 54.

24. From "Equivalence: The Perennial Trend," *PSA Journal* (Spring 1963), 17–21, reprinted in *Minor White: A Living Remembrance* (Millerton, NY: Aperture, 1984), 12–13.

25. James Baker Hall, *Minor White: Rites & Passages* (Millerton, NY: Aperture, 1978).

26. Abe Frajndlich, *Lives I've Never Lived: A Portrait of Minor White* (Cleveland Heights, OH: Arc Press, 1983).

27. Arnold Gassan, *Report: Minor White Workshops and A Dialogue Failed* (Sun Prairie, WI: Baumgartner Publications, 1983).

28. László Moholy-Nagy, *Painting Photography Film,* translated by Janet Seligman (Cambridge, MA: MIT Press, 1969), 28.

29. Julie Saul, "Moholy-Nagy's Photographic Practice at The Bauhaus," in *Moholy-Nagy Fotoplastiks: The Bauhaus Years* (New York: The Bronx Museum of the Arts, 1983), 4–13.

30. Beaumont Newhall, 207.

31. Lucia Moholy-Nagy, *Moholy-Nagy: Marginal Notes* (Krefeld, West Germany: Scherpe Verlag, 1972), 71.

32. Originally published as a limited-edition artist's book in 1972 (Kazuhiko Motomura, Tokyo, and Lustrum Press, New York), *Lines of My Hand* was issued in a trade edition by Pantheon in 1989.

PART THREE

1. Charles Baudelaire, "The Salon of 1859," quoted in Beaumont Newhall, *Photography: Essays & Images* (New York: Museum of Modern Art, 1980), 113.
2. Jack Hurley, *Industry and the Photographic Image* (New York: Dover Publications, 1980), 79.
3. Leo Marx, *The Machine in the Garden, Technology and the Pastoral Idea in America* (New York: Oxford University Press, 1964).
4. Peter Bacon Hales, *Silver Cities: The Photography of American Urbanization, 1839–1915* (Philadelphia: Temple University Press, 1984).
5. Sally Stein, "Making Connections with the Camera: Photography and Social Mobility in the Career of Jacob Riis," *Afterimage* (May 1983), 14.
6. Quoted in Alexander Alland, Sr., *Jacob A. Riis, Photographer and Citizen* (Millerton, NY: Aperture, 1974), 150.
7. Ibid., 202.
8. Ibid., 70.
9. Hales, 5.
10. Hurley, 1.
11. Ibid., 2.
12. James Alinder, ed., *Carleton E. Watkins: Photographs of the Columbia River and Oregon* (Carmel, CA: The Friends of Photography, 1979), 27.
13. Hurley, 76.
14. "Photography Center at the Museum of Modern Art," *Springfield Sunday Union and Republican*, Sept. 11, 1938, 6E; quoted in Susan Dodge Peters, "Elizabeth McCausland on Photography," *Afterimage* (May 1985), 10.
15. Lewis Baltz, *Park City*, essay by Gus Blaisdell (Albuquerque: Artspace Press/ Castelli Graphics, in association with Aperture, Inc., 1980).
16. Lee Friedlander, *Factory Valleys. Ohio and Pennsylvania* (New York: Callaway Editions, 1982).
17. Evans's *American Photographs* recently has been reprinted, in a near-facsimile edition, by The Museum of Modern Art (1988).
18. Roberta Hellman and Marvin Hoshino, "The Photographs of Helen Levitt" *Massachusetts Review*, 19:4, 731–732.
19. John Szarkowski, *Winogrand: Figments from the Real World* (New York: The Museum of Modern Art, 1988).
20. Lee Friedlander, *The American Monument*, essay by Leslie George Katz (New York: The Eakins Press Foundation, 1976).
21. Robert Adams, *The New West: Landscapes Along the Colorado Front Range* (Boulder: Colorado Associated University Press, 1974).

22. Robert Adams, *Denver: A Photographic Survey of the Metropolitan Area*, (Boulder: Colorado Associated University Press, 1977).
23. Robert Adams, *From the Missouri West* (Millerton, NY: Aperture, 1980).
24. Robert Adams, *Our Lives, Our Children* (Millerton, NY: Aperture, 1984).
25. James M. Zanutto, in "An Off-Beat View of the U.S.A.," *Popular Photography*, 46:5 (May 1960), 106; reprinted in Anne Wilkes Tucker, ed., *Robert Frank: New York to Nova Scotia* (Boston: New York Graphic Society, 1986), 37.
26. Susan Sontag, *On Photography* (New York: Farrar, Straus and Giroux, 1977), 58.
27. Ibid., 104.

PART FOUR

1. See, for example, Van Deren Coke, *The Painter and the Photograph: From Delacroix to Warhol* (Albuquerque: Univ. of New Mexico Press, 1964). Photography obviously has borrowed from painting in equal measure; a case even has been made (in Peter Galassi's show *Before Photography*) that some pre-1839 paintings prefigure photography.
2. Frederic Jameson has made a useful distinction between parody and pastiche in his essay "Postmodernism and Consumer Society," noting that "pastiche is blank parody, parody that has lost its sense of humor." In *The Anti-Aesthetic: Essays on Postmodern Culture* (Seattle: Bay Press, 1983), 114.
3. Susan Sontag, *On Photography* (New York: Farrar, Straus and Giroux, 1977), 147, 149.
4. Douglas Crimp's seminal essay "Pictures," *October* 8 (spring 1979), introduced this notion into the critical discourse. See also his "The Photographic Activity of Postmodernism," *October* 15 (winter 1980).
5. Craig Owens, "The Medusa Effect or, The Specular Ruse," *Art in America* 72 (January 1984), 98.
6. Richard Prince, *Why I Go to the Movies Alone* (New York: Tanam Press, 1983), 63.
7. Sontag, 51.
8. Alan Trachtenberg, "Jan Groover's Photographs," in *Jan Groover: Photographs* (Purchase, NY: Neuberger Museum, 1983), 5.
9. See Susan Kismaric's essay in *Jan Groover* (New York: Museum of Modern Art, 1987).
10. Ibid.
11. Richard Marshall, *Robert Mapplethorpe* (New York and Boston: The Whitney Museum of American Art in association with New York Graphic Society Books, 1988).

PART FIVE

1. André Jammes and Eugenia Parry Janis, *The Art of French Calotype* (Princeton: Princeton University Press, 1983), xii.

2. Abigail Solomon-Godeau, "Calotypomania: The Gourmet Guide to Nineteenth Century Photography," *Afterimage* 11: 1 & 2 (summer 1983), 8.

3. Ibid., 11.

4. Douglas Crimp, "The Museum's Old/The Library's New Subject," *Parachute* 22 (spring 1981), 32–37.

5. Allan Sekula, "On the Invention of Photographic Meaning," *Artforum* (January 1975), 36–45.

6. Sally Stein, "Making Connections with the Camera," *Afterimage* (May 1983), 9–16.

7. James Clifford and George E. Marcus, eds., *Writing Culture. The Poetics and Politics of Ethnography* (Berkeley: The University of California Press, 1986).

8. C. D. B. Bryan, *The National Geographic: 100 Years of Adventure and Discovery* (New York: Harry N. Abrams, 1988).

9. Susan Meiselas, *Nicaragua* (New York: Pantheon Books, 1981).

10. Marc Riboud, *Visions of China,* introduction by Orville Schell (New York: Pantheon Books, 1981).

11. There is also a book of the same name, *In Our Time: The World as Seen by Magnum Photographers* (New York: W. W. Norton & Co., 1989).

12. Dan Hofstadter, "Stealing a March on the World," Part 2, *The New Yorker,* Oct. 30, 1989, 49.

13. Ibid., Part 1, Oct. 23, 1989, 82.

14. *El Salvador,* text by Carolyn Forche, edited by Harry Mattison, Susan Meiselas, and Fae Rubenstein (New York and London: Writers and Readers Cooperative, 1983).

15. Larry Clark, *Teenage Lust,* self-published, 1983.

PART SIX

1. See Oliver Wendell Holmes, "The Stereoscope and the Stereograph," *The Atlantic Monthly* 3 (June 1859), reprinted in Beaumont Newhall, ed., *Photography: Essays and Images* (New York: Museum of Modern Art, 1980), 54.

2. Both shows are well documented by their catalogs: *On the Art of Fixing a Shadow: One Hundred and Fifty Years of Photography*, by Sarah Greenough, Joel Snyder, David Travis, and Colin Westerbeck (Washington DC: The National Gallery of Art, 1989), and *The Art of Photography, 1839–1989,* edited by Mike Weaver (New Haven: Yale University Press, 1989).

3. Susan Sontag, *On Photography* (New York: Farrar, Straus, & Giroux, 1977), 51–53.

4. See, notably, Baudrillard's book *Simulations* (New York: Semiotext[e], 1983).

5. For Barthes's essential view of photographs as cultural signs, see his *Mythologies* (New York: Hill & Wang, 1972) and *Image-Music-Text* (New York: Hill & Wang, 1977).

6. This judgment does not include the Museum of Modern Art's "Photography Until Now" show, organized by John Szarkowski, which appeared in 1990, after these comments were written. But since Szarkowski has long been instrumental in formulating a modernist view of photography, one can speculate that it could.

7. The exhibition, organized by guest curator Joshua P. Smith, is documented in the book *The Photography of Invention: American Pictures of the 1980s* (Washington, DC: The National Museum of American Art, 1989).

8. Baudrillard, *Simulations,* 12.

9. Walter Benjamin, "The Work of Art in the Age of Mechanical Reproduction," in *Illuminations,* translated by Hannah Arendt (New York: Schocken Books, 1969), 217–251.

10. Andrew Pollack, "Chips That Emulate Functions of the Retina," *New York Times,* August 23, 1987, D-6.

11. Cynthia Goodman, *Digital Visions: Computers and Art* (New York: Harry N. Abrams, 1987), 10.

12. A. D. Coleman, "Fiche and Chips: Technological Premonitions," *Camera Austria* 10 (October 1982), 37–39.

13. Deborah A. Hoover, "Profession: Artist, A Contradiction in Terms?" *Art New England* (October 1987), 16.

14. Neil Postman, "TV or Not TV," *Village Voice,* May 6, 1986, 43.

15. Walter Benjamin, "The Work of Art in the Age of Mechanical Reproduction," in *Video Culture: A Critical Investigation,* ed. John G. Hanhardt (Layton, UT: Gibbs M. Smith, Inc., 1986). 40, 41.

16. Hans Magnus Enzensberger, "Constituents of a Theory of the Media," *The Consciousness Industry,* translated by Stuart Hood (New York: The Seabury Press, 1974), reprinted in *Video Culture,* 107.

17. Jean Baudrillard, "Requiem for the Media," from *For a Critique of the Political Economy of the Sign,* translated by Charles Levin (St. Louis: Telos Press, 1981), reprinted in *Video Culture,* 124–143.

18. Ronald Takaki, *A Different Mirror: A History of Multicultural America.* Boston: Little, Brown & Co., 1993

19. Benjamin, Arendt translation, 226.

20. Allan Sekula, "The Traffic in Photographs," in *Photography Against the Grain; Essays and Photo Works 1973–1983* (Halifax: The Press of the Nova Scotia College of Art and Design, 1984), 79.

21. Michael Foucault, "The Subject and Power," in

Art After Modernism; Rethinking Representation
(New York: The New Museum of Contemporary Art,
1984), 427.

22. Deborah Irmas, *Sophie Calle: A Survey*
(Los Angeles: Fred Hoffman Gallery, 1989), 10.

23. Rosalind E. Krauss, "Notes on the Index:
Seventies Art in America," October 4 (summer 1977),
pp. 58–67.

24. John Szarkowski, the director of the Department
of Photography at the Museum of Modern Art in New
York from 1962 to 1991, is without a doubt the most
lucid explicator of this point of view. See, in
particular, his article "A Different Kind of Art," *The
New York Times Sunday Magazine*, April 13, 1975.

25. Beaumont Newhall's *The History of Photography
from 1939 to the Present Day* (New York: The
Museum of Modern Art, 1982) was first published as
an exhibition catalog in 1937 and is now in its fifth
edition.

26. Among the sesquicentennial exhibitions mounted
in 1989 or thereafter were *On the Art of Fixing a
Shadow* (National Gallery of Art, Washington,
DC/The Art Institute of Chicago), *The Art of
Photography, 1839–1989* (Royal Academy of Arts,
London/Museum of Fine Arts, Houston), and
Photography Until Now (Museum of Modern Art,
New York).

27. *The Waking Dream: Photography's First Century*
was organized by the Metropolitan Museum of Art,
New York, and appeared there March 25–July 4, 1993.

28. *Image World* was the title of a much discussed
exhibition at the Whitney Museum of American Art,
November 8, 1989 to February 18, 1990. See *Image
World: Art and Media Culture*, by Marvin Heiferman
and Lisa Philips with John G. Hanhardt (New York:
Whitney Museum of American Art, 1989).

29. See Richard Prince, *Why I Go to the Movies Alone*
(New York: Tanam Press, 1983).

30. Sontag, 52.

31. Ibid, 111.

32. See André Jammes and Eugenia Parry Janis, *The
Art of the French Calotype* (Princeton, NJ: Princeton
University Press, 1983), 48, 52–56.

33. Sekula, 86–87.

Credits

TEXT CREDITS

"The Crisis of the Real," copyright © 1986, The Photographic Resource Center, Boston.

"Ansel Adams: The Politics of Natural Space," copyright © 1984, The Foundation for Cultural Review, Inc., New York.

"Richard Avedon's Portraits: Inverted Fashion, Fashionable Mud," copyright © 1987 *Art Press*, Paris.

"Photographic Culture in a Drawn World," copyright © 1984, Independent Curators Incorporated, New York.

"Laurie Simmons: Water Buoyed," copyright © 1981, The Soho Weekly News, New York.

"The Representation of Abstraction/The Abstraction of Representation," copyright © 1989, The Anderson Gallery, Virginia Commonwealth University and the Emerson Gallery, Hamilton College.

"Looking at Television," copyright © 1988, Independent Curators Incorporated, New York.

"Joel Sternfeld: The Itinerant Vision," appeared in *Joel Sternfeld: American Prospects* (New York: Times Books), copyright © 1987, Andy Grundberg.

"Displaced Sympathies: A Reading of Bill Burke's Portraits," was published in *Bill Burke: Portraits* (New York: Ecco Press), copyright © 1987, Andy Grundberg.

"Edward Weston's Late Landscapes" was published in *E.W.: 100 Years* (Carmel, CA: The Friends of Photography), copyright © 1986, Andy Grundberg.

"Photography in the Age of Electronic Simulation," "Subject and Style: Prospects for a New Documentary," and "The Machine and The Garden: Photography, Technology and the End of Innocent Space" are published here for the first time. Copyright © 1990, Andy Grundberg.

Introduction to *Tracing Cultures*, copyright © 1995, The Friends of Photography/Ansel Adams Center San Francisco.

"Photography's Dark Side: The Work of Sophie Calle," First published in *Mills College Art Gallery Bulletin,* Vol. II, 1991–1992.

"Sweet Illusion: Vic Muniz's *Sigmund*," copyright © 1997, *Artforum*.

Foreword to *Once Removed: Portraits* by J. John Priola, copyright © 1998, (New York: Arena Editions), NY, used by permission.

"Photography Beside Itself," copyright Henry Art Gallery, originally published in *After Art: Rethinking 150 Years of Photography,* 1994.

All other essays in this volume originally appeared in the *New York Times*. Copyright © 1999, Andy Grundberg.

PICTURE CREDITS

Frontispiece. Joe Gioia, *Andy Grundberg*, 1988. © by Joe Gioia.

1. Sherrie Levine, *After Walker Evans*, 1981. Courtesy Mary Boone Gallery, New York.

2. Louise Lawler, *Artist's Studio (Allan McCollum)*, 1983. Courtesy Metro Pictures Gallery, New York.

3. Alfred Stieglitz, *Georgia O'Keeffe*, 1918. Courtesy Metropolitan Museum of Art, New York.

4. Edward Weston, *Hill and Telephone Poles, Ranch County*, 1937. Courtesy Center of Creative Photography, Tuscon.

5. Ansel Adams, *Half Dome, Merced River, Winter, Yosemite National Park*, ca. 1938. Courtesy The Ansel Adams Trust.

6. Minor White, *Vicinity of Naples*, New York, 1955. Courtesy The Minor White Archive, Princeton University.

7. László Moholy-Nagy, Untitled *(Looking down from the Berlin Radio Tower)*, 1937. Courtesy The Art Institute of Chicago.

8. Jacob A. Riis, *Prayer Time in the Nursery, Five Points House of Industry*, ca. 1900. Courtesy Museum of the City of New York.

9. Walker Evans, *Self Portrait*, 1927. Courtesy Metropolitan Museum of Art, New York.

10. Helen Lewitt, Untitled ca. 1942, Courtesy Laurence Miller Gallery, New York.

11. Robert Adams, *Boulder County*, 1983. From *To Make It Home*, published by Aperture, 1990.

12. Joel Sternfeld, *Glen Canyon Dam, Page, Arizona*, 1982. © by Joel Sternfeld. Courtesy Pace/MacGill Gallery, New York.

13. Nan Goldin, *Nan and Brian in Bed, New York City*, 1983. Courtesy Nan Goldin.

14. Mark Tansey, *Action Painting II*, 1984. Courtesy Curt Marcus Gallery, New York.

15. Andy Warhol, Untitled (*Brooke Shields*), 1976–86. Courtesy Robert Miller Gallery, New York.

16. Chuck Close, *Maquette for "Francesco,"* 1987. © Chuck Close. Courtesy Pace/MacGill Gallery, New York.

17. Lucas Samaras, *Sittings (8x10)*, 1979. © Lucas Samaras. Courtesy Pace/MacGill Gallery, New York.

18. Cindy Sherman, *Untitled #155*, 1985. Courtesy Metro Pictures Gallery, New York.

19. Laurie Simmons, *Family Flying*, 1981. Courtesy Metro Pictures Gallery, New York.

20. Barbara Kruger, Untitled (*I shop therefore I am*), 1987. Courtesy Mary Boone Gallery, New York.

21. Richard Prince, Untitled (*Cowboy*), 1980–84. Courtesy Barbara Gladstone Gallery, New York.

22. Robert Cumming, *Tricycle and Cat*, 1981. Courtesy of the Artist. Reproduction slide by Stephen Petegorsky.

23. Jan Groover, Untitled 1983. Courtesy Robert Miller Gallery, New York.

24. Annette Lemieux, *Broken Parts*, 1989. Courtesy Josh Baer Gallery, New York.

25. Robert Mapplethorpe, *Thomas & Dovanna*, 1986. Courtesy Robert Miller Gallery, New York.

26. Doug and Mike Starn, *Double Rembrandt with Steps*, 1987–88. Courtesy Stux Gallery, New York.

27. Adam Fuss, Untitled, 1990. Courtesy Robert Miller Gallery, New York.

28. James Welling, Untitled 1981. Courtesy Jay Gorney Gallery, New York.

29. Lewis Hine, *Italian Immigrants, Eastside, New York*, ca. 1910. Courtesy George Eastman House.

30. *National Geographic*, Photographer unknown, 1896. Courtesy of *National Geographic*, Washington.

31. Francesco Scavullo, *Fawn Hall*, 1989. © by Scavullo, New York.

32. Marc Riboud, *The Antique Dealers Street*, 1965. Courtesy Magnum Photos.

33. Eugene Richards, *Crack Plague in the Red Hook*, 1988. Courtesy Magnum Photos.

34. Gilles Peress, *Demonstration in a stadium*, Tabriz, 1979. Courtesy Magnum Photos.

35. Larry Clark, Untitled (from 42nd Street Series), 1979.

36. Judith Joy Ross, Untitled (Eurana Park, Weatherly, Pennsylvania), 1982.

37. Nicholas Nixon, *Tom Moran and His Mother, Catherine Moran*, August 1987.

38. Bill Burke, *Lewis Vote Cool*, Valley View, Kentucky, 1975.

39. Larry Johnson, Untitled (*Black Box*), 1987. Courtesy 303 Gallery, New York.

40. Nancy Burson with Richard Carling and David Kramlich, *Three Major Races*, 1982. Courtesy Nancy Burson.

41. Robert Heinecken, *Connie Chung/Bill Kurtis*, 1985. Courtesy Curatorial Assistance, Pasadena.

42. NASA, *Exploding Challenger*, 1986. Courtesy NASA.

43. Dinh Q. Le, *Crossing Paths*, 1997. Courtesy Los Angeles Center for Photographic Studies, Los Angeles, from the private collection of Mrs. Doan Tu Diep.

44. J. John Priola, *Vince*, 1995. Courtesy Fraenkel Gallery, San Francisco.

Front cover photograph. Cindy Sherman, *Untitled #21*, 1985, Courtesy Metro Pictures Gallery, New York.

Back cover photograph. Laurie Simmons, *Walking Camera (Jimmy the Camera) II*, 1987. Courtesy Metro Pictures Gallery, New York.

Bibliography

BOOKS

Photography and Art: Interactions Since 1946, with Kathleen McCarthy Gauss, (New York: Abbeville Press, 1987).

Alexey Brodovitch (New York: Harry N. Abrams Inc., 1989).

Grundberg's Goof-Proof Photography Guide (New York: Fireside, 1989).

Mike and Doug Starn (New York: Harry N. Abrams Inc., 1990).

INTRODUCTORY ESSAYS, BOOKS

Missives, photographs by Anne Turyn (New York: Alfred van der Marck, 1986).

Bill Burke: Portraits (New York: Ecco Press/A Polaroid Book, 1987).

American Prospects, photographs by Joel Sternfeld (New York: Times Books, 1987).

Silent Passage, photographs by Mikael Levin (New York: Hudson Hills Press, 1988).

EXHIBITIONS ORGANIZED

Masking/Unmasking: Aspects of Post-Modernist Photography, The Friends of Photography Gallery, Carmel, California 1984.

Painted Pictures, Midtown Arts Center, Houston 1986.

Photography and Art: Interactions Since 1946, with Kathleen McCarthy Gauss, co-sponsored by the Los Angeles County Museum of Art and the Museum of Art, Fort Lauderdale (traveled to the Queens Museum, New York, and the Des Moines Art Center) [catalog] 1987.

Images of Desire: Portrayals in Recent Advertising Photography. Goldie Paley Gallery, Moore College of Art, Philadelphia (traveled to Cincinnati Art Center, the Queens Museum, Salina Art Center) [catalog] 1989.

INTRODUCTORY ESSAYS, EXHIBITION CATALOGS

"Kertész and Harbutt: Sympathetic Explorations," Plains Art Museum, Moorhead, Minnesota, 1978.

"Lee Friedlander Factory Valleys," Akron Art Museum, 1982.

"Drawing: After Photography," traveling exhibition, Independent Curators Inc., New York, 1984.

"Echo and Narcissus," for *Split Visions,* Artists Space, New York, 1985.

"Looking at Television," for *Acceptable Entertainment,* Independent Curators Inc., New York, 1988.

"Images of Desire: Portrayals in Recent Advertising Photography," Moore College of Art, Philadelphia, 1989.

"The Representation of Abstraction/The Abstraction of Representation," for *Abstraction in Contemporary Photography,* Emerson Gallery, Hamilton College, and Anderson Gallery, Virginia Commonwealth University, 1989.

ANTHOLOGIZED ESSAYS

"Edward Weston Rethought," in *The Camera Viewed* (New York: E. P. Dutton, 1979).

"Toward a Critical Pluralism," in *Reading into Photography* (Albuquerque: University of New Mexico Press, 1982).

"Edward Weston's Late Landscapes," in *EW: 100, Centennial Essays in Honor of Edward Weston* (Carmel, California: Friends of Photography, 1986).

"On the Dissecting Table: The Unnatural Coupling of Surrealism and Photography," in *The Critical Image* (Seattle: Bay Press, 1990).

SELECTED ESSAYS AND REVIEWS

Afterimage

"Some Thoughts on Two Photographs, New York City, Television, Flash, and Criticism (Among Other Things)" (January 1978).
"The Academy" (April 1980).
"Toward a Critical Pluralism" (October 1980).
"An Interview with John Szarkowski" (October 1984).

Art in America

"Edward Weston Rethought" (July-August 1975).
"Chicago: Moholy and After" (September-October 1976).
"Siskind at 75" (March-April 1979).
"Elegant and Existential: The Photographs of Ray K. Metzker" (May 1985).

Art Press (Paris)

"Richard Avedon: Inverted Fashion, Fashionable Mud" 120 (December 1987).
"Frank Stella: Abstraction and Mannerism" (interview), 125 (May 1988).

Close-up

"Against the Grain: Postwar Photography, New York Style" (spring 1986).

Modern Photography

"Currents in American Photography," with Julia Scully (series), 1978–1982.
"100 Years of Color," with Julia Scully and Mary O'Grady (June 1976).
"Portraits," with Julia Scully and Mary O'Grady (June 1977).
"Photos That Lie" (May 1978).
"Lee Friedlander. Extending the Play of Perception" (July 1978).

"Joel Meyerowitz's Cape Cod: Making Beauty an Issue" (June 1979).
"Inhabited Terrain: Joel Sternfeld's American Landscapes" (March 1980).
"Ray Metzker: Form as Expression" (November 1981).
"Landscape: Image and Idea," with Julia Scully, Howard Millard and Carol Squiers (August 1982).
"About Face" (November 1983).

The New Criterion

"John Berger and Photography" (March 1983).
"Ansel Adams: The Politics of Natural Space" (November 1984).

The New York Times Book Review

"Pictures of Change," review of *Nicaragua* by Susan Meiselas and *Visions of China* by Marc Riboud, June 14, 1981.
"Death in the Photograph," review of *Camera Lucida* by Roland Barthes, August 23, 1981.
"The Point of Photographs," review of *Beauty in Photography* by Robert Adams, November 29, 1981.
"Picture Takers with Style," review of *The Art Of French Calotype* by André Jammes and Eugenia Parry Janis, May 15, 1983.
"Self-Portraits Minus the Self," review of *Cindy Sherman,* July 22, 1984.

The New York Times Sunday Magazine

"Another Side of Rauschenberg," October 18, 1981
Positive (MIT Creative Photography Laboratory)
"Photography in Academe: Prospects for Survival," 1981–82.
Views (Photographic Resource Center, Boston) "The Crisis of the Real," (fall 1986).

Index